Surrealism and film after 1945

Manchester University Press

Surrealism and film after 1945

Absolutely modern mysteries

Edited by Kristoffer Noheden and Abigail Susik

MANCHESTER UNIVERSITY PRESS

Published by Manchester University Press
Oxford Road, Manchester M13 9PL

www.manchesteruniversitypress.co.uk

British Library Cataloguing-in-Publication Data
A catalogue record for this book is available from the British
Library

ISBN 978 1 5261 4998 5 hardback

First published 2021

Typeset
by Sunrise Setting Ltd, Brixham

To Alan Glass

Contents

Contents

Plates

Figures

Contributors

Mikkel Bolt Rasmussen is Professor in Political Aesthetics at the University of Copenhagen. He writes on the intersection of contemporary art, the avant-garde, and the revolutionary tradition, and he is the author of numerous books, including *After the Great Refusal: Essays on Contemporary Art, Its Contradictions and Difficulties* (Zero Books, 2018), *Trump's Counter-Revolution* (Zero Books, 2018), and *Hegel after Occupy* (Sternberg Press, 2019).

Krzysztof Fijałkowski is Professor of Visual Culture at Norwich University of the Arts. As a writer and researcher, he specialises in the history and theory of international surrealism, particularly surrealism in Central and Eastern Europe; surrealism, photography, and the object; and the relationship between surrealism and design. Recent publications include, as joint editor and contributor, *Surrealism: Key Concepts* (Routledge, 2016) and *The International Encyclopedia of Surrealism* (Bloomsbury, 2019).

Felicity Gee is Senior Lecturer in World Cinema at the University of Exeter. She is the author of the forthcoming monograph *Magic Realism: The Avant-Garde in Exile* (Routledge, 2020), and has published on Luis Buñuel, surrealism, avant-garde film, the Japanese avant-garde, and affect theory. She was awarded a British Academy grant to conduct archival research in Cuba on the interdisciplinary work of Alejo Carpentier. Felicity's research straddles film, art history, and literary studies, and her current projects investigate the collaborative work of modernist writers and artists that takes place across and between media.

Tom Gunning is Professor Emeritus in the Department of Cinema and Media at the University of Chicago. He is the author of *D. W. Griffith and the Origins of American Narrative Film* (University of Illinois Press, 1986) and *The Films of Fritz Lang: Allegories of Vision and Modernity* (British Film Institute, 2000), as well as over 150 articles on early cinema, film history and theory, avant-garde film, film genre, and cinema and modernism.

With André Gaudreault he originated the influential theory of the 'Cinema of Attractions'. In 2009 he was awarded an Andrew A. Mellon Distinguished Achievement Award and in 2010 was elected to the American Academy of Arts and Sciences. He is currently working on a book on the invention of the moving image. His theatre piece, created in collaboration with director Travis Preston, *Fantômas: Revenge of the Image* premiered in 2017 at the Wuzhen International Theatre Festival in Wuzhen, China.

Paul Hammond (1947–2020) was a writer, translator, painter, and a participant in surrealist activities in England and Spain. Among his many books are *L'Âge d'or* (BFI, 1997), *The Shadow and Its Shadow: Surrealist Writings on the Cinema* (3rd edn, City Lights, 2000), *Constellations of Miró, Breton* (City Lights, 2000), and *Luis Buñuel: The Red Years, 1929–1939* (with Román Gubern, University of Wisconsin Press, 2012).

Michael Löwy is Emeritus Research Director in social sciences at the Centre national de la recherche scientifique (CNRS) and lectures at the École des hautes études en sciences sociales. He is an active member of contemporary surrealist groups. He has published several books and many articles, translated into 29 languages. Among his works translated into English are *Redemption and Utopia: Libertarian Judaism in Central Europe* (Stanford University Press, 1992), *On Changing the World: Essays in Political Philosophy, from Karl Marx to Walter Benjamin* (Humanities Press, 1993), *Romanticism against the Tide of Modernity* (with Robert Sayre, Duke University Press, 2001), *Fire Alarm: Reading Walter Benjamin's 'On the Concept of History'* (Verso, 2005), *Morning Star: Surrealism, Marxism, Anarchism, Situationism, Utopia* (University of Texas Press, 2009), and *Romantic Anti-Capitalism and Nature: The Enchanted Garden* (Routledge, 2020).

Arnaud Maillet is Associate Professor in contemporary art history at Sorbonne University (Arts Faculty), and a member of the Centre André Chastel, Laboratoire de Recherche en Histoire de l'Art (UMR 8150). His research interests intersect with the history of art and the history of the gaze. His books include *The Claude Glass: Use and Meaning of the Black Mirror in Western Art* (Zone Books, 2004; French edition: *Le miroir noir. Enquête sur le côté obscur du reflet* (Kargo / L'Eclat, 2005)), *Prothèses lunatiques. Les lunettes, de la science aux fantasmes* (Kargo / Amsterdam, 2007; Italian translation: *Gli Occhiali. Scienza, arte, illusioni* (Milan: Raffaello Cortina, 2010)), and *Per Barclay, photographer* (rue Visconti, 2011).

Kristoffer Noheden is Research Fellow in the Department of Media Studies, Stockholm University. He is the author of *Surrealism, Cinema, and the*

Search for a New Myth (Palgrave Macmillan, 2017) and some twenty articles and book chapters on surrealism in relation to ecology, exhibition history, film theory, and occultism. Noheden's current research concerns animals and ecology in surrealist art, film, and writing from 1919 to 2018, as well as the history of surrealism in Sweden. He is co-curator of the exhibition *Alan Glass: Surrealism's Secret* at Leeds Arts University in 2021.

Gavin Parkinson is Professor of Modern Art at The Courtauld Institute of Art, London and was editor of the Ashgate and Routledge series Studies in Surrealism. He has published numerous essays and articles, mainly on surrealism. His books are *Enchanted Ground: André Breton, Modernism and the Surrealist Appraisal of Fin-de-Siècle Painting* (Bloomsbury, 2018), *Futures of Surrealism* (Yale University Press, 2015), *Surrealism, Art and Modern Science* (Yale University Press, 2008), *The Duchamp Book* (Tate Publishing, 2008), and the edited collection *Surrealism, Science Fiction and Comics* (Liverpool University Press, 2015); and *Robert Rauschenberg and Surrealism: Art, 'Sensibility' and War in the 1960s* is forthcoming from Bloomsbury.

Michael Richardson is Visiting Fellow at Goldsmiths, University of London. He is the author of numerous publications on surrealism and other topics, including *Surrealism and Cinema* (Berg, 2006), and is general editor of *The International Encyclopedia of Surrealism* (Bloomsbury, 2019).

Abigail Susik is Associate Professor of Art History at Willamette University and the author of *Surrealist Sabotage and the War on Work* (Manchester University Press, 2021). She has published many essays devoted to surrealism, and is co-editor of *Radical Dreams: Surrealism, Counterculture, Resistance* (Penn State University Press, 2021). She co-curated the exhibition *Alan Glass: Surrealism's Secret* at Leeds Arts University in 2021, and she also curated a major survey of Imogen Cunningham's photographs at the Hallie Ford Museum of Art in 2016. Susik is a founding board member of the International Study for the Society of Surrealism and co-organiser of its 2018, 2019, and 2022 conferences.

Acknowledgements

This volume came into being thanks to the collaboration, friendship, and sheer enthusiasm of many scholars working in the interdisciplinary and international field of surrealism studies. It was an excited hotel-lobby conversation after a Modernist Studies Association (MSA) conference panel on surrealism in Pasadena, CA in November, 2016 that sparked the earliest conceptualisation of this project. Tessel M. Bauduin and Kristoffer Noheden co-organised a session for MSA 18, and Abigail Susik made their acquaintance when she contributed a paper. This project would not have occurred without Tessel's collegiality and commitment to the field.

The next step towards this volume was the three-panel stream 'Surrealism and Film after 1950' that we organised at the MSA conference in Amsterdam in August the following year. We want to thank all the speakers for their participation, as well as Tania Ørum and Roger Rothman, who agreed to chair the sessions. Between 2016 and 2020, we presented aspects of our own chapters for this volume at various venues, including Museo de Arte Moderno, Mexico City, and the First Annual International Society for the Study of Surrealism Conference, at Bucknell University in Lewisburg (2018).

Matthew Frost at Manchester University Press has been a sheer joy to work with, and we are extremely grateful for his ongoing enthusiasm for this project and all the patient assistance he offered along the way. Many people contributed assistance with images and permissions, and in particular we thank: Alan Glass, who supplied our extraordinary cover image as well as an interior plate, Michel Zimbacca, Karin Kyburz, and Gallery Wendi Norris. We are also grateful to the Department of Media Studies at Stockholm University, who generously supplied a grant to cover part of the image costs as well as indexing.

We are also indebted to conversations with numerous people, including Rikki Ducornet, Alan Glass, Mattias Forshage, Niklas Nenzén, V. Vale, Anna Watz, Per Faxneld, Robert Shehu-Ansell, Susan Aberth, M. E. Warlick, Patricia Allmer, Judith Noble, Gabriel Weisz Carrington, Luis Urías, Tufic Makhlouf Akl, and Manuel Felguérez, whose knowledge of surrealism and

many other topics has helped inform our work with this volume. We extend a sincere thanks to Ron Sakolsky, who published a short preview of our own two chapters in *The Oystercatcher* (2019).

Finally, we want to thank our contributors for their groundbreaking scholarship and their dedication to this project. Special thanks are due to Paul Hammond, who came to the volume at a late stage and who, with great generosity and enthusiasm, agreed to contribute a chapter in spite of serious health problems. Although writing while living with advanced stages of the cancer that would ultimately take his life, amid bouts of chemotherapy and during the first wave of the pandemic, Paul Hammond composed all but his essay's conclusion in a mere three months. His spirit and his scholarship remain an inspiration, and this volume as a whole is testament to the lasting influence of his work across several decades of writings and translations. 2020–21 also saw the tragic demise of surrealist cineastes Nelly Kaplan, Petr Kral, Georges Goldfayn and Michael Zimbacca, whose films and writings were vital for the surrealist spirit to persist in the cinema.

Introduction: absolutely modern mysteries

Abigail Susik and Kristoffer Noheden

In 1951, André Breton wrote that the cinema is the place where 'the only *absolutely modern* mystery is celebrated'.[1] 'What we saw in movies, which-ever they were,' Breton wrote, 'was only a lyrical substance that had to be mixed and stirred in bulk and haphazardly. I think what we prized most in them, to the point of being indifferent to anything else, was this capacity to transport the mind elsewhere.'[2] Fusing modernity and mystery, ritual and technology, Breton's allusion to Arthur Rimbaud's imperative to be abso-lutely modern is energised by his assertion of film's capacity to unsettle the sta-tus quo and explode conventions. A medium at once immediate and occult, film charged art and life with an electric significance attuned to the forces of love and desire.[3] Film, and popular film in particular, possessed transportive qualities infused with poetry of the kind so valued by the surrealists, but was unique in that it immersed the masses in a darkened, oneiric sphere in which the fabric of their daily lives was viscerally distanced, fragmented, and trans-formed into a flux of images akin to the logic of dreams.

Surrealists invested film with similar expectations even before the move-ment's official inception in 1924. In the early years, surrealist writers includ-ing Breton, Louis Aragon, and Jean Goudal lauded the medium for its seemingly innate, involuntary dissolution of the borders between reality and imagination, waking life and dreams, as well as its transmutation of everyday objects and environments into dramatic personages and settings for incur-sions of marvellous poetry.[4] Early surrealism's emphasis on automatism and collective explorations of the unplumbed depths of the city found a counter-part in the camera's 'blind' gaze on the hieroglyphs of the material world and its juxtaposition of things and views ordinarily kept separate.[5] Subversions of societal repression erupted in Chaplin shorts as much as in Feuillade feuille-tons, the Tramp and the phantasmic Fantômas both undermining the logic of identity and providing glimpses into the unruly machinations of the uncon-scious. If film was replete with moments of an involuntary surrealist sensibil-ity, the surrealists, cognisant of the cost and technical skills involved in film-making, were nevertheless wary of the possibility of making voluntary

surrealist film. Early attempts at surrealist cinema, such as Man Ray's
Emak-Bakia (1926) and Germaine Dulac's Artaud adaptation *La Coquille et
le clergyman* (1928), were deemed failures by the surrealists compared with
the rich poetry emanating from genre fare. A new kind of savage cinematic
poetry was introduced by Luis Buñuel and Salvador Dalí in their debut short
Un chien andalou (1929). Enthusiastically received by surrealists, *Un chien
andalou* realised a script purportedly written with automatic methods, and in
a style that drew upon slapstick comedy as well as film's disorientating poten-
tial for creating unlikely metaphors through cuts and juxtapositions. For their
next film, *L'Âge d'or* (1930), Buñuel and Dalí – the latter's engagement in the
film dwindling – collaborated with many members of the surrealist group,
turning film-making into an experiment in surrealist collectivity. In a group
statement, the surrealists insist upon the explosive political power of *L'Âge
d'or*.[6] Fascists confirmed their belief in the film's incendiary potential when
they stormed the theatre in Paris where it was showing. The escalation of
white supremacy and fascist oppression throughout the 1930s and World War
II had a significant impact upon the post-war surrealist approach to film.[7]

After World War II, Breton became more interested in the nature of cinema's
role in 'this era of *inhumanism*'.[8] 'As in a Wood' was first published in a special
surrealist issue, nos 4–5, of the journal *L'Âge du cinéma*, a short-lived but lively
publication with a strong predilection for surrealism throughout its six issues
published between 1951 and 1952 (Figures 0.1 and 0.2). In this pivotal post-
war meditation on film, Breton emphasised cinema's powerful disruptive
potential, which was not necessarily a given in commercial film productions,
but, rather, could be strategically tapped into by an intentional form of specta-
torship privileging an extreme 'disorientation' (*sur-dépaysement*) capable of
destabilising perceived reality. 'There is a way of going to a movie theater just
as others go to church … irrespective of what is showing on the screen,' he
asserted.[9]

Following the end of World War II, the surrealist group in Paris reformed
and attracted several new members. These included a host of ardent cine-
philes devouring the many films shown around the city in theatres, from the
Paris Cinémathèque to the working-class fleapits. Among them were Robert
Benayoun, Georges Goldfayn, Ado Kyrou, and Gérard Legrand, who com-
prised the editorial board of *L'Âge du cinéma*. Contributors to the special
surrealist issue 4–5 in September of 1951 included surrealist stalwarts Breton,
Benjamin Péret, and Toyen, alongside younger members such as Jean-Louis
Bédouin, Nora Mitrani, and Michel Zimbacca. In his contribution to *L'Âge
du cinéma*, Péret lashed out against commercial film, which he chastised for
its corruption of a once scintillating and promising medium.[10] Like Péret,
Breton felt that film had betrayed some of its initial power by succumbing to
'a theatrical type of action', but unlike his poet peer, Breton still discerned a

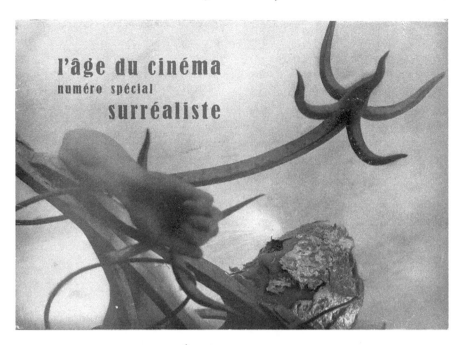

Figure 0.1　*L'Âge du cinéma* 4–5 (1951), cover

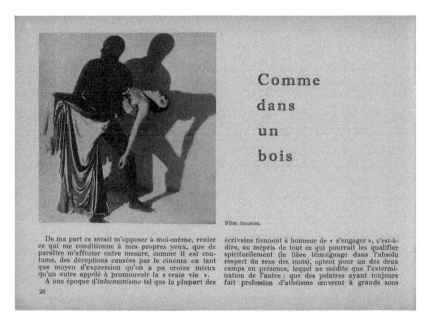

Figure 0.2　André Breton, 'Comme dans un bois', in *L'Âge du cinéma* 4–5 (1951)

shimmering potential in film.[11] Not only did the cinema allow for a thoroughly modern, collective, and non-religious mystery to be celebrated. Film also had an unparalleled capacity to 'trigger the mechanism of *correspondences*', an enigmatic quality that conjoined the archaic and the modern via its very ontology as modernity's premier medium.[12] This mechanism depended more often than not upon 'as great a discord as possible between the "message" intended by the film and the frame of mind of its recipient', combined with the medium's use of montage and editing to dialectically collide opposites, such as night and day.[13] Yet, if the surrealist reception of popular cinema went deliberately against the grain of narrative and plot, according to Breton, the ultimate goal of this form of discordant viewing was the revelation of heightened awareness that led to new horizons of experience and consciousness. Human biases, fears, and oppressive tendencies might be challenged by the disorientating experience of watching a film in a darkened theatre in the company of complete strangers. A healing of the fractured world might also be effected by film's fragmentation and then reconstitution of filmed reality. Film, then, incarnated surrealism's continued insistence on the necessity of a radical transformation of the world.

Consolidating the continued significance of film for surrealism in a different way, a limited edition of the *L'Âge du cinéma* issue was signed by all seventeen contributors and included five film strips, under the rubric of 'symptomatic filmomanias', as well as a black-and-white linocut by the Cuban artist Wifredo Lam (Figure 0.3). The spectral, spiny creatures etched in white lines on a black background in Lam's linocut evoke the pairing of black-and-white film with cave painting, perhaps giving further credence to Breton's description of the cinema as a place where rituals take place in a profoundly modern setting. Taken together, the contributions to the special surrealist issue of *L'Âge du cinéma* indicated that for surrealism, film was as ripe as ever with promises of intoxication, enchantment, and strategies for resisting 'inhumanism'. But where the early surrealist writings on film have secured their place in film history and the history of film theory, the surrealist movement's presence in post-war film culture remains a blind spot in film studies.[14]

Surrealism and Film after 1945: Absolutely Modern Mysteries provides the first coherent and expansive look into the dynamic heterogeneity of transnational surrealist film culture since the mid-twentieth century, with a focus on the myriad ways in which surrealists themselves engaged with cinema. Past literature on this subject by critics and surrealists has focused largely on three primary areas: films made by surrealists and surrealist film theory from the first half of the twentieth century; the wide array of commercial films favoured by surrealists; and, finally, films or directors directly or indirectly influenced by surrealism. Rather than return to these more familiar

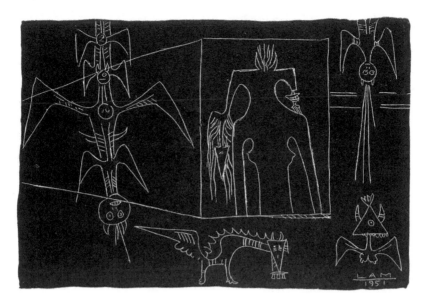

Figure 0.3 Wifredo Lam, untitled linocut 005 (5101), 1951

inquiries, our volume seeks to expand the existing discourse and catalyse future studies of this rich topic by working under the presumption that surrealist cinema and its widespread impact cannot be fully understood unless its drastically understudied post-war history is consistently acknowledged and charted. This volume, with its necessarily circumscribed scope, is just one point of commencement for an undertaking that requires extended future research into many different subjects. While pre-World War II surrealist cinema and surrealist-influenced films are addressed at times in the chapters that follow, our emphasis lies elsewhere. Instead of seeking to delimit the field by rigorously distinguishing between that which is surrealist and that which influences or is influenced by surrealism, our methodological aim broadens the scope of surrealism's history and simultaneously deepens our understanding of its pervasive role in international film culture. We ultimately seek a more refined set of tools for the analysis of the long life of surrealist film.

Surrealism's engagement with film after 1945 was not confined to criticism, but extended to a rich legacy of film-making, screenplay writing, scenography, and occasionally acting. In the seventy-five years since the end of World War II, an increasingly international and gender-diverse set of surrealist or surrealist-affiliated film-makers and contributors have interacted with the movement in and through film. As the chapters in this volume demonstrate, Maya Deren, Nelly Kaplan, Luis Buñuel, Jan Švankmajer, Joseph Cornell, Alejandro Jodorowsky, Max Ernst, Robert Benayoun,

Michel Zimbacca, Wilhelm Freddie, the Danish faction of the Situationist International, Alan Glass, Juan López Moctezuma, Jean Desvilles, and Leonora Carrington are but a selection of the many figures who have contributed in various capacities to surrealist cinema after World War II. Some of them, including Freddie, Benayoun, Zimbacca, and Švankmajer, were, or still are, active participants in a reinvigorated surrealism with broad geographic reach. Others, like Buñuel, Carrington, Jodorowsky, and Glass, imaginatively individualised their approaches to surrealism in Mexico. Still others, like Deren and the Danish Situationists, had conflicted relationships with surrealism. Regarding the two American film-makers, Cornell exhibited with the surrealists, but kept a certain distance from them; Deren, on the other hand, posited her films and poetics to be in opposition to surrealism, but her development as a film-maker was notably shaped by her proximity to surrealists in exile in New York during the war. Taken in sum, the film-makers, artists, writers, actors, and critics discussed in this book hailed from Argentina, Canada, Chile, the former Czechoslovakia, Denmark, England, France, Germany, Mexico, Spain, and the United States. They were directly involved at some point with a living, transnational surrealism that has continued to grow and morph throughout the post-World War II period and into the present moment. It is our contention, therefore, that their contributions to surrealist film, as well as to the vast sphere of surrealist-influenced film that lies beyond the parameters of our study, only makes sense in relation to this dynamic development and transnational context of surrealism in its later decades.

Surrealism in the post-World War II climate

Surrealism appears to be something of a repressed other in the history and historiographies of post-war film culture. Evading received categories and expected tastes, surrealism has escaped being assimilated into narratives of either the modernist or the cult film, instead retaining a polymorphous position. With a few notable exceptions, film-studies scholarship tends to confine surrealist film to a small number of examples from the inter-war period and limit itself to the early period of surrealist film criticism.[15] Kristin Thompson and David Bordwell's standard textbook, *Film History*, claims that, 'During the early 1930s, Surrealism as a unified movement was breaking up … By 1933, the European phase of the movement was over, but, as with Dada, Surrealism's influence was felt strongly in the era after World War II.'[16] Declared dead, surrealism is reduced from a radical collective, political, and transformative force to a historical aesthetic influence. Why has there been a tendency to ignore the long life and international parameters of surrealist

cinema? It is likely not possible to arrive at an exact explanation, but there are intimations of certain causes, some of which are generally relevant for surrealism studies and some of which are specific to film studies.

Thompson and Bordwell's dating of surrealism's demise to 1933 is an extreme variation of the tendency of scholarship in all fields to claim that surrealism ended with the outbreak of World War II; or, when surrealism's continued existence is acknowledged, it is usually dismissed as having 'lost its strength' and become 'arcane and disappointing'.[17] The 'filmic output' of surrealists in general was perceived to be 'modest' and lacking in 'surprise' after World War II, and the dissemination of surrealist ideas into popular culture at large was understood for the most part as a situation of 'surrealism's gold' as 'devalued currency'.[18] Such reactions can be traced in part back to the French cultural and political climate following World War II. Art historian Alyce Mahon notes that when the war ended, Paris was in the dual grips of existentialism, with its belief in the torment caused by free will and its call for 'engagement' in art and literature, and Stalinism, which had infiltrated cultural institutions. In post-war Paris, surrealists found that their opposition to humanist notions of free will, their refusal to instrumentalise art by placing it directly in the service of politics or commerce, their long-standing hostility to media attention, and their adamant refusal, dating back to 1932, of Stalinism, were more inopportune than ever. Surrealism was subsequently relegated either to the past or to irrelevance by the cultural establishment.[19]

The large international exhibition *Le Surréalisme en 1947*, which manifested the international reach of surrealism and announced the movement's post-war strategy of searching for a new myth to strengthen the grounds for collective action, was largely considered obscurantist and reactionary by the press and fellow intellectuals. Such judgements continued to hound surrealism. It made little difference that surrealists were highly aware of the changing conditions for revolt and subversive poetic action following a war that deployed technology and rational organisation to such extreme ends that the very existence of life on the planet was threatened. Rather than being a retreat into the arcane, the surrealist turn to myth and magic was an at once measured and desperate attempt at countering the destructive tendencies in the culture surrounding it, whether in the form of the perils of unfettered technology, rampant science, or the anti-libertarian machinations of Stalinism, capitalism, and France's ongoing colonial exploitation. Turning to Trotskyism, anarchism, and Romantic utopianism, the French surrealist group sought out alternative routes for radical political action in their vigilant struggles against what Breton later defined as 'miserabilism', or the entwined threat of Stalinism, fascism, and capitalist technocracy.[20] Surrealism's deviation from the dominant tendency in left politics combined with

its explorations of myth and magic led to a marginalisation in aesthetic and intellectual history that is far from proportionate when one considers the movement's lively and restless transnational activities, and the profound, persistent impact it has made on culture at large.[21]

In the last fifteen years or so, a more interdisciplinary and comprehensive field of surrealism studies has emerged, propelled in particular by game-changing contributions by art historians, literary scholars, political theorists, and practising surrealists, making it impossible to deny surrealism's expansive parameters both historically and geographically.[22] In this reinvigorated study of surrealism, attention has also been drawn to the movement's complex engagement with such topics as science, philosophy, ecology, crime, work, counterculture, occultism, gender, and race.[23] These advances present the development of surrealism as complex, adventurous, and invigorating, and surrealism itself as radically anti-authoritarian. No longer does scholarship fixate on simplified models of conflict, such as presuming that surrealism was permanently riven as a result of debates in the 1930s between Breton and the editor of the journal *Documents*, Georges Bataille. Scholars who adhered to this prominent narrative between the mid-1980s and the early 2000s typically sided with the presumably more materialist Bataille against a Breton often ridiculed for his purported idealism. While Bataille and his circle constituted an alternative to Bretonian surrealism in the inter-war period, by World War II Breton and Bataille were no longer antagonists, as is evidenced by Bataille contributing an essay to the *Le Surréalisme en 1947* exhibition and devoting a significant number of articles to surrealism.[24] Looking beyond the hermeneutic framework of a surrealism both dominated and divided by Bretonian and Bataillian theories, current scholarship in interdisciplinary surrealism studies has demonstrated a concerted effort to de-hierarchise the skewed focus on these important pre-war tendencies by placing them in conversation with lesser-known sources and contributors from surrealism's vast milieu, but this rapidly developing field's investigations have not yet made their full impact on the study of surrealist film and its substantial reach.

New approaches to surrealism and film

There are also more specific mechanisms that have mitigated against surrealism in film history. One of these may be a persistent scholarly fascination with the French film journal *Cahiers du cinéma*. As Michael Richardson shows in his chapter in this volume, many surrealist film critics contributed to the rival film journal *Positif*. Founded in 1952, *Positif* positioned itself against the better-known (particularly in the anglophone world) *Cahiers du*

cinéma and the French new wave (*nouvelle vague*) film-makers associated with it.[25] The *Cahiers* critics' championing of the auteur theory, along with their promotion of the new wave, left lasting marks on film criticism and film theory, which appear as strong as ever, even in the throes of a by now decades-long critical questioning of the notion of the auteur.[26] If *Cahiers du cinéma* made a tangible mark on the mainstream of film history and theory, outside of France *Positif* and its writers have mainly affected the more marginal regions of cinephilia.[27] Surrealist critics tended to navigate according to a compass calibrated to steer them to a maximum of poetic expression, rather than to conventional notions of quality. Perhaps we can call it a diagonal cinephilia, with a gloss on Roger Caillois' transversal concept of diagonal science.[28] Much as Caillois seeks to establish points of connection across biology and geology, the natural sciences and literature, so the surrealist critic Kyrou pursued a poetic charge that encompassed early silent cinema, Hollywood comedies, soft-core pornography, exploitation films, and lowbrow horror, as well as a select few works by art film-makers including Michelangelo Antonioni, Ingmar Bergman, and Andrzej Wajda.[29] From the outside, the resulting counter-canon likely appeared arbitrary and erratic, fuelled by a disrespectable appetite for the fantastic and for Romantic exoticism.

Difficult to assimilate to the mainstream of film reception, these wild flights between different types of film instead found successors in such phenomena as paracinema, midnight movies, and the cult film, which revelled in sensational and so-good-it's-bad films in considerably less discerning ways than that of the poetically driven surrealists.[30] Still, some surrealist films fit comfortably within such omnivorous paracinephiliac cultures. Kyrou's *The Monk* (*Le Moine*, 1972), Harry Kümel's vampire film *Daughters of Darkness* (*Les Lèvres rouges*, 1971), with a script by former surrealist Jean Ferry, and Jodorowsky's *The Holy Mountain* (*La montaña sagrada*, 1973) embrace excess, champion bad taste, and bend genre tropes in ways that seem designed to speak to these contexts; Jodorowsky's *El Topo* (1970) was indeed the first midnight movie in New York. Surrealist critics have also made a more far-reaching mark on film history by coining the influential term 'film noir' to describe a body of American crime films.[31]

But it is not only surrealist film criticism that is too transversal and unpredictable to be easily manageable. Parallel to the resurgence of surrealist film criticism after World War II, an unprecedented number of transnational surrealists or surrealist-affiliates tried their hands at making films, co-directing, or writing scenarios. Among them, beside those already mentioned, were Marcel Mariën, Ado Kyrou, Georges Franju, Jacques Brunius, Walerian Borowczyk, Roland Topor, Fernando Arrabal, Ludvik Švab, and David Jařab – but also such adjacent film-makers as Wojciech Has, Alain Resnais, Jean Rouch, Chris Marker, Raúl Ruiz, René Laloux, and André Delvaux.[32]

A few of these rose to fame, but those closest to surrealism have remained on the margins of film history. Similarly, the films by Benayoun, Kaplan, and Kyrou, some of which are discussed in this volume, received scant attention compared with those of the new wave and its permutations. Numerous other instances of surrealist film-makers traversing the inter-war and post-war periods also abound, beyond the well-known and extensively studied examples of Luis Buñuel, Salvador Dalí, Hans Richter, and, increasingly in recent scholarship, Jean Painlevé.[33] Other examples are more evasive. Raymond Borde's 1964 documentary on the cross-dressing magic paintings and photography of Pierre Molinière is frustratingly difficult to find. Some films from the surrealist orbit pose particular challenges to film history, such as the unfinished, lost, or home movies by Alice Rahon, Jindřich Heisler and Georges Goldfayn, René Magritte, Henri Michaux, Martin Stejskal, George Melly, and Robert Short.

The sustained but sometimes conflicted surrealist investment in film can also be seen in the fact that Breton in 1963 proposed a documentary film on surrealism as a riposte to the frequent declarations of the movement's death.[34] Taking up the idea, Benayoun and Brunius set out an ambitious plan to render surrealist activities more concretely captivating through film. Although the project was stalled by creative differences only a few days into filming and never completed, the very idea of a revitalising documentary on surrealism speaks to the surrealists' unceasing belief in the medium as an energising vehicle for the reenchantment of the world. Attempts have also been made at documentaries devoted to surrealist exhibitions. Jorge Camacho and Michel Zimbacca attempted to make a film about the 1965 exhibition *L'Écart absolu* but never managed to raise enough funding; some of the extant footage was issued on the 2012 DVD *Les Surréalistes et le cinéma*. RE/Search maverick V. Vale brought his film camera with him when he visited the 1976 Chicago surrealist exhibition *Marvelous Freedom, Vigilance of Desire*. After a long time in storage, the footage was edited by experimental film-maker Marian Wallace and screened at a June 2018 exhibition celebrating the fiftieth anniversary of the Gallery Bugs Bunny in Chicago.

The diversity of format and style in the films mentioned and in the ones discussed in the pages of this book may be another reason why a paradigm for surrealist film has proven so inchoate and difficult to assess by critics and scholars. In spite of the status of Buñuel and Dalí's pioneering *Un chien andalou* as an avant-garde classic, surrealist film cannot be subsumed under such rubrics as avant-garde or experimental film. Instead, we suggest two avenues: the first is to consider surrealist film less as essence, and more as a relation between the surrealist movement as a living historical entity and the medium of film; the second is to compare the multiplicity of film formats and styles with the even broader manifestation of surrealism in art

and literature. Ado Kyrou secured the first avenue already in the title of his comprehensive 1953 study, *Le Surréalisme au cinéma*. In it, he examined a handful of surrealist films alongside a much broader selection of films that could be productively viewed from the perspective of surrealism – or, as Breton put it, they contained a lyrical substance to be extracted and blended into a potent tonic. Surrealism at once dethrones the 'author' as producer, and empowers the spectator or reader as 'receiver'. The surrealist approach to film may represent the pinnacle of these democratising ideas set into action.

As for the second avenue, the question of styles and formats, surrealism has always evinced a disinterest in modernist ideals about medium specificity. In 1935, Breton demonstrated as much when he drew on Hegel's aesthetic theory to argue that poetry is the most important art form.[35] But, unlike Hegel, Breton did not think of this poetry as bound to a particular medium, method, or style; rather, poetry is a generalised mode of unpredictability and exploration which can take expression in many different media, including film. Much as when it comes to the study of surrealist writing, a focus on stylistic traits will not allow us to pin down the wildly varied films that have emerged out of the movement. And in the same way that surrealist art encompasses the figurative and the non-figurative, painting, collage, sculpture, and assemblage, surrealist film alternates between short film, documentary, and feature film; it may employ collage techniques and animation as well as deceptively straightforward narratives.

Another persistent problem in discussing surrealist film in a broader historical and stylistic scope is the dilution of the word 'surrealism' and its derivatives, 'surreal' and 'surrealist'. In everyday parlance, 'surreal' has come to designate anything that is perceived to be odd, dreamlike, or bizarre. Such usage, as Richardson points out in *Surrealism and Cinema*, has spread to the vocabulary of critics, many of whom describe films as surrealist based on themes, imagery, or moods that are sometimes far removed from the sociopolitical goals pursued by surrealism.[36] Conceiving of this book, we have followed Richardson in contending that surrealism is something at once more specific and greater than a style or a set of themes; it is, rather, 'a shifting point of magnetism around which the collective activity of the surrealists revolves'.[37] This activity is not fixed, but is dialectical and evolving, and in often notably different ways in different times and regions. Establishing the parameters of organised surrealist activity as a core part of any definition of surrealism does not mean to dogmatically fix Paris or other locations as the centres of surrealism. On the contrary, it is a necessary step on the way to arriving at a more precise designation of the often neglected manifestations of surrealism outside of Paris, as well as a potent means of establishing the specific conditions under which films were made.

Overview of chapters

This volume features eleven new essays by leading and emerging researchers organised in a roughly chronological progression, covering films, film projects, criticism, and related cultural phenomena of diverse kinds dating from the final years of World War II to the beginning of the new millennium. The subjects treated dart back and forth across the dispersed geographic loci of international surrealism, tracing myriad surrealist networks and lineages that sparked in and spanned from Mexico to the United States, from Denmark to France, and from Spain back to Mexico and beyond, highlighting the ways in which surrealist film often accompanied the movement's own peripatetic travels and extended duration. Apparent in an overarching fashion among the essays is the theme of the constant negotiation and investigation of the potentialities and limits of film and its theoretical reception by surrealists and affiliates of the movement. Even if early surrealist film theorists such as Goudal thought that in itself film inherently resembled the structure of the dream,[38] scrutiny of the vivid sphere of international post-war surrealist film reveals that surrealism never ceased pushing the boundaries of this medium's capacity for radical transformation along the mid-century lines laid out by Benayoun, Kyrou, Breton, and others.

The first four chapters of the collection cast their focus on resonances shared between surrealism and elected, inadvertent, or adjacent directors, films, and topics. Krzysztof Fijałkowski's research on American film-maker Maya Deren's films of the mid-1940s demonstrates the way in which surrealism's intricate international networks activated and shaped this continued negotiation of film during the World War II era. Despite the fact that Deren was not a surrealist and vocally distanced her experimental films from surrealism, Fijałkowski examines works such as the unfinished *Witch's Cradle* (1943), which features Marcel Duchamp and references his *Mile of String* installation from 1942, in light of their implicit and explicit ties to the movement. Not only can thematic affinities with surrealism relating to ritual and identity be surmised in Deren's films, Fijałkowski argues; the nature of surrealism's own discursive framework as a dynamic network is informed by her bold filmic 'conversation' with surrealism at this time. Michael Löwy's essay, devoted to Michel Zimbacca's film *L'Invention du monde* (1952), likewise addresses the question of surrealist affinities enunciated through film, yet analyses surrealism's principled avidity for indigeneity and tribal cultures rather than the movement's reception by contemporaneous affiliates. Made with the assistance of Jean-Louis Bédouin and narrated with a commentary by the poet Benjamin Péret, *L'Invention du monde* is a poetic composition despite its documentary footage and stills of ethnographic objects. As members of the Paris surrealist group, these contributors attest at once to French surrealism's pre-war investment in indigenous

cultures as an aspect of the movement's anti-colonialist critique of the capitalist nation state and to the lasting significance of such identifications in the wake of fascism's grave threat to humanity.

In a lyrical exploration of the role of mediated and fragmented memory and eroticism in the boxes, collages, and films of American artist Joseph Cornell, Tom Gunning explains how surrealism itself becomes an important element in the artist's fundamental operation of the transformation of reality. Cornell's is an American vernacular appropriation of surrealism, according to Gunning, influenced by symbolism and Romanticism as uniquely expressed in the United States, and American cinema culture forms an essential aspect of this cultural reiteration. Not only do films such as *A Legend for Fountains* (1957) exemplify the deeply cinematic nature of Cornell's practice. For Gunning, all of Cornell's works, across media, are paradoxically melancholic-ecstatic 'machines of vision' that cannily manipulate surrealism's 'idiom'.

Luis Buñuel's significance for post-war surrealist film is indisputable, but it is less well known that the legendary film-maker himself was eager to re-establish his surrealist credentials in the early 1950s. In a wide-ranging chapter, Paul Hammond discusses Buñuel's 1950 Mexican feature film *Los olvidados* alongside the director's essay 'The Cinema, Instrument of Poetry', unravelling how Buñuel sought to yoke his late films to surrealism through recurring references to the contemporaneous writings in *L'Âge du cinéma*. Stylistically influenced by neorealism, *Los olvidados* nevertheless pulsates with the surrealist sensibility that Buñuel asserted in his essay, and which was further established in statements by the Mexican surrealist poet Octavio Paz and, more grudgingly, Breton.

The mediation, transmission, and, to a certain extent, mediumism in and of surrealist film remain key strains in the arguments of the three subsequent chapters, which each discuss films from the 1960s. Arnaud Maillet undertakes groundbreaking research devoted to a 1961 film by Jean Desvilles that animates Max Ernst's surrealist collage novel *Une semaine de bonté* (1934). As Maillet states in his detailed technical analysis of the film, it 'is not however a simple adaptation', but a 'genuine transposition', which involves a redefinition of collage and a meditation on the properties of film. Mikkel Bolt Rasmussen chronicles the importance of surrealist film culture, and in particular the films of Danish artist Wilhelm Freddie, for the Scandinavian Drakabygget Situationist movement during the 1960s. As opposed to Guy Debord's Situationist International, which 'regarded film as a contaminated medium', the Drakabygget group consistently paid homage to Freddie and other surrealists in their activities. Next, Gavin Parkinson proposes that surrealist film critic and director Robert Benayoun knowingly tied some of the movement's most speculative ideas about the nature of time, memory, and desire to a broad base of popular culture when he made the science-fiction-influenced feature film

Paris n'existe pas (1969). Scored by pop icon Serge Gainsbourg, who also plays a debonair character in the film, *Paris n'existe pas* is at once steeped in vernacular references to time travel and intertwined with both high modernist and surrealist ideas about the power of the mind to overcome the restrictions of the physical world.

The final four chapters in this volume reground the discussion of post-war surrealist film within the simultaneously distinct and elastic parameters of international surrealism itself, while also looking past those parameters to consider the way in which the movement's approach to film continually reacted to its shifting contexts. As stated above, Michael Richardson's essay clarifies how the movement's significant involvement with the film review *Positif* gave surrealist perspectives a prominent position in French film criticism, from which they, among many other things, formulated an incisive critique of the French new wave and its mouthpiece, *Cahiers du cinéma*. In Richardson's chapter, the contributions of Robert Benayoun, Raymond Borde, Gérard Legrand, Petr Král, and Paolo de Paranagua to *Positif* are discussed in terms of the underlying surrealist aim 'to see beyond what is immediately perceptible in a film'.

In an essay illuminating Leonora Carrington's idiosyncratic engagement with Mexican film, Felicity Gee discusses this artist's self-referential work as art director and costume designer for Juan López Moctezuma's film *The Mansion of Madness* (*La mansión de la locura*, 1973), which adapted Edgar Allan Poe's story 'The System of Doctor Tarr and Professor Fether' (1845). Abigail Susik furthers this dialogue on the impact of Carrington and other surrealists, such as Alan Glass, in Mexican cinema of the early 1970s through an inquiry into the reticulated or delicately interwoven nature of surrealist influence in *The Holy Mountain*, by Alejandro Jodorowsky – also an adaptation, in this case of the unfinished novel by French para-surrealist René Daumal, *Le Mont Analogue* (1952). In the volume's closing pages, Kristoffer Noheden integrates current discourses in ecocriticism and non-human studies into a critical analysis of the role of animals alive and dead in the films of two contemporary directors, Nelly Kaplan and Jan Švankmajer. By positioning the long-standing surrealist attack upon anthropocentrism and human exceptionalism in direct relation to present-day theories about the perils of the Anthropocene epoch, Noheden establishes not only the urgent relevance of surrealist ecological and anti-humanist principles, but also offers a concrete set of examples for the possibilities of interspecies revolt as cinematically imagined by Kaplan and Švankmajer.

Closing statement

Although our volume purposefully does not focus on the vast field of surrealist-influenced directors so often cited in previous studies – from household

names, such as Alfred Hitchcock and David Lynch, to underground film-makers, such as Derek Jarman and Jack Smith – it is our contention that the historiographically grounded approach to post-1945 surrealist film for which our volume advocates can support more stringent discussions of such influence going forward. These discussions might combine the detailed historiography of surrealist film with the movement's opposition to patriarchy, colonialism, racism, and white supremacy in an attempt to understand why surrealist elements have been featured in the work of certain female film-makers in the second half of the twentieth century, limited though these examples unfortunately remain – or, for that matter, in films by directors in Asia, South America, and, recently, the African diaspora. For example, how can the post-war history of surrealist film clarify some of the reasons for which a feminist artist like Carolee Schneemann repeatedly engaged aspects of surrealism in her experimental films from the early 1960s? What might be some of the political reasons for the activation of surrealist elements in post-war Japanese cinema, in the work of Hiroshi Teshigahara, Shohei Imamura, Obayashi Nobuhiko, or Shinya Tsukamoto, for example? What is the context for Colombian author Gabriel García Márquez and Álvaro Cepeda Zamudio's co-direction of the 1954 surrealist-influenced short film *The Blue Lobster* (*La langosta azul*), which was a precursor to magic realism? Finally, how can surrealist film history support the theorisation of Afro-surrealism and the way in which it appears both in the works of prominent directors such as Jordan Peele and of 'young directors from the African diaspora including Adoma Owusu, Cecile Emeke, Chinonye Chukwu and Frances Bodomo', as stated by critic Lanre Bakare?[39] It is not just the apparent ubiquitousness of the influence of surrealism upon film that must be considered in scholarship, but also the significance of and impetus for this cultural phenomenon in terms of the historical and socio-political specificity of surrealism. If Breton's mid-century theories loom large over our volume, this is not to reiterate old dogmas about surrealism or erect the false notion of a surrealist film canon. Rather, we argue for a precise yet flexible view of surrealism as an at one and the same time coherent and diverse movement that fostered a generous and discerning film culture.

Notes

1 Breton, 'As in a Wood', 236, italics original.
2 Ibid., 236.
3 See also Sebbag, *Breton et le cinéma*, 94–7.
4 A generous sampling of surrealist writings on film extending to the post-war period can be found in Hammond, *The Shadow and Its Shadow*. See also A. Virmaux and O. Virmaux, *Les Surréalistes et le cinéma*, and Rabourdin, *Cinéma surréaliste*.

5 In a 1921 essay, Breton calls the film camera 'the blind instrument'. See Breton, 'Max Ernst', 60.

6 The Surrealist Group, 'Manifesto of the Surrealists Concerning *L'Âge d'or*'.

7 Relevant scholarship on the inter-war period includes, for example, Bajac et al., *La Subversion des images*; Kovács, *From Enchantment to Rage*; Kuenzli, *Dada and Surrealist Film*; Vigier, *Aragon et le cinéma*.

8 Breton, 'As in a Wood', 235, italics original.

9 Ibid., 237.

10 Péret, 'Against Commercial Cinema', 59–60.

11 Breton, 'As in a Wood', 240.

12 Ibid., italics original. See also Noheden, 'Against All Aristocracies'.

13 Ibid., 238–9.

14 See the surrealist essays included in Abel, ed., *French Film Theory and Criticism*.

15 For a concise critique, see Christie, 'Histories of the Future', 6–13. Exceptions include Matthews, *Surrealism and Film*; Mitjaville and Roquefort, 'Le Cinéma des surréalistes'; Hammond, *The Shadow and Its Shadow*; Richardson, *Surrealism and Cinema*; Noheden, *Surrealism, Cinema, and the Search for a New Myth*. For scholarship on individual film-makers, see the references in the chapters in this volume. Other recent studies with elements relevant to post-war surrealist film include Svyatskaya, *Conscious Hallucinations*; Elder, *Dada, Surrealism, and the Cinematic Effect*; Fotiade, *Pictures of the Mind*; Owen, *Avant-Garde to New Wave*.

16 Thompson and Bordwell, *Film History*, 159.

17 Harper and Stone, 'Introduction', 4; Kachur, *Displaying the Marvelous*, 206.

18 Short, *The Age of Gold*, 180.

19 See Mahon, *Surrealism and the Politics of Eros*, 107–16.

20 Breton, 'Away with Miserabilism!', 347–8.

21 See Durozoi, *History of the Surrealist Movement*.

22 See ibid.; Mahon, *Surrealism and the Politics of Eros*; Parkinson, *Futures of Surrealism*; Löwy, *Morning Star*; Kelley, *Freedom Dreams*; Harris, 'The Surrealist Movement since the 1940s'.

23 Parkinson, *Surrealism, Art, and Modern Science*; Sebbag, *Potence avec paratonnerre*; Roberts, 'The Ecological Imperative'; Eburne, *Surrealism and the Art of Crime*; Susik, *Surrealist Sabotage and the War on Work*; Susik and King, 'Surrealism as Radicalism'; Bauduin, Ferentinou, and Zamani, *Surrealism, Occultism and Politics*; Rosemont, *Surrealist Women*; Rosemont and Kelley, *Black, Brown, and Beige*.

24 See Bataille, *The Absence of Myth*.

25 Hammond, 'Available Light', 36. See, in particular, Robert Benayoun, 'The Emperor Has No Clothes'.

26 See Graham and Vincendeau, *The French New Wave*.

27 See Wimmer, *Cross-Channel Perspectives*.

28 See Caillois, *The Mask of Medusa*, 9–15.

29 Kyrou, *Le surréalisme au cinéma*. For a recent surrealist commentary on film, see Joubert, *Le Cinéma des surréalistes*.

30 See Sconce, '"Trashing" the Academy'; Hawkins, *Cutting Edge*; Hoberman and Rosenbaum, *Midnight Movies*; Mathijs and Sexton, *Cult Cinema*.
31 Borde and Chaumeton, *A Panorama of American Film Noir*; Naremore, *More than Night*.
32 On Has, see Insdorf, *Intimations*.
33 See King, *Dalí, Surrealism and Cinema*; Susik, 'Animistic Time in Hans Richter's *Vormittagsspuk*'; Cahill, *Zoological Surrealism*. Additional surrealist-associated directors working in this period include Norman McLaren, Larry Jordan, and Les Blank.
34 Breton, 'Surrealism Continues', 312.
35 Breton, 'Surrealist Situation of the Object', 255–78.
36 Richardson, *Surrealism and Cinema*, 2–3. See also Moïne, 'From Surrealist Cinema to Surrealism in Cinema', 98–114.
37 Richardson, *Surrealism and Cinema*, 3.
38 Goudal, 'Surrealism and Cinema', 84–94.
39 Bakare, 'From Beyoncé to *Sorry to Bother You*'. See also Francis, 'Introduction'.

Bibliography

Abel, Richard, ed. *French Film Theory and Criticism: A History/Anthology, 1907–1939*. Two volumes. Princeton, NJ: Princeton University Press, 1993.

Bajac, Quentin et al. *La Subversion des images: surréalisme, photographie, film*. Paris: Éditions du Centre Pompidou, 2009.

Bakare, Lanre. 'From Beyoncé to *Sorry to Bother You*: The New Age of Afro-surrealism'. *Guardian* (6 December 2018). Accessed 9 January 2020. www.theguardian.com/tv-and-radio/2018/dec/06/afro-surrealism-black-artists-racist-society.

Bataille, Georges. *The Absence of Myth: Writings on Surrealism*, edited and translated by Michael Richardson. London: Verso, 1994.

Bauduin, Tessel, Victoria Ferentinou, and Daniel Zamani, eds. *Surrealism, Occultism and Politics: In Search of the Marvellous*. New York: Routledge, 2018.

Benayoun, Robert. 'The Emperor Has No Clothes'. In *The French New Wave: Critical Landmarks*, edited by Peter Graham with Ginette Vincendeau, 163–86. London: BFI, 2009.

Borde, Raymond, and Chaumeton Étienne. *A Panorama of American Film Noir, 1941–1953*, translated by Paul Hammond. San Francisco, CA: City Lights Books, 2002.

Breton, André. 'As in a Wood'. In *Free Rein*, translated by Michel Parmentier and Jacqueline d'Amboise, 235–40. Lincoln, NE: University of Nebraska Press, 1995.

———. 'Away with Miserablism!'. In *Surrealism and Painting*, translated by Simon Watson Taylor, 347–8. Boston, MA: MFA Publications, 2002.

———. 'Max Ernst'. In *The Lost Steps*, translated by Mark Polizzotti, 60–61. Lincoln, NE: University of Nebraska Press, 1996.

———. 'Surrealism Continues'. In *What Is Surrealism? Selected Writings*, edited and translated by Franklin Rosemont, 311–12. New York: Monad, 1978.

———. 'Surrealist Situation of the Object'. In *Manifestoes of Surrealism*, translated by Richard Seaver and Helen R. Lane, 255–78. Ann Arbor, MI: University of Michigan Press, 1972.

Cahill, James Leo. *Zoological Surrealism: The Nonhuman Cinema of Jean Painlevé*. Minneapolis, MN: University of Minnesota Press, 2019.

Caillois, Roger. *The Mask of Medusa*, translated by George Ordish. London: Victor Gollancz, 1964.

Christie, Ian. 'Histories of the Future: Mapping the Avant-Garde'. *Film History* 20, no. 1 (2008): 6–13.

Durozoi, Gérard. *History of the Surrealist Movement*, translated by Alison Anderson. Chicago, IL: University of Chicago Press, 2002.

Eburne, Jonathan P. *Surrealism and the Art of Crime*. Ithaca, NY: Cornell University Press, 2008.

Elder, R. Bruce. *Dada, Surrealism, and the Cinematic Effect*. Waterloo, ON: Wilfrid Laurier University Press, 2013.

Fotiade, Ramona. *Pictures of the Mind: Surrealist Photography and Film*. Oxford: Peter Lang, 2018.

Francis, Terri. 'Introduction: The No-Theory Chant of AfroSurrealism'. *Black Camera* 5, no. 1 (2013), 95–112.

Goudal, Jean. 'Surrealism and Cinema'. In *The Shadow and Its Shadow: Surrealist Writings on the Cinema*, 3rd edn, edited and translated by Paul Hammond, 84–94. San Francisco, CA: City Lights, 2000.

Graham, Peter, with Ginette Vincendeau, eds. *The French New Wave: Critical Landmarks*. London: BFI, 2009.

Hammond, Paul. 'Available Light'. In *The Shadow and Its Shadow: Surrealist Writings on the Cinema*, 3rd edn, edited by Paul Hammond, 1–45. San Francisco: City Lights, 2000.

———, ed. *The Shadow and Its Shadow: Surrealist Writings on Film*, 3rd edn. San Francisco, CA: City Lights, 2000.

Harper, Graeme, and Rob Stone. 'Introduction'. In *The Unsilvered Screen: Surrealism on Film*, edited by Graeme Harper and Rob Stone, 1–8. New York: Wallflower Press, 2007.

Harris, Steven. 'The Surrealist Movement since the 1940s'. In *A Companion to Dada and Surrealism*, edited by David Hopkins, 385–99. Hoboken, NJ: Wiley-Blackwell, 2016.

Hawkins, Joan. *Cutting Edge: Art-Horror and the Horrific Avant-Garde*. Minneapolis, MN: University of Minnesota Press, 2000.

Hoberman, James, and Jonathan Rosenbaum. *Midnight Movies*. New York: Da Capo Press, 1991.

Insdorf, Annette. *Intimations: The Cinema of Wojciech Has*. Evanston, IL: Northwestern University Press, 2017.

Joubert, Alain. *Le Cinéma des surréalistes*. Paris: Maurice Nadeau, 2018.

Kachur, Lewis. *Displaying the Marvelous: Marcel Duchamp, Salvador Dalí, and Surrealist Exhibition Installations*. Cambridge, MA: MIT Press, 2001.

Kelley, Robin D. G. *Freedom Dreams: The Black Radical Imagination*. Boston, MA: Beacon Press, 2002.

King, Elliott H. *Dalí, Surrealism and Cinema*. Harpenden: Kamera, 2007.

Kovács, Steven. *From Enchantment to Rage: The Story of Surrealist Cinema*. Rutherford, NJ: Fairleigh Dickinson, 1979.

Kuenzli, Rudolf E. *Dada and Surrealist Film*. New York: Willis, Locker & Owens, 1987.

Kyrou, Ado. *Le Surréalisme au cinéma*. Paris: Arcanes, 1953.

Löwy, Michael. *Morning Star: Surrealism, Marxism, Anarchism, Situationism, Utopia*. Austin, TX: University of Texas Press, 2009.

Mahon, Alyce. *Surrealism and the Politics of Eros, 1938–1968*. New York: Thames & Hudson, 2005.

Man Ray. *Self-Portrait*. Boston, MA: Little, Brown and Company, 1963.

Mathijs, Ernest, and Jamie Sexton. *Cult Cinema: An Introduction*. Chichester: Wiley-Blackwell, 2011.

Matthews, J. H. *Surrealism and Film*. Ann Arbor, MI: University of Michigan Press, 1971.

Mitjaville, Alain, and Georges Roquefort. 'Le Cinéma des surréalistes'. Special issue, *Les Cahiers de la cinémathèque*, nos 30–1 (1980).

Moïne, Raphaelle. 'From Surrealist Cinema to Surrealism in Cinema: Does a Surrealist Genre Exist in Film?'. *Yale French Studies*, no. 109 (2007): 98–114.

Naremore, James. *More than Night: Film Noir in Its Contexts*. Berkeley, CA: University of California Press, 2000.

Noheden, Kristoffer. 'Against All Aristocracies: Surrealism, Anarchism, and Film'. *Modernism/Modernity* 27, no. 3 (2020): 569–84.

———. *Surrealism, Cinema, and the Search for a New Myth*. Cham: Palgrave Macmillan, 2017.

Owen, Jonathan L. *Avant-Garde to New Wave: Czechoslovak Cinema, Surrealism and the Sixties*. New York: Berghahn, 2013.

Parkinson, Gavin. *Futures of Surrealism: Myth, Science Fiction and Fantastic Art in France, 1936–1969*. New Haven, CT: Yale University Press, 2015.

———. *Surrealism, Art and Modern Science: Relativity, Quantum Mechanics, Epistemology*. New Haven, CT: Yale University Press, 2008.

Péret, Benjamin. 'Against Commercial Cinema'. In *The Shadow and Its Shadow*, 3rd edn, edited and translated by Paul Hammond, 59–60. San Francisco, CA: City Lights, 2000.

Rabourdin, Dominique, ed. *Cinéma surréaliste*. Paris: Jean-Michel Place, 2017.

Richardson, Michael. *Surrealism and Cinema*. Oxford: Berg, 2006.

Roberts, Donna. 'The Ecological Imperative'. In *Surrealism: Key Concepts*, edited by Krzysztof Fijałkowski and Michael Richardson, 217–27. London: Routledge, 2016.

Rosemont, Franklin, and Robin D. G. Kelley, eds. *Black, Brown, and Beige: Surrealist Writings from Africa and the Diaspora*. Austin, TX: University of Texas Press, 2009.

Rosemont, Penelope, ed. *Surrealist Women: An International Anthology*. Austin, TX: University of Texas Press, 1998.

Sebbag, Georges. *Breton et le cinéma*. Paris: Jean-Michel Place, 2016.

———. *Potence avec paratonnerre: Surréalisme et philosophie*. Paris: Hermann, 2012.

Sconce, Jeffrey. '"Trashing" the Academy: Taste, Excess, and An Emerging Politics of Cinematic Style'. *Screen* 36, no. 4 (Winter 1995): 371–93.

Short, Robert. *The Age of Gold: Surrealist Cinema*. London: Creation Books, 2003.

Surrealist Group, The. 'Manifesto of the Surrealists Concerning *L'Âge d'or*'. In *The Shadow and Its Shadow: Surrealist Writings on the Cinema*, 3rd edn, edited and translated by Paul Hammond, 182–9. San Francisco, CA: City Lights, 2000.

Susik, Abigail. 'Animistic Time in Hans Richter's *Vormittagsspuk* (1927–1928)'. In *Time and Temporality in Literary Modernism (1900–1950)*, edited by Jan Baetens et al., 243–58. Leuven: Peeters, 2016.

———. *Surrealist Sabotage and the War on Work*. Manchester: Manchester University Press, 2021.

———, and Elliott H. King. 'Surrealism as Radicalism'. In *Radical Dreams: Surrealism, Counterculture, Resistance*, edited by Elliott H. King and Abigail Susik. University Park, PA: Penn State University Press, 2021.

Svyatskaya, Svetlana et al., ed. *Conscious Hallucinations: Filmic Surrealism*, translated by Stewart Tryster and Juliet Cappetta. Frankfurt am Main: Deutsches Filmmuseum, 2014.

Thompson, Kristin, and David Bordwell. *Film History: An Introduction*, 4th edn. New York: McGraw-Hill Education.

Vigier, Luc. *Aragon et le cinéma*. Paris: Jean-Michel Place, 2015.

Virmaux, Alain, and Odette Virmaux. *Les Surréalistes et le cinéma*. Paris: Seghers, 1976.

Wimmer, Leila. *Cross-Channel Perspectives: The French Reception of British Cinema*. New York: Peter Lang, 2009.

1

Surrealist networks and the films of Maya Deren

Krzysztof Fijałkowski

It might seem contradictory to begin a book devoted to surrealist film after 1945 with a film-maker who categorically rejected surrealism as a context for her work, and whose closest proximity to the movement took place during rather than after World War II. Born in the Ukraine, educated in Europe, Maya Deren (1917–61) would spend most of her adult life in New York, interspersed with field trips to Haiti, developing expansive talents as a writer, theorist, ethnographer, photographer, and teacher. But it is in her activities as a film-maker that her multiple interests converge, in works that have been read as a founding moment in the American avant-garde and, more particularly, as a bridge between European cinema and the establishment of an American tradition of experimental film. From the outset, their vocabulary, beginning with the cyclical, oneiric narrative of *Meshes of the Afternoon*, made with her husband Alexander Hammid in Los Angeles in 1943 and starring Deren herself in a role that keeps shifting or mirroring her identity, was read in relationship to the 1920s surrealist cinema of Buñuel, Dalí, Man Ray, and others. The couple's move soon afterwards to New York would set them in the heart of a vigorous community of local and émigré writers and artists, among them prominent members of the French surrealist group fleeing the war in Europe. It was in this fertile milieu that Deren – at this point still only in her mid-20s – quickly established a solo career. Nearly all of her film projects were either made or initiated in the next four years, ranging from what P. Adams Sitney labels the 'trance films' that succeeded *Meshes of the Afternoon* – *At Land* (1944) and *Ritual in Transfigured Time* (1945–46) – to experimental dance films such as *A Study in Choreography for Camera* (1945) and culminating in the incomplete ventures documenting Haitian vodou that would preoccupy much of the remainder of her life.

It is not only stylistic affiliations that have led to the tendency to position Deren in the context of surrealism, but a whole host of shared themes and approaches, a number of which will be highlighted here: dream, identity, and metamorphosis certainly; but also play, ritual, magic, and in particular a kind of poetic cross-cultural ethnography, all of which also characterise

the interests of the French surrealist group on its reformation after the war. The aim here, then, is neither to claim Deren for surrealism, nor simply to view her works through its lens but, rather, in a more speculative and oblique mode, to set these two voices side by side and see which resonances might have been working in phase to amplify each other. In selecting the New York films (and so leaving out *Meshes of the Afternoon*), and by scrutinising the aspects of their practice that chime with those of the surrealist circles so close at hand to their making, the hope is to gauge how Deren's research can be seen to pick up sensitively on signs that surrealism too was continuing to elicit and explore. These are the elements which would help propel the movement beyond its 'celebrity status' and consequent recuperation during the late 1930s, into the labyrinth of something deeper, more difficult perhaps, in the changed landscape of the world after catastrophe. *At Land, Ritual in Transfigured Time*, and above all the unfinished *Witch's Cradle* (1943) are the works that stand as contemporary to surrealist collective activity in New York, and through which Deren's active participation in its climate of research will be considered here. If Deren's films, ultimately, are not part of surrealism, many of their underlying concerns may be seen as echoing a particular surrealist discourse and sensibility whose aims include the desire to redraw the maps of self or community and the rituals that link them. In the crucible of New York, surrealism's shifting direction was distilled from ingredients that had long been its constituents but whose emerging amalgam would help forge its character for the decades ahead; Maya Deren can be part of this story.

Deren against surrealism

'Under no conditions are these films to be announced or publicized as Surrealist or Freudian' ran a note accompanying Deren's works for screening.[1] The peremptory instruction indicates a frustration that her work had been presented in precisely this way, and, indeed, from the outset her films had been read in the light of surrealism – a term, often superficially understood, that by the mid-1940s was all the rage in the United States. Deren's extensive writings about film and reflections on her own works feature frequent mention of surrealism both as a major contemporary current and as a specific context for experimental cinema; in almost every case this acknowledgement either comes with reservations or is framed in terms of an explicit rejection or surpassing of surrealism as a reference point for her own ambitions.[2] With a few notable exceptions,[3] in the years since her death Deren's commentators have either tended to ignore her preferences and continue to ascribe direct links between her films and European surrealist cinema, often

based on fairly limited analysis confined to film history and theory rather than surrealism as a whole, or to endorse her rejection of the label without much further investigation.[4] Surrealist film critics and historians have often been even more trenchant, not just in terms of Deren, but in refuting any surrealist interest at all in American post-war experimental film. Ado Kyrou, a participant in the post-war surrealist group in Paris, offers this harsh overview in *Le Surréalisme au cinéma*: 'Maya Deren didn't make it past 1925; daft Freudianism, surrealism for well-behaved children and a profound boredom are slightly offset by strong technique and Mme Deren's face which is very beautiful. She is considered the last word in American surrealism, and it must be admitted that she's a genius compared to her colleagues.'[5]

But what was the basis of Deren's critique of surrealism? A closer look at her writings and archives suggests a surprisingly summary reflection. Though we expect her to have been familiar with writings by and about surrealists during her New York years[6] – in particular the prolific journal *View* (1940–47), in which surrealism was a dominant voice and where her own work would be published, but also the surrealist journal *VVV* (1942–44) – her explicit points of reference tend to be more widely known sources on the movement.[7] Two major strands of critique are reiterated in her writings: first, that surrealism, allied to Romanticism, is 'self-avowedly dedicated to externalizing an inner reality whose original integrity has been devotedly preserved',[8] a position that privileges extreme or provocative forms and whose ambitions have been made redundant by science; and, second, in basing itself on Freudian psychoanalysis (and in so doing undermining the latter's therapeutic intent), surrealism's only motor is the unconscious, its sole mode spontaneity.[9] The first charge is more complex to counter: on the one hand, surrealism's dialogue with both Romantic and scientific currents is far more nuanced than Deren allows, while on the other her own films capture more than a little sense of the externalisation of inner reality. The second, of surrealism as spontaneity against consciousness, seems straightforwardly misplaced. While often rebalancing the relationships between the conscious and unconscious (Deren prefers the term 'subconscious'), to the latter's benefit, surrealism in no way seeks to supplant or eradicate consciousness; spontaneity and chance are just two special implements in its much more generous toolkit, used with measures of deliberation and reflection.

If Deren rejected the value of unconscious methodologies, she nevertheless had significant interests in the loss of conscious agency through the experience of trance, a phenomenon to which she would later devote considerable attention in relation to Haitian vodou but was already exploring in the context of dance in one of her earliest publications, 'Religious Possession in Dancing' (1942).[10] This article contains several elements which attract our attention here: a quotation from anthropologist Bronisław Malinowski

on the correlation between magic and chance; references to James Frazer's *Golden Bough*; and an explicit connection between the conditions of trance and hysteria, all of which evoke crossovers with surrealist interests. But we could also note the significance of trance states in surrealism's own earliest history – the so-called 'period of sleeping fits' of 1920–23 – as the laboratory for the emerging movement's methodological, philosophical, and ethical positions, just as 'Religious Possession in Dancing' anticipates Deren's leap into film. The point here is less whether or not Deren would have been aware of these antecedents, but that the formative moment immediately before the launching of her career was spent thinking through some of the same issues that had helped the surrealists to define themselves in Paris two decades previously, even if to different ends.

If Deren's public references to surrealism seem limited, her dismissal of its relevance for her work seems at least in part a rejection of an idea that was already well on the way to becoming a cliché in the wider American culture (and in the face of which the surrealists in New York too were beginning to steer a fresh path, not along the lines of avant-garde innovation but – drawing on pre-modernist themes of utopia, myth, the occult, and nature – deeper into the secret heart of knowledge). Reductive views of Deren's films in relation to the historical European avant-garde clearly frustrated her, but they also in the end miss the point. Far more pertinent to her work of the mid-1940s is the context of contemporary surrealism in New York – something that in some ways is harder to grasp, but which sets her not in stylistic affinity with the movement, but very close to the centre of actual collective surrealist activity, intimacy, and debate.

As is well known, the mass emigration between 1939 and 1941 of members of the Parisian surrealist group fleeing the Occupation led to substantial numbers of them settling in and around New York. They included some of the most significant members of the group: André Breton – by now the movement's undisputed leading light – and his soon to be estranged wife, Jacqueline, but also figures such as Marcel Duchamp, Max Ernst, Robert Lebel, André Masson, Roberto Matta, Gordon Onslow Ford, Kurt Seligmann, Yves Tanguy, and Isabelle Waldberg; while international travel was difficult, correspondence and exchange was still possible for those based in Mexico and the Caribbean, such as Leonora Carrington, Aimé and Suzanne Césaire, Wifredo Lam, Pierre Mabille, Wolfgang Paalen, Benjamin Péret, Alice Rahon, and Remedios Varo; and Man Ray was an occasional visitor from Los Angeles. Added to this already impressive list were a number of Americans sympathetic to surrealism and drawn, more or less urgently, into its orbit, among whom one might highlight collector and gallerist Peggy Guggenheim (married to Ernst for some of this period), gallerist and long-serving promoter of surrealism Julien Levy, and the painter Dorothea Tanning. Public

platforms for the activities of this circle – notably the 1942 exhibition *First Papers of Surrealism*, publications of journals and books, as well as prominent attention from mainstream and specialist press – made up for the material and practical difficulties that limited its possibilities; and, as historians have amply documented, the ideas it unleashed would be highly influential on the subsequent directions of North American art and literature. From her arrival in New York in the spring or summer of 1943, Deren was part of this world. The young writer Charles Duits, a close friend of Breton and other surrealists from late 1942 onwards, enumerates the set he had joined, with its intense daily interactions, in three categories: the 'members of the surrealist group properly speaking', other modernists (like Chagall, Mondrian, or Pollock), and then a list of associated 'writers, philosophers, critics, historians, scholars', among whose eight names is that of Deren.[11] As we shall consider, sporadic but significant connections place her clearly within this circle formed around surrealism: direct links to Guggenheim and Duchamp, roles in her films for surrealist artists and writers, filmed documentation of surrealist artworks, photographs taken by Deren of Breton …

One relevant feature here is the prominence of women in this grouping, an increasing feature of surrealist activity in France but now highly visible: Tanning, Waldberg, and Jacqueline Breton in New York, Carrington, Rahon, and Varo in Mexico, Suzanne Césaire in Martinique; as we will see, in several cases sympathetic connections link their work to Deren's. One might ask why, then, given all of these affinities and proximities, did she not move closer to these liaisons, participate more directly in their activities (as opposed to drawing them into hers)? The answer might lie largely in personal motives: the status of the well-established surrealists – celebrities in the restricted locale of Manhattan's culture – might have made them intimidating, while Breton in particular could be demanding or disconcerting.[12] Driven by an intense creative and intellectual momentum, Deren could be demanding too, her friendships intense and challenging. Perhaps, for a sense that in walking in the same direction Deren nevertheless crossed the street to avoid an encounter that might have promised something more, one may offer a tentative parallel with the biography of Louise Bourgeois, another young European artist of Deren's generation in New York in this period moving close to surrealist circles and who knew its members personally, but maintained a calculated distance from them. Critics, in step with Bourgeois' own later comments, have invariably read this as an ethical (and gender-sensitive) rejection,[13] but it might also just as plausibly have signalled the strong need to establish and protect her still very new practice alone and without the heady but potentially stifling atmosphere of a cabal of elders.

Deren shared several key intellectual reference points that might have been expected at the very least to facilitate sympathetic dialogue with the

émigré surrealists. In addition to her proficiency in French, her highly informed interests included ethnography, a recurring and growing concern for the surrealists in this period; French Symbolist poetry, a topic in her Master's dissertation, where poets such as Baudelaire or Mallarmé were also part of French surrealism's intellectual heritage; and an awareness of the relationships between conscious and unconscious behaviour, through her father who was a prominent psychiatrist. Moreover, in the 1930s she had worked as an activist for the Young People's Socialist League, a Trotskyist organisation that in turn echoed her family history (her father may have known Trotsky personally).[14] While this engagement had been left behind by the time she met the French surrealists, their clear alignment at this time with Trotsky's positions and against Stalinism would immediately have offered a shared ethical and political understanding.

Finally, one more clear link between Deren and surrealist ideas remains to be acknowledged: her husband Alexander Hammid, who under his earlier name, Alexandr Hackenschmied, had been a member of the Czech avant-garde in Prague during the 1920s and 1930s, a film-maker and photographer as well as promoter of local and international practice. Hammid's knowledge of experimental film and photography, and his evident awareness of surrealism in particular, has been frequently cited as a key influence on Deren, most obviously during their collaboration on *Meshes of the Afternoon*, and we know, for instance, that he had previously organised film screenings that included works by Man Ray.[15] What is also pertinent here, however, is the specifically Czech context for his work. His early (1930) and most innovative film, *Aimless Walk* (*Bezúčelná procházka*), may not look much like Paris-based surrealism, but it has a good deal in common with the materialist poetry of the urban everyday that is a key feature both of the cross-disciplinary Devětsil movement, from which first Poetism and then surrealism emerged in Czechoslovakia during this period, and of the Czech surrealist group formed in 1934, notably in the city writings of Vítězslav Nezval or the street photography of Jindřich Štyrský.[16] As cameraman for the anti-Nazi documentary *Crisis* (1939), Hackenschmied seems to have been responsible for the disturbing early section depicting citizens trying on gasmasks, featuring shop displays, and then children, dolls, and mannequins in their grotesque attire, which, in retrospect, looks fully conversant with the contemporary works of Czech surrealists Štyrský and Toyen.[17]

Intuitive but telling links like these keep connecting Deren, often at an underground level, not just to the émigré surrealists in New York but to the attitudes of international surrealism of the 1920s and 1930s. They are in play even before one connects the fascination of Haiti for both parties during the 1940s or, for that matter, begins to prise open the knotted concerns with myth, ritual, magic, and play that were already among Deren's

interests in the early 1940s, and would take centre stage for her by mid-decade, and that were also priorities for surrealism in exactly the same period and would become – for the French group at least – defining characteristics in the post war era.

Witch's Cradle

The moment at which the paths of Deren and the surrealists converge most emphatically is in her incomplete – perhaps, indeed, incompletable – film *Witch's Cradle*, shot in August of 1943 (Figure 1.1). Deren's first solo project, as with many of her films it centres on a female protagonist, countered by a more shadowy male presence, who alternately explores spaces and enacts personal and magical rituals in a series of fluid, dream-like scenes that alternate between relatively conventional and more experimental or manipulated images of characters, staged interiors, and – especially prominent – presentations of sculptures and paintings. Clearly in an unfinished state that nevertheless adds to the film's sense of a fragile and unresolved enigma – its protagonists are doubled or float in and out of shot – the extant footage consists of nearly twelve minutes of loosely edited segments, with some elements of structure and consistency; there seems to be some likelihood,

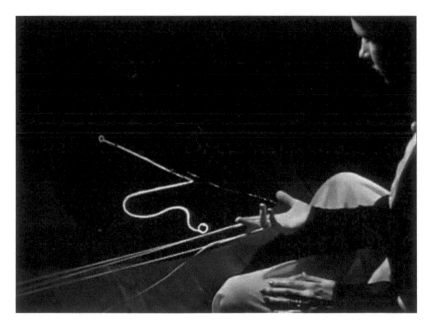

Figure 1.1 Maya Deren, *Witch's Cradle*, 1943

indeed, that these are in fact out-takes from a now lost rough cut.[18] This isn't enough to give a clear idea of her intentions, particularly as it does not fully match the shooting script that includes both missing scenes and some different ordering, but the fact that Deren projected a version of the film at least once implies that she viewed it as a coherent 'work in progress' rather than a failed set of fragments.[19] With a central role for artist Anne Clark (Matta's wife and mother of their twin children, though the couple were separating at the time), the film also circulates around two other 'players' with emphatic surrealist credentials: Duchamp, and Guggenheim's Art of This Century gallery, rigged up with twine and animated as if it too had a living role, with Clark as both seeker in its labyrinth and initiate in its magic rituals. At one level the film acts as a kind of 'home movie' through which to explore the gallery's spaces and exhibits, pointing to the sense in which Deren as an early-career film-maker may here be figured as an 'amateur', in the positive terms of engaging an as yet non-professionalised and open-ended creative practice, testing and risk-taking with all of the occasional technical inconsistencies this might entail. Unlike conventional cinematic 'fantasy', Deren's films begin from immediate actuality – places, objects, and people who are friends not actors. In turn, it's noticeable that a large proportion of the works *Witch's Cradle* draws into its game are by familiar surrealist artists, including Alberto Giacometti, Ernst, Tanguy, Jean Arp, and (with precious images of a now missing poem-object) André Breton. While Sarah Keller argues persuasively that this central role given to works by other artists had the effect of foreclosing Deren's own creative intentions, leading her to abandon the film, it is noticeable that many of them are explored in partial or divergent ways that bring them to life rather than documenting them: Giacometti's *Woman with Her Throat Cut* (1932) suspended on its side and identifiable only from the articulated flail/razor component that bobs like a suggestive pendulum across the fabric décolletage of Clark's dress; Tanguy's *The Sun in Its Jewel Case* (1937) seen as a misty fragment; and an unidentified Ernst (probably *Blind Swimmer (Effect of a Touch)* of 1934, turned on its side) whose eddying lines are followed in extreme close-up.

Just as likely causes of Deren's decision not to pursue the film to completion are its surfeit of ideas, where quite a few of its most powerful moments take the form of tantalisingly short clips that finally are all the more enigmatic for their oblique connection to the rest of the action, and the nagging feeling that technical issues stemming from Deren's relative inexperience, such as problems with consistency in focus and tracking, would have felt inadequate to her strict sense of control (on top of which, since the film was made between exhibitions at the gallery, with Guggenheim allowing only limited access, opportunities for re-shoots were curtailed).[20] As examples of the former, an uncanny dark thread oozing up a woman's arm like a reversed

trail of blood – linked to tattoos of frond-like veins on a pale hand that a few shots later is revealed to be artificial – and a disturbing insert of an actual beating heart provide the film with images that are all the more intense for feeling unresolved and unwarranted.[21] (The veined hand, in a telling coincidence, looks remarkably similar to Meret Oppenheim's design for a pair of gloves with veins that was not realised until 1985, but was based on a detailed drawing made in Basel around 1942–45.[22]) Other instances of the latter include the fascinating but not entirely successful segments of the film that put Duchamp centre stage. Deren treats him like a mannequin, swinging the camera from close-ups homing in on limbs or necklines to mobile overhead views that explore and depersonalise his body through the motif of the animated string inching across his clothes (with the dark thread tugging it still visible, like a parlour trick rather than slick illusion) or coiling and knotting in his hands in an awry game of cat's cradle.

The encounter between Deren and Duchamp (twice MD) is one that feels both arbitrary and essential. Though Deren was on record as an admirer of his work, and, indeed, a sequence of stills from *Witch's Cradle* would be included in the special issue of *View* (series V, no. 1, 1945) dedicated to Duchamp, to which many leading surrealists contributed, it isn't clear how close or lasting their relationship might have been – though close enough, at least, for him to have given her one of his works on glass.[23] Nevertheless, affinities between the two appear in many places: their serious interest in games; the foregrounding of concepts in motivating works; their cultivation of productive friendships. As with Duchamp, what at first appears to be disparity or eclecticism in Deren's oeuvre turns out to coalesce into an integral constellation of ideas. And it's important to emphasise here the extent to which a link to Duchamp constitutes a link to surrealism; while Duchamp may have maintained his independence from the surrealist group, he is so clearly, repeatedly, and ardently claimed by the movement, particularly during this period in New York, that to see him as detached from the wider scope of surrealism makes little sense.

As Deren would probably have known, the material and conceptual possibilities of string figure repeatedly in Duchamp's earlier works, among them the *3 Standard Stoppages* (1913–14), in which lengths of string are used to create templates for a kind of speculative, non-compliant measurement, or *With Hidden Noise* (1916), featuring a ball of twine trapped between metal plates and containing a secret object. Tensions between play and control, the pleasures of drawing non-art materials into the studio, and the complexity lurking in the everyday are all themes that bubble under this concern, and they would emerge most forcefully in Duchamp's best-known use of the medium, in his installation for the exhibition *First Papers of Surrealism* in New York, October 1942 (at which point Deren was still in Los Angeles, so

presumably she knew of it only from secondary sources). Duchamp's cele-
brated intervention, known variously as *His Twine* or *Mile of String*, mar-
shalled great quantities of string to form a dense net around the space and
its exhibits, inhibiting free passage around the show, covering the visual field
in a tangle of lines that was also a network of embodied links from each
object to the next, and forcing the audience to mobilise an active viewing in
which looking became a negotiation. While it clearly relates to Duchamp's
past practice, *Mile of String* can also be seen as a close cousin of the repre-
sentations of networks in contemporaneous surrealist painting, especially
the works from the late 1930s and early 1940s of new recruits to surrealism
Matta and Onslow Ford (both of whom were in New York by 1940). Writ-
ing of his 'cosmic landscape' *Man on a Green Island* (1939), Onslow Ford
would describe the webs and vectors it depicts around an abstracted solitary
individual as 'vibrating force-lines … hammering rays and … linear beings'
that delineate 'the expression of inner worlds beyond our dreams' and pro-
duce a 'two-way perspective' fluctuating between proximity and distance.[24]

A major element of *Witch's Cradle* is an evocation – presumably with
Duchamp's blessing – of *Mile of String*, with cord wound round the environ-
ments of Art of This Century, crossing and dissecting spaces and works,
tugged at by disembodied hands, complicating and connecting everything;
other objects – Duchamp's laced shoes, a wired sculpture by Antoine Pevs-
ner slung on a trapeze – are lured into its netted meanings. As Judith Noble
points out, string is also a material associated with the binding and ritual
repetition of magical practices[25] – something to which contemporary surre-
alists in North America and the Caribbean, who included figures such as
specialist in magic and the occult Kurt Seligmann, and Pierre Mabille,
researching Haitian vodou, would have been alert.[26] The trapeze, moreover,
tethers another connecting thread: the film's title evokes the sinister 'witch's
cradle' wire and leather harness for enacting magical (and sexual) practices
Deren had been shown by the writer and occult practitioner William
Seabrook, for whom she had briefly worked around 1939 as a researcher
but whose attempts to draw her into a more active participation she declined
(in the film, the pleasure/threat ambivalence of Clark's play with Giacometti's
Woman with Her Throat Cut, and her expression throughout that keeps
veering from curiosity to distress – Deren's shooting script says 'horror' – figure
these tensions very clearly). Seabrook, whose approach combined sensation-
alism and more serious research, crossed paths with surrealists – notably
Man Ray and Michel Leiris – on quite a few occasions, and his work had
been published in the pre-war surrealist journal *Documents* as well as during
the war in *View* and *VVV*.[27]

A repeated motif relaying *Mile of String* to Art of This Century is the link
to the gallery's distinctive interior, designed by an architect with close

connections to surrealism both during and after the war, Frederick Kiesler. Deren knew him well, and she was seemingly receptive to his ideas for a magic architecture and 'correalist' design incorporating movement, myth, and ritual in order to rebalance functional and psychic needs.[28] Kiesler's mobile biomorphic furnishings, the innovative curved walls and fixtures, and especially – in the Abstract Gallery space – the zigzag rigging keeping the flexible canvas walls taut and the floor-to-ceiling anchored rope supports used to create free-standing display elements are all played in resonance by Deren's overlay of nets and barriers.[29] Conflating the work of Duchamp and Kiesler in this way (Duchamp was living in Kiesler's apartment at the time) has the effect of folding together the two most significant surrealist exhibition contexts of the early 1940s; the lighting of *Witch's Cradle*, featuring darkened interiors lit only by mobile spotlights, layers on a third: the International Surrealist Exhibition in Paris, 1938 (partly designed by Duchamp, and its exhibitors included Clark), which armed visitors to its private view with torches so as to explore the otherwise unlit gallery.

More than just a striking piece of art direction or re-enactment, Deren's appropriation of these tangled metaphors pitches *Witch's Cradle* into the web of relationships that characterise surrealism in this crucial period for the movement, an interregnum between its haywire success on both sides of the Atlantic during the late 1930s, soured by the recuperations this had brought and menaced by the disasters of conflict and exile, and the slow emergence (for surrealists in France, at least) of new priorities in the post-war era, in which some historical principles were reconfirmed while others were reassessed or replaced.[30] Rather than thinking of the intellectual horizons of post-war surrealism as the sum of individual discoveries and experiences, one might figure them in terms of networks: local, national, and international in scale, transient or sustained, everyday or singular. Figures for such networks can be discerned throughout the movement's interests, just as they are in *Witch's Cradle* – a film that in its unfinished form makes do instead of a storyline with knots of repeated or resonating imagery and gestures; strings and webs guarantee its momentum and its qualities as a snare, providing a literal but multi-linear 'narrative thread', safety net and spider's lair.

This idea of a connectivity that is both tangible and symbolic can be found at several locations in both Deren's research and in the surrealism of the early and late 1940s. For one thing, Duchamp's use of string in the 1942 installation includes a significant link to themes of childhood and play to which Deren also paid attention. While Duchamp invited children to run amok at the private view of *First Papers of Surrealism*,[31] Deren had an ongoing concern with children's street chalk drawings, one linked to her interest (revisited in *Ritual in Transfigured Time*) in cat's cradles and string figures as

part of a wider ethnography of play and anticipating her unrealised plans for a documentary film investigating cross-cultural comparisons of ritual and children's play in Haiti, Bali, and New York.[32] Interest in string figures among ethnographers – research and documentation that, given her knowledge and friendships in this area, Deren may well have been aware of – developed as a distinct specialism from the 1890s over the twentieth century (and particularly engaged women ethnographers); linked to ideas of myth, narrative, intimacy, and exchange, string figures are found throughout the world and across many different cultures, and materialise many of the concerns with ritual, social, and imaginative structures common to Deren and a distinct strand of surrealist enquiry in the pre- and post-war eras.[33] While Deren would photograph children's pavement chalk lines in the later 1940s – linking her use of string in *Witch's Cradle* and her future investigation of ritual drawings in Haiti – from the 1930s onwards the work of New York photographer Helen Levitt also included many images of children at play and notably of street chalk drawings. Showcased at the Museum of Modern Art in 1943, Levitt's images would also be published in both *View* and *VVV*, effectively aligning them within surrealist contexts that themselves already included substantial theoretical concerns with play, and that would continue to inform international surrealism after the war.[34]

While *Witch's Cradle* stages a magical experiment in which multiple strands of enquiry could be braided and tested, its results were destined never to be resolved. It seems plausible, then, that Deren's subsequent resistance to any perceived alignment with surrealism is (both figuratively and literally) bound up in its apparent unravelling. Fiercely self-assured as she was, no doubt its negotiations with so many paraphrased quotations from the recent legacy of surrealism might have troubled as much as energised her: less an authored 'work' than a skein of stuff (in both the archaic and modern senses of this word), tissues in which exchanges and acknowledgements are all too visible. But better than reading *Witch's Cradle* as a stalled project, isn't it better to figure it as a 'constellation-construction'? This is the term the surrealist sculptor Isabelle Waldberg used for her own emerging works of this period,[35] developed in New York from 1942 onwards under the duress of emigration, separation, and parental responsibility. Ranging from table-top scale to the height of a room, the sculptures resemble abstracted aerial line drawings, in which rigour and exuberance are held in balance, defining as much as inhabiting space (Figure 1.2). Made first from wooden dowels, after the war from metal rods, inflected by the artist's knowledge of tribal objects, these constructions speak a strikingly similar language to the networks and armatures that keep arising materially and metaphorically in *Witch's Cradle* as in contemporary surrealist painting. Combining a kind of enchanted mechanics with echoes of skeletal or natural

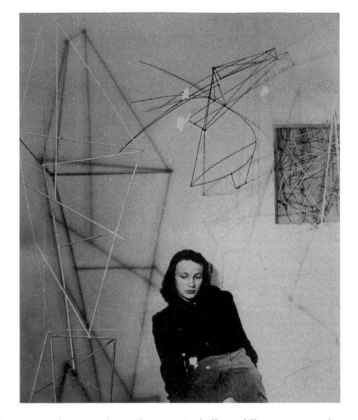

Figure 1.2 Photographer unknown, *Isabelle Waldberg*, New York, 1944

structures, and with subtle motivations of an articulation at the intersection of the body, ritual, and eroticism, it happens that many of these works call to mind scenes and themes from Deren's film.[36]

Free-standing, hung from the wall, or floated near the ceiling, Waldberg's innovative sculptures of this period have barely been discussed in the scholarship on surrealism, despite her background in Georges Bataille's Acéphale group, her place in the inner circle of surrealism in New York, and the sculptures' prominence in contexts such as a personal show at Art of This Century in December 1944, Duchamp's window display of late 1945 at Brentano's book store for Breton's *Le Surréalisme et la peinture*, and the 1947 International Surrealist Exhibition in Paris. While there is no direct evidence that Waldberg and Deren knew each other (the many detailed letters to her husband Patrick Waldberg make no mention of Deren), given the circumstances it seems hard to imagine otherwise. Cross-references are plentiful: both had links to Guggenheim, both collaborated with Duchamp (after

the war he would bequeath Waldberg his Paris studio in rue Larrey), both had husbands working for the OWI (United States Office of War Information, though Patrick was stationed in Europe); but this, in the end, is not really the point. Questing structures, junctures, and crossings over, constellations of materials found immediately to hand; lines against which the gestures of the body may be tested, through which the contours of relationships are plotted: for a moment both Waldberg and Deren seem to have been figuring a concrete diagram of the marvellous.

To be clear, this not a claim for influence or stylistic affinity, but for a correspondence that might be attributed to surrealism's gift for hidden communication: that is, evidence of two individuals – one at a centre of surrealism, the other turning away from its margins – working as sensitive receptors for deep and diffuse strands of thought or experience, materialised as images and objects. In turn, these strands and structures can be discerned as they evolved in the currents and practices of post-war surrealism: notably in the 1947 International Surrealist exhibition, designed by Kiesler and Duchamp, showcasing some of Waldberg's most ambitious work, staged partly around sacred altars informed by surrealism's experience of Haitian ritual and devoted to magic and myth. The following year the Mandrágora surrealist group would organise the *Exposición Internacional Surrealista* at the Galería Dédalo in Santiago de Chile, in which an installation echoed both *First Papers of Surrealism* and (no doubt involuntarily) its recreation and animation for *Witch's Cradle*: in a dark-painted corridor a female mannequin sat on one of a row of chairs among loops and clots of string festooned from the ceiling like a spider among cobwebs, remains of a ritual meal on another chair, threads reaching out to the curls of a text chalked on the wall (Figure 1.3). Finding new contexts, these networks would keep being spun.

Ritual, myth, communication

Deren's subsequent 'trance' films *At Land* and *Ritual in Transfigured Time* would be made without the explicit collaborations with surrealism *Witch's Cradle* had tested out, and by the mid-1940s she was repeatedly insisting on the distance between her work and the movement (whose New York community would henceforth gradually disperse). Nevertheless, affinities and resonances continue; the concluding discussion here can only begin to outline a few. *Ritual in Transfigured Time* is the later film (1945–46), and is in some ways the most focused and accomplished of the series, though less characterised by the experimental disparity of the earlier works. Its opening section in particular pushes forward themes from *Witch's Cradle*. Three

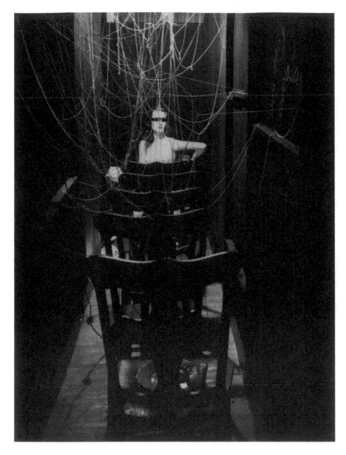

Figure 1.3 Photographer unknown, installation view, *Exposición Internacional Surrealista*, Galéria Dedalo, Santiago de Chile, 1948

women assemble in a sparsely furnished apartment, the spaces of its room material yet uncertain, as we see Deren holding and rocking a skein of wool being gathered into a ball by the dancer Rita Christiani, watched by the writer Anaïs Nin. Glimpsed briefly in the background of the room, what looks like an expansive sculptural form made of curving lines (reminiscent of Waldberg's constructions though clearly not by her) figures a reminder of the objects from Art of This Century (Figure 1.4). Female agency, fluid and converging identities, and especially the location of ritual in everyday environments are all woven in ways that at least obliquely connect to contemporary surrealist practice. At several points, for example, the film's first scenes use doors as liminal and ritual spaces, invitations to initiation that could fruitfully be set next to a key work by Dorothea Tanning: *Birthday* of 1942,

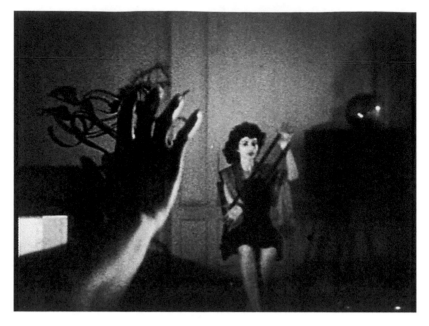

Figure 1.4 Maya Deren, *Ritual in Transfigured Time*, 1945–46

a painting that depicts the artist herself, bare-chested and clad in drapery and mistletoe, standing in an otherwise empty room from which endless half-open doors beckon, at a threshold between the natural and the social, being and becoming. Tanning herself was filmed for a scene in *Ritual*, though the footage was not retained for its final version; indeed, several elements listed in Deren's production notes but omitted from the film – magic symbols, space/time complexity, and sexual aspects – might all have had the effect of making it more available for surrealist readings of the work.[37]

The film's following section choreographs a party as a ritual dance: encounters and relationships are woven and unwoven as Christiani, dressed as a widow, moves among the guests, the action in slow motion and silence imparting a sense of oneiric languor and inevitability to otherwise everyday gestures or meetings, and an insidious eroticism in its lingering gaze upon touching, looking, and partnership. At one level a literal depiction of the complexity of 'networking', the film enacts the tensions and dialectic between personal and social ritual both at the level of its diegesis and, it would seem, at that of its production, where actors (drawn from Deren's pool of friends and contacts) had to repeat the scene to the point of losing their sense of control and selfhood, 'on the verge of hysteria' in the words of Nin.[38] While the results do not resemble surrealist practice, at a deeper level

these are concerns around psychic identity and community that broadly speaking can also be found repeatedly in international surrealist-related research of this era: one might point, for example, to the significance of ethnography for the circle around Wolfgang Paalen's journal *Dyn* in Mexico between 1942 and 1944; or of a sacred sociology of poetry for Jules Monnerot's *La poésie moderne et le sacré*, published in Paris in 1945; or the attempt beginning in 1942 by New York-based Greek surrealist writer Nicolas Calas to tackle 'the problem of behaviour from the point of view of the man who is *aware* of his destinies and who is *conscious* of the significance of intentions'.[39]

At Land of 1944 had also featured a social gathering, one into which the main protagonist, Deren herself, has been magically transported, from her first emergence from the sea on to a beach, crawling from driftwood to banquet table, but during which the convivial party pays her no attention. Tempting as it is to read this as representing Deren's own experience, mingling fascination and rejection, of Manhattan's 'in-crowd' (including the surrealists), the film is ultimately more concerned with its exploration of selfhood in relation to shifting frameworks of time and space, especially in the context of natural environments. Born from the ocean and returning to the shore at the film's end, Deren uses editing to play with conventional continuity, jumping from one space to another or producing circular narratives. Again, in broad terms at least, these interests in space-time and the fourth dimension can also be found in aspects of the debates in contemporary surrealist circles, and especially characterise the research of surrealist artists like Matta (whose notion of an 'inscape' also captures something of the tensions between inner and outer worlds particular to Deren) and Onslow Ford, who together towards the end of the 1930s developed ideas informed partly by recent proposals in physics and mathematics; their paintings of the 1940s continued to explore domains that folded together natural, physical, cosmic, and interior realms around the endless journey of identity.[40]

The articulation of this emerging and unbounded identity within a wilderness – Deren selected an especially inaccessible peninsula for *At Land*'s beach location – can't help but also call to mind elements of Breton's major text from this period, *Arcane 17*. Begun in August 1944 under the influence of the wild seashore and fauna at Gaspé in Quebec, just as *At Land* had been born at Amagansett beach that same summer, the book revolves around themes of myth, landscape, ecology, and above all the emancipation of female power as the principles for a path out of conflict (incarnated by the Star woman of the 17th Arcanum of the Tarot and the mythical figure of Melusine, both of whose representations draw together cosmic and terrestrial themes and specifically situate them between land and water).[41] As Terri

Geis has established, a number of archaic motifs, particularly relating to Ancient Egyptian mythology, can be seen to link Deren's and Breton's concerns as well as those of Aimé Césaire,[42] but the coming together of strands around littoral landscape, wilderness (female) identity, and myth or magic are also powerful connections, especially given *Arcane 17*'s status as a text that presaged many key directions for French surrealism's research priorities in the post-war era. Deren, of course, must have been aware of the resonances between the book and *At Land*, her sympathy strongly implied by the fact that she chose to photograph Breton against Duchamp's window display for its launch at Gotham Book Mart in April 1945; and though by this period she was publicly distancing herself from surrealism, it is notable that her archives show repeated moments when she specified that Breton knew and supported her films.[43]

From ritual to myth to magic, Deren's films of the mid-1940s occupy a space that was also a domain of the contemporary and developing concerns of international surrealism, and they aimed to explore, in the words of Marina Warner, 'the profound affinity between the material properties of film and inner states of the mind'.[44] Despite her reservations about the surrealist unconscious, these works address the possibility that film is an unfolding imaginative process that takes place within an ongoing community of correspondences. That these ideas would find themselves restaged in a life-changing encounter with Haiti and vodou, one that surrealism too had so recently undergone and that would help carry it forward towards its emerging priorities, is just one more sign of the implicit dialogue between Deren and the movement at a significant turning point for them both.[45] 'Far more than anything else, cinema consists of the eye for magic,' wrote Deren in 1946, 'that which perceives and reveals the marvellous in whatsoever it looks upon.'[46] Many surrealists of the post-war era, in which film would become so central a concern, might well have concurred.

Notes

1 Deren, undated note, cited in Keller, *Maya Deren*, 84.
2 See, for example, McPherson, *Essential Deren*, 42ff, 57ff, 87.
3 Noble, 'Clear Dreaming', 210–26; Geis, '"Death by Amnesia"'.
4 The former is a feature of scholarship following P. Adams Sitney's study *Visionary Film*, which devotes its opening chapters to Deren but starts with a detailed description of *Un chien andalou*. The latter characterises, for example, several essays in Nichols, *Maya Deren and the American Avant-Garde*, including the additional tendency to draw parallels with figures such as Marcel Duchamp, Georges Bataille, and Antonin Artaud without acknowledging that these are also essentially surrealist contexts.

5 Kyrou, *Le Surréalisme au cinéma*, 200.

6 Deren's library included a number of books relating to surrealism; see Clark, Hodson, and Neiman, *The Legend of Maya Deren* 2, 58 (henceforth cited as LMD2).

7 Letters from 1938–39, for example, mention Dalí's *The Persistence of Memory* – see Clark, Hodson, and Neiman, *The Legend of Maya Deren* 1, 384, 390 (henceforth cited as LMD1).

8 Deren, 'An Anagram of Ideas on Art', 62.

9 McPherson, *Essential Deren* – for example, 39, 43, 49, 57, 62.

10 LMD1, 480–97.

11 Duits, *André Breton a-t-il dit passe*, 90–1.

12 Duits describes Breton in this period as 'large, heavy, imposing, and a little bit frightening': ibid., 76.

13 See, for example, Nixon, *Fantastic Reality*.

14 LMD1, 29–30, 220ff.

15 Monoskop, 'Alexander Hackenschmied'. Both Hammid and Deren specifically refer to Man Ray's photography – see LMD2, 35, 114.

16 On the everyday and urban space in Czech surrealism, see, for example, Fijałkowski, Richardson, and Walker, *Surrealism and Photography in Czechoslovakia*.

17 LMD2, 19; a well-known 1929 photograph of Štyrský and Toyen shows them wearing industrial face masks, to similarly unsettling effect.

18 Ibid., 150.

19 For the script, see ibid., 163–5; on showing the work, see 150, 151.

20 Ibid., 151.

21 Again, we should remember that these may be out-takes; a still of the heart, reproduced in ibid., 156 but not in the extant footage, shows it slit to reveal an eye inside it.

22 See Meyer-Thoss, *Meret Oppenheim*, 90; other sources date the idea to the 1930s.

23 LMD2, 130.

24 Onslow-Ford, cited in Pierre, 'Gordon Onslow Ford', 190. Briony Fer explores webs and connectivity in Matta's works in 'Networks', 35–45.

25 Noble, 'Clear Dreaming', 217.

26 'I was concerned', Deren would write in 1945 in a note on the film, 'with the impression that surrealistic objects were, in a sense, the cabbalistic symbols of the twentieth century; for the surrealist artists, like the feudal magicians and witches, were motivated by a desire to deal with the real forces underlying events … and to discard the validity of surface and apparent causation' (LMD2, 149). Magic/occult interventions were a notable theme in other surrealist circles at this time, particularly in Bucharest – research of which Deren would have been entirely unaware.

27 See LMD1, 405–13; Noble, 'Clear Dreaming', 210–11, 217.

28 LMD2, 137–8. On Kiesler's theories in the context of Art of this Century, see, for example, 'Note on Designing the Gallery', 42–4.

29 For the history of the gallery, see Davidson and Rylands, *Peggy Guggenheim & Frederick Kiesler*; see 190–1 for images of the Abstract Gallery.

30 'You don't realise, but you're in the process of breaking a lot of strings', said Seligmann to Duits when the poet attended his first group meeting in New York (Duits, *André Breton*, 43).

31 Hopkins, 'Duchamp'.

32 See Neiman, 'An Introduction to the Notebook of Maya Deren, 1947', 5–7. Neiman recalls anthropologist Margaret Mead's 'most vivid memory of the proposed film on ritual and children's games was of seeing Deren trace hopscotch lines in the air ... to define an artificial ritual space, a frame of reference, boundaries that may not be crossed or stepped upon' (14).

33 A useful overview is McKenzie, *One Continuous Loop*. My thanks to Victoria Mitchell for steering me in these directions.

34 See Levitt, *In the Street*. Breton owned several works by Levitt – see the online archive of his collection at www.andrebreton.fr/person/12896 (accessed 25 September 2018).

35 Isabelle Waldberg, letter of 27 July 1943, in Waldberg, *Un amour acéphale*, 67.

36 For Waldberg's work and career, see Waldberg, *Isabelle Waldberg* and www.isabellewaldberg.com. Intriguingly, Deren too had a wire-and-string mobile suspended from the ceiling in her Morton Street apartment (it may have been Hamid's – see the photograph c. 1944 and comment in LMD2, 130–1); in later years she would hang a fishnet over her bed (LMD2, 132).

37 Noble, 'Clear Dreaming', 220–1; Keller, *Maya Deren*, 131–2. Duits also had a role in this film; another young surrealist poet, Philip Lamantia, appears in *At Land*.

38 LMD2, 534.

39 Calas, in Hoff, *Nicolas Calas and the Challenge of Surrealism*, 196.

40 See, for example, Alix, *Gordon Onslow Ford*, 200. Deren acknowledged that 'the defiance of normal time ... and space' was the domain of both magicians and 'surrealist painters and poets' (LMD2, 149).

41 Breton, *Arcanum 17*, 59ff. 'I bewitch and I multiply', writes Breton of Melusine (76). 'I obey the freshness of water, capable of erecting its palace of mirrors in one drop and I'm heading for the earth which loves me, for the earth which couldn't fulfil the seed's promise without me'; could the reader have been persuaded this was Deren speaking?

42 Geis, '"Death by Amnesia"'.

43 On Deren's photographs, see LMD2, 145–7; for Breton's endorsement in her grant applications, see ibid., 190 (Breton has 'seen and praised' *At Land*), 356–7. Deren would also cite endorsements from Duchamp, Ernst, and Levy.

44 Warner, 'Dancing the White Darkness'.

45 See Geis, '"The Old Horizon Withdraws"', 173–89.

46 Deren, 'Magic Is New', 206.

Bibliography

Alix, Josefina et al., eds.. *Gordon Onslow Ford: mirando en lo profundo*. Santiago de Compostela: Fundación Eugenio Granell, 1998.

Breton, André. *Arcanum 17*, translated by Zack Rogow. Los Angeles, CA: Sun and Moon Press, 1994.

Clark, Veve A., Millicent Hodson, and Catrina Neiman. *The Legend of Maya Deren: A Documentary Biography and Collected Works*, volume 1, part 1: Signatures (1917–42). New York: Anthology Film Archives, 1984.

———. *The Legend of Maya Deren: A Documentary Biography and Collected Works*, volume 1, part 2: Chambers (1942–47). New York: Anthology Film Archives, 1988.

Davidson, Susan, and Philip, Rylands eds. *Peggy Guggenheim & Frederick Kiesler: The Story of Art of This Century*. New York: Guggenheim Museum, 2004.

Deren, Maya. 'An Anagram of Ideas on Art, Form and Film'. In *Essential Deren*, edited by Bruce McPherson, 34–109. Kingston, NY: Documentext, 2005.

———. 'Magic is New'. In *Essential Deren*, edited by Bruce McPherson, 197–206. Kingston, NY: Documentext, 2005.

Duits, Charles. *André Breton a-t-il dit passe*. Paris: Denoël, 1969.

Fer, Briony. 'Networks: Graphic Strategies from Matta to Matta-Clark'. In *Transmission: The Art of Matta and Gordon Matta-Clark*, 35–45. San Diego, CA: San Diego Museum of Art, 2006.

Fijałkowski, Krzysztof, Michael Richardson, and Ian Walker. *Surrealism and Photography in Czechoslovakia: On the Needles of Days*. Farnham: Ashgate, 2013.

Geis, Terri. '"Death by Amnesia": Maya Deren, Egypt, and "Racial" Memory'. *Dada/Surrealism*, no. 19 (2013). Accessed 19 October 2018. http://digital.lib. uiowa.edu/dadasur/dadasur19/dadasur19-geis.htm.

———. '"The Old Horizon Withdraws": Surrealist connections in Martinique and Haiti – Suzanne Césaire and André Breton, Maya Deren and André Pierre'. In *Intersections: Women Artists/Surrealism/Modernism*, edited by Patricia Allmer, 173–89. Manchester: Manchester University Press, 2016.

Hammond, Paul, ed. *The Shadow and Its Shadow: Surrealist Writings on the Cinema*, 3rd edn. San Francisco, CA: City Lights, 2000.

Hoff, Lena. *Nicolas Calas and the Challenge of Surrealism*. Copenhagen: Museum Tusculanum Press, 2014.

Hopkins, David. 'Duchamp, Childhood, Work and Play: The Vernissage for First Papers of Surrealism, New York, 1942'. *Tate Papers*, no. 22 (2014). Accessed 19 October 2018. www.tate.org.uk/research/publications/tate-papers/22/duchamp-childhood-work-and-play-the-vernissage-for-first-papers-of-surrealism-new-york-1942.

Keller, Sarah. *Maya Deren: Incomplete Control*. New York: Columbia University Press, 2015.

Kiesler, Frederick. 'Note on Designing the Gallery'. In *Selected Writings*, edited by Siegried Gohr and Gunda Luyke, 42–4. Ostfildern: Verlag Gerd Hatje, 1996.

Kyrou, Ado. *Le Surréalisme au cinéma*. Paris: Ramsay, 1985.

Levitt, Helen. *In The Street: Chalk Drawings and Messages, New York City 1938–1948*. Durham, NC: Duke University Press, 1987.

McKenzie, Robyn. *One Continuous Loop: Making and Meaning in the String Figures of Yirrkala*. PhD thesis, Australian National University, 2016. Accessed 19 October 2018. https://openresearch-repository.anu.edu.au/bitstream/1885/111068/37/McKenzie%20Thesis%20Vol-1_Text.pdf.

McPherson, Bruce, ed. *Essential Deren: Collected Writings on Film by Maya Deren.* Kingston, NY: Documentext, 2005.

Meyer-Thoss, Christiane. *Meret Oppenheim: Book of Ideas.* Bern: Verlag Gachnang & Springer, 1996.

Monoskop. 'Alexandr Hackenschmied'. Accessed June 25, 2018. https://monoskop. org/Alexandr_Hackenschmied.

Neiman, Catrina. 'An Introduction to the Notebook of Maya Deren, 1947'. *October,* no. 14 (1980), 3–15.

Nichols, Bill, ed. *Maya Deren and the American Avant-Garde.* Berkeley, CA: University of California Press, 2001.

Nixon, Mignon. *Fantastic Reality: Louise Bourgeois and a Story of Modern Art.* Cambridge, MA: MIT Press, 2005.

Noble, Judith. 'Clear Dreaming: Maya Deren, Surrealism and Magic'. In *Surrealism, Occultism and Politics: In Search of the Marvellous,* edited by Tessel Bauduin, Victoria Ferentinou, and Daniel Zamani, 210–26. New York: Routledge, 2017.

Pierre, José. 'Gordon Onslow Ford, Parisian'. In *Gordon Onslow Ford: Mirando en lo profundo,* edited by Josefina Alix et al., 187–91. Santiago de Compostela: Fundación Eugenio Granell, 1998.

Richardson, Michael. *Surrealism and Cinema.* Oxford: Berg, 2006.

Sitney, P. Adams. *Visionary Film: The American Avant-Garde, 1943–2000.* Oxford: Oxford University Press, 2002.

Waldberg, Michel. *Isabelle Waldberg.* Paris: La Différence, 1992.

——, ed. *Un amour acéphale: Patrick Waldberg, Isabelle Waldberg, Correspondance 1940–1949.* Paris: La Difference, 1992.

Warner, Marina. 'Dancing the White Darkness: Maya Deren'. *Tate Etc.,* no. 10 (Summer 2007). www.tate.org.uk/context-comment/articles/dancing-white-darkness.

2

Savage art: Michel Zimbacca's *L'Invention du monde*

Michael Löwy

L'Invention du monde is one of the most important surrealist documentary films. Directed in 1952 by Michel Zimbacca, with the help of Jean-Louis Bédouin, it presents views of the 'savage arts' – objects, dances, music – with a commentary by the poet Benjamin Péret; all three were active members of the Parisian surrealist group. It is not an ethnographic film, but rather a unique surrealist poetical mythological piece (Figure 2.1).

The attraction of 'primitive' or 'savage' cultures is a recurring theme in Romanticism, where it can inspire a revolutionary critique of modern civilisation, as is the case for Jean-Jacques Rousseau in his *Discourse on the Origins of Inequality* (1755) – an essay which can be considered one of the founding documents of Romanticism. Marx and Engels did not hide their admiration for the egalitarian, democratic way of life of those still living at the stage of 'primitive communism', such as the indigenous peoples of North America. Engels was greatly inspired, in *The Origins of Family, State and Private Property* (1884), by the work of the American Romantic anthropologist Lewis Morgan, whose writings celebrated the free and interdependent universe of 'primitive' tribes, represented by the Iroquois Confederacy. Here is a passage from Morgan's work, quoted by Engels, and in turn quoted by Breton in his 1945 lecture on Romanticism in Haiti:

> Since the beginning of civilization, the accumulation of wealth has become so enormous, its forms so diverse, its application so extensive and its administration so skilful in the interests of the property-owners, that this wealth has become, in the eyes of the people, a force impossible to master Democracy in its administration, fraternity in society, the equality of rights, and universal education will inaugurate the next, superior stage of society This will be a revival – but in a superior form – of the liberty, equality and fraternity of the ancient gentes.[1]

Surrealism is one of the most important manifestations of the Romantic perspective in the twentieth century. Romanticism is much more than a literary movement from the early nineteenth century: as a worldview, it is a protest against capitalist modernity, in the name of pre-modern values;

Figure 2.1 Michel Zimbacca with Jean-Louis Bédouin,
L'Invention du monde, 1952

present in all spheres of cultural life, it has taken different forms, from the eighteenth to the twenty-first centuries.[2] One of its essential aspects is the discontent with the *disenchantment of the world*. Max Weber noted in a celebrated talk, 'Science as a Vocation' (1919): 'The fate of our times is characterized by rationalization and intellectualization and, above all, by the "disenchantment of the world" (*entzauberung der Welt*).'[3] Romanticism may be viewed as being to a large extent a desperate attempt to re-enchant the world.

In surrealism this often takes the form of the rediscovery of magic art, and of the mythology and marvellous manifestations of 'savage art' – a term surrealists preferred to the usual one, 'primitive art', with its depreciative connotations. 'Savage' for them meant the opposite of 'civilised', and it had a rebellious and antagonistic meaning. The surrealist interest in primitive civilisations was not limited to their ways of life, but was also focused on the spiritual quality of their artistic works, and more significantly so. Oceanic art represents, according to André Breton – in his famous 1948 essay 'Oceania' – 'the greatest effort ever to account for the interpenetration of mind and matter, to overcome the dualism of perception and representation'. He goes so far as to suggest that the surrealist path, since its beginning – and throughout the 1920s – 'is inseparable from the seduction, the fascination'

exercised by the works of the indigenous peoples of the Americas, the North Pole, or New Ireland (Oceania).[4]

Why such a strong attraction? Here is the explanation proposed by Breton in the same text: 'the marvelous, with all it implies in terms of surprise, splendor, and dazzling outlook on to something other than what we are able to know, has never enjoyed, in visual art, the triumph it scores with some first-rate Oceanic objects'.[5]

The extraordinary charge of *subjectivity* in primitive arts also seduced the surrealists. Here's what Vincent Bounoure – surrealist and expert on 'primitive' arts – has written regarding the surprising flash, the 'piercing rays', of the eyes of Oceanic figures:

> The power of subjectivity (the mana of old-fashioned ethnological vocabulary) expressed by the gaze: there is no reality to which Oceania had been more sensitive. Such an incitement was completely lacking in Greece – Hegel ceaselessly reproaches (Greece) for its marble eyes, the vacant stare of its gods. It's quite remarkable that the expression of the gaze had suggested to the Oceanic peoples the use of methods foreign to the art of sculpture, powerless by itself – always according to Hegel – to express the interior light. Oceania had innumerable materials at its disposal to intensify that strength. Inserted in the orbit of the eye, cowries, seeds and berries, pearls and shell each in turn animate the Oceanic subjectivity.[6]

The surrealist Romantic empathy with pre-capitalist 'primitive' cultures is one of the reasons for their categorical opposition to colonialism, from their denunciation of the French war against the Arab resistance led by Abd-el-Krim (in the Rif mountains of North Africa) in 1925, to their support for the right of desertion from the colonial war in Algeria, in the famous *Manifesto of the 121* (1961). Colonialism was, in their eyes, the despicable attempt by the Western imperial powers to impose, by brutal military means, the capitalist way of life and reactionary Western religions on the indigenous peoples, repressing or destroying their rich cultural world.

For the surrealists, the magic relation to nature and the intensity of the marvellous were essential components of 'savage' culture and artefacts, in opposition to the oppressive capitalist and mercantile modern Western civilisation (Figure 2.2). Their interest in savage art is therefore directly linked to their anti-colonialist commitment, and to their desire to 're-enchant' the world. André Breton collected art from the Americas (the Hopi Kachina dolls) and Oceania, and was fascinated by Mexican indigenous cultures, an attitude shared by Benjamin Péret. In 1945 Breton visited Hopi communities in the United States, with the intention of writing a book on their art (only a notebook remained of this project). And at the end of the same year, he visited Haiti and gave several talks celebrating the magical spirit of Afro-Haitian culture.[7]

Figure 2.2 Michel Zimbacca with Jean-Louis Bédouin,
L'Invention du monde, 1952

Another aspect of the 'primitive' cultures which attracted the surrealists as it did the early German Romantics (such as Friedrich Schlegel) as a powerful way of world-enchantment was myth. The importance of myth for surrealism lies also in the fact that it constitutes a profane alternative to the grip of religion on the non-rational. It is in this sense that we must interpret Breton's remark – taken as a provocative and iconoclastic image – in the dedication of a copy of *Mad Love* (1937) sent to his friend Armand Hoog: 'Let's demolish the churches, starting with the most beautiful, so that no stone rests upon another. Then will live the New Myth!'[8] For Breton and his friends, myth was a precious crystal of fire; they refused to abandon it to fascist mythomaniacs. In the 1937 text 'Nonnational Boundaries of Surrealism', Breton suggests that surrealism must be assigned the task of 'elaborating a collective myth appropriate to our period', whose simultaneously erotic and subversive role would be analogous to that played in the eighteenth century, just before the French Revolution, by the Gothic novel.[9] Everything thus seems to indicate that for him, myth and utopia are inseparable; if they are not identical, they are at least linked by a system of communicating vessels which assures the passage of desire between the two spheres. As we will see below, Benjamin Péret was one of the surrealists most deeply concerned with 'primitive' myths and their poetic and utopian significance.

L'Invention du monde needs to be seen as part of this (Romantic) surrealist attraction to the non-Western, non-modern, and pre-capitalist cosmos, with its enchanted, magical, and mythical elements. These were cultures where humans and nature were intimately related – unlike Western civilisation – and where the high and the low, heaven and earth, were not opposed, as in Christianity. Moreover, for them art was not a separate domain, as in the West, but part of their life, their rituals, their ceremonies, their magical relation to the world.

The idea of producing a documentary on the savage arts came from Michel Zimbacca. Of Syrian origin, but born in Paris in 1924, Zimbacca joined the surrealist group in 1949. Poet, painter, and film-maker, he was very much attracted to the 'primitive' arts, and decided it was time for the surrealists to pay homage to them. After some time he was joined by Jean-Louis Bédouin (1929–96), poet and essayist, who had a vast knowledge of pre-modern cultures but no experience in film-making.

The twenty-six-minute film shows photos and artefacts from the Americas, Asia, Africa, and Oceania, mainly taken from the collections of the Muséee de L'Homme in Paris, but also from the British Museum and the Museums of Basel, Bremen, Berlin, Hamburg, Leiden, Mexico City, Brooklyn, Chicago, New York, Ottawa, Saint-Louis, Santa Fé, and Sidney, as well as from private collections. It also includes a few cuts from ethnographic pictures, showing ritual dances and ceremonies. Zimbacca filmed objects which belonged to André Breton, at his home, among which are his collection of Hopi dolls and various Oceanian objects (Figure 2.3). He also visited Claude Lévi-Strauss, who permitted him to film several pieces from his collection of masks, as well as some friendly merchants in 'primitive' arts. Some of the objects were borrowed from surrealist friends, including Péret, Jacques-Bernard Brunius, and Man Ray.

Zimbacca would put the objects or the photos on a table, and film them from above, vertically. In some cases he would give to the objects some slow movement, therefore enhancing their dramatic power. The montage (editing, assembling) of the images did not organise them according to their origin. Zimbacca and Bédouin followed two essential surrealist poetical principles: analogy and free association. The links between the objects were given by some topics: the Cosmos, Man and Woman, Life and Death, the Mask and the Face, Totems and Animals, Myths and Legends.[10]

Zimbacca and Bédouin also selected the impressive musical background to the film from the collections of musical ethnology at the Musée de l'Homme. It includes songs, dances, and other pieces from Mexico (Figure 2.4), Japan, Bali, Brazil, Australia, Africa (Pygmies), the United States (indigenous tribes), Haiti (vodou), and more.

One of the most original ideas in the film is the view of the various savage cultures as expression of a *universal human spirit*, drawing on the infinite

Figure 2.3 Michel Zimbacca with Jean-Louis Bédouin,
L'Invention du monde, 1952

Figure 2.4 Michel Zimbacca with Jean-Louis Bédouin,
L'Invention du monde, 1952

resources of the unconscious (in the Freudian meaning). The origin of the pieces is not ignored, but the movement of the film follows a mytho-poetical logic, which emphasises the unity of the magical universe to which all pre-modern cultures belonged. It is a brilliant insight, which distinguishes *L'Invention du monde* from most ethnographic documentaries. It is above all a *poetical* film, which has more to do with Sigmund Freud – art as expression of unconscious libido – than with scientific anthropology.

A separate section of the film, *Quetzalcoatl, le serpent emplumé*, is dedicated to the Aztec myth of Quetzalcoatl, the Feathered Serpent, God of Death and Resurrection. As an incarnation of the planet Venus, Quetzalcoatl sacrifices himself in order to resurrect as the Morning Star. The material for this section is the sixteenth century *Codex Borgia,* with language and images from Mexican artists, and the commentary was written by Péret. By emphasising a specific cultural universe, this part is quite different, in form and content, from the main film. The film-makers, considering that it would break the dynamic movement, leading to a symbolic universalism, of the larger film, decided to produce it separately. They were helped in their work by Professor Lehman, an anthropologist of the Musée de l'Homme and specialist in South American indigenous cultures.

The power of *L'Invention du monde* owes much to the commentary, written by Benjamin Péret and read off-screen by actor friends: Gaston Modot, Roger Blin, François Valorbe, Thérèse Eliot, Dominique Chautemps, Doudou Ndiaye, Douta Secx, and Jacques Winsberg. Once the montage was complete, Zimbacca and Bédouin brought the film to Péret, who then added the commentary: a striking, incantatory, lyrical, mytho-poetical, and dramatic text, a unique piece without precedent or sequel. Text and image seem to be in a relation of *elective affinity*, where each reinforces the radiance of the other.

Péret was also a great admirer of savage cultures. He collected Brazilian artefacts of indigenous and African-Brazilian origin, and was preparing an anthology of indigenous myths and legends from the Americas.[11] In 1943 he wrote an introduction to this anthology, which generated an enthusiastic response from Breton and his friends, who at the time were exiled in the United States. They published it as a pamphlet titled *La Parole est á Péret* (Péret has the word) under the imprint Les Éditions surréalistes. In this piece the surrealist poet argued that 'the primitive myth is above all poetical exaltation', and it documents 'the freedom of mind of the people which invented it'. The myths and legends of the Americas are the collective product of societies which ignored inequalities and oppressions; in an emancipated world of the future, when social inequality and political oppression will be suppressed, marvellous new myths will be created, as a sort of 'universal progressive poetry', as Friedrich Schlegel defined the myths of the future.[12] In other words, for Péret as for Breton, myth and utopia are inseparably linked.

The way in which Péret's commentary for *L'Invention du monde* narrates a process of humanity getting acquainted with the universe and enduring a symbolic death and rebirth also documents this utopian moment: surrealism puts its hope in the worldview embodied in savage art for its capacity to counter alienation and turn the tide of human destructiveness. In this narrative, myth is omnipresent, as the key figure of the discourse and as the instrument for the alchemical fusion of the poetical words and the picture's images. Péret mentions mainly ancestral myths about the origins of the world, from the Mayas to the Marquesas Islands, and from the Aztecs to the Navajos. And, of course, the short complement on Quetzalcoatl (the *Codex Borgia*) is entirely composed of a mythical narrative.

Péret's text does not translate well, but here is a loose attempt to render the first paragraphs:

The fire circle where the scorpions commit suicide animates nature.

It is the wheel of life that turns eternally.

Human beings, 'those whose desires take the form of clouds', consult it for life and immortality.

From the one to the other, moves forward the funerary ship with the death rowers.

With the soul of the Egyptian dead, it bears witness to the human adventure over the furious waves of the ages that rise, or fossils drying across time.

Sometimes one calls on a wall the powerful buffalo or one implores the ostrich carried by the wind to stop in order to hide its stupid head. By engraving on the stone the prey that he desires, the beast he wants to tame, the human being affirms its power. But in order to shape nature in accordance with his desires, he must first exorcise it.

He transposes the universe into a world of signs and of symbols which create a direct link between him and the unknown powers he wants to approach.[13]

The reference to scorpions may be a homage – deliberate or unconscious – to the first scene in Luis Buñuel's subversive surrealist film *L'Âge d'or* (1930), which shows a ferocious battle among scorpions…

Bédouin worked with Péret in fitting the text with the images and in a testimony many years later commented: 'he invested himself in the enterprise with enthusiasm; without him, without his innate sense of the relation between verbal image and its visual equivalent, without his capacity of adaptation to the technique of *montage*, we could not have made this film'.[14]

In a commentary written when the film was finished, Michel Zimbacca wrote:

Surrealism had recognised a long time ago in the objects of primitive cultures the common foundation of human nature, seized in one single movement, in

one single act of thought. For the surrealists, the most precious thing in this 'legendary treasure of humanity' is the fact that, in relation to these masks, to these strange figures, these lost symbols, it is impossible to separate the rational from the irrational, the known from the unknown, thought from action …. In order to bring together these realities objectively so distant from each other, so distant from us, it was necessary for something to speak, for minds to open, so that the statues of wood and stone become alive, proclaiming the continuity of life and the immemorial idea of human unity. In order to seize this language rising from the symbols, nothing less than the immediate word of Benjamin Péret was needed; in writing the commentary of the film he accomplished the meeting of primitive thinking with modern poetry.[15]

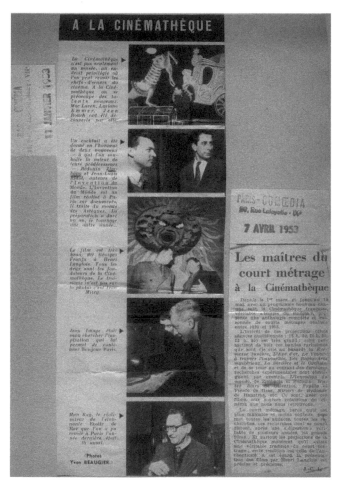

Figure 2.5 Cutting from the Paris Cinémathèque programme for the premiere of *L'Invention du monde*, 1953

L'invention du monde was presented in the beginning of 1953 at the French Cinémathèque, in the presence of André Breton and his surrealist friends, as well as Henri Langlois, the head of the Cinémathèque, and well-known documentary producers Georges Franju and Jean Rouch (Figure 2.5). It was received with great enthusiasm, and a few months later it was exhibited, as a short, in various cinemas. With the help of surrealist Jacques-Bernard Brunius, it was also projected at the Institute of Contemporary Arts in London and at the Film Festival of Edinburgh. And then... nothing. For many years, the film was practically forgotten, and was shown only in rare private sessions, as in 2001, at the Summer University of the Trotskyist Ligue Communiste Revolutionnaire, in the presence of Zimbacca. Finally, in 2012 it was released on DVD by the film historian Francis Lecomte, and has enjoyed a mythical resurrection.

In 1968 Michel Zimbacca produced another surrealist short film, *Ni d'Eve ni d'Adam*; it features Jean Benoît wearing the terrifying costume he invented based on the legendary figure of the nineteenth-century necrophile Sergeant Bertrand, and which he wore at the opening of the 1965 exhibition *L'Ecart absolu*. In 1969, when the surrealist group split, Zimbacca and Bounoure were among those who refused the dissolution, and decided, with their friends in Paris and Prague, to continue the surrealist adventure. In the last decades Zimbacca has published several collections of poems – for instance, *Le Centaure inoxydable* (Paris: Editions Surréalistes, 1994) and *Sans cent vierges ni virgule* (Montreal: Sonambula Loplop, 2017) – and actively participated in the initiatives of the Paris Group of the surrealist movement – tracts, collective statements, collective games, art exhibitions – as well as in its journal *SURR* (*Surréalisme, Utopie, Rêve, Revolte*). He is still in 2020 an active member of the Paris group, where he embodies the continuity with the original group formed by Breton and his friends.

Notes

1 Breton, 'Conferences d'Haïti, IV', 268–9.
2 See Löwy and Sayre, *Romanticism against the Tide of Modernity*.
3 Weber, 'Science as a Vocation', 302.
4 Breton, 'Oceania', 172.
5 Ibid., 173.
6 Bounoure, *Le Surréalisme et les arts sauvages*, 104.
7 Breton's conferences contributed to igniting an uprising which brought down the dictatorship in Haiti. See Löwy and Bloncourt, *Messagers de la tempête*.
8 Quoted in Beaujour, 'André Breton mythographe', 218.
9 Breton, 'Nonnational Boundaries of Surrealism', 14–15.
10 Michel Zimbacca, interview with the author, 17 January 2018.

11 Péret, *Anthologie des mythes*; Péret, *Arts primitifs et populaires du Brésil.*
12 Péret, *Anthologie des mythes,* 25–30.
13 Péret, 'Commentaire de *L'Invention du monde*', 58.
14 Zimbacca, *Les Surréalistes et le cinéma,* 50.
15 Ibid., 57.

Bibliography

Beaujour, Michel. 'André Breton mythographe: *Arcane 17*'. *Études françaises* 3, no. 2 (1967): 215–33.

Bounoure, Vincent. *Le Surréalisme et les arts sauvages.* Paris: L'Harmattan, 2001.

Breton, André. 'Conferences d'Haïti, IV'. In *Oeuvres complètes*, volume 3, edited by Marguerite Bonnet et al., 252–74. Paris: Gallimard, 1999.

———. 'Nonnational Boundaries of Surrealism'. In *Free Rein*, translated by Michel Parmentier and Jacqueline d'Amboise, 7–18. Lincoln, NE: University of Nebraska Press, 1995.

———. 'Oceania'. In *Free Rein*, translated by Michel Parmentier and Jacqueline d'Amboise, 170–4. Lincoln, NE: University of Nebraska Press, 1995.

Löwy, Michael, and Gerald Bloncourt. *Messagers de la tempête: André Breton et la revolution de Janvier 1946 en Haïti.* Paris: Le Temps des Cérises, 2007.

Löwy, Michael, and Robert Sayre. *Romanticism against the Tide of Modernity*, translated by Catherine Porter. Durham, NC: Duke University Press, 2001.

Péret, Benjamin. *Anthologie des mythes, légendes et contes populaires d'Amérique.* Paris: Albin Michel, 1960.

———. *Arts primitifs et populaires du Brésil: Photographies inédites*, edited by Jerôme Duwa and Leonor Lourenço de Abreu. Paris: Editions du Sandre, 2017.

———. 'Commentaire de *L'Invention du monde*'. In *Les Surréalistes et le cinéma*, edited by Michel Zimbacca, 58–63. Paris: Choses Vues, 2012.

Weber, Max. 'Science as a Vocation'. In *From Max Weber: Essays in Sociology*, 129–56. London, Routledge, 1967.

Zimbacca, Michel, ed. *Les Surréalistes et le cinéma.* Paris: Choses Vues, 2012.

3

Joseph Cornell's American appropriation of surrealism by means of cinema[1]

Tom Gunning

Joseph Cornell: surrealist or symbolist?

From 1932 until his death in 1972 Joseph Cornell produced a series of major works – boxes, collages, and films – expanding and transforming the idiom of surrealism through a profoundly American appropriation, deeply mediated by cinema. Cornell is best known for his boxes, rectangular shallow containers covered with glass that frame a variety of juxtaposed objects, images, and texts. These boxes recall surrealist objects, such as those showcased in the 1936 *Exposition surréaliste d'objets*, or the Dada objects of Kurt Schwitters and Marcel Duchamp, especially the readymades, whose influence Cornell enthusiastically acknowledged. Surrealist objects included found objects, such as Breton's 'Cinderella Ashtray' discovered in a flea market, as well as constructions that transform common objects into oneiric presences, such as Man Ray's clothes iron studded with nails, or Meret Oppenheim's fur-lined teacup.[2] Cornell's first exhibition at Julian Levy's Gallery in 1932 was titled 'The Objects of Joseph Cornell',[3] and he often referred to his works as 'Objects', especially during the 1930s and 1940s.[4] But Cornell's arrangements transcend the dissonance of a surrealist joke, resembling reliquaries of odds and ends caught between random meaninglessness and deep significance. The boxes extend the allegorical space of surrealist painting into the third dimension, and render material the verbal juxtaposition of distant realities found in surrealist literature.

Art historian William Rubin found that Cornell's 'style and iconography are unthinkable without surrealism'.[5] Cornell emerged within the surrealist milieu, one of the first (excluding the expatriate Man Ray) American artists to do so. Connections are undeniable: Max Ernst's collages and the surrealist objects inspired the first works Cornell produced. He participated in the earliest American exhibitions of surrealist art at Julian Levy's gallery (1932) and the Museum of Modern Art (1936), and supplied the cover illustration for Levy's exhibition catalogue. A photograph of his early work *Glass Ball*

was reproduced in the surrealist journal *Minotaure* in 1938, while in 1941 Breton cited Cornell as an American surrealist.[6] Levy claimed Cornell created 'perhaps the first series of Surrealist objects made in the U.S.A'.[7] But Cornell also expressed discomfort with the association, requesting Alfred Barr, head of the newly formed Museum of Modern Art in New York City, to describe him not as a surrealist but as an American 'Constructivist'.[8] More revealingly, Cornell declared that, in contrast to the black magic of the surrealists, his art was white magic.[9] Art historian Dore Ashton has even claimed that Cornell 'was not a surrealist at all', adding: 'It was as a Symbolist rather than a Surrealist that Cornell experienced his life and work.'[10] Cornell revered the symbolist poets, from Nerval to Mallarmé. However, Breton claimed this tradition as a source of surrealism. Profound as his debt to the nineteenth-century symbolists may be, Cornell's embrace of modernist techniques of montage gave his work a different tone.

Cornell admired the unity he found in the Romantic area, which he described as 'all of one piece',[11] but his constructions radically juxtapose disparate elements, however magical their relation may be. The most misleading (because, in some sense, accurate) approach to Cornell's works is to describe them as nostalgic. The current understanding of this term as a wistful longing for simpler times obscures its Greek root, *algos*, 'pain' – as in neuralgia, nerve pain. Cornell's longing for the unity of the Romantic era depended upon a painful sense of its loss. His nostalgia cannot be reduced to a sentimental reminiscence of past times or childhood pleasures. These rigorously rectangular boxes contain a world of dispersed fragments, broken shards – a realm of detritus.

Cornell was a passionate collector, but he was hardly a traditional connoisseur of rarities. He resembles a gleaner, finding value in what has been left behind, or a beachcomber seizing on a lucky find. Cornell preserved what others would discard. In contrast to the symbolist aesthete, such as J. K. Huysmans' Des Esseintes, who surrounded himself with the unique and exotic and insulated himself from the vulgarity of a mass-produced culture, Cornell gathered the commonplace, celebrating mass-produced objects and processes of mechanical reproduction. Cornell's biographer Deborah Solomon has pointed out that his montages of commercial art anticipated the Pop Art of the 1960s, albeit with a different tone,[12] but Cornell's boxes lack the irony of Pop Art. He re-enchanted the flotsam and jetsam of commercial culture, finding in them the fragments of the unfulfilled utopian dreams of modern consumer culture.

A devoted Francophile, Cornell endowed his work with references to symbolist poets – Nerval, Baudelaire, Mallarmé, Laforgue. But I claim Cornell for another symbolist school, the mode of American Romanticism that literary critic Charles Feidelson Jr called American symbolism. A group of American writers around the Civil War – Feidelson lists Nathaniel

Hawthorne, Herman Melville, Edgar Poe, and Walt Whitman, and I would add Emily Dickinson – lift the metaphors and symbolism of the Romantic movement into a precociously modern zone of ambivalence.[13] Goethe and the German Romantics – Moritz, the Schlegel brothers, and Schelling – separated symbol from allegory. In allegory an image represents a specific meaning; in contrast, the meaning of a symbol remains evocative and multiple. Tzvetan Todorov summarises: 'The meaning of the allegory is finite, that of the symbol is infinite, inexhaustible; or again, meaning is completed, ended and thus in a sense dead in allegory; it is active and living in the symbol.'[14] For Feidelson, Hawthorne exemplifies the tension American symbolists introduced, vacillating between a stable allegory and the mystery of the symbol: 'the symbolism leads to an inconclusive luxuriance of meaning, while allegory imposes the pat moral and the simplified character'.[15]

The 'Custom House' prologue to Hawthorne's *The Scarlet Letter* captures the power of the symbol as the narrator discovers Hester Prynne's Scarlet A in the archives. The A stands for adultery, but its shameful meaning seems contradicted by the beauty of its needlework. As he handles the antique cloth the narrator says: 'My eyes fastened themselves upon the old scarlet letter, and would not be turned aside. Certainly there was some deep meaning in it most worthy of interpretation, and which, as it were, streamed forth from the mystic symbol, subtly communicating itself to my sensibilities, but evading the analysis of my mind.'[16]

Hawthorne transforms this emblem of sin into more than an allegory, endowing it with the dialectical and enigmatic quality of the Romantic symbol. The American writers that Feidelson cited constructed works around such enigmatic symbols, which promise meaning but evade simple translation. But the Americans take the ambiguity of the symbol one step further, questioning the very issue of meaning. As Feidelson puts it: 'Hawthorne's subject is not only the meaning of adultery but also meaning in general; not only *what* the focal symbol means, but also *how* it gains significance.'[17] Melville's white whale torments readers and characters with the promise, and refusal, of meaning. 'The Doubloon' chapter of *Moby Dick* demonstrates the infinity of possible meanings, as characters offer diverse readings of the emblematic coin nailed to the Pequod's mast. Similarly, Edgar Allan Poe's story 'The Man of the Crowd' presents a mysterious urban wanderer described by the narrator with a German phrase meaning 'it does not permit itself to be read', adding: 'there are some secrets which do not permit themselves to be told'.[18]

These authors produce aborted allegories. Their refusal of interpretation gives them a jagged bite, anticipating modernists like Joyce, Kafka, and Andrei Bely. Cornell derives from the Romantic tradition but swerves away from its unity. His symbols arise from the ruins of allegory. In the early twentieth century Walter Benjamin returned to allegory to understand the

modernist energies of both expressionism and surrealism, rather than the Romantic symbol. Benjamin provokingly valorised allegory's artificial and constructed nature, which the Romantics had scorned, claiming allegory could spark a modernist energy.[19] The danger of the Romantic symbol for Benjamin lay in its promise of transcendence and unity. Howard Caygill has summarised Benjamin's revalorisation of allegory and critique of the symbol: 'The symbol tries to make the finite participate in the infinite, to freeze the moment into an image of eternity, while allegory inscribes death into signification, making the relationship between appearance and essence one which is provisional and endangered.'[20]

Melville, Poe, and Hawthorne created images – an embroidered A, a mysterious city wanderer, a white whale – that invoke more than simple representation. But in contrast to a medieval allegory or Bunyan's *Pilgrim Progress*, we lack a key that will supply the meaning. We experience what critic Edwin Honig calls the 'allegorical waver', the moment where the *Gestalt* shifts from representation to significance.[21] According to Feidelson, this experience invokes the Romantic symbol, whose resonance exceeds any simple decoding. Benjamin adds a modern twist, avoiding the transcendence of the symbol through the revaluing of allegory. From this perspective, Hawthorne's wavering allegories may be anticipations of modernism, rather than residues of Puritan ideology. In place of the fullness of insight that the symbol brings, allegory's discontinuous world triggers melancholia or Baudelaire's spleen.

Medicine for melancholy: techniques of extension

Consider Albrecht Dürer's famous image of melancholia. A dark angel ponders seemingly random objects strewn before him. This heap of objects could have tumbled from a Cornell box – the sphere, the succession of numbers, the hourglass, the cherub, and the view of the sky even recall some of Cornell's recurrent icons, especially in his late collages. Benjamin describes Dürer's scene: 'the utensils of active life are lying around unused on the floor, as objects of contemplation'.[22] The melancholic gaze focuses the paradox of allegory: 'In its tenacious self-absorption it embraces dead objects in its contemplation, in order to redeem them.'[23] Benjamin located the modern resurgence of allegory – and melancholy – in the work of symbolist poet Baudelaire: 'Baudelaire's genius, which is fed on melancholy, is an allegorical genius.'[24] Baudelaire's poem 'Spleen' describes an accumulation of disparate objects:

> One of those huge and cluttered chiffoniers –
> Drawers stuffed with verses, lawsuits, balance sheets,
> Love letters, locks of hair rolled in receipts –
> Hides fewer secrets than my woeful brain.[25]

An urban flâneur, Baudelaire set a pattern of mobile contemplation that Cornell followed in his strolls through Manhattan. These urban forays yielded booty for his boxes and collages. The shelves of Cornell's basement workshop strained under his pickings from dime stores, used bookstores, and photography archives – recalling Baudelaire's cluttered chiffonier and woeful brain.

Cornell's activities of collection and construction reflected his alternation between moods of excitement and melancholy. His voluminous jottings record, often with great poignancy, his day-to-day, even hour-to-hour, mood swings. A note from 29 May 1956 expresses this complex weave: 'one of those visitations or moods just (hovering on deep depression) and exultation in endless unfoldment of city doings in many directions (and the accompanying energy for this seemingly endless inclination (thirst whatever it is) … Nervous kind of reaction sometimes (often) at home that should be the signal for metaphysical work'.[26] It is tricky to interpret such personal notes – and for more reasons than their fragmentary and allusive qualities or eccentric syntax and punctuation. But they reveal mastering his moods as a central motive for his work. Cornell's mood swings provided both material and structure. He strove to evoke and sustain his moments of ecstasy; but he also struggled with the loss of such experiences. Cornell's deep relation to melancholy springs from the tension between his attempt to preserve, and the inevitable fading of, ecstatic experience.

Throughout his creative life Cornell experienced those moments of 'profane illumination' that Walter Benjamin saw as the essence of surrealism.[27] Breton had defined surrealism as embracing the experience of the marvellous, rather than an art movement. Surreality, Breton claimed was a state of being, not an artistic style: 'I believe in the future resolution of these two states, dream and reality, which are seemingly so contradictory, into a kind of absolute reality, a *surreality*, if one may so speak. It is in quest of this surreality that I am going.'[28] Reconciling these experiences formed the centre of Cornell's life and work. Recalling his moments of deep reverie, Diane Waldman found Cornell's 'dreamlike state more surreal than his so-called Surrealist work'.[29] But if Breton proclaims this reconciliation with the bold confidence of an explorer annexing a new world, Cornell experienced the process as fraught with anxiety and melancholy as much as ecstasy.

Cornell was haunted by the ways in which dreams and the experience of the marvellous fade away. His work strives to preserve the moment of vision and its attendant emotions. A note from 1969 states: 'before it fades / Not too hard to hold but one knows that it is going fast dream business evident'.[30] Most precious and difficult to preserve were moments Cornell referred to as revelation, illuminations, grace, or visitations. Although ardently desired, these came upon him unwilled, 'unexpected',[31] or 'surprising',[32] emerging

without notice from everyday and ephemeral phenomenon. He described one instance: 'Sunny Saturday morning while putting up the screens a white cat walked up the drive in the busy atmosphere evoking feelings strangely wonderful. I remember nothing aside from this fact – the intensity of them seemed sufficient.'[33]

Transcendent interruptions of everyday routine formed the weft and weave of Cornell's creative life. He describes their power: 'strong sense of "visitation" enveloping me – sudden awareness of things (the commonplace) being different + the impossibility of capturing the phenomenon in words'.[34] Kirsten Hoving has listed the terms Cornell used for these interruptions: 'unfoldments', 'illumination', 'enrichment', 'distillation', 'extensions', 'sparkings', 'quickening', and 'crystallization'.[35]

These visitations recall accounts of mystical experiences, but Cornell also understood such sudden transformations of the world in relation to the surrealist quest for the marvellous: The 'expected unexpected' – like the surrealist 'state of expectancy' ('état d'attente', or openness to whatsoever might happen).[36] Such exaltation could decline into melancholy. Cornell spoke of 'the yawning nightmare illusion of depression alternating with glories unfailing and always beyond human expression'.[37] His creative process strove to retain and renew these visitations, to 'crystalize' them. Besides the perilous task of seeking to express exultation, Cornell had to fend off abysses of what he called 'bitter feelings of reversal',[38] a sense of futility. Lynda Hartigan quotes Cornell: 'A day of mixed strains – familiar depression and exasperation relieved by periods of "clearing" with encouraging feelings of progression.' She comments that 'his "seesawing" frame of mind (as Cornell termed it) became an integral part of his working process'.[39] P. Adams Sitney puts it succinctly, describing Cornell as 'a dialectician of experience'.[40] Cornell's boxes are magical: not in advertising's redefinition of 'magic' as the fulfilment of consumer desire, but as apparatuses that attract the energy of enchantment and ward off negative forces that threaten from the other side. Art historian Carter Ratcliff says it best: 'his boxes are not the dead residue of long mechanical tasks, but enchanted machines, vehicles for transporting the spirit'.[41]

Cornell's boxes are more than inert packages of nostalgic or charming objects. They are devices – machines – performing predetermined tasks. They neither present nor represent anything. Rather, as machines they *do* something, although Cornell was always uncertain about their ability to accomplish the tasks for which he designed them, concerned that they were 'falling short of a desired once glimpsed goal'.[42] His collages were in effect ghost traps, as he put it, 'sheer haunting magic, caught in a box as [*] with mirror effects'.[43] These energies might be caught but they could not be fixed or frozen. As in all machines, energies power moving parts.

Cornell often describes his transcendental moments as 'overflowing'. These glimpsed moments – the gait of a strolling cat, the grace of a young girl getting off a bus, a certain slant of morning light – would overwhelm him and transform the world about him. Through his constructions Cornell attempts to 'catch the impossibility overflowings charged with overflowing emotions'.[44] Such flows could not be grasped in a static image. Cornell describes his process as active, as 'unfoldment' or 'extension'. This flow may be elusive, but this unfixed nature heightens its motive power. Cornell poignantly writes:

> 'unfoldment' perspective in its poetic aspects – this frequent experience of a kind of enchantment in which a wavering difficult frame of mind (after dreary frustration) the incidents of a day (or portion) unfold with such beautiful graciousness – the most 'trivial', 'commonplace'
>
> but life flows too fast, as now, there never seems time to catch up & make up –[45]

'Unfolding' and 'overflowing' reference the dynamic aspect of ecstatic experience, its ungraspable and expanding nature. A note from Cornell's Garden Center dossier reads: 'rapid overflow of experience … overcrowding of incident and experience ever opening paths leading even farther afield. Unbelievably rich cross-indexing (of experience) the ceaseless flow and interlacing of experience.'[46]

Ever-expanding overflow leads to the 'extensions' that Cornell made of this experience. He did not simply hold on to it, but channelled it into a dynamic series of associations that sustained its transforming power. In the Garden Center dossier (notes and images that Cornell assembled over decades reflecting on the time in 1944–45 when he worked at a centre for gardening supplies) Cornell describes 'extension' as a method for crystallising these transcendental experiences: '"Extensions" / Evocations of experience at unexpected times and place with such a force, significant + "extension" or complement of the original inspiration + joy as to make them something worth of being developed + evaluated.'[47] Cornell intended his works to create these extensions for the viewer. It is in this sense that they are in motion. Correctly viewed, they set the viewer in motion as well.

Machines of vision: Cornell's cinema by other means

Many of Cornell's boxes possess moving parts (although curatorial preservation policies prevent most of us from ever experiencing them). Beyond the sand fountains, pinball slides, and shifting puzzle fragments, miniature music boxes, designed to be turned, shaken or stirred, the mechanics of optical devices in motion inspired a major thread of Cornell's works. Annette

Michelson observed: '[Cornell] will increasingly use those [objects] that can move – thimbles rotating on needles and balls suspended on string – and introduce the suggestion, as in the later boxes, of suspended or arrested movement'.[48] Carter Ratcliff quotes a rich note Cornell wrote after one of his foraging trips into Manhattan:

> impressions intriguingly diverse. – that in order to hold fast, one might assemble, assort, and arrange into a cabinet – the contraption kind of the amusement resorts with endless ingenuity of effect, worked by coin and plunger or brightly colored pin-balls – traveling inclined runways – starting in motion compartment after compartment with a symphony of mechanical magic of sight and sound borrowed from the motion picture art – into childhood – into fantasy – through the streets of New York – through tropical skies – etc. – into the receiving trays the balls come to rest releasing prizes.[49]

Cornell's topoi swarm here – childhood, fantasy, New York City streets, tropical skies – moving over a labyrinthine mechanical pathway.

Movement in Cornell's work is a dialectic of stillness and motion. Julian Levy recognised this from the get-go. Commenting on Cornell's first direct engagement with the cinema, his scenario *Monsieur Phot* (which Levy published in his 1936 anthology *Surrealism*) and the still images from stereographs that Cornell interspersed in it, Levy wrote:

> Cornell's cinematic imagination proved to be an extraordinary exaggeration of the very elements on which motion pictures are mechanically based; the rapid sequence of still images projected at a speed to fuse them by momentum of psychological assumption. Cornell spaced his sequence of stills to an almost unbearable lag, making the utmost demands on one's psyche to furnish continuity of a wild and improvised sort.[50]

As any cinema textbook indicates, cinematic motion relies upon a dialectical leap from the succession of still images imprinted on a film strip to the animated images projected on the screen. This technical and perceptual aspect of cinema held great implications for Cornell. Cinematic movement responds both literally and allegorically to Cornell's dilemma: how can a transcendental moment be preserved without rendering it static, without killing its transformative possibilities?

Victor Frankenstein discovered that reanimation is not only difficult but dangerous. Cinematic motion might dissolve, as Henri Bergson feared, into a purely mechanical repetition of still images, bereft of life.[51] Jodi Hauptman has claimed that Cornell embalmed his obsessions, making them prisoners of his desire, that his boxes dedicated to movie stars freeze the actresses they enframe 'removing them from their *motion* pictures' in which they lived and breathed.[52] While I admit this possibility haunts Cornell's work, I never experience the 1946 Bacall Penny Arcade as frozen. As Hauptman demonstrates,

this box celebrates and refracts the movies as much as the star. The succession of pictures of Bacall at different stages in her life recalls a film strip, and the rolling ball within the box animates the mobile pathways of Cornell's circuits of desire. Rather than tombs of embalmed memories, Cornell's works rehearse a seesaw between stillness and movement. Hauptman ultimately acknowledges this contradiction: 'Cornell always wants to hold fast and make his subjects immortal – which leads to morbid preservation – but he also loves the letting go.'[53] It is the essence of overflow and extension to exceed any frame and forge a bond between maker and viewer. 'Movement, either implied or actual,' says Jasper Sharp, 'is an integral aspect of his work, often extending to involve the participation of the viewer'.[54]

While Hollywood cinema labours to conceal its succession of still images with a seamless continuity of motion, Cornell returned to cinema's mechanical origins in the 'philosophical toys' of the nineteenth century, which amused children by demonstrating the perceptual transformations triggered by rapidly moving still images. Cornell understood his boxes as belonging to this tradition, musing: 'perhaps a definition of a box could be as a kind of "forgotten game", a philosophical toy of the Victorian era, with poetic or magical "moving parts"'.[55] His *Jouet surréaliste* from the 30s playfully recreated such optical devices, especially the Thaumatrope (Plate 1). Invented in the early nineteenth century, the Thaumatrope demonstrated 'persistence of vision', whereby rapidly alternating images appear superimposed. An image of a bird quickly alternating with an image of a cage would appear as an image of a bird *in* a cage.[56] Cornell's *Jouet* pasted images on the front and back of circular paddles which could be spun rapidly and thereby fuse the images. According to Matthew Affron, Cornell also collected phenakistiscope discs and owned a miniature version of a Mutoscope.[57] Both these devices animated rapidly moving still images into apparent motion. Predecessors of the cinema, such hand-operated toys created the perception of motion. But they also revealed the phenomenon of apparent motion as based in still pictures, rendering the dialectic of cinematic motion, occluded in projected cinema, highly visible.

Cinema and its mechanisms offered Cornell more than just the fantasy of the movies and the alluring image of female stars. These supplied material, but the perceptual and mechanical dialectics of cinema offered him structure. Beyond 'stargazing' the cinema served Cornell as a tool for his investigation of vision and images. Besides the Thaumatrope, Cornell's early works includes accordion-like pieces – *Panorama* (c. 1934) and *Object fenêtre* (1937) – which unfold to create mobile and extensive images.[58] His refashioning of a book, the French *Journal d'agriculture practique*, not only had many elements that the reader had to manipulate, but pages 222–42 have a flipbook on the upper-right corner, images of a woman, which, when flipped

rapidly, show her turning and facing the viewer and turning away again.[59] Hauptman lists the visual media named in the pagoda-shaped text Cornell designed for his 1941 piece in *View* magazine entitled 'The Crystal Cage (Portrait of Bernice)', including, fireworks, daguerreotypes, mirages, magic lanterns, illuminations, miracles of perspective, dioramas, a microscope, a kaleidoscope, reflections, a camera obscura, planetariums, zoetropes, cinematography, cycloramas, spectrums, scenic railways, and mirrors.[60] Even the ivory pagoda that Berenice has her millionaire parents bring her from Europe possesses crystal lenses through which she can make astronomical observations. Many of these optical devices are designed to be looked into, like the eighteenth-century Dutch peepshows or perspective boxes that Cornell loved. A small object Cornell made in the 1930s, *Beehive*, possesses a tiny peephole through which one can see its four thimbles endlessly multiplied by mirrors.[61] The subtitle, 'seen through the stereoscope', of Cornell's scenario *Monsieur Phot* imagined that film as viewed through an optical device. Peepshows form a small part Cornell's oeuvre, but many of his boxes contain circular portholes through which rolling balls are glimpsed, and the glass-paned boxes themselves should be thought of as optical devices, focused on the act of looking, more than containers.

Cornell's recreation of philosophical toys recapitulated the invention of cinema, renewing its original dialectic of still and moving images. The photographic experiments of physiologist Etienne-Jules Marey (1830–1904) played a key role in this invention, even though his main purpose was to analyse the movement of people, animals, and natural phenomena. His *chronophotographs* ('photographs of time') parsed motion into a series of still photographs. Cornell referenced this analysis of motion in a number of works. An early collage, *Man Shooting* (c. 1930s), transformed an 1882 illustration showing Marey's assistant aiming a 'fusil photographique', a 'photographic rifle' designed to capture instantaneous photographs of birds in flight, a theme that would be central to later Cornell films.[62] *Man Shooting* montaged the original illustration with disparate elements in different scales: a large bird on a perch, his bill seeming to nudge – or skewer – the shooter; a miniature circular fortification surrounding the platform where he stands; and a music stand in front of the man, as if he fired according to a score.[63] Cornell also pasted Marey's chronophotographs of motion on his Thaumatrope paddles in *Le Voyageur dans les glaces* (c. 1934), animating their figures into brief bursts of motion.[64] The repetitive frames of Cornell's compartmentalised boxes – those forming a grid of rectangular forms, such as his dovecotes or window façades – resemble the successive images of cinema. For a magazine cover of *Dance Index* Cornell laid out the separate frames of a film he had discovered of turn-of-the-century dancer Loie Fuller.[65] Fuller and her serpentine dance of swirling fabrics had formed a

popular subject of early cinema, along with speeding locomotives, teeming city streets and ocean waves.[66] At first glance Cornell's magazine cover looks like one of his compartmentalised boxes, decomposing the motion of cinema into a grid of still images.

Chronophotography's analysis of motion into separate frames provided the structure for several boxes in which Cornell juxtaposed images with objects. In the 1939 box known as *Black Hunter* four chronophotographs of a man firing a rifle appear on the left (Plate 2). Each of the images captures a different stage of smoke emerging from the rifle barrel. On the right side of the box, glimpsed through a series of four portholes, white balls are suspended on black string which seem to be the targets at which the man fires. Diane Waldman informs us: 'When *Black Hunter* is tilted to the side, four circular glass discs – with images of a seashell, a bird being born, a bird in flight and a shot bird – roll across the images of the hunter.'[67] The still images, the rolling discs, the suspended balls embody or invoke motion. In 1940 Cornell fashioned a box titled *Object: Hotel Theatricals by the Grandson of Monsieur Phot Saturday Afternoons*, referring back to his scenario *Monsieur Phot*. Four strips of photographs show successive stages of a young man performing a dance or acrobatics. While not actual Marey chronophotographs, they invoke motion analysis, breaking actions into a series of stills. Actual motion accompanies this representation of action as marbles roll along each of four levels of images.[68] Such devices indicate more than an 'influence' from cinema. They become paracinema, the animation of images other than by the standard cinematic apparatus, a term introduced by Ken Jacobs, a New York film-maker whose contact with Cornell influenced his own work in the 1960s.[69] Such devices allowed Cornell to reconceive the nature of modern artworks and their relation to the viewer. These devices of vision and imagination picked up surrealism's challenge – not to stock art galleries with saleable goods but to transform experience.

A cinema of glimpses

Cornell also made films, beginning with *Rose Hobart* in 1936. His films fall into two basic categories: collage films that reedited pre-existing footage; and films shot by other film-makers (Stan Brakhage and Rudy Burkhardt) under Cornell's direction. The collage films created irrational but highly evocative juxtapositions through editing, recalling Breton's Maldororian definition of the surrealist image as the joining of distant realities. Annette Michelson claims that a mutual 'enchantment with the generative power of montage' formed Cornell's primary bond with the surrealists.[70] The directed films derive from Cornell's wandering observations as an urban flâneur.

A loose trilogy – *A Legend for Fountains* (1957), *Nymphlight* (1957), and *Aviary* (1955) – follow the wandering of female characters within the flow of city life. Two films – *Centuries of June* (1955) and *Gnir Rednow* (1955) – shot by Brakhage undertook a preservation project, recording constructions slated for demolition: the Third Avenue El in Manhattan and a house in Queens whose gothic towers obsessed Cornell. All these films discover fleeting moments within the architectural structures of urban space.

Like his boxes, Cornell's films explore the flexibility of motion that might best be described by the many meanings of the word 'play'. In his recent discussion of Cornell's cinema Michael Piggot relates philosopher Hans-Georg Gadamer's understanding of 'play' to Cornell's description of some of his boxes as 'games'.[71] Gadamer cites play's range of associations: 'we find talk of the play of light, the play of waves, the play of gears or parts of machinery, the interplay of limbs, the play of forces, the play of gnats, even a play on words. In each case what is intended is to and fro movement that is not tied to any goal that would bring it to an end.'[72]

The dictionary gives one meaning of 'play' as the effect of 'constantly changing movement', as in 'the play of light'.[73] In *Monsieur Phot* Cornell referred to the 'play' of water in a fountain, a visual motif that recurs in his films. Games can be extremely serious; though play may lack a purposeful goal, something remains at stake. Cornell staked not only his artistic practice but his mental balance on such play, undertaking playful but serious quests. His 1941 homage to movie star Hedy Lamarr, described her as 'Le chasseur d'images' – the hunter (or seeker) of images.[74] Lynda Hartigan applied this phrase to Cornell, referring to his endless trawling of variety stores and used bookshops, seeking images for his creations.[75] As a gamesman, Cornell not only sought the spoils his restless searches yielded, but loved the hunt itself. The action of the hunt belongs not only to the hunter but to the quarry that flees. Cornell sought the fleeting image in a game of hide-and-seek. The cinema supplied him with an image that trembled and turned, recalling the moving parts – the suspended balls or rolling marbles, the vibrating watch springs, the rings dangling on rods or shifting waves of sand – that animate his boxes.

Cornell's most famous film, *Rose Hobart*, decomposed the narrative continuity of a Hollywood film, transforming it into a series of discontinuous fetishised moments of erotic and exotic expectancy. Cornell cannibalised George Medford's 1931 melodrama *East of Borneo*: he eliminated the original film's dialogue, substituting a recording of ersatz Brazilian jazz; he slowed down the film's action by projecting it at silent speed (16 frames per second rather than sound speed of 24 frames); and he dyed the film blue by projecting it through tinted glass. With the conventional narrative rendered illegible, the images Cornell liberated from the plot gained mystery. The

beauty of the star, the unjustly ignored Rose Hobart, shines through the clichés of a jungle melodrama (an erupting volcano, native dancers, swarming crocodiles, night-time torchlight processions). Liberated from dramatic structures, Hobart's performance becomes enigmatic and ambiguous. The purpose of her romantic quest in the original plot erased, she becomes a wandering observer, rather than an active protagonist. Made graceful by the slowed-down motion, Hobart's off-screen gaze expresses low-key anxiety more than dramatic fear, projecting puzzlement or restless boredom. Hobart becomes an enchanted wanderer in this artificially blue-tinted night-world, exuding an undefined ennui, a 1930s Monica Vitti lost in a blue jungle rather than a *Red Desert*.[76]

Cornell's films enact scenarios of witnessing. His urban films (and *Rose Hobart*) revolve around female wanderers. The young women flâneurs of *A Legend for Fountains*, *Aviary*, and *Nymphlight* inhabit urban locations. But rather than scenarios anchored in subjectivity, these films lose themselves in an ever-changing urban scene, just as Cornell sought to do in his aimless walks that inspired these films. *A Legend for Fountains* opens as his female protagonist, played by Suzanne Miller, descends a dark stairway and exits through an arched corridor. Her slow pace resembles the somnambulist protagonists of the trance films made by American avant-garde film-makers of this era such as Maya Deren, Curtis Harrington, and Brakhage (especially in Brakhage's *Reflections on Black* (1955)).[77] Of all his films, *Legend* most recalls Cornell's boxes, with its interpolated texts from the poetry of Garcia Lorca, and its motif of looking through glass. Cornell positions Miller as an observer from a window holding a kitten. She projects melancholy, a waif adrift in an urban maze. About a third of the way through the film, however, the camera lifts from street level to follow the flight of distant birds through the sky. Soon after this moment of aerial liberation the film abandons its female observer. Cornell merges with the flow of life on Mulberry Street with a nearly documentary eye, recalling the work of street photographer Helen Levitt: watching children's games and reading chalked graffiti messages asserting love or proclaiming identity. The camera peers into shop windows as Cornell did in his Manhattan voyages, lingering over a large doll in a box that recalls Cornell's box Bébé Marie, and discovering the beaming sun-face advertising Il Sole antipasto that would become an element in Cornell's Sun Boxes.[78] The plenitude of urban sights has expanded beyond the frame of a single viewer.

Aviary (which, oddly, Sitney claimed 'is not mediated by a protagonist at all')[79] follows its female flâneur through an exploration of Manhattan's Union Square. But the film focuses primarily on the movement of birds, which are only glimpsed from afar in *Legend*. Mediating between the overarching treetops that open the film and the park that grounds it stands a towering statue of a mother holding children. We first see the female

protagonist caressing the butterflies, lion heads, and salamanders that decorate the statue's base. Burkhardt's camera follows flocks of pigeons in earthbound strolls as well as airborne flights. The park becomes a utopian space shared by people and birds, watched over by a maternal giantess. The young woman does not appear as often as Miller does in *Legend*, and her demeanour seems less melancholy. In one shot she cradles her chin in hand as she looks at the camera, recalling the pose of Dürer's angel; but her face expresses wonder as she gazes upward. The camera seems to imitate the freedom of the birds, unmoored and mobile, filming brief glimpses rather than projecting a mastering gaze.

In *Nymphlight* the female protagonist (played by Gwen Thomas) enters the film with an Alice-in-Wonderland-like romp, flourishing her torn parasol. But after she looks off-screen in a stunning close-up, the film shifts focus to the ever-changing succession of park loafers, strollers, and workers. The close-up is directly followed by lingering shots of a girl of about ten years who seems lost in thought as she stands on a walkway. As Sitney eloquently puts it: 'As our attention is directed from the presence of the girl to what she sees, she gradually withdraws from the film. She is the spirit of the place, and once the film has heightened our attention to its orders, making her way of seeing ours, she vanishes.'[80] As the film ends, we glimpse the protagonist's parasol abandoned in a trash basket. In all these films the camera surveys the walkways, the façades of building, and the tracery of tree branches with handheld movements in search of nothing in particular, but delighted by everything taken in. This wandering viewpoint expresses the aesthetic Cornell called 'metaphysique d'ephemera',[81] devoted to the passing moment, celebrating the briefly experienced. Cinema was originally invented to record this smack of the instant and only later became devoted to telling stories. Cornell's films rediscover this original impulse, ignoring stories or plots (*Rose Hobart* even prises such moments loose from their narrative setting).

In contrast to the mastering gaze that some theorists have claimed as a foundation of classical cinema, Cornell's films engage an ephemeral view, a series of glimpses. The metaphysics of this unfixed vision reveals Cornell's unique appropriation of the surrealist image and its exploration of chance encounters. The Garden Center dossier contains Cornell's most sustained speculation on visionary experience and its dialectic of appearance and disappearance. The experience he described in the section he called 'the Floral Still Life' shows this vividly. In November of 1944 while bicycling to his job at the Garden Center Cornell passed a delivery truck whose side bore a painted still life of the meat and fish it transported. This mobile glimpse triggered 'metamorphoses of the sign into something more poetical', a transcendent moment that Cornell sought to recall and preserve. Some two years later he encountered the same delivery truck parked in a shopping centre

and his initial experience collapsed. He described his disillusionment in a letter to poet Mina Loy:

> For I glimpsed that in MOTION exactly two years ago for the first time on a beautiful clear shining day on a ride on my bicycle ... That little still-life is still traveling in my 'chambers of imagery'; it has picked up many a gleaming and poetic bit since then. And to see it stock still before one's eyes (the paint the worse for wear) no one in the least interested in passing before it as I did on my bike ... was all kind of a mocking challenge.[82]

Lindsay Blair's analysis of the Garden Center dossier traces not only this seesaw between initial revelation and later disillusionment, but Cornell's attempt to 'extend' the original experience: 'He hoards his memories and works on retaining a state of readiness for when the associative faculty might strike',[83] even over extended time. After some years Cornell connected the delivery-truck image with a reproduction he saw in *Life* magazine of Jan Van Eyck's Ghent altarpiece. This renewed the circuit of experience and imagery begun with the glimpse of the moving van. I stress the power of the initial *glimpse*, the brief vision in motion, contrasted with the depressing effect of a static view. The dilemma that faced Cornell, and which his work in various media addressed, was recreating the spontaneous spark of inspiration without freezing it into an inert cenotaph of dead experience. His solution lay in creating works that generate a flow of energy, re-weaving images into a living web. Cornell's collages of images, his assembly of objects and acts of filming and editing, aspired to this task. Cinema as Cornell practised it corresponded to his dialectic of experience: a movement based in a succession of still images; a technique of preservation that could retain the evanescence of a chance encounter.

An American surrealist?

Nathaniel Hawthorne's 1832 short story 'Roger Malvin's Burial' tells a uniquely American Gothic tale of betrayal and retribution, played out not in a ruined European castle but the American wilderness. Fleeing a battle with Native Americans, the protagonist Reuben Bourne abandons Roger Malvin, gravely wounded, in the forest, vowing to return and rescue him if he can, and to bury him if he finds him dead. However, although he marries Malvin's daughter Dorcas, he never returns and lives his life under the burden of this secret guilt. Years later, travelling with his wife and son Cyrus through the wilderness, he discovers he has returned to the site of his earlier treachery. Hunting for game, he fires into a thicket and discovers to his horror he has shot Cyrus on the very site where he abandoned Roger Malvin. This tale of fateful repetition is played out beneath a granite cliff 'not unlike a gigantic grave-stone upon which the veins seemed to form an inscription in forgotten

characters'.[84] Hawthorne wavers between presenting this cliff face as an allegorical emblem of fate and a more ambiguous symbol mediating between wild nature and cultural significance. The smooth rock face resembles, Hawthorne says, a mirror, reflecting Reuben's memory of his past deed, while the patterns traced by its mineral veins resemble an inscription in 'forgotten characters'.[85] A symbol looms here, an American questioning of significance itself, written in undecipherable hieroglyphics.

Can Cornell fit into this American symbolist tradition? Certainly, his work trafficked in images of pronounced, but undefined, significance. The surrealists had widened the cleavage the American symbolists made between image and meaning, rendering the Romantic symbol inherently contradictory and unresolvable. It does seem difficult to fit gigantic gravestones and white whales into Cornell's humble boxes and modest films. Issues of scale forbid it. But if we look through the wrong end of the telescope (a practice Cornell recommended), the American symbolist that Cornell most frequently cited might come into focus. Like Cornell, Emily Dickinson delighted in wedging the metaphysical into domestic space. As Sitney puts it: 'The sublime in Dickinson's poetry flashes out from mundane particulars.'[86] There is nothing cosy about the domestic scale found in both Dickinson and Cornell. True terror dwells in these nooks and crannies, as much as in the primeval forest.

Dore Ashton has noted correspondences between Dickinson and Cornell: their love of compartmentalisation; their writing on scraps of paper from diverse sources; their love of dashes in their punctuation – and the sudden silent breath they figure. Poet Charles Simic writes of Dickinson and Cornell: 'They are without precedent, eccentric, original and thoroughly American. If her poems are like his boxes, a space where secrets are kept, his boxes are like her poems, the place of unlikely things coming together.'[87] They share a similar sense of compass, each valuing the haven of simple enclosed spaces, and yet possessing an inner orientation towards infinite directions. Cornell called his kitchen, with its view of his miniscule backyard, his observatory. His box dedicated to Dickinson, *Toward the Blue Peninsula: For Emily Dickson* (c. 1953), envisioned the bedroom in which she wrote as a window opening on to the infinite.[88] Cornell produced many of his boxes in series: Soap Bubbles, Hotels; Slot Machines, Aviaries, Observatories. *Blue Peninsula* could fit in at least three of these: hotels with their white interiors and dominant windows; aviaries with their wire mesh cages and long dowels for perches; and observatories that open on to the heavens. But *Blue Peninsula* also flouts aspects of each of these: no hotel name plastered to the wall; no starry sky visible through the window, only a blue horizon; and – most striking – this bird has flown without even shedding a feather. Robert Lehrman, who owned this box, describes its central conflict: 'the box creates its contained space, and also opens a window to the

beyond'.[89] The emptiness of the room, underscored by the place of exit, echoes with the absence of any bird we could name or recognise.

The Dickinson poem referenced by Cornell's title weighs the ambivalence of desire and escape, as desire for confines questions desire for fulfilment:

> It might be lonelier
> Without the Loneliness –
> I'm so accustomed to my Fate –
> Perhaps the Other – Peace –
>
> Would interrupt the Dark –
> And crowd the little Room –
> Too scant – by Cubits – to contain
> The Sacrament – of Him –
>
> I am not used to Hope –
> It might intrude upon –
> Its sweet parade – blaspheme the place –
> Ordained to Suffering –
>
> It might be easier
> To fail – with Land in Sight –
> Than gain – My Blue Peninsula –
> To perish – of Delight – [90]

Surrealism opened a portal through which Cornell could imagine flying away from his own confines, or welcoming in the flow of chance encounters. But did he ever join the party? Surrealism promised another European rarity, like the texts and images Cornell stored in his cellar archive, which he contemplated and recombined, rearranged and set in motion. Surrealism provided Cornell with possibilities rather than doctrines. Breton spoke of the surrealist image as the 'fixed explosive', a contradiction of energies in which a frozen pause triggered a violent release.[91] Less explosive, but no less powerful, Cornell seized – then released – an instant, believing that setting it into motion was the only way to retain it.

Is it only my personal association that sees the window at the back of the *Blue Peninsula* box as the portal in a movie-projection booth and that indistinct blue haze as the aura of some invisible movie, perhaps the blue nightglow emanating from *Rose Hobart*?

Notes

1 Dedicated to my teachers and mentors Annette Michelson and P. Adams Sitney, who wrote the earliest and best essays on Cornell and cinema; and in memoriam Edwin and Lindy Bergman, pioneering collectors of Cornell and who endowed my named professorship at Chicago.

2 Breton, *Mad Love*, 28–32; Rubin, *Dada, Surrealism and Their Heritage*, 143–57; Ades, 'The Transcendental Surrealism of Joseph Cornell', 24–5.

3 Solomon, *Utopia Parkway*, 90.

4 Hartigan, 'Selected Works', 58.

5 Rubin, *Dada, Surrealism and Their Heritage*, 148.

6 Ades, 'The Transcendental Surrealism of Joseph Cornell', 18–20.

7 Levy, *Memoir of an Art Gallery*, 79.

8 Bann, 'Cornell and the Tradition of Curiosity', 20.

9 Quoted in Hauptman, *Joseph Cornell*, 35; Cornell, *Joseph Cornell*, 31.

10 Ashton, *A Joseph Cornell Album*, 6, 13.

11 Ibid., 19.

12 Solomon, *Utopia Parkway*, 253.

13 Feidelson Jr, *Symbolism and American Literature*.

14 Todorov, *Theories of the Symbol*, 206.

15 Feidelson, *Symbolism and American Literature*, 15.

16 Hawthorne, *The Scarlet Letter*, 33.

17 Feidelson, *Symbolism and American Literature*, 10.

18 Poe, 'The Man of the Crowd', 388–96.

19 Benjamin, *The Origin of German Tragic Drama*, 159–235.

20 Caygill, *Walter Benjamin*, 59.

21 Honig, *Dark Conceit*, 129.

22 Benjamin, *The Origin of German Tragic Drama*, 140.

23 Ibid., 157.

24 Benjamin, 'Paris, Capital of the Nineteenth Century', 156.

25 Baudelaire, 'Spleen', 140.

26 Cornell, *Joseph Cornell*, 206.

27 Benjamin, 'Surrealism', 179.

28 Breton, 'Manifesto of Surrealism', 14.

29 Waldman, *Joseph Cornell*, 7.

30 Cornell, *Joseph Cornell*, 424.

31 Ibid., 99, 105.

32 Ibid., 369.

33 Ibid., 114.

34 Ibid., 259.

35 Hoving, *Joseph Cornell and Astronomy*, 19.

36 Cornell, *Joseph Cornell*, 364.

37 Ibid., 371.

38 Ibid., 140.

39 Hartigan, 'Joseph Cornell', 103.

40 Sitney, *The Cinema of Poetry*, 113.

41 Ratcliff, 'Joseph Cornell', 49.

42 Cornell, *Joseph Cornell*, 373.

43 Ibid., 269.

44 Ibid., 28.

45 Ibid., 249.

46 Quoted in Lea and Sharp, *Joseph Cornell*, 31.

47 Cornell, *Joseph Cornell*, 109.

48 Michelson, '*Rose Hobart* and *Monsieur Phot*', 143.

49 Cornell, quoted in Ratcliff, 'Joseph Cornell', 46.

50 Levy, *Memoir of an Art Gallery*, 229.

51 Bergson, *Creative Evolution*, 304–15.

52 Hauptman, *Joseph Cornell*, 53.

53 Ibid., 133.

54 Lea and Sharp, *Joseph Cornell* 102.

55 Ades, 'The Transcendental Surrealism of Joseph Cornell', 29.

56 On the Thaumatrope, see Gunning, 'Hand and Eye', 495–515.

57 Affron, 'Joseph Cornell's Optical Toys', 114.

58 Lea and Sharpe, *Joseph Cornell, Wanderlust*, 94–7; 106–7.

59 Leppanen-Guerra, 'Framing the Imagination', 49, 59.

60 Hauptman, *Joseph Cornell*, 176.

61 Lea and Sharpe, *Joseph Cornell* 150–1.

62 The original illustration is reproduced in Frizot, *E. J. Marey*, 27.

63 Hauptman, *Joseph Cornell*, 64.

64 Lea and Sharpe, *Joseph Cornell*, 102–3.

65 Ashton, *A Joseph Cornell Album*, 63.

66 On Fuller and early cinema, see Gunning, 'Loïe Fuller and the Art of Motion', 75–90.

67 Waldman, *Joseph Cornell*, 49, 122.

68 Lea and Sharpe, *Joseph Cornell*, 118–19.

69 On the interrelation between Jacobs' films and *Rose Hobart*, see Gunning, 'Dr. Jacobs' Dream Work', 210–18.

70 Michelson, '*Rose Hobart* and *Monsieur Phot*', 141.

71 Piggot, *Joseph Cornell versus the Cinema*, 52, 56.

72 Gadamer, *Truth and Method*, 93, quoted in Piggott, *Joseph Cornell versus the Cinema*, 40.

73 Merriam Webster dictionary online, 'Play'. www.merriam-webster.com/dictionary/play.

74 Cornell, 'Enchanted Wanderer', 153.

75 Hartigan, 'Joseph Cornell, Le Chasseur d'Images', 74–83.

76 Adam Lowenstein offers the most perceptive treatment of *Rose Hobart* in his *Dreaming of Cinema*, 149–68, with a keen sensitivity to the role of the star in Cornell's creation of a 'collaborative spectatorship'.

77 For trance films, see Sitney, *Visionary Film*, 20–1.

78 Hoving, *Joseph Cornell and Astronomy*, 185–8.

79 Sitney, 'The Cinematic Gaze of Joseph Cornell', 84.

80 Sitney, *The Cinema of Poetry*, 134.

81 Cornell, *Joseph Cornell*, 106.

82 Cornell, quoted in Blair, *Joseph Cornell's Vision of Spiritual Order*, 57.

83 Blair, *Joseph Cornell's Vision of Spiritual Order*, 60.

84 Hawthorne, 'Roger Malvin's Burial', 88.

85 Ibid., 88, 104.

86 Sitney, *The Cinema of Poetry*, 135.

87 Simic, *Dime-Store Alchemy*, 75.
88 Solomon, *Utopia Parkway*, 376.
89 Lehrman, 'Living with Cornell', 208.
90 Dickinson, '405', 316.
91 Breton, *Mad Love*, 19.

Bibliography

Ades, Dawn. 'The Transcendental Surrealism of Joseph Cornell'. In *Joseph Cornell*, edited by Kynaston McShine, 24–5. New York: Museum of Modern Art, 1980.

Affron, Matthew. 'Joseph Cornell's Optical Toys'. In *Cornell and Surrealism*, edited by Matthew Affron and Sylvie Raymond, 104–21. Charlottesville, VA: The Fralin Museum of Art, 2015.

Ashton, Dore. *A Joseph Cornell Album*. Cambridge: Da Capo Press, 1974.

Bann, Stephen. 'Cornell and the Tradition of Curiosity'. In *Joseph Cornell and Surrealism*, edited by Matthew Affron and Sylvie Raymond, 18–31. Charlottesville, VA: The Fralin Museum of Art, 2015.

Baudelaire, Charles. 'Spleen'. In *Selected Poems from Les Fleurs du mal*, translated by Norman Shapiro, 140–1. Chicago, IL: University of Chicago Press, 1998.

Benjamin, Walter. *The Origin of German Tragic Drama*, translated by John Osborne. London: NLB, 1977.

———. 'Paris, Capital of the Nineteenth Century'. In *Reflections*, translated by Edmund Jephcott, 146–62. New York: Harcourt Brace Jovanovich Editions, 1978.

———. 'Surrealism'. In *Reflections*, translated by Edmund Jephcott, 177–92. New York: Harcourt Brace Jovanovich Editions, 1978.

Bergson, Henri. *Creative Evolution*, translated by Arthur Mitchell. Lanham, MD: University Press of America, 1983.

Blair, Lindsay. *Joseph Cornell's Vision of Spiritual Order*. London: Reaktion Books, 1999.

Breton, André. *Mad Love*, translated by Mary Ann Caws. Lincoln, NE: University of Nebraska Press, 1987.

———. 'Manifesto of Surrealism'. In *Manifestoes of Surrealism*, translated by Richard Seaver and Helen R. Lane, 1–47. Ann Arbor, MI: University of Michigan Press, 1972.

Caygill, Howard. *Walter Benjamin: The Color of Experience*. London: Routledge, 1998.

Cornell, Joseph. 'Enchanted Wanderer'. In Dore Ashton, *A Joseph Cornell Album*, 153. Cambridge: Da Capo Press, 1974.

———. *Joseph Cornell: Theater of the Mind*, edited by Mary Ann Caws. New York: Thames and Hudson, 1993.

Dickinson, Emily. '405'. In *The Poems of Emily Dickinson*, edited by Thomas H. Johnson, 316. Cambridge, MA: The Belknap Press of Harvard University Press, 1979.

Feidelson Jr, Charles. *Symbolism and American Literature*. Chicago: University of Chicago Press, 1953.

Frizot, Michel, ed. *E. J. Marey, 1830/1904: La photographie du mouvement*. Paris: Centre Georges Pompidou Musée National d'art Moderne, 1977.

Gadamer, Hans-Georg. *Truth and Method*. New York: Seabury Press, 1975.

Gunning, Tom. 'Dr. Jacobs' Dream Work: Ken Jacobs' *The Doctor's Dream*'. *Millennium Film Journal*, nos 10/11 (1981–82): 210–18.

———. 'Hand and Eye: Excavating a New Technology of the Image in the Victorian era'. *Victorian Studies* 54, no. 3 (2012): 495–515.

———. 'Loïe Fuller and the Art of Motion'. In *Camera Obscura, Camera Lucida: Essays in Honor of Annette Michelson*, edited by Richard Allen and Malcolm Turvey, 75–90. Amsterdam: University of Amsterdam Press, 2003.

Hartigan, Lynda. 'Joseph Cornell: A Biography'. In *Joseph Cornell*, edited by Kynaston McShine, 91–119. New York: Museum of Modern Art, 1980.

———. 'Joseph Cornell, Le Chasseur d'Images'. In *Cornell and Surrealism*, edited by Matthew Affron and Sylvie Raymond, 74–83. Charlottesville, VA: The Fralin Museum of Art, 2015.

———. 'Selected Works'. In *Joseph Cornell: Shadowplay Eterniday*, 31–204. New York: Thames and Hudson, 2006.

Hauptman, Jodi. *Joseph Cornell: Stargazing in the Cinema*. New Haven, CT: Yale University Press, 1999.

Hawthorne, Nathaniel. 'Roger Malvin's Burial'. In *Tales and Sketches*, 88–107. New York: Library of America, 1982.

———. *The Scarlet Letter*. Boston, MA: James R. Osgood and Company, 1878.

Honig, Edwin. *Dark Conceit: The Making of Allegory*. New York: Oxford University Press, 1959.

Hoving, Kristin. *Joseph Cornell and Astronomy: A Case for the Stars*. Princeton, NJ: Princeton University Press, 2009.

Lea, Sarah, and Jasper Sharp. *Joseph Cornell, Wanderlust*. London: Royal Academy of Arts, 2015.

Lehrman, Robert. 'Living with Cornell: A Collector's View'. In *Joseph Cornell: Shadowplay Eterniday*, 206–28. New York: Thames and Hudson, 2006.

Leppanen-Guerra, Analisa. 'Framing the Imagination: Joseph Cornell's Children's Book for Adults'. In *Joseph Cornell's Manual of Marvels*, 48–60. London: Thames and Hudson, 2012.

Levy, Julien. *Memoir of an Art Gallery*. Boston, MA: MFA Publications, 2003.

Lowenstein, Adam. *Dreaming of Cinema: Spectatorship, Surrealism, and the Age of Digital Media*. New York: Columbia University Press, 2015.

Michelson, Annette. '*Rose Hobart* and *Monsieur Phot*: Early Films from Utopia Parkway'. In *On the Eve of the Future: Selected Writings on Film*, 137–64. Cambridge, MA: MIT Press, 2017.

Piggot, Michael. *Joseph Cornell versus the Cinema*. London: Bloomsbury, 2015.

Poe, Edgar Allan. 'The Man of the Crowd'. In *Poetry and Tales*, 388–96. New York: The Library of America, 1984.

Ratcliff, Carter. 'Joseph Cornell: Mechanic of the Ineffable'. In *Joseph Cornell*, edited by Kynaston McShine, 43–67. New York: Museum of Modern Art, 1980.

Rubin, William. *Dada, Surrealism and Their Heritage*. New York: Museum of Modern Art, 1968.

Simic, Charles. *Dime-Store Alchemy: The Art of Joseph Cornell*. New York: New York Review of Books, 1992.

Sitney, P. Adams. *The Cinema of Poetry*. Oxford: Oxford University Press, 2015.

———. 'The Cinematic Gaze of Joseph Cornell'. In *Joseph Cornell*, edited by Kynaston McShine, 69–89. New York: Museum of Modern Art, 1980.

———. *Visionary Film: The American Avant-Garde*. New York: Oxford University Press, 1974.

Solomon, Deborah. *Utopia Parkway: The Life and Work of Joseph Cornell*. New York: Other Press, 1997.

Todorov, Tzvetan. *Theories of the Symbol*. Translated by Catherine Porter. Ithaca, NY: Cornell University Press, 1982.

Waldman, Diane. *Joseph Cornell: Master of Dreams*. New York: Abrams, 2002.

4

Buñuel *renascitur*: return of the prodigious son

Paul Hammond

> Just a few years ago Buñuel invited me to view, in private, one of his films. When it was over, he asked me: 'Will Breton find it to be in the surrealist tradition?'
>
> Octavio Paz, *On Poets and Others* (1967)

Luis Buñuel was little given to making concerted theoretical pronouncements on the how and why of moviemaking: a brace of essays in the late 1920s,[1] while active in French and Spanish avant-garde film culture and as a student at Jean Epstein's Académie du cinéma, and a further intervention in 1953 – the text which preoccupies us here, since it reaffirms a credo that will permeate much of his oeuvre throughout the post-war period. That credo is surrealism.

'El cine, instrumento de poesía' (The Cinema, Instrument of Poetry) was first published in the December 1958 number of *La Revista de la Universidad de México*, but it dates back a further five years to a paper the reclusive director gave in 1953 at a round table on film and poetry at the National Autonomous University of Mexico (UNAM).[2] I will chance my arm and suggest, following perusal of the numbers for the year of its delivery, that the talk was given sometime between 30 October and 16 November 1953 at an extended symposium on modern poetry held at the UNAM. (The inaugural lecture was given by Octavio Paz, whose name will often appear in this essay.)

In much of the literature Buñuel's text is unquestioningly dated to 1958. Even when cited correctly – as in Aranda's *Luis Buñuel: Biografía crítica*, suggesting that the author has gone back to the original document – no mention is made of its crucial preamble, signed by one J. G. T. Jaime García Terrés was the editor of *La Revista de la Universidad de México* in both October–November 1953 and December 1958. In his introductory remarks he defiantly confesses that he had clandestinely tape-recorded Buñuel's intervention five years earlier so that when it proved impossible, due to the author's

crustiness, to acquire the original text for publication in 1958 García Terrés simply transcribed the tape and published it without his permission.[3]

Since it is so beautifully argued, so tightly written, we can do no better – after omitting Buñuel's own opening paragraph, which limits itself to setting the scene of the original UNAM presentation – than to quote his *prise de position* verbatim:

> Octavio Paz has said, 'It suffices for a chained man to close his eyes for him to have the power to make the world explode', and I, paraphrasing him, add, it would suffice for the white eyelid of the screen to reflect the light proper to it to blow up the universe. But for the moment we can sleep in peace, since the light of cinema is being conveniently meted out and enchained. In none of the traditional arts does there exist a disproportion as great as in the cinema between possibility and realization. In acting in a direct way on the spectator, presenting him with human beings and concrete things, in isolating him, thanks to the silence, the darkness, from what we might call his psychic habitat, the cinema becomes capable of captivating him as no other human expression can. But it is capable of brutalizing him like no other, too. Unfortunately the vast majority of current cinemas appear to have no other mission than this: their screens wallow in the moral and intellectual vacuity on which the cinema thrives, a cinema that limits itself to imitating the novel or the theater, with the difference that its means are less rich when it comes to expressing different psychologies; they repeat *ad infinitum* the same stories the nineteenth century grew tired of telling and that are still being repeated in the contemporary novel.
>
> A moderately cultured person would fling aside in disdain the book that contained any of the plots the major films relate to us. And yet, seated comfortably in the darkness of the cinema, dazzled by a light and movement that exert an almost hypnotic power over him, attracted by the interest of the human face and ultra-rapid changes of location, that same more or less cultured person placidly accepts the hoariest of clichés.
>
> By virtue of such hypnagogic inhibition the movie spectator loses a high percentage of his intellectual faculties. I'll give you a concrete example: the film *Detective Story* ... The plot structure is perfect, the director magnificent, the actors extraordinary, the realization inspired, etc., etc. Fine, all that talent, all that *savoir-faire*, all the paraphernalia that the machinery of the film entails has been put at the service of a stupid story notable for its moral baseness. This puts me in mind of that extraordinary Opus II machine, a gigantic piece of equipment, manufactured from the finest quality steel, with a thousand complicated gears, tubes, pressure gauges, dials, as precise as a wristwatch, as imposing as an ocean liner, whose sole purpose was to frank the mail.
>
> Mystery, the essential element of any work of art, is for the most part lacking in films. Scriptwriters, directors and producers take a lot of care not to disturb our peace of mind by opening the marvelous window of the screen onto the

liberating world of poetry. On that screen they prefer to depict issues that might be an extension of our ordinary lives, to repeat the same drama a thousand times, to make us forget the long hours of our workaday world. And all this, as is natural, fully sanctioned by conventional morality, by governmental and international censorship, by religion, presided over by good taste and embellished with white humor and the other prosaic imperatives of reality.

If we wish to see good cinema, rarely will we encounter it in major productions or in those others that come sanctioned by film criticism and the backing of the public. The personal story, the private drama of an individual, cannot, I believe, interest anyone worthy of living his era to the full; if the spectator shares something of the joys, sorrows or anxieties of a screen character it must be because he sees reflected therein the joys, sorrows or anxieties of society as a whole, and therefore his own as well. The lack of work, insecurity of life, fear of war, social injustice, etc., are things that, in affecting all people today, also affect the spectator; but that Mr. X might not be happy at home and so seeks a woman friend to distract him, a friend who he will finally abandon in order to go back to his altruistic wife, is doubtless all very moral and edifying but it leaves us completely indifferent.

At times the cinematic essence gushes forth unwontedly in some anodyne film, in a slapstick comedy or poverty row serial. Man Ray has said, in a phrase redolent with meaning: 'the worst films I might have seen, the ones that send me off to sleep, always contain five marvelous minutes, and the best, the most celebrated ones, *only* have five minutes worth seeing: that is, in both good and bad movies, and over and above, or despite, the good intentions of their makers, cinematic poetry strives to come to the surface and show itself'.

The cinema is a marvelous and dangerous weapon if a free spirit wields it. It's the finest instrument there is for expressing the world of dreams, of the emotions, of instinct. Due to the way it works the mechanism for producing film images is, of all the means of human expression, the one that is most like the mind of man, or better still, the one which best imitates the functioning of the mind while dreaming. J. B. Brunius draws our attention to the fact that the darkness that gradually invades the auditorium is the same as closing the eyes: next, on the screen, and within man, the dark night of unconsciousness begins to make inroads; as in the dream, the images appear and disappear by means of dissolves or fades-in and out; time and space become flexible, contract and stretch at will, chronological order and relative values of duration no longer correspond to reality; cyclical action may elapse in a few minutes or in several centuries; the movements speed up the time lags.

The cinema seems to have been invented in order to express the subconscious life that so deeply penetrates poetry with its roots; despite that, it is almost never used for such ends. Among the modern tendencies of cinema the best known is the so-called neorealist one. Its films offer up slices of real life to the eyes of the spectator, with characters taken from the street and with authentic

buildings and interiors even. Aside from a few exceptions, and I especially cite *The Bicycle Thief*, neorealism has done nothing to emphasize what is particular about cinema, namely mystery and the fantastic. What use are all those visual trappings to us if the situations, the motives that drive the characters, their reactions, the plots themselves are modeled on the most sentimental and conformist literature? The only interesting contribution that not neorealism but Zavattini personally has made is raising the anodyne act to the level of a dramatic category. In *Umberto D,* one of the more interesting films neorealism has come up with, a domestic servant takes a whole reel, ten minutes that is, to perform actions that until quite recently would have seemed unworthy of the screen. We see the servant go into the kitchen, light her stove, put a pan on it, repeatedly splash water from a pitcher onto a line of ants marching in Indian file towards some food, give a thermometer to an old man who isn't feeling well, etc., etc. Despite the triviality of these situations, the action is followed with interest and even with suspense.

Neorealism has introduced into cinematic expression a number of elements that enrich its language, yet nothing more. Neorealist reality is incomplete, official; reasonable, above all else; but poetry, mystery, that which completes and extends immediate reality, is completely absent from its productions. It confuses ironic fantasy with the fantastic and black humor.

'The most admirable thing about the fantastic', André Breton has said, 'is that the fantastic doesn't exist, everything is real'. Speaking with Zavattini himself a while ago, I expressed my nonconformity with neorealism: we were eating together, and the first example that occurred to me was the glass of wine from which I happened to be drinking. For a neorealist, I said to him, a glass is a glass and nothing more: we witness how they remove it from the cupboard, fill it with drink, take it to the kitchen to be washed, where the maid servant breaks it, for which she could be dismissed from the house or not, etc. Contemplated by different people that same glass can be a thousand different things, however, because each person charges what he or she is looking at with emotion, and nobody sees it as it is, but how his or her desires and state of mind wish to see it. I advocate a cinema that makes me see that kind of glass, because such a cinema will give me an integral vision of reality, augment my knowledge of things and of people, and open up to me the marvelous world of the unknown, all the things I cannot read about in the daily papers or encounter in the street.

Don't think from what I've been saying that I'm only advocating a cinema devoted exclusively to the expression of the fantastic or to mystery, an escapist cinema that, disdaining our everyday world, would seek to submerge us in the unconscious world of the dream. Albeit very briefly, I indicated just now the crucial importance I give to the film that tackles contemporary man's major problems, not considered in isolation as a unique case, but in his relations with other men. I make my own the words of Engels, who defines the novelist's function thus (for novelist read film-maker): 'The novelist will have acquitted

himself honorably if by conscientiously describing the real mutual relations he breaks down the conventionalized illusions dominating them, shatters the optimism of the bourgeois world, causes doubt about the eternal validity of the existing order, and this without directly offering a solution or even, under some circumstances, taking an ostensible partisan stand.'⁴

A few remarks: first, the backdrop to 'The Cinema, Instrument of Poetry' is the international success of Buñuel's *Los olvidados* (1950), which has put him back on the map, in Europe at least, following his disappearance as a film-maker after 1933's *Land without Bread* (*Las Hurdes*); once *Los olvidados* is awarded a couple of prestigious prizes at the 4th Cannes Film Festival of 1951,⁵ Buñuel is recognised as one of the geniuses of world cinema. Second, since *Los olvidados* and Italian neorealism are contemporaneous, Buñuel, wary of the conflation of the two, to the detriment of his own movie, feels compelled to define the parameters of both neorealism and surrealism. Third, 'The Cinema, Instrument of Poetry' is a surrealist text through and through; four of the six names cited in the essay – Breton, Paz, Brunius, Man Ray – are surrealists: their names and their ideas help buttress its argument and reinforce its authority. Fourth, both *Los olvidados* and 'The Cinema, Instrument of Poetry' mark the return to the surrealist fold of this *cinéaste maudit*, at least as a far-flung fellow traveller using the ideas of the movement as his moral-poetic compass.

For in 1950–51, prior to the spectacular lift-off of his film, Buñuel was a figure who'd been lost to surrealism since the ventilating of the Aragon Affair in 1932, when in traumatic circumstances Louis Aragon led a faction of pro-communists, including the Spaniard, out of the surrealist group, the better to serve the French Communist Party (PCF) and, behind the scenes, the Comintern.⁶ In the eyes of André Breton, guarantor and memory of the movement, Buñuel had, by putting himself at the orders of the PCF, and by bowdlerising *L'Âge d'or* in a worker-friendly director's cut, remained in disgrace until 1951, the year *Los olvidados* was released to enormous acclaim in France. This disqualification is graphically shown by Maurice Henry in a drawing published in the 'Almanach surréaliste du demi-siècle', a special number of the Paris magazine *La Nef* of March 1950. In this amalgam of precursors and members of the surrealist group, the stippling obscuring their features denotes the degree of disrepute or dissidence into which the subject has sunk, often for adhering to Stalinism. Buñuel's is the fourth face descending on the left, beneath Trotsky and alongside film comedian W. C. Fields, both of whose immaculate features contrast with the cineast's contamination (Figure 4.1).

By the time he recorded the penultimate instalment of his radio interviews with André Parinaud in 1951, broadcast the following year, Breton's opinion of the film-maker was more forgiving, albeit still tinged with a

Figure 4.1 Maurice Henry, untitled, undated drawing published in the 'Almanach surréaliste du demi-siècle', special number of *La Nef* (March 1950)

certain acrimony. Speaking of the post-1945 reconfiguration of surrealism, and, *pace* the survival of an old guard and the influx of young initiates who had responded to the call, of its need – in the face of the ferocious hostility towards surrealism of the Stalinist-dominated culture of post-war Paris – for those kindred poets, writers, and artists who without pertaining to the group per se were producing lyrical work that was essentially surrealist, he drove his point home that the movement 'cannot be limited to those who willingly fill its current ranks', before going on to say, 'Today any number of works without being strictly surrealist, share more or less deeply in its spirit' (he singles out Malcolm de Chazal, Julien Gracq, and Georges Schehadé). When it comes to pro-surrealist moviemakers, Breton immediately cites Buñuel's name: 'Even if … *Los olvidados* demonstrates a formal break with *Un chien andalou* (1929) and *L'Âge d'or* (1930), such a film, when compared to the earlier two, nonetheless shows the continuity of Buñuel's spirit – which, like

it or not, is a constituent part of surrealism.'[7] (Oh, the abiding acidity of that 'like it or not'.) In an unpublished interview with a *Paris-Match* reporter in November 1951 Breton returned to the fray: 'With respect to *L'Âge d'or*, *Los olvidados* does not bear the stamp, in terms of substance, of a concession of any note. In terms of form, it does. As Octavio Paz says in the very fine text he has devoted to the film in *L'Âge du cinéma*, no. 3, here "the gate of dreams seems sealed forever; the only gate remaining open is the gate of blood".'[8]

Which brings us to what I want to argue is the surrealist contribution to not just the revelation of *Los olvidados* but also to the content of 'The Cinema, Instrument of Poetry'. Consider, first, the role Paz, as a vector of the group around Breton, played in the April 1951 programming of the movie at the Cannes Film Festival and in its winning of two awards there; and, second, the emergence of the only surrealist film magazine, *L'Âge du cinéma*, in March 1951, edited by a number of those young initiates, cinephiles all. It is the ideas expressed in this short-lived powerhouse of a magazine (1951–52) that irrigate, suffuse, much of Buñuel's 1953 essay.

Paz was present at a private pre-Cannes screening of *Los olvidados* for the film-maker's surrealist and communist friends. Buñuel spent December 1950 in Paris presenting *Los olvidados* and while in the capital he screened it at Studio 28, scene of the triumph of *Un chien andalou* and the downfall of *L'Âge d'or*. There, Breton and Aragon set eyes on each other for the first time in eighteen years. (The fur did not fly.) Also present was another former surrealist and intimate of Breton's, Georges Sadoul, now the PCF's most influential film critic, who deemed *Los olvidados*, which clearly contravened the tenets of socialist realism, to be bourgeois and overly pessimistic. The surrealists, meanwhile, were enthused.[9]

It was Buñuel himself who mandated the Mexican wordsmith to present his film at Cannes, presumably during his month's stay in Paris in December 1950. The two men had first met in July 1937 at the Republican Spanish Embassy in Paris, where Buñuel headed the antifascist film propaganda campaign; the 23-year-old Paz was en route for Valencia as one of two Mexican delegates to the 2nd International Congress of Writers for the Defence of Culture, the strings of which were being pulled by the Comintern. (Paz was, apparently, a low-profile Workers Party of Marxist Unification (POUM) sympathiser.) Not long afterwards he was able to see *Un chien andalou* and *L'Âge d'or*: 'For me, the second film was, in the strict sense of the word, a revelation: the sudden appearance of a truth hidden and buried, but alive. I discovered that the age of gold is in each of us and that it has the face of passion.'[10]

Paz, a secretary at the Mexican Embassy in Paris between 1946 and the end of 1951, was appointed as a delegate to Cannes and, even though there

was already an official Mexican entry, he managed to inveigle the festival organisers to substitute it with Buñuel's film. Given the corrosive image the latter communicated of the social reality of the Mexican capital – and this in the context of the technocratic optimism and flight to the cities of Miguel Alemán's developmentalist government (1946–52) – the release in November 1950 of *Los olvidados* there had been an unmitigated disaster, with the film being withdrawn from circulation by its producer, Oscar Dancigers, after only three days; consequently, many Mexican functionaries, intellectuals, and critics lamented the showing at Cannes of a failure of a film that, moreover, denigrated their country. Part of Paz's strategy for undermining such opposition was to seek the collusion of Henri Langlois, director of the Cinémathèque in Paris, and of Ado Kyrou and Robert Benayoun of *L'Âge du cinéma*, in mobilising the many artists and writers who resided on the Côte d'Azur (Picasso, Chagall, Cocteau, Trauner et al.), inviting them to the event at which the film was to be shown.[11] One of these, Jacques Prévert, accepted with alacrity by coming up with a seventy-line poem, 'Los olvidados'.

To prepare the ground, Paz penned 'Buñuel the Poet' – quoted in due course by both Breton and the film-maker – which was mimeographed and distributed to those attending the *Los olvidados* première on 10 April. In it he argued that the film was a synthesis of surrealism, both frenetic (*Un chien andalou*, *L'Âge d'or*) and terse (*Land without Bread*), the Spanish picaresque and realist traditions (Cervantes, Quevedo, Velázquez, Goya, Galdós, Valle-Inclán), and of such archetypal Mexican obsessions as Coatlicue, the Aztec goddess of death and fertility, and sacrifice. (Paz had just published his psychohistory of the tragic Mexican mindset, *The Labyrinth of Solitude*.) How to paraphrase a marvellous poet and critic like Octavio Paz? Better to briefly quote him:

> Buñuel constructs a film in which the action is precise as a mechanism, hallucinatory as a dream, implacable as the silent encroachment of lava flow … But *Los olvidados* is something more than a realist film. Dream, desire, horror, delirium, chance, the nocturnal part of life, also play their part. And the gravity of the reality it shows us is atrocious in such a way that in the end it appears impossible to us, unbearable. And it is: reality is *unbearable*; and that is why, because he cannot bear it, man kills and dies, loves and creates.[12]

The Paz who militated on behalf of *Los olvidados* was a member of the surrealist group. By his own account it was Benjamin Péret who introduced him to Breton sometime after May 1948 and Péret's return to Paris from exile. Paz had known Péret in Mexico during the latter's wartime exile (December 1941–February 1948); the surrealist poet and revolutionary had introduced him to other displaced surrealists: Leonora Carrington, Wolfgang Paalen, Remedios Varo. By March 1950 Paz was publishing in the selfsame

'Almanach surréaliste du demi-siècle' that featured the derogatory Buñuel cartoon; this was a prose poem, dated January 1949, about the Aztec warrior goddess, Itzapapalotl, 'The Obsidian Butterfly'. In line with his induction of new voices to the surrealist movement, in 1950 Breton proposed Paz's collection of poems *Liberté sur parole*, translated by Péret and Jean-Clarence Lambert, for his new 'Révélations' series for Gallimard, alongside Georges Schehadé, Jean Ferry, and Maurice Fourré. (Only the latter's *La Nuit du Rose-Hôtel* would appear at that time.) Between March and May 1951 Paz would put his name to several surrealist tracts, some minor (on the Carrouges–Pastoureau affair), one of them major: 'Haute fréquence', which announces the advent of a score of new adherents, the young men and women who would become its main proponents over the next two decades. On the last day of November 1951 Paz left Paris for his next diplomatic posting, New Delhi. Restored to Paris from 1959 to 1962, he would contribute to the magazine *Le Surréalisme, même* and participate in the international surrealist exhibition, *EROS* (1959–60).

It is now time to turn to Buñuel's essay, 'The Cinema, Instrument of Poetry'. Its immediate source of inspiration, I would argue, is *L'Âge du cinéma*; literally so, for of the six thinkers cited to substantiate his argument, four – Paz, Man Ray, Brunius, Breton, surrealists to a man – are quoted or paraphrased from the pages of the magazine.

Thirty years ago I had occasion to write about the year 1951 in general and *L'Âge du cinéma* in particular:

> The production of a clutch of short films, plus the founding of a review devoted solely to cinema demonstrated the importance of the latter for the Paris group around Breton. In 1951 Georges Goldfayn and Jindrich Heisler completed their collage film *Revue surréaliste*. A year later Michel Zimbacca and Jean-Louis Bédouin made *L'Invention du monde*, after a scenario by Péret. The review *L'Âge du cinéma*, invoking the 'cinéma age' Breton alluded to in [his essay] 'As in Wood' ran to five [*sic*] wonderful issues through 1951. The publisher was Adonis (Ado) Kyrou; Robert Benayoun was editor-in-chief; the editorial board comprised Ion Daïfis, Maxime Ducasse, Georges Goldfayn, Georges Kaplan, J.-C. Lambert, and Gérard Legrand. The editorial in issue 1 reads:

> 'Pro cinematic oneirism, contra drab realism, *L'Âge du cinéma* intends to illuminate every manifestation of the Avant-Garde. Cinema is not a static art and the Avant-Garde of 1951 does not consist, as some people think, in the clumsy plagiarising of 1920s filmmaking; far from being a well-tried formula, it is a state of mind. It is reflected more in the personal visions of certain unusual individuals; it is discovered by chance in serials, comedies, musicals, adventure

films and productions for kids rather than in the "difficult" masterpieces of those men dubbed geniuses. Richness of inspiration, the prerogative of many low-budget films, seems to us more important than the retrograde tours de force of certain aesthetes.'

In a statement that sits uneasily with most definitions of the avant-garde, the *L'Âge du cinéma* editors disavowed the customary benchmark of formal invention and anti-narrative intent, invoking instead a viable oddness of vision on the vitiated periphery of mainstream cinema. Number 4/5 of the review is a bumper Surrealist issue. In many ways the crowning achievement of their thought on film and, indeed, one of the most important of all Surrealist collective statements, this number is a powerhouse of past and future obsessions.[13]

Buñuel's startling opening gambit in 'The Cinema, Instrument of Poetry', a paraphrase of Paz in which the unbridled human imagination would seek exteriorisation in the 'white eyelid' of an incendiary cinema screen is drawn from 'Buñuel the Poet', which was published in issue 3 of the magazine.[14]

When Buñuel approvingly alludes to Man Ray's amused stoicism and spirit of contradiction – which he shares – when viewing, perhaps after snapping out of the somnolence it has hitherto inculcated in him, five marvellous minutes in some turkey or other on the screen before him, he (Buñuel) is referring to the closing remarks of an essay by Man Ray, 'Art et cinéma', that appeared in *L'Âge du cinéma* 2.[15]

Much of what Buñuel says of film's capacity for expressing the world of dreams, emotions, instincts, and the way film language is the finest analogue to the dreaming mind, in fact to human mentation as a whole, finds its validation in the theorising of Jacques Brunius – in concrete terms to his contribution to issue 4–5 of *L'Âge du cinéma*, 'Le Rêve, l'inconscient, le merveilleux' (The Dream, the Unconscious, the Marvellous).[16] Where Brunius is particularly interesting is in his insistence on the oneiric aspects of the cinematic experience per se as an initiatary palpation of the primary process thinking freighted by film. Interestingly, Brunius signs off his essay – which would find definitive form in his book *En marge du cinéma français* (1954), published at the behest of Ado Kyrou in his shortlived 'Ombres blanches' collection for Eric Losfeld[17] – with the same Breton quote Buñuel used: 'the fantastic doesn't exist, everything is real'. Habitual in surrealist writing, the authoritative use of such a canonic Breton quotation is employed with telling effect by the Spaniard, who yokes it to his discussion of Italian neorealism.

Although I may, in emphasising the influence of *L'Âge du cinéma* on Buñuel, be accused of reducing him to some grandma being taught to suck eggs – he, the *inventor* of surrealist cinema; surely he knew where its capabilities lay! – it is worthwhile alluding to a couple of other contributions to this unique surrealist film magazine that may have coloured the ideas expressed in 'The Cinema, Instrument of Poetry', but which are not directly

referenced in it. The maximum programme of a meta-realistic cinema of mystery, irrationality, and revelation is, Buñuel argues, forever stymied by the brutalising domestication and moral debasement of the film industry in terms and tones that are reminiscent of, if not directly inspired by, Péret's 'Against Commercial Cinema', which appeared in the first issue of *L'Âge du cinéma*. (For Buñuel an expression of such vacuous baseness is William Wyler's 1951 police procedural *Detective Story*.) Compare Péret's argument with the second paragraph of the Spaniard's essay:

> With cinema not only is anything possible, but the marvelous itself is placed within reach. And yet never have we seen such a disproportion between the immensity of its possibilities and the mediocrity of its results. In acting so directly on the spectator the cinema is capable of overwhelming, disquieting and enthralling him or her like no other medium. Yet as well as awakening, it is also capable of brutalizing and it is this, alas, that we have witnessed as the cinema, a cultural form without precedent, has developed into an industry governed by sordid market forces incapable of distinguishing a work of the mind from a sack of flour.[18]

The second contribution with leverage is, I would contend, Robert Benayoun's 'Remarks on Cinematic Oneirism', which appeared in *L'Âge du cinéma* 2. In it the young surrealist – who would go on to produce a fascinating body of film writing on, *inter alia*, Buster Keaton, Jerry Lewis, Alain Resnais, and Tex Avery, as well as direct a couple of feature films which are nourished by the surrealist tradition – argued that cinematic language, which is by nature unreal, illogical, ought to seek satisfaction in the unreal (*l'irréel*): 'It is in oneirism, then, that it can rediscover the veritable essence of human beings; the dream, an element common to all authentic individuals, the reassuring measure for man of his own interior richness, offers a much more revealing symbolism than that of fixed things.' Later on he will evoke 'the delirious and aberrant nature of the [oneiric image, which] brings the beauties of total poetry to the viewer. In its highest manifestations, it is the frankly surreal language of certain visionaries like Buñuel, Richter, Man Ray, W. C. Fields, etc.'.[19] That Benayoun, Kyrou, Legrand, Goldfayn et al. considered Buñuel to be an all but peerless figure is attested to by the 'See–Don't See' list of directors that appeared in the surrealist group issue of *L'Âge du cinéma*. Said directors are paired to telling effect: for example, *see* Robert Hamer, *don't see* Roberto Rossellini; *see* H. G. Clouzot, *don't see* Jean Cocteau. There are five names in the *see* column who have no nefarious foil in the *don't see* one; they are Charlie Chaplin, Harry Langdon, Jean Renoir, Josef von Sternberg, and Luis Buñuel.[20]

Vindicated and energised by the ideas in *L'Âge du cinéma*, by the fervour vis-à-vis his figure of its surrealist editors, Buñuel was re-visioning his own

commitment to a more personal and scandalous, poetic moviemaking, in contrast to his bread-and-butter work in commercial Mexican film. And it is the fulgurating take-off of *Los olvidados*, a feature on which he is given free rein by Oscar Dancigers on the back of having delivered a couple of box-office successes – *Gran Casino* (1946–47) and *El gran calavera* (1949) – that made this possible.

According to Dancigers, it was after seeing the early neorealist social drama *Shoeshine* (*Sciuscià*, Vittorio de Sica, 1946), released in Mexico City in August 1948, that the producer suggested making a film about impoverished street kids in the Mexican capital to Buñuel. Four months later the latter would write to his confidant José Rubia Barcia, a Spanish Republican living in exile in Los Angeles, that he was about to embark on *Los olvidados*, which he characterised as a melange of elements from *L'Âge d'or* and *Land without Bread* as they had mutated over the last fifteen years.

The political, social, moral and economic upheavals engendered by the Allied liberation of Italy from German occupation (1944–45) also found its expression in a new kind of film-making: neorealism, as represented by the contemporary oeuvre of Vittorio de Sica, Roberto Rossellini, and Luchino Visconti. In a prescient text from 1948, written as the canon was being constituted, André Bazin argued that:

> Italian [neorealist] films are first and foremost reconstituted reportage ... As a result, the Italian films have an exceptionally documentary quality ... What is a ceaseless source of wonder, ensuring the Italian cinema a wide moral audience among the Western nations, is the significance it gives to the portrayal of actuality ... The Italian cinema is certainly the only one which preserves, in the midst of the period it depicts, a revolutionary humanism.[21]

The aesthetic strategies implemented by neorealism to lend it a soi-disant authenticity include 'an amalgam of players' (Bazin), this being a cohort of professional actors, non-professionals, and street crowds from proletarian or lumpenproletarian backgrounds; filming on the streets of Italy's big cities, decimated during the Allied offensive against the retreating Wehrmacht (see *Paisan* (*Paisà*), directed by Rossellini in 1946) or its idle wastelands and newly constructed suburbs (*Miracle in Milan*, Vittorio de Sica, 1946); a tendency to focus on destitute, streetwise children (*Shoeshine* uses genuine street urchins); the use of dialect and argot by the protagonists.

Editors' note: Paul Hammond passed away on 10 July 2020, before he could finish this essay. Thanks to the support of Paul Hammond's widow, Ana Forcada, and according to the author's wishes, we publish it here in its incomplete form as a tribute to this great scholar of surrealist film.

Hammond's notes for the conclusion of his essay provide the following clues as to the intended direction of its remarks:

In 'The Cinema, Instrument of Poetry', Buñuel is at pains to drive a wedge between any perceived continuity between neo-realism and the sur-realism of *Los olvidados* ...

There are two strands running through *L'Âge du cinéma*: on the one hand the definition and creation of a nascent avant-garde and experimental cinema ... And on the other, the expression of a surrealist vision of cinema past and present as a personal enterprise, manifest or latent, wilful or accidental, of poetic revelation ...

This will be the paradigm for the 1950s, until 1961, when *Viridiana* announces the final great run of surrealism-infused titles, largely co-scripted with Jean-Claude Carrière, but also Julio Alejandro and Alcoriza; differentiated from a dozen other minor 'plebeian' works, the 1950s 'surrealist' movies might include *Él* (1953), *Abismos de pasión* (1953–54), *The Criminal Life of Archibaldo de la Cruz* (1955) and *Nazarín* (1958) ...

Sánchez Vidal and *neo-surrealism* in the Carrière oeuvre. (Neo in the derogatory sense of the word). It is merely the sublation of that *maudit*, absent work at the core of cinema as practised by the surrealists: *L'Âge d'or*, which was only given a general release. (My notion of the flawed nature of theorising surrealism and film when the key work was largely invisible; albeit visible to those who knew how to seek it out) ...

In addition, Forcada has paraphrased her last conversation with Hammond regarding what he hoped to convey at the end of his essay:

In contrast to surrealist film, in neorealism there is no presence of the uncanny, dreams, or poetry – or when there is, it is always inscribed in daily life. Even if Breton considered *Los olvidados* to be a neorealist film, Buñuel was ultimately faithful to surrealism and the concept of mystery in surrealist film. In *Los olvidados* there are oneiric scenes expressing fears and desires – a recognition that any subject has an unconscious.[22]

Notes

1　Buñuel, 'The Cinematic Shot' (1927) and '*Découpage*, or Cinematic Segmentation' (1928). See Buñuel, *An Unspeakable Betrayal*, 125–30, 131–5.
2　Buñuel, 'El cine', 1–2, 15.
3　García Terrés' transcription resulted in one monumental gaffe, namely the evocation in the concluding paragraph of a thinker called 'Emers'. Emers is Engels. See Buñuel, 'Poésie et cinéma', 70–4. It must have been an erudite Simon & Schuster editor or the translator of Kyrou's *Luis Buñuel* (French first edition, 1962), Adrienne Foulke, who first corrected García Terrés' lapsus in 1963. In the meantime, depending on one's source, the innocent reader may still be lumbered with Emers: even the standard version of Buñuel's writings in English, *An Unspeakable Betrayal*, cites his name.

4 Buñuel, 'El cine', 1–2, 15, translated in Hammond, *The Shadow and Its Shadow* (2000), 112–16.

5 The enthusiastic reception of *Los olvidados* did not guarantee it the Grand Prix – this went to two other films: Alf Sjöberg's *Miss Julie* and Vittorio de Sica's *Miracle in Milan* – but it won the prize for Best Director and the International Critics' Prize.

6 There is an exhaustive discussion of the Aragon Affair and its aftermath in Gubern and Hammond, *Luis Buñuel*, 85–115.

7 Breton, *Conversations*, 163, 164.

8 Breton, 'Sur *Los* olvidados', 1128.

9 This was a reversal of the positions taken by the warring disciplines vis-à-vis a 1931 Soviet movie about delinquent street kids, Nikolai Ekk's *The Road to Life* (*Putyovka v zhizn*).

10 Paz, 'Cannes', 163.

11 For an anecdotal account of his propaganda efforts on behalf of *Los olvidados*, see ibid., passim.

12 Paz, 'Buñuel the Poet', 153–4. For the complete version of this mutable essay, see Paz, 'Le poète Buñuel', 26–9.

13 Hammond, ed., *The Shadow and Its Shadow* (1991), 39. The *sic* alludes to the existence of six, not five, numbers; I do not have this sixth number, published sometime in 1952, in my library.

14 Buñuel had no need to wait for *L'Âge du cinéma*, of course; Paz had sent him a typescript of the Spanish original by early April.

15 Man Ray, 'Art et cinéma', 16. To be sure, Man Ray and Buñuel went back a long way: *Un chien andalou*'s momentous first outing was as a backup short to the American's *Mystères du château du dé* at its Studio des Ursulines première on 6 June 1929. Man Ray was invited to travel to Las Hurdes in 1933 as second cameraman for the filming of *Land without Bread*. The aborted 1946 movie *Sewers of Los Angeles*, based on a scenario co-written with Man Ray about a lovelorn teenage girl living in a vast rubbish dump, is in all likelihood, given the lack of any documentary evidence, yet another Buñuel tall tale, but the subject matter resonates with *Los olvidados*.

16 Brunius, 'Le Rêve', 12. Brunius and Buñuel went back even further. It was Brunius who invited the young Spaniard to contribute film criticism to *Cahiers d'art* in 1927. In 1930 Buñuel insisted Brunius serve as his assistant director on *L'Âge d'or*. (It's a pity the Frenchman never left an account of the experience in his voluminous writings on cinema.)

17 One of the other 'Ombres blanches' titles that made it into print was Kyrou's *Le Surréalisme au cinéma* (1953). The Greek surrealist would pen one of the first monographs on our man: Kyrou, *Luis Buñuel*. Donning his film-maker's cap he went on to direct *The Monk* (1972), from a Buñuel–Carrière scenario.

18 Péret, 'Contre le cinéma commercial', 7–8, translated in Hammond, *The Shadow and Its Shadow* (2000), 59–60. Péret had been Buñuel's favourite surrealist poet ever since the ribald, fecund Dalí days of the late 1920s.

19 Benayoun, 'Propos sur l'onirisme cinématographique', 3–6, translated in Hammond, *The Shadow and Its Shadow* (2000), 107–11.

20 The Surrealist Group, 'Voyez', 2, translated in Hammond, *The Shadow and Its Shadow* (2000), 46–7.
21 Bazin, 'An Aesthetic of Reality', 20–1.
22 Editors' note: other relevant sources that the author referenced in his general bibliography for this unfinished essay include: Buñuel, *Mon dernier soupir*; Buñuel, *My Last Breath*; Buñuel, *Obra literaria*; Paz, 'La tradition d'un art passionel et féroce'; Paz, 'The Tradition of a Fierce and Passional Art'; Polizzotti, *Los Olvidados*; and Sánchez Vidal, 'El largo camino hacia *Los olvidados*'.

Bibliography

Bazin, André. 'An Aesthetic of Reality: Neorealism (Cinematic Realism and the Italian School of the Liberation)'. In *What Is Cinema?*, volume II, translated by Hugh Gray, 16–40. Berkeley, CA: University of California Press, 1971.

Benayoun, Robert. 'Propos sur l'onirisme cinématographique'. *L'Âge du cinéma*, no. 2 (1951): 3–6.

Breton, André. *Conversations: The Autobiography of Surrealism*, translated by Mark Polizzotti. New York: Paragon House, 1993.

———. 'Sur *Los olvidados*' [1951]. In *Œuvres completes*, volume 3, edited by Marguerite Bonnet et al., 1124–30, 1472–3. Paris: Gallimard, 1999.

Brunius, Jacques B. 'Le Rêve, l'inconscient, le merveilleux'. *L'Âge du cinéma*, nos 4–5 (1951): 10–14.

Buñuel, Luis. 'El cine, instrumento de poesía'. *Revista de la Universidad de México* XIII, no. 4 (December 1958): 1–2, 15.

———. 'The Cinema, Instrument of Poetry'. In *The Shadow and Its Shadow: Surrealist Writings on the Cinema*, 3rd edn, edited and translated by Paul Hammond, 112–116. San Francisco, CA: City Lights, 2000.

———. *Luis Buñuel. Correspondencia escogida*, edited by Jo Evans and Breixo Viejo. Madrid: Cátedra, 2018.

———. *Mon dernier soupir*. Paris: Robert Laffont, 1982.

———. *My Last Breath*, translated by Abigail Israel. London: Jonathan Cape, 1984.

———. *Obra literaria*. Zaragoza: Ediciones de Heraldo de Aragón, 1982.

———. 'Poésie et cinéma', translated by Michèle Firk and Manuel Michel. *Cinéma* 59, no. 37 (June 1959): 70–4.

———. *An Unspeakable Betrayal: Selected Writings of Luis Buñuel*, translated by Garrett White. Berkeley, CA: University of California Press, 2000.

Gubern, Román, and Paul Hammond. *Luis Buñuel: The Red Years 1929–1939*. Madison, WI: University of Wisconsin Press, 2012.

Hammond, Paul, ed. *The Shadow and Its Shadow: Surrealist Writings on the Cinema*, 2nd edn. Edinburgh: Polygon, 1991.

———, ed. *The Shadow and Its Shadow: Surrealist Writings on the Cinema*, 3rd edn. San Francisco, CA: City Lights, 2000.

Kyrou, Ado. *Luis Buñuel*. Paris: Editions Seghers, 1962.

———. *Luis Buñuel: An Introduction*, translated by Adrienne Foulke. New York: Simon & Schuster, 1963.

————. *Le Surréalisme au cinéma*. Paris: Arcanes, 1953.

Man Ray. 'Art et cinéma'. *L'Âge du cinéma*, no. 2 (1951): 15–16.

Paz, Octavio. 'Buñuel the Poet' [1951]. In *On Poets and Others*, translated by Michael Schmidt, 152–6. Manchester: Carcanet Press, 1987.

————. 'Cannes, 1951: *Los olvidados*' [1983]. In *On Poets and Others*, translated by Michael Schmidt, 162–5. Manchester: Carcanet Press, 1987.

————. 'Le poète Buñuel'. *L'Âge du cinéma*, no. 3 (1951): 26–9.

————. *On Poets and Others*, translated by Michael Schmidt. Manchester: Carcanet Press, 1987.

————. 'La tradition d'un art passionel et féroce' [1951]. In *Luis Buñuel*, by Ado Kyrou, 186–93. Paris: Editions Seghers, 1962.

————. 'The Tradition of a Fierce and Passional Art' [1951]. In *Luis Buñuel: An Introduction*, by Ado Kyrou, translated by Adrienne Foulke, 186–9. New York: Simon & Schuster, 1963.

Péret, Benjamin. 'Contre le cinéma commercial'. *L'Âge du cinéma*, no. 1 (1951): 7–8.

Polizzotti, Mark. *Los Olvidados*. London: British Film Institute, 2006.

Sánchez Vidal, Agustín. 'El largo camino hacia *Los olvidados*'. In *'Los olvidados'. Una película de Luis Buñuel*, by Agustín Sánchez Vidal et al. Mexico City: Fundación Televisa; Madrid: Turner, 2004.

The Surrealist Group. 'Voyez – ne voyez pas'. *L'Âge du cinéma*, nos 4–5 (1951): 2.

From Max Ernst's collage to Jean Desvilles' cut-out animation: transposing *Une semaine de bonté* to film[1]

Arnaud Maillet

During the summer of 1933, Max Ernst cut out illustrations from various books found mainly in the library of the castle of Vigonelo belonging to Maria Ruspoli, Duchess de Gramont, probably without her knowledge.[2] After dissecting these engravings, he made the 184 collages which were to form his third collage novel, *Une semaine de bonté*.[3] Published between April and December 1934 as five booklets printed by Editions Jeanne Bucher, the 'novel', as the subtitle terms it, included 182 out of the 184 collages. Arranged both chronologically and thematically, each series of pictures corresponds to a day of the week linked to an 'element' with a matching 'example'. The first booklet has Sunday as its sign, along with *Mud*, and the Belfort Lion. The second booklet links Monday to *Water* as both element and example. The third booklet associates Tuesday, *Fire*, with the Dragon's Court. The fourth has Wednesday, *Blood*, and Oedipus. The fifth and last booklet groups together the last three days of the week: Thursday, *Black*; first example: the cockerel's laughter; other example: Easter Island; Friday, *Sight*; example: the inside of sight; Saturday, element: *Unknown*; example: the key to songs.[4]

In 1961, Jean Desvilles made an animated film based on this emblematic work.[5] Given that film in general and animated film in particular are essentially about movement, how did Desvilles adapt Max Ernst's collages, which by their nature are fixed? And, as a corollary: if collage is not just a technique but a generic notion that provides a key to comprehending the complexity of Ernst's work, as Werner Spies has rightly explained, then how to understand the fact that the film-maker was given the artist's consent to cut up and detach the collages that Ernst had so painstakingly assembled barely thirty years before?[6]

According to Desvilles, this collage novel 'retells the myth of the world being created in seven days, but the elements that take part in the creation are none other than the seven deadly sins', so that on Wednesday, for

instance, 'Oedipus is seen as a bandit with the head of a bird of prey committing abduction, rape, murder'. In this case, seeing the images without any captions was a primordial experience. Unlike his two previous collage novels, *Une semaine de bonté* 'abandons the captions' so the 'images speak for themselves'.[7] The story is then purely visual. From the outset, the collage novel was in itself extremely cinematic.

For the publication of his collage novel, Max Ernst had used woodcut engravings taken from illustrated fiction, works popularising science, technology, and medicine, magazines and reviews such as *La Nature*, and even a few classical works of literature or poetry such as an 1866 edition of Milton's *Paradise Lost* with engravings by Gustave Doré.[8] However, most of the woodcuts came from 'serialized stories in the daily papers, and novels appearing in weekly instalments'.[9] As François Albera noted, the same sources, which everyone read at the time, also supplied subject matter to early cinema. While the engravings may have been a little dated when Ernst used them, they were still popular, and their genres were 'well defined with relatively set codes, whether suspense, horror, sadism, the slum underworld, travel, elements of surprise, and scientific and technical inventions'.[10] Such genres were all to be found in early cinema, along with 'outraged, emphatic poses and grandiloquent, expressive gestures linked to a whole anthropology of feelings and affects' – exactly the same as those in the engraved cut-outs.[11]

Also according to Albera, there are three other comparisons to be made between the collage novel and film, the first of which uses a 'continuous process of story-telling, montage, contrasts in scale, varying angles, and planes in vectorialized space following a temporal logic' – elements also to be found in film grammar.[12] Ernst's first two collage novels had moreover clearly referenced projected and moving imagery.[13] Projected imagery is clearly visible via allusions to the magic lantern: this may be seen hanging from a naked woman's pubis projecting the enlarged image of a man, the true projection of desire;[14] or eyes projecting a beam of light on to a door showing the image of a beetle, like the solar microscopes revealing animalcules inside a camera obscura, a famously amusing physics experiment from the eighteenth century.[15] The idea of distance viewing – television, literally – is even evoked with the appearance of a moustached face on the back of a chair used opportunistically as a screen in the dining car of a train – the very image of the voyeuristic gaze upon the female sex.[16] Motion picture imagery is also present in a collage showing the physiological station used by the distinguished scientist Étienne-Jules Marey to study human and animal locomotion by deconstructing movement.[17] Another collage shows a gigantic zoetrope inside which a young girl protects her eyes with one hand, groping her way forwards with the other in the midst of seagulls, whose flight Marey had deconstructed, one of the birds 'flying out of the machine'.[18]

Last, while Ernst's collages allow the gaze to alternate between the whole and the different elements forming the whole, they also unfold along a narrative line not dissimilar from film's temporal development – this is the case whichever way the plates are viewed, whether 'turned like pages in a portfolio or hung at an exhibition', since they are numbered and have an order.[19] Ernst avoided the layout he had used for his first two collage novels, where the plates figured only on the uneven pages, and in *Une semaine de bonté* chose to have two plates opposite each other in favour of visual confrontation not unlike a form of film montage.

Whatever the case, something akin to a magic-lantern show and cinematic experience is as much at work in the plates as in the way they are viewed – which André Pieyre de Mandiargues noted in his preface to the film adaptation of *La femme 100 têtes* by Éric Duvivier.[20] In fact, Ernst wanted 'to make contemplating the book – pages quickly turned – something like a magic lantern show. Ernst's visual poem is in a way part of the ancestry of cinema. It is therefore only natural that it should have been adapted to the screen.'[21] As early as 1921, André Breton was no doubt the first to note the cinematic quality of Ernst's collages due to the changes in visual perception brought about by motion pictures – for instance, montage, slow motion, and accelerated motion.[22] Here, just as collage was substituted for painting's perspective representation, so the camera's moving frame shattered notions of a Euclidian representation of space.[23] As Abigail Susik has stated: 'Ernst's collages of 1919–1921 are radically innovative for Breton because they abandon as their main focus the old game of naturalism via perspective and pursue instead a blatantly filmic brand of illusionism.'[24]

In 1947, just after the end of the war, Hans Richter, with Ernst's assistance, adapted a series of plates from *Une semaine de bonté*, mainly those concerned with *Water* (*Une semaine de bonté*, plates 8–11), as a first sequence for *Dreams that Money Can Buy* (07'24"–17'19"), titled *Desire*.[25] In 1959, Richter noted that Ernst's collage novel provided him with 'inexhaustible anecdotal subject-matter. The latent content on each separate sheet seemed to resist the limits imposed by the image frame. The field of interiority and dreams which surrealism had been challenging for the previous twenty years – a dimension in which the invisible was made visible – became *an inexhaustible source of inspiration*.'[26] Given this, it comes as no surprise that in 1967 Éric Duvivier made a medium-length film of *La femme 100 têtes* with a mise-en-scène of actors, sets, and various superimpositions, which also freely adapted Ernst's collages. But often, Ernst inspired others in ways that were not so literal. Sometimes it was the idea of recycling and collage developed by Ernst that gave rise to further collages and collage films (found footage) such as those by Joseph Cornell.[27] At other times, the desired effect was more to create an atmosphere of crime, or the surrealist

character Loplop cropped up, as, for example, in Georges Franju's 1963 film *Judex*, when the eponymous character enters the costume ball, his head a bird of prey.[28]

In other cases, the collage technique itself was adapted to the screen, with figures and collages being animated. In the 1960s, Larry Jordan, directly inspired by Ernst's collage novels, animated collages of Victorian engravings and incorporated memories of surrealist poetry in films such as *Duo Concertantes* (1962–64).[29] In such a context, it was only natural that Jean Desvilles should also explore the cinematic dimension of Ernst's collage novel and make a screen adaptation of *Une semaine de bonté* (1960–61). However, though engravings lend themselves particularly well to film's narrative temporality, 'transposing the static antagonism of the plates into a dynamic form' proved a challenge.[30]

In 1960, Desvilles, a newly divorced artist and scenic painter, was invited by Ernst and Dorothea Tanning to stay with them in Huismes, in the Touraine area of France.[31] In order to cheer him up, the couple spent many memorable evenings, as Desvilles recalled: 'we laughed a lot, and drank a lot'. During one such evening, they had an idea to make the first film about Tanning and her artwork.[32] After this, they decided to make another film out of *Une semaine de bonté* – Ernst had miraculously recovered the original collages. They had been exhibited in Madrid in 1936, and would most certainly have been destroyed during the bombing had it not been for a kind soul who managed to save them *in extremis*. Ernst bound the plates into one large volume for his library. Desvilles had them photographed one by one by Daniel Harispe who made around three-hundred photographic prints.[33] The job of animating them then began, using the prints that Desvilles cut out. The animation was completed frame by frame, using an animation stand from Equipe Arcady, a company that played a significant role in developing films on art in France after 1945.[34] The peg bars on the animation stand table were so precise that when the photographs were moved frame by frame, the impression of a camera moving over the collage reproductions was created, or when the cut out parts of the photographs, such as figures or objects, were moved, a genuine sense of animation was achieved. And to give the impression of dolly in or out shots, the camera facing down to the table was gently moved up and down the pedestal. The film was funded by Ernst personally, and required six months' work including the two to three months of filming.[35] Prints were made on a daily basis so that the rushes from the day before could be reviewed. The text was written by Ernst himself and was spoken by radio announcer Jean Toscane to provide the solemn tone required to contrast with the images. The music was composed by Georges Delerue and the soundtrack was optically recorded live, each section being done over and over in a loop with each corresponding film

sequence also in a loop projected on to a screen opposite the orchestra. Another soundtrack was made for the narrator's voice, and a third for sound effects. This ambitious film was shot in black and white on 35 mm Kodak stock, and copied in 35 mm prints. It represented France at many festivals and received two different awards.[36]

Preparation for filming and animation meant that Desvilles had to manipulate, cut out, paste, and even re-paint the photo prints. Each time something was cut out of a photo print, the gap that was left had to be disguised. In such cases, his talent as a painter came to the fore as he imitated to perfection the fine lines and cross-hatch shading on the wood engravings. One example comes to mind: the film shows a guillotine by itself and the blade falling (04'40") – a complete invention on the part of Desvilles from the collage of *Le Lion de Belfort* no. 32 in which the guillotine in the background is partly obscured by the executioner holding out the head of a condemned man. Unfortunately, force of circumstance, such as the film-maker's divorce, meant that this preparatory material was subsequently lost.

The film, then, raises a number of issues regarding the conditions for adapting a collage novel into an animated film. If the sole aim was to photographically reproduce Max Ernst's collages, the viewer would be better off simply looking at the book, flicking through the images at leisure without the constraints of the film unwinding. Jean Desvilles' film is not, however, a simple adaptation, but an actual transposal which takes into account the specific nature and properties of film. As the essence of film is movement, 'transposing plates … into a dynamic form' necessarily involves a redefinition of collage.[37]

One of the first concrete problems the film-maker encountered even before the work on animation began was to match the camera frame's horizontal format with the vertical format of the collages to be filmed. The simplest solution was to take the camera as close as possible to the vertical edges of the collage and leave some of the top or bottom, or both, out of the frame. The other solution was to film the collage as a whole, adding extra cut-outs or painted elements that would compensate for the blanks on either side. For instance, on one shot where the central motif comes from *Le Lion de Belfort* no. 15, a door half-hidden by a curtain from the collage *L'eau* no. 15 has been added on the right, and on the left a wrought iron gate has clearly been painted in by Desvilles himself, inspired by the collage *L'eau* no. 9. And why not? Desvilles was only following Ernst's own technique when he re-worked 'certain plates in pencil and/or gouache' as he made the collages three decades previously.[38]

The illusion of camera movement within the depth of each filmed plate was another solution to the challenge of matching the differently formatted frames. The camera either starts by framing incongruous, even monstrous,

details, such as a close-up of a gigantic bat (09'28"), ending up with a long shot; or the opposite, starting with a long shot and then focusing the viewer's attention on a close-up of some detail of a crime, such as the faces of young women in a train compartment, one tied up (02'16"), the next gagged (02'24").

The medium of cinema creates the illusion of continuity where the book, in its codex form, operates using dichotomy: division from one page to another, from one plate to another. In the film, the plates are indeed sometimes juxtaposed and filmed in continuity, cancelling the segmentation that is peculiar to the pages of a book: the camera moves smoothly from one plate to another exactly the same way that Henri Storck around 1945 unframed paintings by Paul Delvaux in order to film them in a continuous manner.[39] Jean Desvilles also created a unitary, homogeneous, fluid world from juxtaposed plates that were initially separate, starting with their division into pages. From the cycle titled *L'eau* (nos 8 to 12), he filmed up to five consecutive engravings (05'32") assembled into a long lateral panel hung together with joins that he painted and pasted on in order to visually achieve a lateral travelling effect. This technique also heightened the surreality of a world that was already surreal. Then, to attain an even greater degree of fluidity for the tracking shot from one plate to another, Desvilles went so far as to add another special effect which gave the impression of a river running in the lower part of the animated collages (05'07"). This he achieved by moving over each other different layers of transparent celluloid on to which the undulations of water were painted.

Even more interesting are the liberties Desvilles took with Ernst's original collages. He does not hesitate to repeat the same figure in a setting he invents, as is seen with the woman committing suicide by throwing herself off a quayside (*Le Lion de Belfort* no. 6), where the figure is repeated, re-pasted and recombined six times to really create the impression of her falling, not unlike Marey's chronophotography, which deconstructed movement (02'36"). Also in the film, certain plates are viewed back to front (03'07" – *Le Lion de Belfort* no. 7[40]), or else their order is reversed in comparison to the book (02'10" – *Le Lion de Belfort* nos 16 and 17 ; 05'07"– *L'eau* nos 4 and 5). At other times, the film *découpage* completely rearranges not only the order of the plates but also the collages' internal coherence, thus creating new ones. One example is the shot showing a man climbing up a rope from the water to a quayside (02'50", after *Le Lion de Belfort* no. 7) into which a close-up of a lion's head, a detail from a completely different plate (*Le Lion de Belfort* no. 26), has been inserted. Collage in this case has become full-fledged montage.

The simplest animation effect of all the various techniques is cut-out, a variation on paper cut-outs, lending movement to the individual parts of the

filmed work. Most often, Desvilles unpeels the layers from Ernst's collages to animate them frame by frame. On occasion, he even goes as far as to de-articulate some of the figures, like the figure of a young woman whose upper body is raised before her whole body moves into standing position (08'44"). Yet this process poses a perplexing difficulty – why would Ernst agree to his collages being altered in this way? Animation was tantamount to renouncing the photographic unity of his collages. Werner Spies explains, however, that for Ernst the collages were like 'maquettes', while the photo shots taken for the book edition were the 'definitive works'. The photo reproductions 'concealed the joins', all the physical traces of the cutting out, because the montage and the gluing processes were a 'secret' that had to be 'closely guarded'. Ernst's refusal to exhibit the original work – the originals were only shown once, in 1936 in Spain – was precisely because he did not want the manual aspect of his work, the thick layers of the engravings, to be seen. On the contrary, he strove to lend an appearance of coherence and continuity to imaginary space, and a degree of verisimilitude to 'plausible spaces'.[41] His goal in masking the purely technical operations used in collage was to show the extent to which surreal elements are found *in* reality, not to one side or superimposed on it. The continuity between disparate elements attained in the collages had to be sacrificed to the process of 'unpasting' (*décollage*). And as the figures could only be animated when detached from one another, this process consequently cancelled any attempt to conceal the montage and the unity in the collage, thereby running the risk of robbing the filmed work of any surreal effect.

However, before tackling the knotty question of the frame-by-frame animation of the figures and the de-collage of the collages, the way in which Desvilles went about animating these elements should be examined. Two methods were available to him: either to keep the background, even if changes were necessary, or do without it. For the latter case, various figures were taken from the different plates and animated against a dark grey background in order to recreate a narrative: for instance, a woman holding a lamp leads a couple, whose heads are birds of prey, as they carry a woman who is tied up, through all kinds of objects, wrought iron gates, and dead bodies (12'56"). Otherwise, to suggest interior vision, three details from three different collages appear, seemingly floating in the screen's black space (16'06", then 16'34"). Or the silhouettes of battered women are animated and seem to dance a frenzied cancan against a neutral grey or black background (17'28").

When the background is maintained, as was the case for adapting *L'eau* no. 22, the original collage, which was extended spatially by the addition of two side elements, was also modified temporally. The fixed elements which made up the original do not all appear simultaneously, since it is only when

the woman disappears in the water that the dead body appears, floating into focus. The synchronicity of the original collages was replaced by diachroneity when the same elements were animated.

On occasion, Desvilles adds moving collages to Ernst's original fixed collages. For instance, in *L'eau* no. 3, a woman's shoe stamps around by itself, two birds flap about, a woman's head with a bizarre hairdo disappears only to reappear,[42] and there is a floating barrel with a death's head on it (05'24"). Elsewhere, the woman who originated in collage *L'eau* no. 22 suddenly crosses the screen from the shot of collage no. 1 in *La cour du Dragon* (06'57"), although she is not present in the original collage: such invention signifies a potential for narrative continuity. In the scene viewed from a theatre balcony between stage curtains, three morbid collages appear from *Rire du coq* nos 6, 8, and 9 (14'17", shot taken from *Rire du coq*, no. 7).[43] The way in which the sequences unwind clearly refers to magic-lantern shows and even to film projection. The temporality given to the original collages by Desvilles is made visible by animating the 'picture within the picture', a theme of which Ernst was fond.[44] The opening between the stage curtains, the mirrors, paintings, and dressing screens taken from bourgeois interiors show not what is, but what will be – that is, the fulfilment of desire, as can be seen with the two women holding hands, but who, in the painting above them, are about to kiss (08'16") – a reactivation of the topos in painting of the magic mirror that shows the future, as shown, for instance, in Lukas Furtenagel's *The Painter Hans Burgkmair and His Wife Anna* (1529)[45] or Jacopo Tintoretto's *Venus and Mars Surprised by Vulcan* (c. 1551).[46]

Similarly, the panels on a dressing screen fade into an image of the snake-tempter, phallic in shape, prefiguring penetration while a couple embrace in the foreground; soon the image of a voyeur appears in the final panel of the screen, giving the impression that the man is watching a woman seated at the back of the room (07'43", after *La cour du Dragon* no. 33). Another form of a painting in a painting occurs with an image appearing on a smoke-screen, reminiscent of Etienne-Gaspard Robertson's phantasmagoria in which ghosts and skeletons appeared through a smokescreen (10'06", after *La cour du Dragon* no. 27): these magic-lantern visions are details cut from other collages (*La cour du Dragon* nos 19 and 31). Such fades between parts of images – including the back-to-front reversal of a young woman at 8'47" – were achieved using the animation stand and are, in fact, genuine moving collages. At other times, they manage to slide from one shot to another as a form of montage.

Another special cinematic feature is the flicker effect applied to a detail framed through a door or a painting. The windows of a train carriage, for instance, show a quick alternation between night and daytime views (02'09"). In one case, there is no frame at all: a woman's naked bust and the

French flag alternate between positive and negative images (14'50"). At other times, the flickering is the whole image sparkling, as the effect is achieved by alternating frames, rather than shots. This is, therefore, no longer the domain of collage, which is created spatially within a single shot or frame, but of montage, which is a temporal succession of shots or frames on the screen. A shot from collage *Œdipe* no. 13 alternates with another filming a detail from collage *Œdipe* no. 7: the montage accelerates to such an extent that it is no longer about editing shots, but a succession of frames designed to suggest the violence of crime and the criminal urge (12'40").

In this way, the collage and assemblage of the plates went hand in hand with editing shots. Richter suggested to Ernst that they work together on his first 'film in a film', titled *Desire*, a sequence from *Dreams that Money Can Buy* based on collages from *Une semaine de bonté*. He also noted, in 1959, the analogy between collage and montage:

> This montage corresponds so closely to the collages in modern painting that one wonders whether collages weren't suggested by the teachings of cinema, or if, on the other hand, cinema syntax was not stimulated by the technique of paper collage. Newspaper cut-outs and tram tickets by Schwitters, cogs, gearings, portraits in oils and cheese wrappings, but first and foremost, the demonic dreamlike interworld evoked by Max Ernst.[47]

On the one hand, such comments go back to what Ernst wrote about collage, that 'though feathers make plumage, glue does not make a collage'.[48] Paraphrasing words by André Breton, who in turn had borrowed them from Lautréamont, collage is the 'coupling of two realities that to all appearances cannot be coupled, on a plane that apparently does not suit them'.[49] From this 'chance encounter between two distant realities on an unsuitable plane' there comes into being 'a spark', or an effect of 'systematic estrangement'.[50] In the 1930s, the time of the Second Surrealist Manifesto, Breton's thesis was that surrealism no longer had anything to do with dreams: an imaginary parallel world such as Walt Disney's is not surreal. The surreal, on the contrary, was found in reality, or rather in the gaze brought to bear upon that world: a gaze of estrangement, an oblique gaze that turns the familiar into the *unheimlich*.[51]

The 'demonic dreamlike interworld', mentioned by Richter concerning Ernst's collages, is strongly reminiscent of what Robert Desnos wrote in 1930 regarding *La Femme 100 têtes* in *Documents*: 'A poet is a wolf for poetry. He fights it, conquers it, tears it apart tooth and claw. He feeds off it … Without a taste for bloody murder, there is no valid work in this area.'[52] Such a 'taste for murder, and the tang of blood' are common to the great surrealist works, from *La Femme 100 têtes* to Luis Buñuel's first two films – it is no accident that Ernst played the part of the bandit chief in *L'Âge d'or* (1930).

In this way, 'for the poet, there are no hallucinations. There is reality,' wrote Desnos. 'And it is to the spectacle of a broader reality than is normally acknowledged that the inventor of collages invites us.'[53] Desnos therefore talked about the 'imperialism of the déjà vu' given that 'Max Ernst ripped a shred of cloth from the Marvelous and restored it to Reality's torn gown'.[54] Other figures close to the surrealists' circle developed similar concepts of reality. Already in 1929, though in other circumstances, Carl Einstein evoked 'the murderous power of the work of art' as opposed to 'the optimistic unity between reality' and art.[55] The same year, Georges Bataille suggested that facts induce horror.[56] In 1951, Octavio Paz explained the difference opposing the surrealists and reality when he wrote that *Un chien andalou* and *L'Âge d'or* 'marked the first aggressively deliberate incursion of poetry into the art of moving pictures'. The reason given was that 'while the surrealist theme of Buñuel's [first two] films is humankind's fight against an asphyxiating and mutilating reality', it is because ultimately 'reality cannot be endured. This is why people kill and die, love and create.'[57]

But what happened to these surrealist features once *Une semaine de bonté* was adapted to the screen? Did the film manage to translate the work of art's 'murderous power'?

Jean Desvilles' film fulfilled two goals: he did not only wish to make an art film, almost a documentary about art, but also an exhibition film – that is, a film that was both an experimental work in its own right and a way of showing Max Ernst's collages. He was not simply looking to tell a story when animating the collages. He also wanted to renew the way they were exhibited, as he personally told me.[58] Making a film with the collages was a way of making them visible again, at a time when Ernst did not seem as avant-garde as he once had, competing against Art Informel in the 1950s, then the invention of the happening by Allan Kaprow (1959), and, in 1960, the beginnings of Pop Art in the United States, and the New Realism in France. Ernst may well have seen in film a different way of showing his work, just as he had already seen engravings as a way of circulating his work to the public: 'Multiples can be socially useful by helping works that have become too costly to circulate, and so increase the ways in which an artist can communicate with the public.'[59]

Using the moving image would assist Ernst to come back to the forefront of the art scene through a wider distribution and promotion of his work despite changing trends in art and the public's lack of interest. After all, each sequence in Hans Richter's *Dreams that Money Can Buy* 'can be compared with the window displays of department stores', as Georges Goldfayn savagely commented in 1956.[60] Each sequence does, in fact, show one of Richter's former avant-garde friends – Ernst, Fernand Léger, Man Ray, Marcel Duchamp, Richard Huelsenbeck, and Alexander Calder – who had presented or made

variations on one or more of their works. The emerging notion of the screen as showcase, to which Frederick Kiesler greatly contributed,[61] had already appeared in 1925 with Marcel Duchamp's only film, *Anémic Cinéma*, which showed his rotating half-sphere and its rotating discs in action.[62]

When filming Ernst's collages in the early 1960s, Desvilles' concerns were the same as other film-makers filming artwork in the mid-1940s. Going back to an idea developed particularly by Jean Epstein, according to whom cinema is animist in nature,[63] Henri Lemaître, writing in 1956 on the relationship between cinema and the fine arts, said that 'in so far as cinema is indeed an *animist* art with regard to form, figures and volumes, it will come to *vitalize* the other arts, both architecture and painting'.[64] For all these film-makers – Pierre Kast, Alain Resnais, Henri-Georges Clouzot, and Desvilles in France; Henri Storck and Paul Haesaerts in Belgium; Luciano Emmer in Italy – it was not a question of simply filming works of art, but also animating them, making them move. Cinema, the art of movement, was also looking for its film-makers to achieve 'an organic unity between painting, music and poetry', to produce 'an autonomous and new creation', de facto transforming film into 'a sort of artistic complex', or better still, a 'dynamic synthesis of the arts'.[65] Works of art were, then, filmed as if they were movie stars. Pablo Picasso understood this when he defended *Guernica* (1949) by Alain Resnais, who had been accused of not sufficiently showing the painting.[66] Yet for anyone wanting to see paintings there were books and museums, and Picasso felt that the point of the short film was to use his paintings like stars in order to tell a story.[67] Many books reproduced his works, so film ought to stage them. Otherwise, what was the use in filming them? Jean Desvilles' film obviously went completely in this direction, his film functioning as both an art film and a film about experimental art – like all important films on art from this period – as well as renewing the way in which Ernst's collages were exhibited.

Similar research was going on in the publishing world,[68] especially the engagement with the issue of montage, having recourse to film grammar as when choosing shot size for the reproduction of illustrations – for instance, André Malraux on Goya, Georges Sadoul on Callot, etc. So this golden age of films on art, from the mid-1940s to the 1960s, went alongside a breakthrough in art books – part of a post-war policy to popularise the visual arts and combat memories of World War II barbarity.[69] For Malraux, whose *Musée imaginaire* juxtaposed artwork from differing periods, cultures, and styles, the structural organisation of 'the art book was, just like a film, a succession of images arranged on the basis of montage'.[70]

For reference, Ernst was delighted with the animation work and suggested that Desvilles also adapt *La femme 100 têtes*, which Ernst would personally have funded. However, both artist and film-maker gave up on the

idea, realising that they would not be able to tell any new story with the collage novel as they had done with *Une semaine de bonté*. Neither would they have managed to introduce any technical novelty. Shortly thereafter, Ernst introduced Desvilles to art historian John Rewald, who decided to fund the film-maker's third short film for Picasso's *Tauromaquia* (1961). He focused on the picador, narrating three points in the character's life based on one hundred and twenty of Picasso's wash drawings, with a text written by Michel Leiris.[71] But that's another story.

Notes

1 My warmest thanks go to Abigail Susik and Kristoffer Noheden for inviting me to take part in a 2017 symposium on surrealist cinema from the 1950s and for publishing part of the proceedings. I would also like to thank the participants for their questions and suggestions. My keen thanks also to Jean Desvilles for the detailed accounts and fruitful discussions we enjoyed in 2017 and 2018. Lastly, I thank my faithful translators, Elaine Briggs and Anna Briggs, for their work.

2 According to Valentine Hugo, as reproduced in Spies, *Max Ernst, Une semaine de bonté*, 36.

3 Ernst, *Une semaine de bonté ou Les sept éléments capitaux*. Ernst's first two collage novels were *La femme 100 têtes* (1929, 147 collages) and *Rêve d'une petite fille qui voulut entrer au Carmel* (1930, 79 collages).

4 Spies, *Max Ernst, Une semaine de bonté*. This version will be used when referring to the numbered collages. Note: 'the key to songs' is a literal translation of 'la clé des chants', which puns on the phrase 'prendre la clé des champs', expressing a 'run for freedom', as in 'to take off for the wild blue yonder' (translators' note).

5 Desvilles, *Une semaine de bonté ou les sept éléments capitaux*, 1961, 35mm film, black and white, sound, 18'. A copy of the film is logged at the Bibliothèque Kandinsky at the Centre Pompidou with the number: cote F 169. Edition DVD-R video (PAL): Boulogne-Billancourt, Arts et résonnances, 2007.

6 Spies, *Max Ernst, Les collages*, 18 *sq*.

7 Desvilles, presentation text on the back of the DVD cover.

8 Spies, *Max Ernst, Une semaine de bonté*, 36–7.

9 Albera, 'Exposition au Musée d'Orsay', 130.

10 Ibid., 130.

11 Ibid., 131.

12 Ibid., 134.

13 Ibid.

14 Ernst, *La femme 100 têtes*, 91.

15 Ernst, *Rêve d'une petite fille qui voulut entrer au Carmel*, 51.

16 Ernst, *La femme 100 têtes*, 121.

17 Ibid., 51.

18 Ernst, *Rêve d'une petite fille qui voulut entrer au Carmel*, 81; Albera, 'Exposition au Musée d'Orsay', 135.

19 Albera, 'Exposition au Musée d'Orsay', 134. The first public exhibition of the original plates for *Une semaine de bonté* took place in Madrid in 1936. Miraculously saved from the bombings, they have only been shown once since that time, in the travelling exhibition of 2008–9. See Spies, *Max Ernst, Une semaine de bonté*.

20 Éric Duvivier, *La femme 100 têtes*, 1967, 16 (35) mm film, black and white, sound, 20'. 'La femme 100 têtes' (the woman with 100 heads) is equivocal according to what is heard. Its two other homonyms are: 'la femme sans tête' (the woman with no head), and 'la femme s'entête' (the woman stubbornly persists) (translators' note).

21 André Pieyre de Mandiargues, opening text for Éric Duvivier's film.

22 Breton, 'Max Ernst', 246.

23 Maillet, 'Du panorama au cinéma', 127–39.

24 Susik, '"The Man of these Infinite Possibilities"', 81.

25 Hans Richter, *Dreams that Money can Buy*, 1944–47, 16 mm film, colour, sound, 85'.

26 Richter, 'Peinture et film', 26, italics original.

27 Ramond and Affron, *Joseph Cornell et les surréalistes à New York*.

28 Spies, *Max Ernst–Loplop*; Georges Franju, *Judex*, 1963, 35 mm film, black and white, sound, 104'.

29 Larry Jordan, *Duo Concertantes*, 1962–64, 16 mm film, black and white, sound, 9'. See Elder, *Dada,* 433–506.

30 André Pieyre de Mandiargues, opening text to Éric Duvivier's film.

31 Spies, Join-Lambert, and Drost, *Max Ernst*.

32 Jean Desvilles, *Dorothea Tanning ou le regard ébloui*, 1960–61, 35 mm film, colour, sound, 11'.

33 Desvilles refused to work from the photographic reproductions in the Jeanne Bucher edition, which he judged as lacking clarity. Many details had indeed been lost in the 1934 printed edition. Bearing this in mind, when certain shots or details from the film are compared with the excellent reproductions in the 2009 catalogue *Collages originaux*, doubts do arise: might there have been a mix of photographic sources, some of which were taken from the 1934 edition?

34 'L'Équipe Arcady', 15; Berthomée, 'Les courts métrages d'art en France', 102–4.

35 This was also the case for the first film on Dorothea Tanning.

36 The film was screened at the Berlin, Venice, San Sebastien, Bergamo, Budapest, Montevideo, Vienna, and Oberhausen festivals and the Paris Biennale. Awards: first prize at the Vancouver Festival; prize for outstanding quality awarded by the Centre National de la Cinématographie française.

37 André Pieyre de Mandiargues, opening text to Éric Duvivier's film.

38 Spies, *Max Ernst, Une semaine de bonté*, 334.

39 Henri Storck, *Le monde de Paul Delvaux*, 1944–46, 35 mm film, black and white, sound, 11'.

40 In this particular case, neither Desvilles nor Ernst noticed the mirror-image reversal from the original collage in the film.

41 Spies, *Max Ernst, Les collages*, 68–9. See Krauss, *The Optical Unconscious*, 53.

42 From collage *Oedipe* no. 20.

43 The same thing occurs at 15'23" with a composite shot built up from *L'île de Pâques* collages nos 2 and 3 recreating a window framed by curtains opening on to a spectacle of collages showing prostitution and alcoholism (*L'île de Pâques* nos 6 and 7).

44 Spies, *Max Ernst–Loplop*, 53–6.

45 Lukas Furtenagel, *The Painter Hans Burgkmair and His Wife Anna*, 1529, oil on wood, 60 x 52 cm, Vienna, Kunsthistorisches Museum.

46 Jacopo Tintoretto, *Venus and Mars Surprised by Vulcan*, c. 1551, oil on canvas, 135 x 198 cm, Munich, Alte Pinakothek.

47 Richter, 'Peinture et film', 26.

48 Ernst, *Écritures*, 256.

49 Ibid., 256. Breton later quotes this definition by Ernst: Breton, 'Entretiens radiophoniques', 470.

50 Ernst, *Écritures*, 253–4, 256.

51 On the disorientating effect of watching films, see Breton, 'As in a Wood', 235–6.

52 Desnos, 'La femme 100 têtes', 238–9.

53 Ibid., 238.

54 Ibid., 238–9. See Albera, 'Exposition au Musée d'Orsay', 136–7.

55 Einstein, 'Notes sur le cubisme', 152.

56 Bataille, 'Dictionnaire', 216.

57 Paz, 'Le poète Buñuel', 26–8.

58 This is why a copy of Desvilles' film is logged with the documentary films on art in the Bibliothèque Kandinsky (Musée National d'Art Moderne – Centre Pompidou) and not in the collection of experimental films or artists' films at the Musée National d'Art Moderne (Centre Pompidou).

59 Quoted in Adhémar, *Max Ernst*, ix.

60 Goldfayn, 'Cinéma anémique', 155.

61 Frederick Kiesler created the scenography for Art of This Century, the permanent exhibition in the Peggy Guggenheim collection, while she produced the Richter film *Dreams that Money Can Buy*. See Michaud, 'Le Film fait exposition', 10.

62 Marcel Duchamp, *Anémic Cinéma*, 1925, 35 mm film, black and white, silent, 7'.

63 Cinema, the art of movement, reveals the movement of the world: Epstein, *Le cinématographe vu de l'Etna*, 134: 'One of cinema's greatest strengths is its animism. On the screen, there is no still life. Objects have attitudes. Trees gesticulate. Mountains, just like this Etna, signify. Every accessory becomes a character.'

64 Lemaître, *Beaux-arts et cinéma*, 58.

65 Ibid., 60. See Susik, '"The Man of These Infinite Possibilities"', 61–87.

66 Alain Resnais, Robert Hessens, *Guernica*, 1949, 16 mm film, black and white, sound, 13'.

67 Breteau, 'Entretien avec Alain Resnais', 22.

68 Smith, 'Moving Pictures', 163–73.

69 Lemaître, *Beaux-Arts et cinéma*, 139–40. See Jacobs, *Framing Pictures*, 4, 34 no. 12.

70 Jacobs, *Framing Pictures*, 5.

71 Jean Desvilles, *Picasso, romancero du picador*, 1961, 35 mm film, black and white, sound, 13'. Idea and realisation, Jean Desvilles, from 120 wash drawings by Pablo Picasso. This film represented France at the Moscow, Leipzig, Venice, Porto Rico, Melbourne, Budapest, San Sebastian, and Rio de Janeiro festivals, at the Paris Biennale, and the Musée d'art moderne Centre Georges Pompidou. Award: prize for outstanding quality given by the Centre National de la Cinématographie français.

Bibliography

Adhémar, Jean. *Max Ernst, Estampes et livres illustrés*. Paris: Bibliothèque nationale, 1975.

Albera, François. 'Exposition au Musée d'Orsay: Une semaine de bonté de Max Ernst: "la robe déchirée du réel"'. *1895*, no. 58 (2009): 128–37.

Bataille, Georges. 'Dictionnaire – œil'. *Documents* 1, no. 4 (1929): 215–18.

Berthomée, Jean-Pierre. 'Les courts métrages d'art en France: 1946–1961'. In *Le Court métrage français de 1945 à 1968: De l'âge d'or aux contrebandiers*, edited by Dominique Bluher and François Thomas, 95–109. Rennes: Presses Univsersitaires de Rennes, 2005.

Breteau, Gisèle. 'Entretien avec Alain Resnais'. In *Abécédaire des films sur l'art moderne et contemporain, 1905–1984*, 21–22. Paris: Centre Georges Pompidou, Centre National des Arts Plastiques, 1985.

Breton, André. 'As in a Wood'. In *Free Rein*, translated by Michel Parmentier and Jacqueline d'Amboise, 235–40. Lincoln, NE: University of Nebraska Press, 1995.

———. 'Entretiens radiophoniques, V'. In *Œuvres complètes*, volume 3, edited by Marguerite Bonnet et al., 465–72. Paris: Gallimard, 1999.

———. 'Max Ernst'. In *Œuvres complètes*, volume 1, edited by Marguerite Bonnet et al., 246. Paris: Gallimard, 1988.

Desnos, Robert. 'La femme 100 têtes, par Max Ernst (Editions du Carrefour)'. *Documents*, 1, no. 4 (1930): 238–9.

Einstein, Carl. 'Notes sur le cubisme'. *Documents* 1, no. 3 (1929): 146–55.

Elder, R. Bruce. *Dada, Surrealism, and the Cinematic Effect*. Waterloo: Wilfrid Laurier University Press, 2013.

Epstein, Jean. *Le cinématographe vu de l'Etna* (1926). In *Écrits sur le cinéma*, volume 1, 131–52. Paris: Seghers, 1974.

Ernst, Max. *Écritures*. Paris: Gallimard, 1970.

———. *La Femme 100 têtes*. Paris: Éditions du Carrefour, 1929.

———. *Rêve d'une petite fille qui voulut entrer au Carmel*. Paris: Éditions du Carrefour, 1930.

———. *Une semaine de bonté ou Les sept éléments capitaux: Roman*, 5 volumes. Paris: Jeanne Bucher, 1934.

Goldfayn, Georges. 'Cinéma anémique'. *Le Surréalisme, même*, no. 1 (1956): 155.

Hamus-Vallée, Réjane and Caroline Renouard. *Superviseur des effets visuels pour le cinéma*. Paris: Eyrolles, 2016.

Jacobs, Steven. *Framing Pictures: Film and the Visual Arts*. Edinburgh: Edinburgh University Press, 2011.

Krauss, Rosalind E. *The Optical Unconscious*. Cambridge, MA: MIT Press, 1994.

Lemaître, Henri. *Beaux-arts et cinéma*. Paris: Cerf, 1956.

Maillet, Arnaud. 'Du panorama au cinéma: l'image mobile'. In *Le panorama, un art trompeur*, edited by Jean-Roch Bouiller, Ségolène Le Men, Laurence Madeline, and Giusy Pisano, 127–39. Villeneuve d'Ascq: Presses universitaires du Septentrion, 2019.

Michaud, Philippe-Alain. 'Le Film fait exposition'. In *L'exposition d'un film*, edited by Mathieu Copeland, 7–18. Dijon: Les Presses du réel, 2015.

Paz, Octavio. 'Le poète Buñuel'. *L'Âge du cinéma*, no. 3 (1951): 26–29.

Ramond, Sylvie, and Matthew Affron, eds. *Joseph Cornell et les surréalistes à New York: Dali, Duchamp, Ernst, Man Ray...* Paris: Hazan, 2013.

Richter, Hans. 'Peinture et film'. *xxᵉ siècle*, no. 12 (1959): 25–28.

Smith, Douglas. 'Moving Pictures: The Art Documentaries of Alain Resnais and Henri-Georges Clouzot in Theoretical Context (Benjamin, Malraux and Bazin)'. *Studies in European Cinema* 1, no. 3 (2004): 163–73.

Spies, Werner. *Max Ernst, Les collages: Inventaire et contradictions*. Paris: Gallimard, 1984.

———. *Max Ernst–Loplop: L'artiste et son double*. Paris, Gallimard, 1997.

———, ed. *Max Ernst, Une semaine de bonté: Les collages originaux*. Paris: Gallimard, Musée d'Orsay/Madrid: Fondation MAPFRE, 2009.

———, Sophie Join-Lambert, and Julia Drost, eds. *Max Ernst, Le jardin de la France*. Cinisello Balsamo: Silvana Editoriale, 2009.

Susik, Abigail. '"The Man of These Infinite Possibilities": Max Ernst's Cinematic Collages'. *Contemporaneity: Historical Presence in Visual Culture*, no. 1 (2011): 61–87.

6

The uncontrollable in art: the Second Situationist International on freedom, Freddie, and film[1]

Mikkel Bolt Rasmussen

As is well known, the Situationist International had an antagonistic relationship with cinema. As Guy Debord put it in the 1978 film *In Girum Imus Nocte et Consumimur Igni*, 'the cinema, too, must be destroyed'.[2] Debord and the Situationists argued consistently that both commercial and experimental cinema in their existing forms were in need of destruction. Cinema had to be unmade in order to make room for a completely different cinema, that did not partake in the spectacle in which 'all that was once directly lived has become mere representation'.[3] Following the split in the Situationist International in 1961, Debord's group did not engage in filmic activity of any kind, preferring instead to commit itself to a radical critique in writing of the film medium.

It is perhaps less well known that this was not the only Situationist stance on cinema. After the split in the Situationist organisation, the Danish artist Jørgen Nash established a rival Situationist group that operated under different names, from the Second Situationist International to Situationist Bauhaus to the Drakabygget movement. The two Situationist factions that emerged from the split in 1961 shared a belief in the necessity of liberating art but differed considerably when it came to the proper use of art and cinema. Together with the Danish art critic turned artist, film director, and provocateur Jens Jørgen Thorsen and other Danish, Swedish, and British artists, Nash not only made a number of films from 1962 onwards but also organised several experimental-film festivals. At these festivals, Nash and his cohorts screened not only their own films but also contemporary experimental films from both Western and Eastern Europe and the United States, as well as older avant-garde films, most notably by the Danish Surrealist Wilhelm Freddie, whom Nash and Thorsen held in great esteem.

A closer look at Nash and Thorsen's use of the medium of film enables us to revisit and expand the analysis of the relationship between surrealism and the Situationist International. As I will show, the Scandinavian Situationists did not only abstain from any direct critique of surrealism, but actively

sought to ally themselves with Freddie. They perceived the older surrealist painter to be a contemporary rather than a historical (and thus 'superseded') artist provoking a timid bourgeois public sphere. Nash, Thorsen, and Freddie were in fact allies in the eyes of the younger Situationists. As will thus become apparent, not all Situationists gave up on film and not all Situationists distanced themselves from the surrealist predecessors, seeking instead collaboration with them.

The Situationists against film

As Thomas Levin, Pino Bertelli, Fabien Danesi, and others have shown, Debord and the First Situationist International subjected the practice of filmic representation to critical investigation, expanding the critique of film as a medium and as a particular mode of cultural reproduction of capitalist society into an all-inclusive critique of what the Situationists termed the 'spectacle commodity economy'.[4] Film was being used to consolidate the spectacle, and the Situationist aim to liberate film needed to deploy cinema against cinema. This meant experimenting with anti-films and showing how genuine historical film was an impossibility in the spectacle, but it primarily meant developing a ruthless critique of the medium of film and engaging in virulent attacks on contemporary so-called avant-garde film-makers such as Julien Duvivier, Federico Fellini, Alain Resnais, and Jean-Luc Godard.[5]

For Debord and his small vanguard, the filmic medium needed to be attacked. It fostered passivity; it was a staging of separation. But for them the medium also gestured towards a different kind of cinema which expressed historical necessity and abolished the separation between theory and practice. If this kind of creative expression succeeded, art would reveal itself to be part of a historical process that showed it was impossible to create anything new *as art*. What remained was a kind of radical critical residue, the avant-garde *effect*.[6]

Nash and Thorsen took a much more experimental and open approach to cinema, seeking to use the medium of film to attack what they perceived to be a sterile bourgeois society. Film was an important medium in the fight between free art and a strait-laced, repressive society that sought to limit the freedom of art, and it would be foolish to renounce and abandon it. All artistic instruments were to be used. It was not primarily a question of critiquing the medium of film and showing film's damaged nature, but of liberating art's potential in a narrow-minded society in the here and now. The task was to provoke a timid bourgeois public and activate audience members in order to turn them into co-creators of their own lives: 'Take control of your own life!'[7] Both films and film festivals were a means to that end.

The split

While the history of the First Situationist International is by now fairly well known, the history of the rival Second Situationist International has received less attention. The group was established as a result of the split in the Situationist group, following disagreements over how to deal with the publication of the seventh issue of the German Gruppe SPUR's journal in January 1962.[8] A majority of the central committee argued that Gruppe SPUR was using Situationist ideas to succeed in the art market and thus had to be thrown out of the Situationist group. Other members of the central committee – among them Jørgen Nash – disagreed.

The majority moved quickly, excluding Nash as well. He was a 'falsifier' who not only lied about SPUR's exclusion – according to Debord and the others, Nash voted in favour of the exclusion but then changed his mind afterwards – but he had also attempted to use the Situationists' ideas in order to 'arrive' as an artist himself.[9] Nash thus represented a much wider problem involving the role and use of art, an issue that had been debated at the two previous conferences in London in 1960 and Gothenburg in 1961, in which it was decided that there could be no such thing as a Situationist artwork.

During the conference in Gothenburg, Raoul Vaneigem had set forth the complex Situationist stance on art, arguing that 'traditional' modern art was no longer possible as a critical gesture.[10] Only insofar as the entirety of society was reconstructed could 'separate' art be renewed, becoming a kind of post-artistic explosion that united theory and practice. Under capitalist rule, art could at best be a reified expression of a previous radical gesture: modern art had come to an end. With the defeat of the proletarian uprising in the early 1920s, the conditions of possibility of modern art had disappeared, and art had since been capable only of consolidating ruling tastes. Situationists were free to create critical personal 'non-Situationist' artefacts, Vaneigem said, but it was important that these artefacts were not regarded as Situationist art. There was no Situationist art.

Nash and Gruppe SPUR objected to Vaneigem's argument. They argued that it was precisely in art that the Situationists were able to articulate a critique of present society, and that it was in the art milieu that the Situationists had made important advances, establishing contact with experimental artists across Europe. They were sceptical of the way in which Vaneigem embedded Situationist theory in Marxism, referring to the proletariat as a potential class-of-consciousness and as the revolutionary subject in waiting. According to Nash and SPUR, the proletariat had become integrated into the new welfare society and had thus lost its historical agency. It was through art – the last vestige of freedom – that the Situationist project could be set in motion and ultimately realised. As we can see in retrospect, both factions

wished to realise art, but they differed when it came to the means and the analysis of the necessary preconditions. The group that gathered around Debord and Vaneigem argued that it was necessary to negate art because it was just another expression of how the capitalist mode of production separated proletarians from one another and rendered them passive.

The dissenting artists also sought to realise art but did not understand why it would be necessary to revive a Hegelian-Marxist vocabulary concerning the proletariat. Art was still *the* resource. The artists were also critical of the institutionalisation and commercialisation of art in post-war Europe, but they did not wish to relinquish the creativity of art. Art was not dead.[11] Instead of basing their sense of revolutionary possibilities on the ability of the proletariat to revolt, the artists wished to realise art in the here and now, transforming audience members into active participants. According to Nash and Thorsen, 'the essential in Situationism is the relationship of human beings to the forces of creativity; it is the intention to realise these forces through moments of creativity. The Situationist idea is based on the use and the forces of creativity directly in the social environment.'[12] They thus insisted on free use of artistic means of expression and new modes of symbolic production. The revolution will begin in art. Artists should seize power and take over the means of symbolic production, realising art and thereby liberating the aesthetic energy with which humans are equipped. Everybody should become an artist.

The new society and the obsolescence of Marxism

This had been Nash's position all along. As he put it in a 1959 article: 'It seems that art and poetry is in fact the last unique stimulus in social life.'[13] Nash was sceptical of the line that Vaneigem had advanced at the conference in Gothenburg and did not subscribe to what he perceived to be a more political and theoretical turn in the Situationist group. The Situationist International was an art group, not some kind of political vanguard. Nash regarded the coming into being of the Scandinavian welfare societies in this period as an erosion of Marxist theory and practice, and he drifted towards anarchism, describing his practice as anarcho-Situationist. While Debord was reading George Lukàcs' highly speculative Hegelian-Marxist works from the 1920s and participating in meetings with the Trotskyist Socialisme ou Barbarie group, Nash was much more aligned to a kind of anarchist modernism where art should be realised here and now in spontaneous transgressions in which the artist transformed the audience into participants.

In Denmark and Sweden, where Nash was active, class struggle seemed to be in the process of gradually being replaced by a new class compromise in

which the working class was integrated into the state, leaving art – and, more specifically, the artist – as the only genuine oppositional force. Nash wrote in 1959:

> Especially in welfare society where social security and insurance benefits are the great political show act, especially in this society must the artist or, as I prefer to call him, "the art creator" become the one who looks without compromise for the adventurous amidst a time-stamped and automated everyday life and disrupts the common man's pious belief in finished goods from the aesthetic canned food industry.[14]

In the new society that was coming into being, the 'art creator' was the true revolutionary, capable not only of provoking an ever more passive audience but also of activating the audience and turning them into co-creators of a new life filled with new myths. Nash refused to give up on art.

But the new society was not only a welfare society in which the proletariat had been absorbed by the capitalist state; it was also a consumer society in which art was being transformed into readymade aesthetic experiences. The art creator opposed this expanded design process by expressing himself. Art was a vital force that should be deployed in 'practical experiments' in the here and now – a kind of actionist prank. As Nash put it:

> It has always been the role of art to materialise human needs and desires in sensual form. A man driven by his passion is an amateur, a lover and a hater. Either the artist is an amateur, driven by his burning wish for expressing himself, or else he is not an artist at all. If art is reduced to a craft or a profession, as we have seen with many well-oiled entertainment machines, then art no longer exists.[15]

For Nash, art was an expression of a basic human playfulness and had nothing to do with design or art as a specialised activity. Art was variation and play and thus challenged the means-to-an-end rationality of modern capitalist society. Confronted by a society characterised by the industrialisation of culture and the commodification of desire, it was important to experiment without predetermined goals and to be playful without any notion of use value or surplus value. Art was an aesthetic surplus,[16] and the role of the art creator was to set up experimental situations that liberated art's playfulness, activating the audience. 'It should be a human right to not always be an extra in the production process and a spectator after work,' Nash stated.[17] The goal was universal participation. Nash and his cohorts were thus critical of the First Situationist International's retreat from practical experiments and its embrace of what Nash perceived to be a totalising unified theory. 'We intend to produce our theories after the event,' he said.[18] The Situationist project could not be the elaboration of a single conceptual, vanguardist ideology. It had to focus instead on practical experiments in the here and now.

The freedom of art

Nash did not delay in responding to the exclusion. He immediately established a rival Situationist group, in which he was joined by Ansgar Elde and the Swedish painter Hardy Strid, who had both been members of the Situationist group, as well as Thorsen and poet Gordon Fazakerley, and various other artists, musicians, and bohemians.[19] Nash had the year before acquired a farm in southern Sweden, partly financed by Asger Jorn. The farm was turned into an artistic community called Drakabygget (the Dragon's Inn). Nash described Drakabygget as a 'house of freedom for the international avant-garde'.[20] From here, Nash and his new Situationist group launched a breathtaking number of 'practical experiments'. They mounted exhibitions in galleries across Scandinavia and staged provocative performances in several cities in Denmark and Sweden, attacking what they perceived to be the two countries' sterile and repressive cultural policy. 'We want to create new rituals. Rituals are human thinking shaped in social patterns. Every cultural pattern is a ritual … This is the first time it has been said to the audience: Come and join us. Get down to it. Everybody has right of appeal,' they argued.[21] The usual contemplative gaze at the artist's creative gestures was to be replaced by active co-creation. The individual work of art was to be replaced by a collective, cultic performance. An exhibition in a gallery in Copenhagen in December 1962 in which the audience was asked to help create a huge collage in the exhibition space continued in the streets, where the artists and those who joined them painted slogans on walls and hoardings. Nash and Thorsen were arrested by the police during the performance.[22] They considered this to be a perfect example of not only the repressive nature of capitalist society but also the transgressive power of art. 'The modern art that is of importance today is opposed to the authorities and is becoming ever more anti-authoritarian,' Nash wrote triumphantly in the first issue of the journal *Drakabygget* from 1962.[23]

This was the primary conflict in modern society, according to the two art creators, Nash and Thorsen. That art was a transgressive power was confirmed to Nash and Thorsen by a number of court cases and scandals in the early 1960s, in which artists and writers were accused of blasphemy. These court cases made it important to Nash and Thorsen to defend the freedom of art as well as to test the limits of a fairly narrow bourgeois public sphere. The more repressive the authorities showed themselves to be in the various national contexts, the more they confirmed the Scandinavian Situationists' notion of art as a radical transgressive force. Art was a way of provoking the authorities and a timid bourgeois public.

If the First Situationist International recoiled from the recuperative light of the spectacle, the Drakabygget movement basked in the attention of the

media. The bigger the scandal the better. The media was the battlefield. Instead of trying to escape and become 'angels of purity', like Debord, the Scandinavians Situationists sought to work the media, quickly creating scandals that would provoke reactions.[24] Nash and Thorsen often worked together with journalists from Danish and Swedish newspapers in order to get attention and cause a stir. When Thorsen walked around in Odense as Jesus Christ, carrying a large cross in connection with the opening of the 'Seven Rebels' exhibition in 1962, he himself called a photographer from the daily paper *Information*, ensuring that his performance did not go unnoticed in the press. Nash and Thorsen were shrewd operators and did not care about notions of authenticity or artistic copyright, producing fake Jorn paintings, blackmailing gallerists, and cheating colleagues.[25] They sought to scandalise both the established art institution as well as the broader public sphere. The goal was to liberate the spectator from his or her passive role as a consumer of dull representations. Nash described this practice as 'spiritual anarchism'.[26]

The First Situationist International's Hegelian-Marxist philosophy of history and the idea of the proletariat as the subject of history was thus replaced by a much looser and more open-ended anarchism that stressed a kind of actionist realisation of art through pranks and provocations in and through the media.[27] Nash and Thorsen believed in the possibility of shocking the bourgeois public sphere and mobilising young people. The primary opposition in post-war welfare society was that between, on the one hand, free art, and, on the other hand, a repressive bourgeois morality and new consumer aesthetics that turned art into design.

The trial against art

The legal prosecutions against various artists in the early 1960s were of great importance to the anarcho-Situationist Nash and Thorsen.[28] The trials showed that art was a subversive power capable of shaking sterile and boring bourgeois existence, liberating people from existence as extras or spectators. Art should enter into battle against bourgeois culture, the entertainment industry, and technology, creating a new world. It was thus foolish to abandon art, as the First Situationist International did. Art was the playing field the Situationists had to occupy. The programme was to liberate art or free the energy and creativity that lay dormant in art.

Gruppe SPUR was charged with blasphemy in December 1961. The sixth issue that triggered the confiscation of the entire run of the journal had been created during a stay at Drakabygget in the summer of 1961. The issue was titled 'SPUR im Exil' as a defiant reaction to rumours that the authorities

had considered confiscating the fifth issue. When the new issue arrived in Munich, it was confiscated by the local authorities, who charged the group with desecrating religion. The perceived opposition between experimental art and conformist West German society came to a head with the court case. Like Nash and Thorsen, the Gruppe SPUR collective had positioned itself in opposition to the authorities and to what the group perceived to be the ruling taste of a bourgeois post-Nazi German society: 'Once the world is turned into a gigantic sea of ruins, the search for experimental forms of life can enter a creative phase.'[29] The fourth issue had tellingly been titled 'Die Verfolgung der Künstler' (The Persecution of the Artist). In May 1962, in the District Court in Munich, SPUR was charged with heresy, blasphemy, and the dissemination of obscene publications. The defendants received jail sentences, and all confiscated copies of SPUR were to be destroyed. The artists appealed the verdict, and, during the second court proceeding, several art critics and writers testified in defence of SPUR. In the end, Heinrad Prem, Dieter Kunzelmann, and Hans Peter Zimmer were sentenced to five months' probation while Helmut Sturm was found not guilty.[30]

The SPUR trial was important to Nash and Thorsen, but it was just one among several cases where post-war society tried to repress art and limit the freedom of art, which Nash and Thorsen cherished so much. In the same year in which SPUR became entangled in the court case in West Germany, the publication of Henry Miller's *The Tropic of Cancer* led to over sixty obscenity lawsuits in more than twenty-one states in the United States. Pennsylvania Supreme Court Justice Michel Musmanno famously described Miller's novel as 'not a book. It is a cesspool, an open sewer, a pit of putrefaction, a slimy gathering of all that is rotten in the debris of human depravity.'[31]

But it was not just in West Germany and the United States that the authorities had it in for art. In November 1961, the Danish police confiscated three artworks by Wilhelm Freddie at an exhibition opening at Galerie Köpcke in Copenhagen.[32] The three works were copies of originals that had been confiscated by the police back in 1937.[33] By the early 1960s, Freddie was the grand old man of Danish surrealism, who had served jail time on account of his provocative art. Freddie was in his 50s in the early 1960s, but he was still pulling pranks and deliberately sought to confront a timid Danish cultural public sphere. An eager Danish press reported daily from the proceedings against Freddie the following year. The extravagantly dressed Freddie, whose ultra-slim signature moustache became his calling card, won the case. The police released his artworks, the copies as well as the originals.

Jens Jørgen Thorsen wrote with admiration about Freddie's artistic practice in the 1967 article 'Wilhelm Freddie: frihedens store alkymist' (Wilhelm Freddie: The Great Alchemist of Liberty): Freddie had 'expanded surrealism into an integrating force that had a direct effect on its own time, on the

material level of reality', and so 'the liberty that Freddie manifested ... [was] identical with the struggle of a whole era for cultural freedom'.[34] Freddie was a beacon for Nash and Thorsen, a perfect example of an art creator who was not afraid to shock and provoke. Freddie's surrealism thus served as an important precursor to the practical experiments in which the Scandinavian Situationists engaged. While Debord and the First Situationist International were busy distancing themselves from the Parisian surrealist movement, both in its historical and post-war versions,[35] Nash and Thorsen had a much less hostile attitude towards surrealism. They not only referred to the surrealist movement in the 1920s as an important precursor but also staunchly defended and praised Freddie.[36] As Thorsen wrote, Freddie had been able to transgress the boundary between the art institution and everyday life as had no other surrealist. Breton and his Paris-based comrades had not succeeded in causing big scandals, but, Thorsen wrote, Freddie had managed to do so several times. Freddie thus practised cultural freedom like no other.[37]

The early 1960s trials against contemporary art, targeting Wilhelm Freddie, Henry Miller, and Gruppe SPUR, proved to Nash and Thorsen that art was an exceptional means of introducing a new anarchist ethics into society. This repression testified to the fact that the authorities were afraid of free art. The battle lines were clear: a culturally conservative society fought against aesthetic freedom. There is no doubt that certain segments of Western society were indeed hostile to the bohemian lifestyle and anarchist experiments of the Second Situationist International and the artists with whom they aligned themselves. The force of the 'normal' was overwhelming in Scandinavia and the West in the early 1960s, and Nash, Thorsen, and the artists associated with the Second Situationist International vehemently fought prevailing sexual and moral norms, deliberately seeking to provoke a reactionary cultural public sphere and the authorities. Nash and Thorsen considered themselves to be part of a nonconformist cultural offensive. The art creator was a revolutionary.

Drakabygget's cinematic offensive

Following the split in the Situationist International, the First Situationist International limited its interaction with cinema to analyses of what it found to be deficiencies in the use of the cinematic medium in contemporary film. Nash and Thorsen for their part had no problem making films and setting up film festivals. Film was just another medium that the art creator could use in the battle against a boring and repressive society. Giving up on film was a mistake, and Nash and Thorsen argued that the task was to intensify

practical experiments of the kind in which Debord had engaged in his 'anti-Situationist' films, made before the split in the Situationist group. The year before the split, Nash had been involved in making the third film produced by the Danish-French Experimental Film Company, funded and financed by Asger Jorn. The first two productions had been Debord's *On the Passage of a Few People through a Rather Brief Moment in Time* (*Sur le passage de quelques personnes à travers une assez courte unite de temps*) from 1959 and *Critique of Separation* (*Critique de la séparation*) from 1961. The Danish-French Experimental Film Company's third film was the 1961 fifteen-minute-long, 16 mm, black-and-white *So ein Ding muss ich auch haben* (*Such a Thing I Also Need*), a collaborative creation of Nash, the Danish artist Albert Mertz, and Gruppe SPUR. The film was shot in Munich and portrayed a family of three – the typical nuclear family with a father, mother, and small child. The parents, wearing masks, have tied the child to the balcony of their apartment. To the irritation of the father, the child keeps throwing a ball down into the street. The father does not want to play but has to fetch the ball repeatedly. The film consists of shots of the family and scenes of dreary urban life, with people walking robot-like up and down the streets of Munich. The sadness and monotony of the German post-war bourgeoisie is juxtaposed not just with the child who wants to play, but also with Gruppe SPUR and Nash, who appear in the film running through the streets. The artists are wearing masks and they play around, breaking through the film's credits with an umbrella. The film establishes a crude opposition between play and the repressive rational bourgeois existence of the German *Wirtschaftswunder* (economic miracle). The soundtrack consists of scores by Jean Dubuffet and Jorn, played on toy instruments. The film ends with the artists wearing prison numbers on their clothes and passers-by pulling guns from their pockets, foreshadowing a civil-war-like situation in which creativity clashes with conformity.

The following year, Nash, Thorsen, and Gruppe SPUR worked on a sequel, *Aus Westdeutschland Nicht Neues* (*All Quiet on the West German Front*), which was, however, never completed. In 1963, Thorsen collaborated with Danish poet and film director Jørgen Leth and film photographer Ole John to create a twelve-minute minimalist film portrait of the American jazz pianist Bud Powell, called *Stop for Bud*.[38] During the first eight minutes, we see Powell walking around in Copenhagen and by the city's harbour, accompanied by the sound of Powell playing his piano. It is just Bud and his music, but they are separate: sound and image are two different things. Leth would go on to fine-tune the reduced documentary format with films showing Warhol eating a burger and the Paris–Roubaix bike race. Thorsen was more interested in cinema as an event in which something happened, as a situation in an actionist Situationist sense, with audience members becoming active

participants in contesting authorities and institutions. As Thorsen and Nash laconically put it: 'To turn a person into a spectator is to cut off his balls.'[39]

Thorsen made a number of films in this period. In 1969, he turned Miller's *Quiet Days in Clichy* into a full-length feature film, but in the early and mid-1960s he created more experimental short films. *Do You Want Success?* from 1963 consists of clips from an old colour advertising film for the hair gel Brylcreem. Thorsen repeats the advertising taking place in a speedboat, with three smiling women admiring a cool-looking, Brylcreem-glistening man, but he turns the commercial inside out, destroying its persuasive qualities. He reused the Brylcreem material in later films, including *Tom, Empty, Vide, Leer* from 1966, which consisted mainly of clear film but also very short clips of found footage, such as the Brylcreem commercial, scenes from a football match, and clips from Thorsen's 1965 film about the Danish painter Paul Gadegaard's decoration of a shirt factory in Herning. The soundtrack consists of short snippets of chopped-up spinet music. Thorsen used repetition and the confrontational effect of ultra-short clips in *Fotorama*, from 1960–64, which also consisted of found footage; and he painted on the film reel – for instance, a black dot on the footage from a football match (Figure 6.1). In other films, he experimented with still images: *Viet Nam* from 1969 consists of just one image of a dead Vietnamese man with a bullet hole in his forehead (Figure 6.2). The soundtrack was 'The Internationale' and the US national anthem. *Viet Nam Nam* was another montage film from 1969, composed of clips of various heads of state, ending with an exploding image of Ho Chi Minh.

Figure 6.1 Jens Jørgen Thorsen, *Fotorama*, 1960–64

Figure 6.2 Jens Jørgen Thorsen, *Viet Nam*, 1969

In a sense, the festivals that Nash and Thorsen organised were the real cinematic experiments or situations they wished to create. The individual film was less important than the cinematic experience as an expanded process in which projected images and sound created a kind of proto-installation, blurring the established roles of director, actor, and spectator. Nash and Thorsen often projected several films at once, both in order to experiment with the interplay between the films but also in order to create an encompassing cinematic atmosphere of play and transgression.[40]

In 1964 and 1965, Nash and Thorsen organised five film festivals in Sweden and Denmark with the motto 'The film-maker as professional amateur'. They screened both their own films and contemporary experimental films by directors such as Chris Marker, Witold Leszczynski, William Klein, and Yōji Kuri. The festivals were presented as a continuation of the battle for free art against both censorship and the commercialisation of film.

> The only reason we get involved in this kind of huge event is that we want to fight the commercialisation and state control of film art. We want to contribute to the creation of a better intellectual climate that gives the film artist the opportunity to make films that are different, films that break down the moral prejudices and anaemic boundaries between life and art. We acclaim the principle of the trioletic: the film-maker as professional amateur. And since these 'Anarcho-Situationist' film festivals produce no financial benefits for us in terms of our own film production but only saddle us with enemies among the funding cultural authorities, the prize-awarding judges in the tower blocks of art, the cavalry of officialdom, the parade horses, and the film academies, not to mention the film police with their lynch mob censorship – we have long since signed Jonas Mekas' manifesto in *Film Culture*: 'It is the duty of the artist to ignore bad laws and fight them every moment of his life.'[41]

As with many of Nash's and Thorsen's practical experiments, the film festivals quickly resulted in scandal. Thorsen had, in collaboration with Novi Maruni and Niels Holt, made a short film called *Pornoshop* that juxtaposed images from commercial pornographic movies and stills from pornographic magazines with shots that showed sex in a less commercialised manner. The contrast between the two kinds of sex images was too much for the Swedish authorities, which confiscated the film reel when it was shown in Halmstad.[42] 'Worse than anything else. Swedish protest storm against Danish intercourse film' ran a headline in the Swedish daily *Expressen*. 'Sickening, far beyond decency, really disgusting, surpassing everything shown publicly, shoddy, sad. These are just some of the reactions to the film.'[43] Nash and Thorsen used the confiscation to great effect and quickly announced film festivals in several Swedish and Danish towns, using the media to create a stir. By announcing a festival in Silkeborg, Thorsen prompted journalists to call the local cinema, which, as expected, refused to host the festival and screen *Pornoshop*. This was an effective way of turning the conflict between free art and a repressive public sphere into a dramatic representation. In a final attempt to actually screen *Pornoshop* and circumvent Danish film censorship, Thorsen set up a film club at Borup Folk High School in Copenhagen, allowing club members to see the film. This was the only context in which unrated films could legally be shown in Denmark at the time. 'We declare war on Danish film censorship. They probably say that Danish film censorship does not censor. Why not just end it then? The official censorship does not even prevent the commercial film but instead strives to render the uncontrollable film art illegal.'[44]

Nash's and Thorsen's admiration for surrealism and especially for Freddie was also evident in the film festivals, which included both of Freddie's films: *The Definitive Rejection of the Request for a Kiss* (*Det definitive afslag på anmodningen om et kys*) from 1949 and *Eaten Horizons* (*Spiste horisonter*) from 1950. Both films are short – one and a half minutes and four minutes long respectively – but are filled with surreal juxtapositions and mesmerising scenes that reject any kind of easy narration or 'meaning'. The first film shares its title with a painting by Freddie from 1940 of close-ups of five female mouths in a line against a black background. The first mouth is closed, the second is half open, the third is wide open, the fourth seems to be screaming with the tongue hanging out, and the fifth is closed. The film too is centred on a female mouth. The first shot is a close-up of a mouth, in which the tongue begins to move, as if searching for something. The screen goes black, and then we see the face of man (Freddie) rolling his eyes. After a moment, there is some noise, followed by a woman's scream, then some inaudible swearing in Danish.

Freddie's second film contains more scenes and playful set-ups but is also a strong visualisation of oppositions and transformations. The main character is a piece of bread, which appears and disappears in a number of scenes.

The bread first appears under the bare foot of a man sitting at a café table, and this is juxtaposed with a lava- or excrement-like substance that two men are eating from the inside of a female body, thereby uncovering the bread inside the body. This scene is followed by one in which a ball is bouncing inside a closed white room, where the heads of smiling children appear. In the final scene, the bread appears again and is cut in two, revealing a lava-like substance within.[45] Freddie's puzzling films were much to the liking of Thorsen and Nash, especially in their refusal of any easily identifiable meaning and in their sexually loaded motifs. As Thorsen put it, in Freddie's art 'magic explodes all frames'.[46] Although Thorsen and Nash themselves preferred to engage in much more clear-cut critiques of cultural and political authorities, they were inspired by Freddie's experimental and sexually charged visual language and saw his magic transformations and rejection of easy interpretations as a perfect expression of the playfulness of art. It was this very playfulness that they sought to liberate and let loose in everyday life.

In comparison to Freddie's visually complex art, Nash's and Thorsen's practical experiments were much more direct. The two Scandinavian Situationists were less interested in subtle aesthetic effects and preferred to cause a stir and provoke, even if it meant giving up on an idea of the openness of the individual artwork. Putting into practice the playfulness of art was the paradoxical art-political programme to which they dedicated themselves, even if this meant turning art's playfulness into pornography and crude attacks on authorities. For Thorsen and Nash, pornography was a means of provoking a bourgeois public sphere, of sparking a battle for an anarchist life in which people could finally truly live and not just survive.

The battle against the authorities was the most important thing for the Scandinavian Situationists. If Freddie and his art possessed a sphinx-like quality, Nash and Thorsen were much more explicit and did not ty to conceal anything in their attacks on local cultural authorities. This can be taken quite literally in the case of Thorsen, who began painting naked (including painting with his penis) in public as well as posing as a naked Jesus Christ carrying a large cross.[47] The censored artist creator became a haunted Jesus Christ, seeking to destroy the narrow-minded moralism of a complacent bourgeoisie. The fight against censorship was a fight for freedom: artistic freedom came to stand for sexual and political freedom, too.[48] When Thorsen and Nash organised a large procession for artistic freedom through the main street in Copenhagen in 1965, the Swedish artist Carl Magnus carried a large sign around his neck with the text 'Artistic freedom has no moral boundaries'.[49]

Freddie's playful conflict with the authorities in the 1930s and in 1962 was thus part of the same struggle the anarcho-Situationists were fighting. To Nash and Thorsen there was a clear continuity between surrealism and the Situationists, and they were fighting alongside Freddie against a

reactionary bourgeoisie. This lesser-known Situationist stance is markedly different from that of Debord and the First International, who considered surrealism to be hugely important but, in accordance with their Hegelian-Marxist conception of history, a thing of the past. Dada and surrealism had to be superseded by a new cultural front that could not take the form of art in any kind of limited sense. Only the proletariat could realise poetry.

Exit or actionism

The First Situationist International considered itself to be active at the end of modernism, conceiving its practical critique as '*enfants perdus*' in the sense of an art of war, meaning class war in a specific historical situation of secular crisis, following the first efforts and defeats of the proletarian revolution. The Drakabygget movement, on the other hand, retained the role of the artist and sought to critique the new phase of capitalist commodification with artistic experiments and media stunts that attacked specific targets of power and cultural authority. Nash and Thorsen practised an actionist anarchist version of the Situationist project in which they sought to stimulate people into taking part in guerrilla actionist pranks, turning audience members into artists and liberating the creative forces of art in everyday life. The anarcho-Situationists were not afraid of becoming 'a spectacle of refusal', and Nash and Thorsen were more than willing to take this risk. They had no time for long theoretical discussions or Marxist analyses of spectacular capitalist reproduction. The revolution was to take place in the here and now, with the art creator as a kind of impatient and crazed stage director who had no boundaries. Film was less to be destroyed through a revolutionary critique than put to use as a particularly potent medium for provocation, with its capacity to juxtapose pornography and advertising imagery, shocking a timid bourgeois audience and convincing them of the necessity of a new world.

Notes

1 I dedicate this article to the late, great Danish film historian Carl Nørrested, whose article 'The Drakabygget Films' remains the go-to essay on the topic of Drakabygget's cinematic experiments.

2 Debord, *In Girum Imus Nocte*, 190.

3 Debord, *Society of the Spectacle*, 12.

4 Levin, 'Dismantling the Spectacle', 72–123; Bertelli, *Guy Debord*; Danesi, Flahutez, and Guy, *La fabrique du cinéma de Guy Debord*.

5 See the following texts originally published in the journal *Internationale Situationniste*: 'Cinema after Alain Resnais'; 'Sunset Boulevard'; 'The Role of Godard'; 'Cinema and Revolution'.

6 As Guy Debord explained in a letter to Robert Estivals, the avant-garde 'carries in itself the victory *of its criteria of judgment* against the era (that is to say, against official values, because the avant-garde exactly represents this era from the point of view of the history that will follow it)'. Debord, 'Guy Debord to Robert Estivals', March 1963.

7 Thorsen, 'Opråb på Documenta 5', 29.

8 For a nuanced account of the split, see Slater, 'Divided We Stand', 1–48.

9 'Proclamation from the First Situationist International' [1962], ibid., p. 75.

10 See the report of the conference in 'The Fifth SI Conference in Göteborg'.

11 As Thorsen put it: 'The commuicative phase of art is not its death. Not at all. But the expansion of art.' Thorsen, 'Kunstens kommunikative fase', 74.

12 Nash and Thorsen, 'Co-Ritus Interview', 206.

13 Nash, 'Lignelsen om det moderne menneske', 46.

14 Nash, 'Kunstskaberen og demokratiet', 58.

15 Ibid., 57.

16 Nash was heavily influenced by his older brother Asger Jorn's theory of vandalism and the potential of creativity to create new social relationships through art. Nash could in a sense be seen to more directly and openly embody the idea of creative vandalism, always transgressing, even on a personal level, provoking friends and collaborators. For an account of Jorn's ideas concerning art, see Shield, *Comparative Vandalism*.

17 Nash, 'Lignelsen om det moderne menneske', 45.

18 Nash et al., 'The Struggle of the Situcratic Society', 94.

19 For a presentation of Nash's activities, see the only biography of Nash so far: Morell, *Poesien breder sig*. Nash himself gives an account of the practice of the Second Situationist International in a number of texts, including 'Who Are the Situationists?', 228–31. Jakob Jakobsen has provided the most comprehensive presentation of the Drakabygget movement in 'The Artistic Revolution: On the Situationists, Gangsters and Falsifiers from Drakabygget', 215–75. See also Bolt Rasmussen, 'Raping the World in a Warm Embrace of Fascination', 585–602.

20 Press release by Nash from 1961 quoted by Jakobsen, 'The Artistic Revolution', 230.

21 Thorsen, Nash, and Strid, 'CO-RITUS Manifesto', 125–6.

22 See the collection of newspaper clippings in Fjord and O'Brien, *Situationister 1957–70*, n.p.

23 Nash, 'Den som dør af skræk skal begraves i rendestenen', 61.

24 Kaufmann, 'Angels of Purity', 49–68.

25 For an account of the way in which Nash raised money to run Drakabygget and finance his activities, see the conversation between Fazakarley and Jong, 'Drakabygget', 114–28.

26 Nash, 'Dantevandring', 242.

27 In a sense, Nash and Thorsen's actionist Situationism was closer to something like the Yippies' and Abbie Hoffman's media interventions than to Debord's and the First Situationist's iconoclastic stance on film and media. For an analysis of the Yippies' media activism, see Joselit, *Feedback*.

28 Issue 2–3 of *Drakabygget* was largely devoted to the cases against SPUR, Freddie, and Miller, and the opening text by Nash was titled 'Konstens frihet. 5 november 1962' (Art's freedom. 5 November 1962).

29 Gruppe SPUR, 'Atomic Bombs for the Culture Industry', 123.

30 Nash wrote an account of the trial, 'Intet nyt fra Vesttyskland', 97–111. For an account of the circumstances surrounding Gruppe SPUR's trial, see Diedrichsen, 'Verfolgung und Selbstverfolgung', 46–52.

31 Musmano, quoted in Forshaw, *Sex and Film*, 134.

32 Nash and Thorsen met each other for the first time at the opening of Freddie's exhibition in 1962. In this sense, Freddie's surrealism was the common denominator for the two soon-to-be anarcho-Situationists.

33 For an analysis of Freddie's importance to the Danish neo-avant-garde, see Bolt Rasmussen, 'Freddie's Avant-Garde Strategies', 124–35.

34 Thorsen, 'Wilhelm Freddie', 103.

35 See Bolt Rasmussen, 'The Situationist International', 365–87.

36 Nash often critiqued Danish publishing houses not simply for failing to translate Henry Miller's novels but also for locking out 'French surrealist poets from the Danish literary duck pond'. Author's translation. Nash, 'Tale til det Danske Akademi', 69.

37 Thorsen, 'Wilhelm Freddie', 103.

38 In Danish, 'stopforbud' means 'no waiting'.

39 Nash and Thorsen, 'Co-Ritus Interview', 209.

40 See Nørrested, 'The Drakabygget Films', 34.

41 Nash, 'Filmskaberen som professional amatør', n.p.

42 Thorsen claimed to have been tipped off in advance and to have swapped *Pornoshop* with a Donald Duck film, which the police confiscated. See Krarup and Nørrested, *Eksperimentalfilm i Danmark*, 38

43 Nash and Thorsen compiled a scrap book of newspaper articles on their activities, including the film festivals in Fjord and O'Brien, *Situationister 1957–70*, n.p. The quote is from *Expressen*, 15 March 1965.

44 Thorsen, 'Kunst, kusse og kortfilm', n.p.

45 For an analysis of Freddie's two films, see Noheden: *Surrealism*, 34–8; and Richardson, 'The Density of a Smile', 138–47.

46 Thorsen, 'Wilhelm Freddie', 104.

47 For a presentation of Thorsen's life as a transgressive but popular provocateur, see Falbert, *Provo*.

48 For an analysis of Thorsen's attack on censorship and religious authorities, see Gade, 'Liderlighedens fæderland', 17–31.

49 See the photos in Thorsen, *Friheden er ikke til salg*, 14–15.

Bibliography

Bertelli, Pino. *Guy Debord. Il cinema è morto*. Ragusa: La Fiaccola, 2005.

Bolt Rasmussen, Mikkel. 'Freddie's Avant-Garde Strategies'. In *Wilhelm Freddie: Stick the Fork in Your Eye!*, edited by Sven Bjerkhof et al., 124–35. Copenhagen: Statens Museum for Kunst, 2009.

————. 'Raping the World in a Warm Embrace of Fascination: Drakabygget's Anti-Authoritarian Artistic Endeavours'. In *A Cultural History of the Avant-Garde in the Nordic Countries 1950–1975*, edited by Jesper Olsson and Tania Ørum, 582–602. Leiden: Brill-Rodopi, 2016.

————. 'The Situationist International, Surrealism and the Difficult Fusion of Art and Politics'. *Oxford Art Journal* 27, no. 3 (2004): 365–87.

'Cinema after Alain Resnais' [1959], translated by Reuben Keehan. Accessed 18 May 2020. www.cddc.vt.edu/sionline/si/resnais.html.

'Cinema and Revolution' [1969], translated by Ken Knabb. Accessed 18 May 2020. www.bopsecrets.org/SI/12.cinema.htm.

Danesi, Fabien, Fabrice Flahutez, and Emmanuel Guy. *La fabrique du cinéma de Guy Debord*. Arles: Actes Sud, 2013.

Debord, Guy. Guy Debord to Robert Estivals, 15 March 1963, translated by Not Bored. Accessed 18 May 2020. www.notbored.org/debord-15March1963.html.

————. *In Girum Imus Nocte et Consumimur Igni*. In *Œuvres cinématographiques completes, 1952–1978*. Paris: Champs Libre, 1978.

————. *Society of the Spectacle* [1967], translated by Donald Nicholson-Smith. New York: Zone Books, 1994.

Diederichsen, Diedrich. 'Verfolgung und Selbstverfolgung. Die Künstler und ihr "psychischer Mehrwert"'. In *Gruppe SPUR*, edited by Jo-Anne Birnie Danzker and Pia Dornacher, 46–52. München: Hatje Cantz, 2006.

Falbert, Bent. *Provo: Jens Jørgen Thorsen*. København: Politikens Forlag, 2006.

Fazakarley, Gordon, Jakob Jakobsen, and Jacqueline de Jong. 'Drakabygget: A Situationist Utopia or Meeting Place for Displaced Persons'. In *Expect Anything Fear Nothing: The Situationist Movement in Scandinavia and Elsewhere*, edited by Mikkel Bolt Rasmussen and Jakob Jakobsen, 114–28. Copenhagen and New York: Nebula & Autonomedia, 2011.

'The Fifth SI Conference in Göteborg' [1962], translated by Ken Knabb. Accessed 18 May 2020. www.bopsecrets.org/SI/7.conf5.htm.

Fjord, Ambrosius, and Patric O'Brien, eds. *Situationister 1957–70*. Vanløse: Edition Bauhaus Situationistre, 1971.

Forshaw, Barry. *Sex and Film: The Erotic in British, American and World Cinema*. London: Palgrave Macmillan, 2015.

Gade, Rune. 'Liderlighedens fæderland. Noter om pornografiens frigivelse og religions-spørgsmålet'. *Slagmark*, no. 61 (2011): 17–31.

Gruppe SPUR. 'Atomic Bombs for the Culture Industry' [1962], translated by Anja Büchele and Matthew Hyland. In *Cosmonauts of the Future*, edited by Mikkel Bolt Rasmussen and Jakob Jakobsen, 122–3. Copenhagen and New York: Nebula & Autonomedia, 2015.

Jakobsen, Jakob. 'The Artistic Revolution: On the Situationists, Gangsters and Falsifiers from Drakabygget'. In *Expect Anything Fear Nothing: The Situationist Movement in Scandinavia and Elsewhere*, edited by Mikkel Bolt Rasmussen and Jakob Jakobsen, 215–75. Copenhagen and New York: Nebula & Autonomedia, 2011.

Joselit, David. *Feedback: Television against Democracy*. Cambridge, MA: MIT Press, 2007.

Kaufmann, Vincent. 'Angels of Purity'. *October*, no. 79 (1997): 49–68.

Krarup, Helge, and Carl Nørrested. *Eksperimentalfilm i Danmark*. København: Borgen, 1986.

Levin, Tom. 'Dismantling the Spectacle: The Cinema of Guy Debord'. In *On the Passage of a Few People through a Rather Brief Moment in Time: The Situationist International 1957–1972*, edited by Elisabeth Sussman, 72–123. Cambridge, MA: MIT Press, 1989.

Morell, Lars. *Poesien breder sig: Jørgen Nash, Drakabygget & situationisterne*. København: Det kongelige Bibliotek, 1981.

Nash, Jørgen. 'Dantevandring'. In *Standpunkter: 22 danske forfattere tilkendegiver deres holdning til tidens spørgsmål*, 242. Fredensborg: Arena, 1958.

———. 'Den som dør af skræk skal begraves i rendestenen'. *Drakabygget*, no. 1 (1962): 50–61.

———. 'Filmskaberen som professional amatør'. *ÖELAB: Bulletin for Ørestads Eksperimental Laboratorium*, no. 1 (1965).

———. 'Intet nyt fra Vesttyskland: Spurprocessen 1962–66' [1968]. In *Springkniven. Tekster fra kulturrevolutionen*, 97–111. København: Hernov, 1976.

———. 'Kunstskaberen og demokratiet' [1959]. In *Springkniven: Tekster fra kulturrevolutionen*, 56–60. København: Hernov, 1976.

———. 'Lignelsen om det moderne menneske' [1959]. In *Springkniven: Tekster fra kulturrevolutionen*, 42–46. København: Hernov, 1976.

———. 'Tale til det Danske Akademi'. *Drakabygget*, nos 2–3 (1962): 66–72.

———. 'Who Are the Situationists?' [1964]. In *Cosmonauts of the Future*, edited by Mikkel Bolt Rasmussen and Jakob Jakobsen, 228–31. Copenhagen and New York: Nebula & Autonomedia, 2015.

———, and Jens Jørgen Thorsen. 'Co-Ritus Interview: Art is Pop – Co-Ritus is Art – Divided We Stand' [1963]. Translated by Jakob Jakobsen. In *Cosmonauts of the Future: Texts from the Situationist Movement in Scandinavia and Elsewhere*, edited by Mikkel Bolt Rasmussen and Jakob Jakobsen, 206–9. Copenhagen and New York: Nebula & Autonomedia, 2015.

———, Hardy Strid and Jens Jørgen Thorsen. 'Co-Ritus Manifesto' [1962]. Translated by Jakob Jakobsen. In *Cosmonauts of the Future: Texts from the Situationist Movement in Scandinavia and Elsewhere*, edited by Mikkel Bolt Rasmussen and Jakob Jakobsen, 125–7. Copenhagen & New York: Nebula & Autonomedia, 2015.

——— et al. 'The Struggle of the Situcratic Society: A Situationist Manifesto' [1962]. In *Cosmonauts of the Future*, edited by Mikkel Bolt Rasmussen and Jakob Jakobsen, 89–95. Copenhagen and New York: Nebula & Autonomedia, 2015.

Noheden, Kristoffer. *Surrealism, Cinema and the Search for a New Myth*. Cham: Palgrave MacMillan, 2017.

Nørrested, Carl. 'The Drakabygget Films'. In *Expect Anything Fear Nothing: The Situationist Movement in Scandinavia and Elsewhere*, edited by Mikkel Bolt Rasmussen and Jakob Jakobsen, 29–45. Copenhagen and New York: Nebula & Autonomedia, 2011.

Richardson, Michael. 'The Density of a Smile'. In *Wilhelm Freddie: Stick the Fork in Your Eye!*, edited by Sven Bjerkhof et al., 138–47. Copenhagen: Statens Museum for Kunst, 2009.

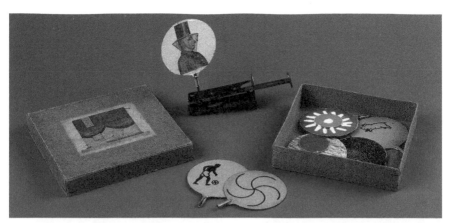

Plate 1 Joseph Cornell, *Jouet surréaliste*, c. 1932

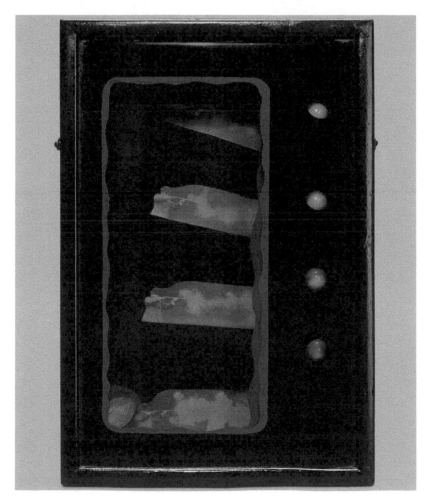

Plate 2 Joseph Cornell, *Untitled (Black Hunter)*, c. 1939

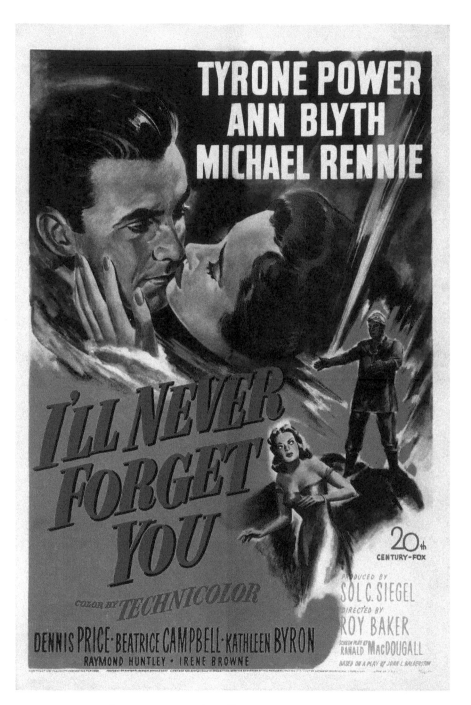

Plate 3 US Poster for *I'll Never Forget You*, 1951

Plate 4 Robert Benayoun, *Paris n'existe pas*, 1969

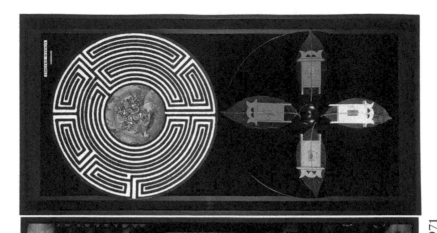

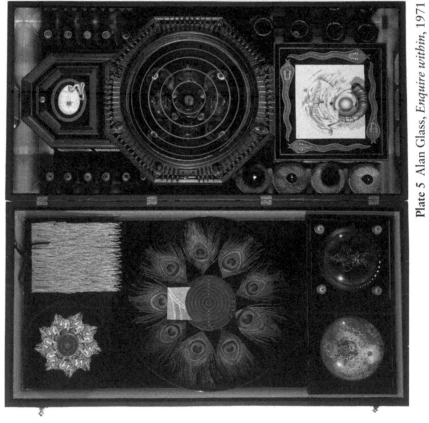

Plate 5 Alan Glass, *Enquire within*, 1971

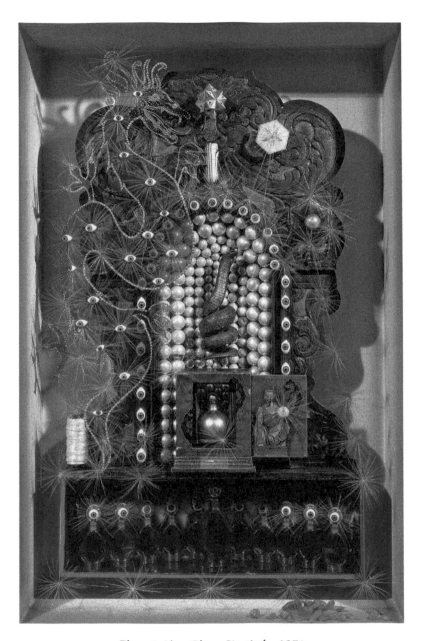

Plate 6 Alan Glass, *Sin título*, 1971

Plate 7 Alejandro Jodorowsky, *The Holy Mountain (La montaña sagrada)*, 1973

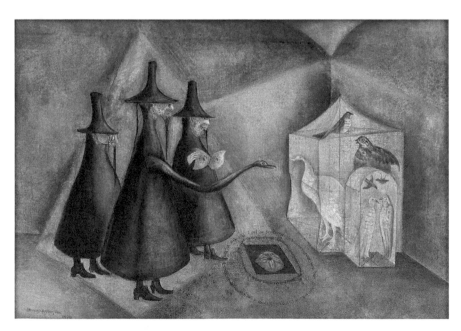

Plate 8 Leonora Carrington, *The Bird Men of Burnley*, 1970

Plate 9 Nelly Kaplan, *Néa*, 1976

Plate 10 Jan Švankmajer, *Insect (Hmyz)*, 2018

Plate 11 Jan Švankmajer, *Insect (Hmyz)*, 2018

'The Role of Godard' [1966], translated by Ken Knabb. Accessed 18 May 2020. www.bopsecrets.org/SI/10.godard.htm.

Shield, Peter. *Comparative Vandalism: Asger Jorn and the Artistic Attitude to Life.* Brookfield, VT: Ashgate, 1998.

Slater, Howard. 'Divided We Stand: An Outline of Scandinavian Situationism'. *Infopool*, no. 4 (2001): 1–48.

'Sunset Boulevard' [1962], translated by Not Bored. Accessed 18 May 2020. www.notbored.org/sunset-boulevard.html.

Thorsen, Jens Jørgen. *Friheden er ikke til salg.* København: Borgan, 1980.

———. 'Kunstens kommunikative fase' [1966]. In *Friheden er ikke til salg*, 71–4. København: Borgan, 1980.

———. 'Kunst, kusse og kortfilm'. In *Situationister 1957–70*, edited by Ambrosius Fjord and Patric O'Brien. Vanløse: Edition Bauhaus Situationistre, 1971.

———. 'Opråb på Documenta 5' [1972]. In *Friheden er ikke til salg*, 27–9. København: Borgan, 1980.

———. 'Wilhelm Freddie: Frihedens store alkymist' [1967]. In *Friheden er ikke til salg*, 99–104. København: Borgan, 1980.

From *Paris n'existe pas* to *Berkeley Square*: surrealism, time travel, and 'second sight'

Gavin Parkinson

The first theatrical performance of John L. Balderston's play *Berkeley Square* took place in London in 1926. Its subsequent international success on Broadway in 1929 led to the film version of 1933, directed by Frank Lloyd, which was faithful to the original script. From then, *Berkeley Square* was lauded by surrealists such as Jacques B. Brunius, André Breton, Robert Benayoun, Gérard Legrand, and others over a period of more than thirty years. A cursory examination of the film exposes the themes that have typically interested surrealists across the long history of the movement; lengthier discussion of this highly suggestive infatuation and one of its main outcomes in surrealism, Benayoun's 1969 film *Paris n'existe pas*, opens unexpected avenues between surrealism and popular culture and even new paths of potential research into the movement. As I will show, Benayoun became a significant figure in the Paris surrealist group from the moment he made contact with it, soon after the war, when surrealism was becoming thoroughly historicised, had yet to engage with science fiction, and was soon to return to its earlier fascination with the paranormal. The themes of this essay, then, range across the earlier, supposedly 'classic', period of inter-war surrealism to the recovery of the movement in the 1960s.

Berkeley Square and surrealism

Set in 1933, *Berkeley Square* tells the story of the melancholy, scholarly, socially well-attached US citizen Peter Standish, played with appropriate agitation by Leslie Howard, reprising his Broadway role (Figure 7.1). Standish inherits a residence in Berkeley Square in the West End of London where he finds a diary and other papers belonging to his ancestor of the same name and, anticipating the heroes of later science-fiction (SF) films as described by Susan Sontag, becomes obsessed by the past to the point of avoiding and neglecting his fiancé, Marjorie.[1] Those close to him are distressed by his new

Figure 7.1 Frank Lloyd, Leslie Howard in *Berkeley Square*, 1933

taste for seclusion and increasingly distracted air; then he finds a way of going 'back' to the past, explaining time travel in an exchange with the Ambassador at the US Embassy by means of an analogy with travel through space. An individual on a boat, he says, cannot see what he has passed beyond a curve in the river, nor what is hidden ahead, yet someone overhead in an airplane can see him, where he has been, and where he is going: his 'past', 'present', and 'future', as though they all exist simultaneously. In this way, Standish or Balderston made the typical error in time-travel yarns of assuming a too close analogy between time and space.

Standish accesses the year 1784 (we are not told in concrete terms how) and replaces his ancestor, convincingly at first with the help of the diary he found, falling in love with Helen instead of Kate (whom his ancestor had married). Meanwhile, he bemuses his contemporaries by using colloquialisms such as 'push off' and 'cockeyed', lapsing into anachronisms to do with empire, democracy, and literature (at one point quoting from Oscar Wilde's *Portrait of Dorian Gray* of 1890). Helen along with other ancestral family members and friends is disturbed by his odd remarks, suspecting him of witchcraft or 'second sight'. Standish goes to have his portrait painted by Sir Joshua Reynolds (which he had seen in the house in 1933), but the artist has trouble completing his portrait and is insulted when Standish mentions his painting *Sarah Siddons as the Tragic Muse* (1784), which was incomplete

and still unnamed at that moment. At a party he meets a duchess painted by Thomas Gainsborough who believes he talks of her in the past as though she were already dead.

Helen is intrigued rather than put off by all this, asking him: 'How can you speak of things that haven't happened yet?' She insists on being told more: 'I must see', she says. Then comes the memorable montage sequence featuring daunting images of our military and industrial modernity, and she is horrified to discover what the twentieth century holds – 'Devils! Demons!' – all this imagined in a film, remember, of 1933, before World War II, the Holocaust, and routine threat of nuclear war. After she declares her love they kiss and although Standish is, in turn, disgusted by the 'dirt, disease, cruelty, smells' of late-eighteenth-century London, he wants to stay with Helen, but she insists that he leave because she knows he will never be happy living among 'the dead'. He returns to the twentieth century, and in a moving finale he visits the grave of Helen in St. Mark's churchyard near Regent's Park. Three years after he left, she had died at the age of twenty-three on 15 June 1787, and her words as a voiceover close the film: 'We shall be together always, Peter. Not in my time nor in yours but in God's.'

Quite apart from such sentiments, mirroring those of *Peter Ibbetson* (1935), which would become the favourite Hollywood film of the surrealists, the main themes of 'second sight' and love in *Berkeley Square* – the first serving to enhance the second – were perfectly in tune with the earlier and current writings of Breton.[2] He saw *Berkeley Square*, possibly while over in England for the opening of the International Surrealist Exhibition at the Burlington Galleries in June 1936, and might have viewed it on the suggestion of Brunius, who later translated the original play into French.[3] Breton wrote in his important article 'Nonnational Boundaries of Surrealism' that year about the manifestation of mythic ideas in *Berkeley Square* through a fantastic premise redolent of the Gothic novel:

> Only a few months ago I was able to satisfy myself, while pondering the singular theme of a remarkable film entitled *Berkeley Square* – the new occupant of an old castle [*château*] manages, by bringing back to life in his hallucinations those who occupied it in former times, not only to mingle with them but also, as he takes part in their activities, to solve the problem of his present behaviour, a most difficult sentimental problem – that the myth of spirits and their possible intercessions is still very much alive.[4]

The 'Gothic period' of *Berkeley Square* was obviously uppermost in the mind of Breton, demonstrated by his reference to the film immediately following a reflection on Horace Walpole's *The Castle of Otranto* (1764). In fact, by a remarkable coincidence, Walpole was actually living in Berkeley Square in 1784, the year the film was set, which Breton could not have

known (Walpole's former home has been demolished). He went on to state in this passage that the Gothic element is not really essential in the continuation of the myth of spirits, though it is easy enough to see that this, as refracted through the 'Gothic period' of the film, was one of the features of *Berkeley Square* that drew his attention.

Notice that Breton's own reading of *Berkeley Square* does not perceive the escapade taking place in some 'beyond' or separate temporal dimension, and certainly not under the gaze of 'God' as we might gather from Helen's remarks at the close of the film, but in the *mind* of Peter Standish. The characters are 'hallucinations' brought about by his delirium, 'enabling him to solve the problem of his present behaviour, a most difficult sentimental problem', by which Breton means that Standish's disturbed demeanour was the outcome of an unconscious disinclination to marry Marjorie, a marriage successfully prevented in the end by his love for Helen. Breton did not offer this interpretation as an option, but, rather, assertively, as though it were Balderston's own meaning; at the same time, he consolidated the Gothic reading by his use of the too grand '*château*' for what is clearly not a castle in the film and could not be in the narrative since it is set in one of the large Georgian houses that are characteristic of Berkeley Square.

Breton made this interpretation in 'Nonnational Boundaries of Surrealism' at the time of his reflections on love, chance, and time that eventually went into *Mad Love* (1937). These included a similar requirement to overcome a 'sentimental problem' of his own in the narrative of the found object set out early on and in the less well-known episode at the villa at Le Fort-Bloqué, which he had very recently written up to close the book, just completed and soon to appear in print.[5] In fact, Breton's wording about *Berkeley Square* is very close to that used in *Mad Love* over the course of his evaluation of Alberto Giacometti's purchase at the Saint-Ouen flea market of a curious wedge-shaped mask meant to cover the top half of the face. After observing Giacometti's precarious susceptibility to 'feminine intervention' and pondering the effects of this on the artist's struggle to complete *The Invisible Object* (1934), particularly the head of the sculpture, which, he claimed, had continued to 'participat[e] in the sentimental uncertainty from which I continue to think the work had sprung', Breton wrote that the discovery of the mask 'seemed to be intended to help Giacometti overcome his indecision on this subject'.[6]

Paris n'existe pas and the 'second sight' movie

Under closer inspection, *Berkeley Square* reveals itself as a buzzing hive of inference and intertextuality. As well as having its origin in the 1926 stage

play and being loosely revisited in the 1965 stage musical *On a Clear Day You Can See Forever*, the 1933 film (which had been lost but was rediscovered in the 1970s and restored for viewing in 2011) was followed by a remake in 1951 starring Tyrone Power and titled *The House in the Square* (or *I'll Never Forget You* in America) (Plate 3). The schmaltzy, soft-focus cult film *Somewhere in Time* of 1980 starring Christopher Reeve and Jane Seymour was 'almost a remake' of *Berkeley Square* according to Leslie Halliwell, though it was actually based on the 1975 romantic SF or fantasy novel originally titled *Bid Time Return* by legendary SF writer Richard Matheson, author of the novel and screenplay *The Incredible Shrinking Man* (1956/7) and a significant contributor to the zombie genre with *I Am Legend* (1954), a novel much admired by Benayoun and adapted for the screen twice, as *The Omega Man* (Boris Sagal, 1971) and *I Am Legend* (Francis Lawrence, 2007).[7] In the opening pages of Matheson's novel, which was reissued under the title *Somewhere in Time* due to the success of the film, the protagonist Richard goes aboard the retired ocean liner *Queen Mary* and surveys the photographic memorabilia: 'There's Leslie Howard; how young he looks. I remember seeing him in a movie called *Berkeley Square*. I recall him time-travelling back to the eighteenth century.'[8] The plot device of *Somewhere in Time* is indeed similar to *Berkeley Square*, as is its emphasis on the primacy of place in the disjointure of time (a hotel – the one used by Billy Wilder when filming *Some Like It Hot* (1959), states Richard – rather than a house in this case).[9] Meanwhile, its theme of two lovers who meet through a place created by the mind (dream or hypnosis) and are united forever young in death is very close to *Peter Ibbetson*, noted earlier, that 'triumph of surrealist thought' in Breton's words.[10]

That such themes are both dear to surrealists and relatively commonplace in popular film is notable in its own right. It is made more so when we observe that there was a significant offshoot of *Berkeley Square* in surrealism, namely the 1969 film by Benayoun titled *Paris n'existe pas*. Born in Morocco, Benayoun had made his first contact with the Parisian surrealists in 1947 and would remain a member of the group from 1950 until its temporary break-up in 1969. He is best remembered as a film critic for the important cinema journal *Positif* and would write monographs on Alain Resnais, Woody Allen, Tex Avery, Buster Keaton, the Marx Brothers, and Jerry Lewis (who was the subject of a six-part series created by Benayoun that was never commercially released), and he would serve on the jury of the Cannes Film Festival in 1980. A collector of and expert on comics, maker of witty, economical collages (Figure 7.2), and writer on humour and eroticism, Benayoun was also one of the most gifted polemicists within the surrealist group and a leading signatory of the *Declaration on the Right to Insubordination in the Algerian War* or *Declaration of the 121* (1960), a major statement against colonialism and condemnation of

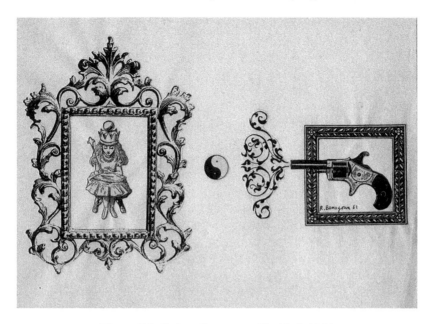

Figure 7.2 Robert Benayoun, Untitled, 1961

military fascism, asserting the legitimacy of revolution in Algeria and aid given to Algerians from France, while defending conscientious objectors and desertion from the French army.[11] He directed two feature films: *Paris n'existe pas* and *Sérieux comme le plaisir* (1975).

Written in 1966, the year of Breton's death, *Paris n'existe pas* was shot in the summer after May '68, completed in February 1969, and released later that year.[12] It bears similarities with Resnais' non-linear time-travel movie *Je t'aime je t'aime* (1968), known to and admired by Benayoun and other surrealists, partly for its collage-like or condensed dream imagery.[13] In spite of its inadequacies – the acting and dialogue are poor, the action is badly paced, the stop-motion sequences look amateurish to us today – *Paris n'existe pas* was commercially successful internationally and deserves our attention as a rare example of film made from within the surrealist group representing an absolutely orthodox surreality. But it is also a very heavily referential document, with an intertextuality that ranges across theory, film, theatre, and fiction from the 1920s to the 1960s. Examination of this, especially its debt to *Berkeley Square*, enriches not only our understanding of the film and of later surrealism but also the perceived potential of film itself within the movement.

The central character of *Paris n'existe pas* is the painter Simon Dévereux, played by Richard Leduc, who would later star in Alain Robbe-Grillet's *L'Eden et après* (1970) and also appear in passing in Luis Buñuel's *That*

Obscure Object of Desire (*Cet obscur objet du désir*, 1977). Simon takes a casual drag on a joint while leaving a party, triggering an amplification of the seer-like properties he already claims for himself: he sees his hip 1960s apartment as it had been in the 1930s, complete with heavy furnishings, chintz, and female tenant (Plate 4). This is Félicienne, Benayoun's version of Balderston's Helen, who at one point is seen holding George du Maurier's original 1891 novel *Peter Ibbetson*, tipping off the film's audience to the tradition Benayoun was drawing upon and contributing to. The story of Simon's growing fascination with and visits to the pre-war period, and his time increasingly divided between Félicienne and his present-day girlfriend Angela, is told partly with the aid of his rather hammy 'philosophical' reflections about time, often in conversations with his intellectual Duchampian friend Laurent (played by a fidgeting Serge Gainsbourg, who also wrote the score for the film). Benayoun meant to go hard on the popular art of Pop and Nouveau Réalisme in *Paris n'existe pas* through Simon's remarks about painting, and we can read it less as a 'real' instance of time travel and more as the fulfilment of a wish by a painter inconsolable about a predicament in the present – namely, the one offered up by commercial contemporary art – and desperate to gain release by living in the past. Accordingly, Simon visits the period from 1929, commonly thought of as the high period of surrealist painting, courtesy of some stock footage containing familiar period landmarks of Paris. The paintings he supposedly creates in the film were actually the work of Bernard Childs, who showed with the Phases group and exhibited at the Galerie du Dragon, which Benayoun and the surrealists visited often in the 1950s and 1960s and which appears in the film.

In an interview with the SF magazine *Fiction* at the time of the release of *Paris n'existe pas*, Benayoun talked with far more intelligence and subtlety about the film than the lumbering final result could ever have allowed us to expect. He affirmed the continuity of surrealism and the relevance for his film of its extended project, saying, first, that it rested on the unverified scientific hypotheses of J. W. Dunne and, second, that he had tried 'to rediscover the allure and enchantment of certain fantastic romances: *Peter Ibbetson*, *Berkeley Square*, or some stories of Henry James', reminding his interviewer that James's final, unfinished novel, 'The Sense of the Past' (1917), had been the narrative source for *Berkeley Square*.[14]

Here, we begin to gain a closer understanding of how surrealist ideas of chance and temporality were returned to and built on in the 1950s in *Paris n'existe pas* and elsewhere. Dunne's book *An Experiment with Time* (1927), which is cited poignantly in Matheson's *Bid Time Return* (the actress Elise McKenna, whom Richard travels back to meet in 1896, is said to allude to it in her autobiography),[15] had attempted to comprehend Dunne's apparently precognitive dreams by proposing a new structure for time through scientific

explanation, with recourse to Albert Einstein's theory of relativity.[16] It posited a separate 'I' to the one *subject to* Einstein's four-dimensional frame of fixed reference that can emerge while the everyday, temporally determined 'I' sleeps and is able to observe the whole of the temporal continuum. In *Paris n'existe pas*, thanks to his potent dose of marijuana, Simon apparently occupies the body of this 'observer', the time-travelling 'I', while awake, and this is confirmed in Benayoun's own remarks about the film's faithfulness to cinematic form generally when he described it to J. H. Matthews as a 'form of story that cannot be adapted as a novel, play in the theatre, or a radio play, in which everything is based on the image, or on successions of images'.[17] Given that Benayoun identified Simon as his spokesman – 'a surrealist in life', as he put it, to the point that Leduc wears Benayoun's clothes for a good portion of the film – we can assume that Simon, who enters the past entirely visually, is not only the 'observer' of Dunne's *Experiment with Time* but also the witness to cinema as the ideal vehicle for surrealism.[18]

Time travel, surrealism, and Henry James

Dunne's book had been read by several surrealist writers, artists, and their friends well before it was translated into French in 1948 as *Le Temps et le Rêve*.[19] It was mentioned frequently by Breton from 1950 to 1955 as a pioneering study of dreams,[20] and he linked it specifically with his own theory of objective chance in his essay 'Le Pont suspendu', which appeared in *Médium: Communication surréaliste*, the journal of the Paris surrealists in the early 1950s.[21] That article brought together several 'time travel' coincidences that had made the rounds of surrealist lore: Giorgio de Chirico's 'prediction' of Apollinaire's fatal war wound in his *Portrait of Apollinaire* (1914), Breton's own 'Night of the Sunflower' episode, retold in *Mad Love*, and Victor Brauner's prefiguration of the loss of his eye in 1938 in the imagery of paintings leading up to it; these are supplemented by the pretext for 'Le Pont suspendu', Breton's recent letter exchange with the Spanish artist Luis Fernández (López) pointing to a possible instance of 'second sight' by Breton of the funeral of Fernández's wife in front of the painting that he owned by the artist, *Paysage bordelais* (c. 1951). The new importance of Dunne's hypothesis of time travel through dreams in *An Experiment with Time* to this later stage of surrealism is evident in Breton's quotation from that book in 'Le Pont suspendu'.[22] It is made by Breton to bear a close relationship with suggestions made within surrealism in Pierre Mabille's essay 'L'Œil du peintre' (1939), which loosely speculated with reference to *Mad Love* that Brauner's accident might demonstrate the human capacity to transcend the restrictions imposed by the five senses, escape the limitations

of 'the immediate sensorial representation of the world', and 'rise beyond visual Euclidean dimensions'.[23]

Breton did not refer to his own *Nadja* (1928) in 'Le Pont suspendu', but that volume lies at the origin of such speculations, in the uncanny predictive faculty of Nadja, the reactions she draws from others when she 'is disturbed by the thought of what has already occurred in this square [the Place Dauphin] and will occur here in the future', and when she 'wonders who she might have been, in Marie-Antoinette's circle'.[24] It was to this set of ideas that Benayoun was referring when he told Matthews that *Paris n'existe pas* contained 'distinct Breton allusions' and was done 'in the most romantic tradition of a few surrealist autobiographical books'.[25] Why, then, did he say at the time of the release of the film in the interview in *Fiction* that the stories of modernist author Henry James, friend of Georges du Maurier, had acted as a further point of reference for *Paris n'existe pas*?[26] And how can *Berkeley Square* be regarded as, at once, an essential entry in the surrealist filmography while holding James's 'The Sense of the Past' as its narrative source?

James died well before surrealism took wing in Breton's *Manifesto of Surrealism* (1924): on 28 February 1916 to be precise, twenty-three days, no less, after the arrival on the scene of surrealism's forerunner Dada at the Cabaret Voltaire in Zürich. Of course, James is usually credited with extending the realist, decidedly non-surrealist lineage of George Eliot, Honoré de Balzac, and Gustave Flaubert before he moved to a more reflexive mode in the 1890s, whereby the teller of the tale ceases to be a distant, Balzacian grand narrator and becomes a character whose consciousness is actively subsumed in and even subject through misunderstandings to the events and behaviour he or she is trying to articulate or comprehend. The modernist concern with the mind as it relates to the world and its representation in James's later work is obviously closer to surrealism, yet even there the overriding realism of his oeuvre seems unequivocally at odds with surrealism's long-running rejection of novelistic narrative, dating from Breton's *Manifesto*.

The inquiry into the paranormal led by Breton and joined by the surrealists in the 1950s, however, makes it easier to develop a case for James as a writer who had much in common with surrealism. The 1950s saw an emphatic return to prominence in France of research into such extra-scientific phenomena as mediumism, spiritualism, clairvoyance, telekinesis, extra-sensory perception, and telepathy, under the term 'parapsychology'. Rivalling the earlier intense interest in 'spiritualism' in France in the period 1919–25, at the time that the first surrealist group was finding its feet, it had a more distant antecedent in the mid-nineteenth century, which included the 'spiritualist' writings and inclinations of the James siblings Alice, William, and Henry. Breton had long been aware of this, as the parapsychologist Jean Bruno noted, yet to my knowledge the one and only time it served as a bridge

between the writings of Henry and the surrealists took place in a brief article of 1954 by Benayoun.[27] Titled 'L'Œil spectral', perhaps to rhyme with Mabille's 'L'Œil du peintre' of fifteen years earlier, this is where Benayoun first noted 'The Sense of the Past' as a source for *Berkeley Square*. Benayoun's text does not make explicit links between James's writings and surrealist themes, yet its existence in a surrealist periodical is tacit confirmation of these. Its interpretation of James was given in the light of the recent French translation of 'The Friends of the Friends' (1896, originally called 'The Way It Came', retitled in 1909), published in close proximity to surrealism by Eric Losfeld's Éditions Arcanes during a period in which surrealism's receptivity towards the paranormal allowed it to entertain an overlap with the supernatural and fantastic.[28] Making an (on first viewing) unorthodox bid for a surrealist reception of James, Benayoun argued that James's early life – including experiences of hallucination, the tutelage of a father who was a devotee of the theological writings of Emanuel Swedenborg and then a follower of the utopian socialist and surrealist precursor Charles Fourier, and a crushing bereavement in the death of his young cousin Mary (Minnie) Temple – engendered in him 'a *sense of lost time*' and a taste for the supernatural to cope with his feeling of loss.[29]

No names are used in James's 'Friends of the Friends'.[30] We are told the fiancé of the narrator of the tale had a vision of his mother, who 'smiled with extraordinary radiance and extended her arms to him, and then as he sprang forward and joyfully opened his own she vanished from the place'; then the 'next morning he heard of her death', while the narrator's closest friend (who is separated from her own husband) had a similar experience, in her case seeing her father who vanished from view and then was reported dead the next day.[31] Because of their shared experience of 'second sight', the narrator tries to arrange for her fiancé and friend to become acquainted, but for five years circumstances persistently prevent this. The friend's estranged husband dies when the two are finally about to meet, but the narrator sabotages the appointment out of jealousy, fearful their encounter will lead to intimacy. When she hears her friend has died suddenly, she tells her fiancé, who is astonished and announces that the friend had come to see him on the night of her death and stared at him in silence for twenty minutes. For Benayoun, this is a typical Jamesian trope:

> All the missed encounters that serve to separate two beings eventually constitute for James a virtual encounter making up for the vexation of two absences. They are resolved definitively in an encounter truer than nature since it determines forever the life of his heroes: the phantasmic apparition, at the hour of her death, of the loved woman. This gift of acute perception, shared by divided predestined lovers, is found everywhere in the *œuvre* of Henry James, where communication with the dead plays an essential role.[32]

Jorge Luis Borges knew of 'no stranger work than that of Henry James', due to the author's unique ambiguity and imprecision.[33] This differed from that of the symbolists, 'whose imprecisions, by eluding meaning, can mean anything', according to Borges, whereas in James, the 'voluntary omission of a part of the novel … allows us to interpret it in one way or the other'.[34] At the end of 'The Friends of the Friends' we are left uncertain as to whether the friend was alive or dead when she went to see the fiancé, just as at the close of *Paris n'existe pas* we are left unsure as to whether reality and dream are separable. After hearing of the mysterious encounter, the narrator of the novella is convinced they have met before or that her deceased friend went to see her fiancé with an ulterior motive. Ultimately, she feels she cannot trust her fiancé, whom she is convinced is in love with her dead friend and continues to visit her in death. She confronts him with this on the eve of their wedding, ending their relationship, and the fiancé dies six years later.

Benayoun's remarks about loss, love, chance, and eternity in *Médium* cite not just 'The Friends of the Friends' and 'The Sense of the Past' but other novels and novellas by James: 'The Madonna of the Future' (1873–75), *The Aspern Papers* (1888), *The Spoils of Poynton* (1897), 'The Turn of the Screw' (1898), 'The Beast in the Jungle' (1903), and 'The Jolly Corner' (1908), as well as James's *Notebooks* (pub. 1947, 1987)[35] and his autobiographical writings in *A Small Boy and Others* (1913). These recall surrealist themes and their representation in film and the 'surrealist autobiographical books' as Benayoun put it in interview about *Paris n'existe pas*, and this is extended in his insistence that all of the supernatural tales of James 'are an eternal confrontation with himself: Henry James was his own phantom, he haunted himself perpetually'.[36] The opening lines of *Nadja* are recalled irresistibly here, where Breton responds to his own question 'Who am I' by speculating that 'perhaps everything would amount to knowing whom I "haunt"', and even goes on to remark that the significance of his image of the ghost might be that it is 'the finite representation of a torment that may be eternal'.[37]

Benayoun sees the self-haunting of James in the comparable experience of missed encounter and/or opportunity in the short narrative 'The Beast in the Jungle', in which John Marcher begins by misremembering details of his earlier meeting with May Bartram and ends with his recognition that the annihilating event that he feels throughout his life awaits him, waiting to pounce (the 'beast' of the title), is the realisation after May's death of his own passionless existence: 'The escape would have been to love her; then, *then* he would have lived.'[38]

As Benayoun relates, a supernatural atmosphere (though unconfirmed, as in 'The Friends of the Friends') surrounds James's 'The Jolly Corner' (1908), a similar story of near, failed, or imagined encounter, in which Spencer Brydon returns to New York from Europe and reacquaints himself with the old

family house, formerly rented out but now empty, and through which he now takes pleasure in wandering at night, finding the past life compressed and memorialised in its walls more real than the one outside them:

> He spoke of the value of all he read into it, into the mere sight of the walls, mere shapes of the rooms, mere sound of the floors, mere feel, in his hand, of the old silver-plated knobs of the several mahogany doors, which suggested the pressure of the palms of the dead; the seventy years of the past in fine that these things represented, the annals of nearly three generations, counting his grand-father's, the one that had ended there, and the impalpable ashes of his long-extinct youth, afloat in the very air like microscopic motes.[39]

Ultimately, Brydon's wandering leads him to an encounter with a version of himself – an episode not unlike the (perhaps) ghostly encounter in 'The Friends of the Friends' but closer to Sigmund Freud's uncanny misrecognition of his own reflection[40] – leading him serendipitously to a romantic union at least comparable with Breton's thesis in *Nadja* that the pursuit of love is also that of the self: '"Who goes there? Is it you, Nadja? Is it true that the beyond, that everything beyond is here in this life? I can't hear you. Who goes there? Is it only me? Is it myself?"'[41]

James's themes emerged in the last quarter of the nineteenth century, pre-dating not only surrealism but film itself, and they intensify in his work in the early years of the twentieth century, as James's reputation grew. We should not be surprised, then, to see them pervade surrealist film in the form of Benayoun's *Paris n'existe pas*, nor mainstream movies such as *Peter Ibbetson* and *Berkeley Square* admired by surrealists.

Conclusion: the Gothic novel and SF

James's unfinished novel 'The Sense of the Past' bears a few basic similarities with *Berkeley Square* and *Paris n'existe pas*. Thirty-year-old American Ralph Pendrel inherits residence number nine in 'Mansfield Square' in London (no such square actually exists). When he goes to visit, his behaviour is very much like the character in 'The Jolly Corner', silently and almost obsessively imagining the lives of its past inhabitants in every detail. This is his sense of the past, as though James were taking the stock phrase to mean a sixth sense that one might heighten and be immersed in, rather like Dunne and Matheson did, and accidentally amplified in Benayoun's Simon Dévereux by marijuana. Pendrel is particularly drawn towards an unusually posed figure in a painted portrait: 'The gentleman in question here had turned his back, and for all the world as if he had turned it *within* the picture', making Ralph's 'attention throb with the idea that the actual attitude might change – that it

had even probably, that it had in fact repeatedly, done so'.[42] After much pacing, he comes to understand the face in the painting as his own:

> He was staring at the answer to the riddle that had been his obsession, but this answer was a wonder of wonders. The young man above the mantel, the young man brown-haired, pale, erect, with the high-collared dark blue coat, the young man revealed, responsible, conscious, quite shining out of the darkness, presented him the face he has prayed to reward his vigil; but the face – miracle of miracles, yes – confounded him as his own.[43]

From there, Pendrel goes, like Peter Standish in *Berkeley Square*, to see the US Ambassador, but Pendrel's passage from 1910 back to 1820 bears no resemblance to time travel as it has come to be visualised through the paraphernalia of SF. Like the self-encounter with the painting – turned into a humorous episode in *Berkeley Square* – it has a closer relationship with the psychological themes and conundrums surrounding identity that we associate with the Gothic novel. James himself alludes to this tradition not only in the incident of the painting, which recalls the animated portrait of the protagonist Manfred's grandfather exiting the frame of the painting in Walpole's *The Castle of Otranto*, but also in the figure of the 'little Horace Walpole man' hypothesised in the notes left behind by James.[44]

Unlike Benayoun, Breton showed no interest in SF.[45] Rather, in the *Manifesto* he had lauded the manner by which the author of the Gothic novel 'freed his main characters from all temporal constraints', and his interpretation of *Berkeley Square* in 'Nonnational Boundaries of Surrealism' was introduced by a lengthy claim of the prophetic quality of *The Castle of Otranto*, which he linked to the *Manifesto*.[46] Walpole's narrative, claimed Breton, 'could only be obtained by relying on the *dreaming* process and on *automatic writing*', uniting in a *mise-en-abyme* the writer in his study and protagonist in his castle, in 'the most favourable place to receive the great prophetic waves'.[47] Breton's unanswerable questions in *Nadja*, seemingly spoken as or through a medium to another outside of this life and to himself at once, had already considered paranormal activity under an expanded reality or surreality; as we saw, Nadja herself routinely visited the past with Breton in their walks through Paris. It is this version of 'time travel' as 'second sight', beyond ordinarily perceived reality, that we see esteemed as surreality in *The Castle of Otranto* and *Berkeley Square*, revisited in *Paris n'existe pas*, and unexpectedly predating surrealism in the writings of the gold-plated modernist Henry James.

Notes

1 'It is interesting that when the scientist in these films is treated negatively, it is usually done through the portrayal of an individual scientist who holes up in his laboratory and neglects his fiancée or his loving wife and children, obsessed by

his daring and dangerous experiments.' Sontag, 'The Imagination of Disaster', 209–25, 223.

2 For a discussion of and context for the similar 'Christian closure' of *Peter Ibbetson*, see Hammond, *The Shadow and Its Shadow*, 33–4. Debate on *Peter Ibbetson* within the movement was frequent, giving it the status of an *'oral tradition'* in the phrase of Peters, 'A Note on Peter Ibbetson', 49, italics original.

3 Seeking a lineage for the Alain Resnais–Alain Robbe-Grillet classic, *Last Year in Marienbad* (1961), Brunius would later list *Berkeley Square* with *The Cabinet of Dr. Caligari* (1920), Buster Keaton's *Sherlock Jr.* (1924), *Peter Ibbetson* (1935), the two Luis Buñuel–Salvador Dalí collaborations, *Un Chien Anadalou* (1929) and *L'Age d'Or* (1930), and Jean Renoir's *Rules of the Game* (1939), along with the less surrealist-friendly *Citizen Kane* (1941): Brunius, 'Every Year in Marienbad', 123.

4 Breton, 'Nonnational Boundaries of Surrealism', 16. The essay was initially a lecture given on 16 June in London during the run of the exhibition, then rewritten and published as Breton, 'Limites non frontières du surréalisme', 1 February 1937. Although *Berkeley Square* premiered in Paris in October 1934, Breton's remark about seeing it 'a few months ago' suggests he might have viewed it in London: see the comments by Marguerite Bonnet in Breton, *Œuvres complètes*, volume 3, 1338, 1344.

5 Breton, *Mad Love*, 25–38, 101–11. Breton wrote out the incident at Le Fort-Bloqué for inclusion in *Mad Love* between 28 August and 1 September 1936 as marked on the manuscript and given by Marguerite Bonnet in Breton, *Oeuvres complètes*, volume 2, 1693. Since Breton begins 'Nonnational Boundaries of Surrealism' by mentioning the recent end 'a few months ago' (on 4 July) of the exhibition in London, we can conclude that the two texts were written close together: Breton, 'Nonnational Boundaries of Surrealism', 7.

6 Breton, *Mad Love*, 26, 30–2.

7 Halliwell, *Halliwell's Filmgoer's Companion*, 106. Reeve had actually appeared in a revival of *Berkeley Square* in an off-Broadway production at the Manhattan Theatre Club in 1975, which perhaps fired his enthusiasm for the script of *Somewhere in Time*. The play also received an outing on the BBC's 'Sunday Night Theatre' strand on 31 May 1959. For Benayoun on *I Am Legend*, which was translated into French in 1955, see his contribution to the two-part *enquête* arranged by Jacques Sternberg: Benayoun, 'Je crois à l'imagination féroce et subversive', 11.

8 Matheson, *Somewhere in Time*, 20.

9 Ibid., 29.

10 Breton, *Mad Love*, 128 n. 2. The 1947 jingoistic British comedy *The Ghosts of Berkeley Square*, starring Robert Morley, has a different source to *Berkeley Square*, in the 1944 novel *No Nightingales* by Caryl Brahms and S. J. Simon (the title alludes to the 1940 song 'A Nightingale Sang in Berkeley Square'), yet its theme of two eighteenth-century ghosts haunting a house through its transformations over the decades up to the First World War has an obvious similarity with Balderston's plot, which itself seems to stem from the reputation of 50 Berkeley Square since the nineteenth century as 'The Most Haunted House in London': www.haunted-london.com/50-berkeley-square (accessed 14 May 2020).

The 1998 BBC mini-series *Berkeley Square*, set in 1902, has no direct connection with the play or film, nor (unfortunately) is there any relationship between the Peter Lorre horror vehicle *Mad Love* (1935), on which Balderston worked, and Breton's book.

11 'Declaration on the Right to Insubordination in the Algerian War', 194–7.

12 See Matthews, *Surrealism and Film*, 129.

13 Benayoun later recalled a lunch with his friend Resnais – a friendship built on a shared love of comics, apparently – some way into work on *Paris n'existe pas*, during which the director announced to him excitedly that he was in the process of making a time-travel film (it would become *Je t'aime je t'aime*), which news unsettled Benayoun, naturally, even though Resnais' film became one of his favourites: Benayoun, *Alain Resnais*, 137, 135. See the semi-favourable review by the surrealist Gérard Legrand, '*Je t'aime je t'aime*', 145–7.

14 Cohn, 'Un entretien avec Robert Benayoun', 145. Author's translation.

15 Matheson, *Somewhere in Time*, 74. Dunne's writings on time fascinated J. B. Priestley, whose *Man and Time* (1964) is consulted by Richard in the novel and is the supposed source of the technique of self-hypnosis by which he enters the past: Matheson, *Somewhere in Time*, 69–73.

16 Dunne, *An Experiment with Time*.

17 Benayoun, quoted in Matthews, *Surrealism and Film*, 130.

18 Ibid., 133

19 See my *Surrealism*, 114–16.

20 See, for instance, Breton, *Conversations*, 241; and Breton et al., *Farouche à quatre feuilles*, 17–18.

21 Breton, 'Le Pont suspendu'. The publication date was January 1955, but for information that it was written in 1953, see the remarks about the manuscript at www.andrebreton.fr/fr/work/56600100888980 (accessed 15 February 2020).

22 Breton, 'Le Pont suspendu', 37. 'Serialism discloses the existence of a reasonable kind of "soul" – an individual soul which has a definite beginning in absolute Time – a soul whose *immortality, being in other dimensions of Time, does not clash with the obvious ending of the individual in the physiologist's Time dimension*', Dunne, *Experiment with Time*, 195–6, italics original.

23 Mabille, 'L'Œil du peintre', 55. Author's translation.

24 Breton, *Nadja*, 83, 85.

25 Quoted in Matthews, *Surrealism and Film*, 129

26 It is worth cataloguing here the time-shift novel by du Maurier's granddaughter Daphne in which the administration of a drug reversing part of the brain to an earlier moment in its chemical history allows first-person narrator Dick Young to access the fourteenth century: du Maurier, *The House on the Strand* (1969).

27 Bruno, 'André Breton et l'expérience de l'illumination', 65. Bruno was referring to Breton's conveyance of James's characterisation of F. W. H. Myers's science as a '*gothic psychology*' during the period Breton was immersed in Gothic novels: Breton, 'The Automatic Message', 129, italics original.

28 James, *Les Amis des amis*. In *Fiction* in the early 1960s, years before it published Benayoun's interview about *Paris n'existe pas*, a brief approving article on James's

supernatural tales had appeared, making the same point about 'The Sense of the Past' and *Berkeley Square* as Benayoun had in this essay on James in *Médium*, and it reprinted the very same translation of 'The Friends of the Friends' by Marie Canavaggia that had been acclaimed by Benayoun in *Médium*: Robin, 'Henry James et les contes surnaturels' 129–31; James, 'Les Amis des amis', 100–27. The relevance of James's supernatural tales to the themes favoured by *Fiction* is confirmed by its publication of *The Turn of the Screw* (1898) in two parts in 1961.

29 Benayoun, 'L'Œil spectral', 16, italics original. His brief reference to Henry's brother William is a reminder of the ground prepared for Benayoun's interpretation of James within surrealism by Breton's 'new myth' of the 'Great Invisibles' of 1942, partly validated by a (mis)quotation – '"Who knows whether, in nature, we do not hold as small a place beside beings whose existence we do not suspect, as our cats and dogs living in our houses at our sides?"' – of William James: Breton, 'Prolegomena to a Third Manifesto of Surrealism or Else', 216–17. Louis Vax made the pertinent point about the James siblings: 'Henry James, son frère William et sa sœur Alice ont été préoccupés par les manifestations de l'au-delà': Vax, *L'art et la littérature fantastique*, 95. For William James's role in setting up the American Society for Psychical Research in Boston in 1885 after hearing of the activities of the Society for Psychical Research in London, of which Frederic W. H. Myers was a member, see Allen, *William James*, 281–2. For discussion of 'Myers's learned and ingenious studies in hypnotism, hallucinations, automatic writing, mediumship, and the whole series of allied phenomena', see James, 'What Psychical Research Has Accomplished', 233. See also the obituary of Myers, which Breton read in French translation: James, 'Frederic Myers's Service to Psychology', 192–202.

30 James, 'The Friends of the Friends', 159–93.
31 Ibid., 164.
32 Benayoun, 'L'Œil spectral', 16. Author's translation.
33 Borges, 'Henry James', 248.
34 Ibid.
35 James, *The Notebooks of Henry James*; James, *The Complete Notebooks of Henry James*.
36 Benayoun, 'L'Œil spectral', 16. Author's translation.
37 Breton, *Nadja*, 11–12.
38 James, *The Beast in the Jungle*, 74.
39 James, 'The Jolly Corner', 204.
40 See Freud, 'The "Uncanny"', 371 n. 1.
41 Breton, *Nadja*, 144.
42 James, 'The Sense of the Past', 252.
43 Ibid., 261.
44 Ibid., 399.
45 In the interview in *Fiction*, Benayoun stated his selective reading of SF as follows: '[j]'ai toujours été hostile à des auteurs comme [Isaac] Asimov, Frederick Pohl, [A. E.] van Vogt, [Robert A.] Heinlein. Et je leur toujours préféré Lewis Padgett,

[Ray] Bradbury, John Wyndham, Fredric Brown ou William Tenn. Ce que je préfère, surtout, ce sont les voyages dans le temps et les histoires de mondes parallèls, lorsqu'ils débouchent sur le fantastique ou sur les légendes: ainsi le vampirisme m'attire beaucoup ... D'autre part, comme je viens du surréalisme, je m'intéresse au fantastique, au merveilleux, sous ses aspects quotidiens': Cohn, 'Un entretien avec Robert Benayoun', 144.

46 Breton, 'Manifesto of Surrealism', 15 (Breton was referring specifically to Matthew Gregory Lewis's novel *The Monk* of 1796).

47 Breton, *Free Rein*, 15, 16.

Bibliography

Allen, Gay Wilson. *William James: A Biography*. London: Rupert Hart-Davis, 1967.

Benayoun, Robert. *Alain Resnais: Arpenteur de l'imaginaire*. Paris: Éditions Stock, 1980.

———. 'Je crois à l'imagination féroce et subversive'. *Arts*, no. 676 (1958): 11.

———. 'L'Œil spectral'. *Médium: Communication surréaliste*, no. 3 (1954): 16.

Borges, Jorge Luis. 'Henry James: *The Abasement of the Northmores*' [1945]. In *Selected Non-Fictions*, edited by Eliot Weinberger, translated by Esther Allen, Suzanne Jill Levine, and Eliot Weinberger, 247–8. London Harmondsworth: Penguin, 1999.

Breton, André. 'The Automatic Message' [1933]. In *Break of Day*, translated by Mark Polizzotti and Mary Ann Caws, 125–43. Lincoln, NE: University of Nebraska Press, 1999 [1934].

———. *Conversations: The Autobiography of Surrealism* [1952], translated by Mark Polizzotti. New York: Paragon House, 1993.

———. *Free Rein* [1953], translated by Michel Parmentier and Jacqueline d'Amboise. Lincoln, NE: University of Nebraska Press, 1995.

———. 'Limites non frontières du surréalisme'. *La Nouvelle Revue Française* 48, no. 281 (1937): 200–15.

———. *Mad Love* [1937], translated by Mary Ann Caws. Lincoln, NE: University of Nebraska Press, 1987.

———. 'Manifesto of Surrealism' [1924]. In *Manifestoes of Surrealism*, translated by Richard Seaver and Helen R. Lane, 1–47. Ann Arbor, MI: University of Michigan Press, 1972.

———. *Nadja* [1928], translated by Richard Howard. New York: Grove, 1960.

———. 'Nonnational Boundaries of Surrealism' [1936–37]. In *Free Rein*, translated by Michel Parmentier and Jacqueline d'Amboise, 7–18. Lincoln, NE: University of Nebraska Press, 1995 [1953].

———. *Œuvres complètes*, volume 2, edited by Marguerite Bonnet et al. Paris: Gallimard, 1992.

———. *Œuvres complètes*, volume 3, edited by Marguerite Bonnet et al. Paris: Gallimard, 1999.

———. 'Le Pont suspendu'. *Médium: Communication surréaliste*, no. 4 (1955): 37.

————. 'Prolegomena to a Third Manifesto of Surrealism or Else' [1942]. In *What Is Surrealism? Selected Writings*, edited by Franklin Rosemont, 209–17. London: Pluto, 1978.

———— et al. *Farouche à quatre feuilles*. Paris: Éditions Bernard Grasset, 1954.

Brunius, Jacques. 'Every Year in Marienbad, or The Discipline of Uncertainty'. *Sight & Sound* 31, no. 3 (1962): 122–7, 153.

Bruno, Jean. 'André Breton et l'expérience de l'illumination'. In *Mélusine*, no. 2 ('Occulte-Occultation'), edited by Henri Béhar, 53–69. Lausanne: L'Age d'Homme, 1981.

Cohn, Bernard. 'Un entretien avec Robert Benayoun'. *Fiction* 17, no. 186 (1969): 144–6.

'Declaration on the Right to Insubordination in the Algerian War' [1960]. In *Surrealism against the Current: Tracts and Declarations*, edited and translated by Michael Richardson and Krzysztof Fijałkowski, 194–7. London: Pluto, 2001.

du Maurier, Daphne. *The House on the Strand* [1969]. London: Virago, 2004.

Dunne, J. W. *An Experiment with Time*. London: A. & C. Black, 1927.

Freud, Sigmund. 'The "Uncanny' [1919]. In *Art and Literature*, 335–76. London: Penguin, 1990.

Halliwell, Leslie. *Halliwell's Filmgoer's Companion*, 8th edn. London: Paladin, 1985.

Hammond, Paul, ed. *The Shadow and Its Shadow: Surrealist Writings on the Cinema*, 3rd edn. San Francisco, CA: City Lights, 2000.

James, Henry. *Les Amis des amis*, translated by Marie Canavaggia. Paris: Éditions Arcanes, 1953.

————. 'Les Amis des amis'. *Fiction* 11, no. 114 (1963): 100–27.

————. *The Beast in the Jungle* [1903]. London: Penguin, 2011.

————. *The Complete Notebooks of Henry James*, edited by Leon Edel and Lyall H. Powers. Oxford and New York: Oxford University Press, 1987.

————. 'The Friends of the Friends' [1896]. In *The Turn of the Screw and Other Stories*, 159–93. London: Vintage, 2007.

————. 'The Jolly Corner' [1908]. In *The Turn of the Screw and Other Stories*, 195–229. London: Vintage, 2007.

————. *The Notebooks of Henry James*, edited by. F. O. Matthiessen and Kenneth B. Murdock. Oxford and New York, Oxford University Press, 1947.

————. 'The Sense of the Past' [1917]. In *The Collected Supernatural and Weird Fiction of Henry James*, volume 4, 205–432. Driffield: Leonaur, 2009.

————. 'Le Tour d'écrou', translated by M. Le Corbeiller, *Fiction* 9, nos 90 and 91 (1961).

James, William. 'Frederic Myers's Service to Psychology' [1901]. In *Essays in Psychical Research*, 192–202. Cambridge, MA: Harvard University Press, 1986.

————. 'What Psychical Research Has Accomplished' [1892]. In *The Will to Believe and Other Essays in Popular Philosophy*, 222–41. Cambridge, MA: Harvard University Press, 1979.

Legrand, Gérard. '*Je t'aime je t'aime*: film française d'Alain Resnais'. *Fiction* 16, no. 176 (1968): 145–7.

Mabille, Pierre. 'L'Œil du peintre'. *Minotaure*, nos 12–13 (1939): 53–56.

Matheson, Richard. *Somewhere in Time* [1975]. New York: TOR, 1998.

Matthews, J. H. *Surrealism and Film*. Ann Arbor, MI: University of Michigan Press, 1971.

Parkinson, Gavin. *Surrealism, Art and Modern Science: Relativity, Quantum Mechanics, Epistemology*. New Haven, CT: Yale University Press, 2008.

Peters, Nancy Joyce. 'A Note on Peter Ibbetson'. In *Surrealism and Its Popular Accomplices*, edited by Franklin Rosemont, 49. San Francisco, CA: City Lights, 1980.

Priestley, J. B. *Man and Time*. London: Aldus, 1964.

Robin, Jean-François. 'Henry James et les contes surnaturels'. *Fiction* 11, no. 114 (1963): 129–31.

Sontag, Susan. 'The Imagination of Disaster' [1965]. In *Against Interpretation*. London: Vintage, 2001 [1967].

Vax, Louis. *L'Art et la littérature fantastique*. Paris: Presses Universitaires de France, 1960.

8

'Open the locksmiths': on the collaboration between surrealism and *Positif*

Michael Richardson

Discussions about the conjunction between surrealism and cinema have tended to revolve around the films made (or more often not made) by the surrealists over the course of the past century. The common perception remains that a specific surrealist interest in cinema peaked in the 1920s, reaching its apotheosis in the two Luis Buñuel–Salvador Dalí collaborations, after which time its interest in film culture gradually declined. Mainstream film criticism generally focuses on the 'legacy' of this period, and the influence exerted by it on a range of film-makers who have emerged since that time and have been co-opted (often extremely fancifully and without any real grasp of the specificities of surrealism itself) to this legacy.

Little attention, however, has been paid to the substantial body of critical writings the surrealists themselves have devoted to the cinema. This is despite the fact that during the 1920s engagement with the cinema was part of the evolution of surrealism. The surrealists wrote scenarios for films they never expected to be made, and film criticism was a preoccupation for several of them. As Paul Hammond has noted, consideration of this material reveals an attitude towards cinema that is 'lyrical, subjective: notations made mentally in the dark, of images that crystallise the poetic response, that become in turn poetic material'.[1] This approach, as Hammond also notes, had something in common with the techniques of psychoanalysis, even if it aimed not to uncover matter repressed in the unconscious but to reveal the latent content of what was manifest. 'Here,' Hammond continues, 'was a project to be realised on every level: aesthetic, moral, social. Objectivised subjectivity could transfigure and redeem our perception and experience of reality by letting us into the affective clandestine life of the material world.'[2]

Robert Desnos and Antonin Artaud in particular took film criticism very seriously, writing about film in conjunction with their numerous scripts, only two of which were ever realised as films: Man Ray made *L'Étoile de mer* (1928; actually, this was drawn from a poem by Desnos rather than from one of the dozen or so scenarios he actually wrote) and Germaine

Dulac took a script by Artaud to make *Le Coquille et le clergyman* (1928) into an avant-garde film that both Artaud and the surrealists regarded as a betrayal of their ideas. This was, however, only the tip of the iceberg, as several other surrealists contributed a substantial body of film criticism that informed the early development of the movement in the ways traced by Paul Hammond in the introduction to his *Shadow and Its Shadow* (2000), which brings together some of the most important surrealist texts on the cinema.

It is true that, along with many other film critics, surrealists' interest in cinema diminished in the 1930s with the coming of sound, Artaud speaking of this as representing its 'precocious old age'. His complaint was that 'the elucidations of the spoken word have put a stop to the unconscious and spontaneous poetry of images; the illustration and the completion of the meaning of an image by the word show the limitations of the cinema'.[3] In contrast, though, Dalí saw sound as the saviour of cinema, bringing with it 'a marvellous impurity and an estimable confusion'.[4]

At the time most surrealists probably agreed with Artaud. Certainly, there was a reduction of surrealist interest in the medium of cinema over the next decade, even if during the 1930s the early surrealist theories about film were put into practice to a certain extent and in minor ways through films made by Joseph Cornell, Jacques Brunius, and Benjamin Fondane. Many other examples have followed, although these have remained isolated examples, and it might be said that a specifically *surrealist cinema* still awaits realisation.

Despite their apparent disagreement, Artaud and Dalí were nevertheless at one on what they demanded from cinema. Both called for films that focus on the concrete and eschew the abstract, that are generated in a spontaneous relation to the material which, as Artaud puts it, allows the lens to go to 'the heart of objects' and 'create its own world'.[5] And both place the emphasis on poetry as the essence of cinema, which Artaud finds in a documentary approach that allows the camera to reveal reality against the 'conscious choice of the mind', while Dalí extols the pre-war Italian 'hysterical cinema'.[6] Both too reject the experimentation of avant-garde films and agree about one film that offers the way forward: the Marx Brothers' *Animal Crackers* (1930). For Dalí it attains 'grave, persistent and brutalising, cold and transparent dispositions and contagions so rarely arrived at'.[7] For Artaud it adds to humour 'something disturbing and tragic, a fatality ... which slips in behind it, like the revelation of a dreadful illness on a profile of absolute beauty'.[8]

Following World War II, however, a new generation came to surrealism which was enamoured by cinema as it was, and which had no real interest in continuing the sort of theorisation of a potential cinema conceived from a surrealist perspective that was the concern of Artaud and Dalí and other

surrealists who had written on film between the wars. The emphasis became far more an analysis of what was surrealist about actually existing films.

These young cineastes would all become key figures both within surrealism and in the film community: Ado Kyrou, Gérard Legrand, and Robert Benayoun principally as critics; Georges Goldfayn and Michel Zimbacca as technicians in the industry – although all of them except Legrand also made films of their own. In 1951 they established their own film journal, *L'Âge du cinéma*, published by Kyrou and with Benayoun as editor. Its title contained a double sense: that the period in which they were living was precisely the 'age of the cinema', but also, as Breton noted in 'As in a Wood', the essay he published in issue nos 4–5 of the journal (August–November 1951), that an 'age of the cinema' is a particular part of the individual life process for people in the twentieth century.[9] This essay, which summarises the first generation of surrealists' disappointment with cinema, also contains Breton's somewhat condescending comment (doubtless a lightly barbed observation aimed at the young cineastes who had founded *L'Âge du cinéma*) that this was an 'age' we outgrow. In fact, most of these surrealist critics did not outgrow their love of cinema and would become significant figures in the development of film criticism in France.

L'Âge du cinéma wasn't a specifically surrealist journal, and it aimed to be a serious film magazine. Its first issue included essays by film-makers Elia Kazan and Billy Wilder on their respective latest films, *Panic in the Streets* and *Sunset Boulevard*, a report on the Montevideo film festival, and a close-up on British actress Margaret Rutherford alongside articles by Benayoun, Kyrou, and Benjamin Péret. In the double issue, nos 4–5, all the articles are written by surrealists and offer a rich panorama of surrealist responses to cinema almost entirely celebrating the surrealist potential of films actually made. Most articles were about films made by non-surrealists, although the issue does contain an essay by Jean-Louis Bédouin and Michel Zimbacca about their film *L'Invention du monde*, and the Belgian film-maker Henri Storck contributed 'La Rue', a scenario for a film never to be made. The issue also offers us advice on which directors we should see, alongside those we should avoid, so F. W. Murnau is recommended against D. W. Griffith, Clouzot against Cocteau, and Cooper and Schoedsack (the makers of *King Kong*) against the auteurists' favourite, Robert Bresson.[10] Disney, the 'Henry Ford of animation' comes in for particular censure (he is advised that 'having swallowed his umbrella', he ought to digest it), as does the critic André Bazin and his newly founded journal *Cahiers du cinéma*, something to which we will return. An obituary is given to Lewis Milestone, director of the admired *All Quiet on the Western Front* (1930), who was killed in Okinawa 'by censors, directors and especially by himself in agreeing to make what his masters wanted'. Milestone's death, of course, was not physical but moral: they

regarded his recent film *Okinawa* as a racist and militarist assertion of US power that betrayed his earlier testament against the ravages and stupidities of war. Although the publication of *L'Âge du cinéma* came to an end after its sixth issue, it set up a primer for surrealist film criticism that would have a significant afterlife.

Following the demise of the journal, Kyrou and Benayoun continued to write professionally about film, and both began contributing in particular to the journal *Positif*, which had been founded in 1952. Kyrou first published in the magazine in the tenth issue, in the summer of 1954, with reviews of *Chronicle of Poor Lovers* (*Cronache di poveri amanti*), a love story set during World War II directed by Italian Marxist Carlo Lizzani, *Five from Barska Street* (*Piatka z ulicy Barskiej*), directed by the Pole Aleksander Ford, and *Cómicos*, directed by the Spaniard Juan Antonio Bardem. The same issue also featured essays by Raymond Borde, who would become part of the surrealist film circle, on Buñuel's *Los Olvidados* (1950). Benayoun began contributing to *Positif* from the twelfth issue (November–December 1954) with an article about animated film.

Thus began an intense and fruitful collaboration between the surrealists and *Positif* that would last for almost half a century (at least until 1997, with the death of Gérard Legrand). During this time six surrealists – Robert Benayoun, Raymond Borde, Ado Kyrou, Petr Král, Gérard Legrand, and Paolo de Paranagua – served lengthy spells on its editorial board, Benayoun and Legrand being stalwarts of the journal from the 1960s to their deaths in the 1990s. Although there has been no surrealist representation on the editorial board since Legrand's death, surrealists such as Alain Joubert and Bertrand Schmitt occasionally still grace its pages. Other participants or fellow travellers in surrealism, such as Jacques Brunius, Jean Ferry, Georges Goldfayn, André Pieyre de Mandiargues, José Pierre, Roger Caillois, Jean Markale, and Paul Hammond, have also published in it from time to time. Without a consideration of this collaboration our understanding of the surrealist relationship with cinema is incomplete. It also adds a further dimension to how we regard French film criticism and the specific contribution that *Positif* has made to it.

Positif was founded in 1952 by Bernard Chardière in Lyons, and from the beginning it established itself in contrast to *Cahiers du cinéma*, founded the previous year by André Bazin, Lo Duca, and Jacques Doniol-Valcroze. Where *Cahiers*, a magazine that emerged from and continued a tradition in French criticism that was politically conservative (if not overtly right-wing) and Christian, often with an explicitly Catholic agenda that valorised individual choice and initiative, *Positif* was left-wing in orientation, agnostic if not atheist, and valorised collective values (both within film and society). This collective sense extended to the way the magazine was edited, never

having an editor-in-chief, but being put together by the editorial board, which comprised 'a group of friends who, drawn together by their love of cinema, would assemble every Sunday afternoon for three or four hours … to discuss the content of the next issues, select a cover, read the articles submitted to the editors and vote on whether or not they would be published'.[11] These were all characteristics that attracted the surrealists to the journal, and the latter aspect, with its resemblance to the organisation of the surrealist group, would undoubtedly have made the surrealists feel at home in its milieu. As Michel Ciment also emphasises, the fact that *Positif* was edited from Lyon, at least at the beginning, shielded it from the sort of Parisian cultural in-fighting to which *Cahiers du cinéma* too easily succumbed. In the 1950s and 1960s in France the stakes were high when it came to film criticism, which should not be divorced from the cultural environment in general, dominated as it was, on the one hand, by the Catholic establishment that *Cahiers* partly represented and, on the other hand, by Communist Party cultural apparatchiks who sought to impose an arid socialist-realist orthodoxy. Communist cultural authority was also allied, if sometimes uneasily, with Jean-Paul Sartre's existentialism. The fact that *Positif* situated itself outside of these currents, while being aligned in a non-partisan way on the left, also made it attractive to the critics within the surrealist circle.

Among the surrealists, Ado Kyrou was the one who most actively pursued and encouraged surrealist interest in film during the 1950s. Already in 1953 he had published *Le Surréalisme au cinéma*, the first book-length study of the subject that aimed to give an encyclopaedic account of how surrealism had been manifest in cinema from its beginnings, often in unheralded ways. Going far beyond the narrow focus of most critics, who considered the surrealist involvement within a very limited sphere, Kyrou regarded cinema itself as essentially surrealist and found its traces in hundreds of films. These traces usually had nothing to do with the intentions of the film-makers, but emerged from the context of the film and perhaps from the nature of cinema itself. Certain film-makers are nevertheless singled out for praise: Georges Méliès, Louis Feuillade, Jean Vigo, Josef von Sternberg, and above all Luis Buñuel. But Kyrou recognised no cultural hierarchy, and all films were treated as being on the same level. In this he was continuing the surrealist engagement with criticism in a way that opposes the conventional view of the high and the low as separable from one another. In the tradition of the journal *Documents* (1929–30), as conceived by Georges Bataille, all cultural manifestations should be treated as emerging from the same source and not be regarded as unique creations of inspired individuals. Horror films, melodramas, film noir, westerns, adventure stories, and animated and comedy films were therefore considered with the same seriousness as the work of supposed 'masters of the art of film'. Kyrou defined his approach to

criticism in these terms: 'Poetic and frenzied criticism, which takes account of everything not visible, of the whole mystery of a film, is the only sort from which necessity imperatively arises. The critic must begin with a fiercely personal interpretation, with the shock produced by the encounter between the film object and the self subject, in order to objectivise its hidden beauties.'[12] In 1957 Kyrou published a sequel to *Le Surréalisme au cinéma*, *Amour, érotisme et cinéma*, in which he extended his arguments, looking most specifically at how love had been treated in film.

The two books reveal Kyrou's strengths and weaknesses as a critic – he had a tendency towards advocacy and bombast, but what he lacked in subtlety he nevertheless made up for in enthusiasm. His two books (still untranslated into English) remain essential starting points for any understanding of how surrealists approach the nature of cinema. This went beyond the actual films viewed. Kyrou was also concerned to celebrate the cinema as a privileged surrealist locale. This was made more apparent in *Manuel du parfait petit spectateur*, published in 1957, a tongue-in-cheek guide to how to behave in the cinema, accompanied with drawings by the great illustrator Siné. If Kyrou writes with a self-certainty that may be off-putting to readers today, it should be remembered that in the 1950s he was fighting not only for a surrealist way of understanding cinema but for film criticism tout court.

Kyrou had just published *Le Surréalisme au cinéma* when he began contributing to *Positif*. His articles range over a wide number of films and topics, from musicals to science fiction and westerns, and he regularly reviewed new films by directors he favoured, notably Ingmar Bergman, Buñuel, John Huston, and Andrzej Wajda. Noteworthy articles include one on science fiction, 'La Science et la fiction' (Science and Fiction) (no. 24, May 1957), and a particularly illuminating one on two 1955 gangster movies, which Kyrou sets against one another. Stuart Heisler's *I Died a Thousand Times*, a remake of *High Sierra* (originally made by Raoul Walsh in 1941), is held up as exemplary in its representation of the outlaw as a rebel, while William Wyler's *The Desperate Hours* is dismissed as a 'simple apology of petty-bourgeois life'.[13] Wyler himself is described as 'an habitual bore, bourgeois to the end of his camera'. This alerts us to the fact that surrealist criticism treats the content of a film as standing for certain moral qualities: Heisler's film endorses the revolt of its outlaw couple, while Wyler's upholds the virtues of family life and common decency against its disruption by the forces of disorder.

Kyrou's interests were not confined to film. In 1953 he founded the journal *Bizarre* with Michel Laclos and Jean Ferry, which would go on to become a cult magazine dedicated to the cultural margins. Its first issue was devoted to the work of Gaston Leroux, author of *The Phantom of the Opera* and one of Kyrou's favourite writers. *Bizarre* would continue to be published

until 1968. Kyrou also tried his hand at film-making, directing a clutch of short films between 1957 and 1964, including *Le Palais idéal* (1958), about the palace constructed by the Facteur Cheval in the south of France. He also made two feature films, *Bloko* (1964), a gritty story of the Resistance in Greece during World War II, which drew on his own experiences as a young man during the war, and a misconceived and rather vulgar version of Matthew Lewis's gothic novel *The Monk* (1972).

Kyrou's contribution to *Positif* is largely confined to the 1950s. Although he remained on the editorial board until the early 1970s, he published little during the 1960s, and his final article, a review of *Night of the Living Dead*, appeared in 1970.

Raymond Borde's involvement with surrealism was more marginal than the others who contributed to *Positif*. Based in Toulouse and trained as a lawyer, he was a member of the Communist Party, from which he took his leave after publishing an article attacking Stalinism in 1958. In 1963 he published *L'Extricable*, a political pamphlet which, along with two films he made in 1960 and 1964 about the surrealist artists Adrien Dax and Pierre Molinier respectively, constitutes his most significant contribution to surrealism.

Borde became involved with film in 1952, setting up a film club in Toulouse, and he joined *Positif* after having written, in collaboration with Etienne Chaumeton, the seminal *Panorama of American Film Noir*, published in 1955. The book had considerable significance not simply as the first study of film noir but also in its sociological approach, treating noir as a manifestation of the sensibility of an age. Characteristic of his contributions to *Positif* was an article on William Wellman (issue 114, March 1970) in which he explores with some subtlety the contradictions of this quintessentially American director, whose films veer between those displaying patriotic and conformist sentiments and others standing as powerful and often subversive social dramas.

In 1964 Borde founded the Toulouse Cinémathèque, of which he would continue to be the programmer until 1996. This activity preoccupied him, and he devoted himself to the problems of film conservation and archiving. The stand he took in 1968 in support of Minister of Culture André Malraux's attempt to remove Henri Langlois, its legendary founder, from his post at the Cinémathèque français alienated him from his surrealist friends, and he left the editorial board of *Positif* in the early 1970s.

Much more than either Kyrou or Borde, it was Robert Benayoun who really put a surrealist stamp on *Positif*. His first article, entitled 'Bilan du nouveau dessin animé' (Consideration of Recent Animated Films), appeared in issue 12 (November–December 1954) (Figure 8.1). It was followed in the next issue by an essay about Fellini's *La Strada* (1954). Over the years Benayoun published hundreds of articles in the magazine (as well as in other film journals), which, were they collected, would run to several book-length

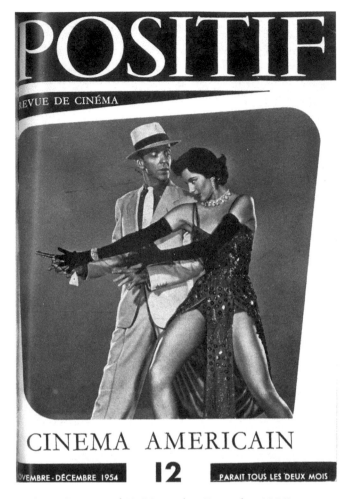

Figure 8.1 *Positif* 12 (November–December 1954), cover

volumes. His final article for *Positif* was a review of Woody Allen's *Alice* (issue 362, 1991), one of the many he wrote about Allen (to whom he also devoted one of his books) over the years. Alain Joubert paid warm tribute to Benayoun upon his death with an article appropriately entitled 'That's All, Folks!' (*Positif*, issue 439, 1997).

Benayoun was a man of myriad enthusiasms. His first book was a collection of his own cartoons, with a preface by Benjamin Péret. An Anglophile, he kept the French surrealist group up to speed with developments in English and American popular culture, translating Charles Fort's *Book of the Damned* among other works and publishing an anthology of nonsense in which English and American writers featured heavily. He also published an

important study of eroticism in surrealism, *Érotique du surréalisme* (1965), and his final book, *Le Rire des surréalistes* (1988), was devoted to showing that surrealism, beyond ideological issues, was above all about having fun. He also wrote several plays, directed three films, and was a cartoonist and the inventor of the photographic technique of imagomorphosis.

As a film critic, Benayoun is probably best known in the English-speaking world as one of the more vocal of those French critics who celebrated the 'genius' of Jerry Lewis. His first essay about the American comic, 'Simple-Simon, ou l'anti-James Dean' (Simple-Simon, or the Anti-James Dean), appeared in issue 29 (1958), and he would remain a devotee over the years, publishing a book about him, *Bonjour, Monsieur Lewis*, in 1972. If Benayoun had a tendency to go overboard in his praise for Lewis (whom he physically resembled and considered a kind of alter-ego), he was a many faceted critic with an often sharp insight and deceptive subtlety. Benayoun was an early advocate of the genius of comedy, animation, and musicals, a champion not only of Lewis but also of W. C. Fields, Tex Avery, Chuck Jones, Monty Python, and Woody Allen. Author of a groundbreaking book on animation, he also wrote monographs on the Marx Brothers, Woody Allen, Buster Keaton, and Alain Resnais.[14]

It is, however, impossible to sum up Benayoun's film criticism, so widely did it range. His favourite directors, whose new films he generally reviewed for *Positif*, were Resnais, Antonioni, Buñuel, Walerian Borowczyk, Robert Altman, Sam Peckinpah, Richard Lester, and Huston. He was vituperative against anyone he considered a 'snob' and was prepared to defend his favoured films and directors in a sometimes fervent manner. An early article, 'Docteur Bergman et monsieur Hyde' (Doctor Bergman and Mister Hyde) (issue 30, July 1956), gives a flavour of his approach. A critique written on the occasion of the opening of what Benayoun considered three very poor films by Bergman, it is not so much critical of Bergman himself as of the adulatory complacency with which his films were being received in Paris (the snobbism that makes a cult of a particular director independently of the quality of his work). At this point in his career Bergman had made eighteen films. Acknowledging that among them were four masterpieces and three partial successes, Benayoun dismisses the other eleven, including the three recently shown, as unqualified failures and pastiches. Benayoun would later (issue 267) pen a superb article, 'La Somme d'un nuit d'hiver' (The Sum of a Winter Night), extolling Bergman's elegiac feature *Fanny and Alexander*, which at the time was thought likely to be the director's final film and testament.

Gérard Legrand published almost as many articles in *Positif* as Benayoun and, similarly, if they were collected together they would constitute several hefty volumes. He first appeared in the magazine in 1961 and thereafter became a regular contributor until his death in 1997. A more cerebral

character than Benayoun, Legrand was a poet and a philosopher, an art as well as a film critic, an expert on pre-Socratic philosophy, and the author of an important work of Hegelian criticism, *Préface au Système de l'éternité* (1971). He was also André Breton's collaborator on *L'Art magique* (1957), a new history of art emphasising its links with magic which was in many ways the surrealist leader's testament about the role of art.

Unlike Benayoun and Kyrou, Legrand separated his film criticism from his activity as a surrealist. And, indeed, one will find little of their sense of advocacy or taste for polemic: most of his reviews are marked by sobriety and a seriousness of purpose. His tastes may also appear rather confounding at first glance from a surrealist perspective. He completely ignores Buñuel, whose films he apparently disliked, as well as most of those film-makers generally valorised by surrealists (the flamboyance of Josef von Sternberg's films left him cold, for instance). He was attracted to thrillers, Italian comedies, and generally to films that he saw as being conjoined in some way with his philosophical interests. A good example of this is a fascinating review of John Boorman's *Hell in the Pacific* (1968) (issue 109, October 1969), which Legrand analyses in terms of Hegel's master and slave dialectic. This philosophical approach is very lightly applied, however, arising from the nature of the film in question rather than being imposed on to it. His favourite directors, among many others, were Otto Preminger, Fritz Lang, Joseph Losey, Kenji Mizoguchi, and – most surprising of all – Eric Rohmer. Notable among his articles are several about actors and actresses. A particularly significant one is on Gene Tierney, 'Deux ou trois choses que je sais de l'absolu' (A Thing or Two I Know about the Absolute) (issue 371, January 1991), in which he sees the actress as having a radiance on screen that comes to embody a beauty that, 'at once fossilised and fleeting', transcends her own personality and limitations as an actress to offer a glimpse of the absolute. In a reflective note published in *Positif* in 1981, Legrand explains that for him the cinema offers greater possibilities than anywhere else of finding 'a droplet of the Absolute on a glass blade'.[15] He might have separated his film criticism from his other surrealist writing, but it is still clear that surrealism remained at the root of it.

The Czech surrealist Petr Král left Prague at the time of the invasion of Czechoslovakia by Warsaw Pact countries in 1968 and found himself in Paris. He began contributing to *Positif* the following year with an article about silent comedian Larry Semon (issue 106, June 1969).[16] The majority of Král's contributions to *Positif* over the years would be concerned with comedy, and he published two volumes devoted to the topic of silent comedy, both of which were published in 1984.[17] Aside from being a writer on film, he is also a poet and prose writer whose works have recently begun to be published in English translation. He has also written and published widely on surrealism, including a study of photography in surrealism and

anthologies of surrealism in Czechoslovakia (*Le Surréalisme en Tchécoslovaquie*, in French, 1983), and Belgium (*Marble Is Eaten Cold*, in Czech, 2010). He has also translated André Breton into Czech.

Where Legrand is cerebral, Král is restless, a wanderer who passes through rather than watches films, catching glimpses of what might be as much as what is. He shares a reflective sense with Legrand but in a more poetic than philosophical way (insofar as they can be separated). Král has given a fascinating and precise account of his approach to film in a text entitled 'La Chair des images' (The Flesh of Images) (*Positif*, issue 243, June 1981). He is, he says, only drawn to films that have a 'fervent' quality. He has little interest in their dramatic or moral qualities and is concerned with a 'vertigo faced with a certain *physical* (or erotic) density' that is 'situated between sensual perception and its continuation in the imagination'. This may arise independently of the story. What he expects from films, as what he expects from reality in general, is 'at once density and exposure to air'. This is what explains his attraction to silent cinema and especially to slapstick comedy (its 'custard-pie morality'). His favourite director, at least for his early films, is Wim Wenders, and he has also written brilliant essays on Andrei Tarkovsky and Louis Feuillade. He also published in *Positif* a long essay on Buñuel's *L'Âge d'or* (issue 247) in which he dismantles some of the mythology that has accrued to this surrealist masterpiece.[18]

The final member of the *Positif* surrealist crew is Paolo Antonio Paranagua (or Paolo de Paranagua). He had been a member of the Brazilian Surrealist Group during the 1960s, an organiser of the 1967 International Exhibition of Surrealism held in São Paulo, *A Phala*, for which he wrote a programmatic manifesto, 'For a Violent Cinema', protesting the domestication of film and advocating a cinema that would be a 'forerunner of delirious commotion capable of violating the citadels of the cowardly for allowing a single citadel to remain standing'.[19] In 1966 Paranagua made a short film based on Breton's *Nadja*, but this appears to have been lost in the mists of time. In 1973 he was arrested along with several colleagues by the Argentinian military regime and held on charges of subversion. An international campaign organised by the surrealists secured his release, and he made his way to Paris and joined *Positif*. By 1981, however, his fervour was somewhat tempered. He wrote that he now considered 'the relations between surrealism and cinema [to] constitute an unfortunate love story'. Surrealist cinema, he proclaims, doesn't exist 'with the immense exception of Saint Luis Buñuel'. While surrealist cinephilia did exist, he continued, it was becoming increasingly difficult to practise because, without himself renouncing surrealism, 'Cinephilia has been intellectualised, whether one wants it or not, it is almost paradoxical to confess a counter current to this universal tendency'.[20] In his articles for *Positif* Paranagua has been more concerned to promote Latin American cinema

than establish a distinctive position as a film critic, and it is therefore not so easy to discern what his film criticism owes to his surrealism.

Each of the surrealists who wrote for *Positif* developed their own approach to film criticism which owes little to that of one another, and in an objective sense it is difficult to detect any 'family resemblance' in their writings that would differentiate their articles from those of the other contributors to *Positif*. As Michel Ciment emphasised, *Positif* has always been constituted as a meeting point for friends united by their cinephilia. Its distinguishing feature has been to remain open to a range of perspectives combined with a combative attitude in support of the sort of cinema it endorsed. The surrealist participants were always responsive to this collective sense (which, indeed, was one of the reasons for their attraction to the journal) and had no wish to impose their own agendas on to it. Nevertheless, surrealist ideas were inflected through the journal by this surrealist collaboration, and the approach towards cinema that *Positif* has consistently maintained is one that surrealists could hardly fail to endorse.

The essential attitude that underlay the publication was an awareness that film did not exist in a vacuum, inured to the broader social, aesthetic, and philosophical issues existing alongside it and to which a film's realisation gave rise. In choosing its name, the journal was indicating that it would assume a positive attitude towards the possibilities of cinema. This chimed with what André Breton at the time was condemning as 'miserabilism', defined as 'the offspring of the perfect coupling of those two vermin, Hitlerite fascism and Stalinism'.[21] If there was a consistent 'line' in *Positif* which drew the surrealists into its ambit, it was probably its commitment – at a time of political and aesthetic puritanism – to cinema as an aspect of the pleasure principle linked to the currents of everyday life, combined with a corresponding hostility towards any sort of didacticism or reductionism. Although from the very beginning situated politically on the left, *Positif* was opposed to ideological dogmatism of any sort about the form cinema should take, something which above all set it at odds with *Cahiers du cinéma*, the journal that would be its perpetual rival.

In order to appreciate the specificity of *Positif*, we need to take into account the significance of its dispute, and frequent confrontations, with *Cahiers*, especially since Benayoun played an important role in these debates.

Cahiers du cinéma, founded in 1951, soon became the most influential film magazine in the world, a position it maintained throughout the 1950s, 1960s, and, in a more problematic way, the 1970s. Like *Positif* it was formed in the context of post-war French cinephilia, and the two magazines initially had much in common: a desire to take film seriously and a fascination with the films coming from Hollywood; and, more generally, both pitted themselves against French cultural parochialism. But from the beginning *Cahiers*

established an ambitious agenda that would impel it into the cultural mainstream, whereas *Positif* was content to remain more 'marginal'.

We have already seen some general points of divergence in the attitudes represented by the two magazines. Let us now look at them in more detail and seek to identify why this is a matter that concerns surrealism and its approach to film criticism.

In its early decades, the evolution of *Cahiers* was played out in three distinct phases. In the 1950s it was identified with the notion of the *politique des auteurs* (the 'auteur theory' as it came to be known in English language criticism). Valorising the author as the creator of a film, this phase was identified most clearly with the work of André Bazin. The second phase begins around 1957 (the year Bazin died), when *Cahiers* becomes the preserve of a group of young critics who would become some of France's most important directors over the next decade, constituting what would become known as the *nouvelle vague* (new wave). These critics-later-to-turn-directors – François Truffaut, Jean-Luc Godard, Jacques Rivette, Rohmer, and Claude Chabrol – would effect a revolution (or, *Positif* writers would argue, more of a 'palace coup') that had profound consequences not only for French cinema but also for that of cinema internationally. The third phase of *Cahiers* would occur post-1968 and entail an abrupt volte-face as it assumed an ultra-gauchiste mode, in which it embraced post-structuralism and Maoism. The writers of *Positif* would strongly oppose each of these phases, often ridiculing the stances taken by the editors and writers of *Cahiers*. When, in December 1961, *Cahiers* issued a questionnaire asking its readers what its significance had been, it received a negative response from Benayoun, although another *Positif* writer, Louis Seguin, was still more caustic: 'I don't think that *Cahiers* has contributed anything at all.'[22]

We have already seen some of the general divergences between the two magazines: collective editorship by a group of friends (*Positif*) versus a clear editorial line (*Cahiers*), a taste for marginality (*Positif*) versus a will to take centre stage (*Cahiers*), a concern to consider film in its historical, social, and political context (*Positif*) versus a somewhat 'formalist' concern to treat it purely in its own terms as film (*Cahiers*). It may appear that, given the enormous influence wielded in the film world by *Cahiers*, the *Positif* critics were doing no more than tilting at windmills. It is true that their influence has been limited in terms of theory and especially in terms of practice, as none of its critics became important directors. We noted that Kyrou and Benayoun did make some films, but with the best will in the world one can only see them as damp squibs compared with the splash made by the *Cahiers* critics mentioned above, all of them, by any criterion, major film-makers who have changed the history of film. In contrast, *Positif* could only lay claim to one significant director directly associating himself with the magazine

– Bertrand Tavernier – even if it might be said that it shared a sensibility with what were sometimes known as the 'Left Bank' film-makers (Chris Marker, Resnais, Agnès Varda). Nevertheless, the critique(s) of the positions of *Cahiers* that *Positif* made over the years still resonate today and are important not only for film debates, but also for an understanding of the relation of surrealism and cinema.

The hostility of the surrealists to *Cahiers* in its beginnings is not difficult to understand, since the magazine was an offshoot of a whole tradition of Catholic and right-wing-inflected media. We have already seen an anonymous comment in issues 4–5 of *L'Age du cinéma* in which the surrealists took pot shots both at *Cahiers*, dismissing the writers in issues 3, 4, and 5 as 'specialists in literary-aesthetic jargon, devoted to the task of making first truths completely unintelligible', and at Bazin, who is ironically praised as a great humourist for the absurdity of his statements. As *Cahiers* evolved, becoming more ideological in strictly cinematic terms, as it asserted the claims of the *politique des auteurs* and placed an increasing emphasis on mise-en-scène, the critique made not only by the surrealists but also by other *Positif* writers would become more refined. At issue for the surrealists in particular was the attitude *Cahiers* took towards popular culture.

Given their interest in popular culture, one might have expected the surrealists to welcome the fact that *Cahiers* took Hollywood cinema seriously, but the approach taken by its critics was the exact opposite of theirs. For the surrealists the division between high culture and popular culture is illusory: any manifestation of culture should be treated on the same level. The valorisation of Hollywood cinema by *Cahiers* did the opposite by seeking to raise it to the level of an 'art'. This was what made the theory of the *politique des auteurs* so important, since by making the director the author of a film it would become possible to analyse film in the same way as 'great' literature or art, as a creation of an artist's unique vision. Without denying the decisive role played by the director in the making of the film, for the critics of *Positif* the director was but one chain in the fundamentally collaborative nature of film, both at the level of how the film was made and how it would be received by audiences. More specifically in the surrealist context, the very idea of the *politique des auteurs* went against Ducasse's injunction for poetry to be made by all, something that cinema more than any other medium, due to its collective nature, was inherently attuned to be able to achieve. For Benayoun, writing in 1962, the *politique des auteurs* constituted 'a new sort of bottle opener that constantly found the wine disappointing'.[23]

It was, however, the emphasis on mise-en-scène, offering a means by which a film could be seen as resulting from a purely technical operation enabling the director's vision to be expressed, that would lead to the second phase of *Cahiers*. In this phase it would initiate and promote the *nouvelle*

vague in French film-making, which Benayoun would derisively dismiss as 'a cinema of furnishing' that would act as a straitjacket to prevent the film from expressing itself.[24] For Benayoun these film-makers' only desire 'is to make films without even thinking about what they want to say'. Indeed, they are 'secretly proud of having nothing to say, but of saying it well'.[25]

Benayoun would be even more acerbic about *Cahiers* a decade later in a long polemical article entitled 'Les Enfants du paradigme' (Children of the Paradigm). By now *Cahiers* was in its 'Maoist' phase, having simultaneously embraced ultra-leftism and post-structuralism. And so Benayoun excoriates the opportunism of *Cahiers*, its tendency to chase intellectual trends even when they contradicted its own previous intellectual viewpoint without providing any explanation of its volte-face. Earlier valorisation of the author espoused by the *politique des auteurs* (which by now had become an 'abominable idea' for the new critics of *Cahiers*) could now be erased by that of the 'death of the author' popularised by late structuralism, although not completely, since the 'author' becomes not the living individual but the 'text' or, as Benayoun put it, referring to the way in which *Cahiers* had recently analysed Buñuel's *Tristana*, 'the complex of productivity and reading responding to the name of the code Buñuel'.[26]

Against this sort of closure, Benayoun, and the writers in *Positif* generally, seek to enlarge the film, giving the reader different ways to think about it. They do not strive to 'read' the film but to 'see' it more clearly. It may be more accurate to say that in the main they are less *critics* in a strict sense than *essayists*. This is certainly so of the surrealist writers, whose intent is not principally to subject the film to a critical analysis but to enlarge its frame of reference, to enable the reader to see it in a broader perspective. This can perhaps be said to be the main consistent focus of the journal over the years.

In some ways such an approach was already set out by Louis Aragon in an early essay:

> If today the cinema does not always show itself to be the powerful evocator it might be [...] it is because the *metteurs en scène*, though sometimes possessed of a keen sense of its beauty, do not recognise its philosophical qualities. I would hope a film-maker were a poet and a philosopher, and a spectator who judges his own work as well. Fully to appreciate, say, Chaplin's *The Vagabond*, I think it indispensable to know and love Pablo Picasso's 'blue period' paintings, in which slim-hipped Harlequins watch over-upright women comb their hair, to have read Kant and Nietzsche, and to believe one's soul is loftier than other people's. You're wasting your time watching *Mon gentilhomme batailler* if you haven't first read Edgar Allan Poe's 'The Philosophy of Furniture', and if you don't know *The Adventures of Arthur Gordon Pym*, what pleasure can you take in the *Naufrage de l'Alden-Bess*?[27]

These words, addressed to film-makers, are perhaps more pointedly directed to critics. For Aragon décor was not a matter of positioning but of *literacy* in its broadest sense – not as the ability to read but as the ability to make connections. It is not enough to *see* what is in front of our eyes; we also need to be able to relate that to what is not directly seen, but upon which that immediate effect depends in terms of intellectual, cultural, social, and political referents. This was what Benayoun insisted on forty years later in saying that a film-maker needs 'an aesthetic and philosophical training able to differentiate creation from mere supervision or *mise-en-scène*'. He emphasises the point with a quotation from jazz pianist Oscar Peterson, that a good pianist needs not to be taught style, but how to think.[28]

Each of the surrealist writers who contributed to *Positif*, though they may be very different in their approaches and tastes, were responsive to Breton's demand to envisage a picture as a window – we need to know what it looks out on – and his insistence that 'nothing appeals to me so much as a vista stretching away before me and *out of sight*'.[29]

This concern to see beyond what is immediately perceptible in a film is what all surrealists share. Moreover, Kyrou, Benayoun, Legrand, and Král in particular, while they may have been passionate about cinema, were equally so about history, philosophy, art, and anthropology. All of them were poets in the surrealist sense, and this is something that characterises all of their contributions to *Positif*, each issue of which has been a thing of beauty, its aesthetic informed by surrealist techniques of juxtaposition and transposition. As Benayoun intimated with the epigraph from Lichtenberg that he used at the head of 'The Children of the Paradigm', it is a matter of opening not the locks but the locksmiths.

Notes

1 Hammond, 'Available Light', 6.
2 Ibid., 9.
3 Artaud, *Collected Works*, 78.
4 Dalí, 'Abstract of a Critical History of the Cinema', 65.
5 Artaud, *Collected Works*, volume 3, 76.
6 Dalí, 'Abstract of a Critical History of the Cinema', 64.
7 Ibid., 66.
8 Artaud, 'The Marx Brothers', 240.
9 Breton, 'As in a Wood', 72–7.
10 The complete list can be found in Hammond, *The Shadow and Its Shadow*, 46–7.
11 Ciment, 'For Your Pleasure', 9.
12 Kyrou, *Le Surréalisme au cinéma*, 279.
13 Kyrou, '*La Maison des otages*', 43.

14 See Benayoun, *Le Dessin animé après Walt Disney*; *Les Marx Brothers*; *Woody Allen beyond Words*; *The Look of Buster Keaton*; and *Alain Resnais*.
15 Legrand, [untitled note], 64.
16 Translated as Král, 'Larry Semon's Message', 166–72.
17 See Král, *Le Burlesque ou morale de la tarte à la crème*; and *Les Burlesques ou parade des somnambules*.
18 Král, 'L'Age d'ôr aujourd'hui', 44–50.
19 Paranagua, 'Manifesto for a Violent Cinema', 43.
20 Paranagua, [untitled note], 38–41.
21 Breton, *Surrealism and Painting*, 347.
22 In 'Enquête', 81.
23 Benayoun, 'The Emperor Has No Clothes', 167. Translation modified.
24 Ibid., 172.
25 Ibid., 171.
26 Benayoun, 'Les Enfants du paradigme', 20.
27 Aragon, 'On Décor', 52.
28 Benayoun, 'The Emperor Has No Clothes', 175. Translation modified.
29 Breton, *Surrealism and Painting*, 8. Breton's emphasis.

Bibliography

Aragon, Louis. 'On Décor'. In *The Shadow and Its Shadow: Surrealist Writings on the Cinema*, 3rd edn, edited and translated by Paul Hammond, 50–4. San Francisco, CA: City Lights, 2000.
Artaud, Antonin. *Collected Works*, volume 3. London: Calder & Boyars, 1972.
———. 'The Marx Brothers'. In *Selected Writings*, edited by Susan Sontag, 240–2. New York: Farrar, Straus and Giroux, 1976.
Benayoun, Robert. *Alain Resnais, arpenteur de l'imaginaire*. Paris: Stock, 1981.
———. 'Bilan du nouveau dessin animé'. *Positif*, no. 12 (November–December 1954): 17.
———. *Bonjour, Monsieur Lewis*. Paris: Losfeld, 1972.
———. *Le Dessin animé après Walt Disney*. Paris: Jean-Jacques Pauvert, 1961.
———. 'Docteur Bergman et monsieur Hyde'. *Positif*, no. 30 (1956): 39–41.
———. 'The Emperor Has No Clothes'. In *The French New Wave: Critical Landmarks*, edited by Peter Graham with Ginette Vincendeau, 163–86. London: BFI, 2009.
———. 'Les Enfants du paradigme'. *Positif*, no. 122 (1970): 7–26.
———. *John Huston*. Paris: Seghers, 1966.
———. *The Look of Buster Keaton*, translated by Russell Conrad. New York: St Martin's Press, 1983.
———. *Les Marx Brothers*. Paris: Seghers, 1980.
———. 'Simple-Simon, ou l'anti-James Dean'. *Positif*, no. 29 (1958): 18–22.
———. 'La Somme d'une nuit d'hiver'. *Positif*, no. 267 (1982): 23–5.
———. *Woody Allen beyond Words*, translated by Alexander Walker. London: Pavilion, 1987.

Borde, Raymond. 'L'épopée à la mesure de l'homme: William Wellman'. *Positif*, no. 114 (March 1970): 36–41.

Borde, Raymond, and Etienne Chaumeton. *Panorama of American Film Noir 1941–1953*, translated by Paul Hammond. San Francisco, CA: City Lights, 2002.

Breton, André. 'As in a Wood'. In *The Shadow and Its Shadow: Surrealist Writings on the Cinema*, 3rd edn, edited and translated by Paul Hammond, 72–7. San Francisco, CA: City Lights, 2000.

———. *Surrealism and Painting*, translated by Simon Watson Taylor. New York: Harper & Row, 1972.

Ciment, Michel. 'For Your Pleasure: A Brief Overview of Fifty Years of *Positif*'. In *Positif: 50 Years*, edited by Michel Ciment and Laurence Kardish, 9–13. New York: Museum of Modern Art, 2002.

Dalí, Salvador. 'Abstract of a Critical History of the Cinema'. In *The Shadow and Its Shadow: Surrealist Writings on the Cinema*, 3rd edn, edited and translated by Paul Hammond, 63–67. San Francisco, CA: City Lights, 2000.

'Enquête: La critique'. *Cahiers du cinéma*, no. 126 (1961): 49–84.

Hammond, Paul. 'Available Light'. In *The Shadow and Its Shadow: Surrealist Writings on the Cinema*, 3rd edn, edited by Paul Hammond, 1–45. San Francisco, CA: City Lights, 2000.

———, ed. *The Shadow and Its Shadow: Surrealist Writings on the Cinema*, 3rd edn. San Francisco, CA: City Lights, 2000.

Joubert, Alain. 'That's All, Folks!'. *Positif*, no. 439 (1997): 66–7.

Král, Petr. 'L'Age d'ôr aujourd'hui'. *Positif*, no. 247 (1981): 44–50.

———. *Le Burlesque ou morale de la tarte à la crème*. Paris: Stock, 1984.

———. *Les Burlesques ou parade des somnambules*. Paris: Stock, 1984.

———. 'La Chair des images'. *Positif*, no. 243 (1981): 37–9.

———. 'Larry Semon's Message'. In *The Shadow and Its Shadow: Surrealist Writings on the Cinema*, 3rd edn, edited and translated by Paul Hammond, 166–72. San Francisco, CA: City Lights, 2000.

Kyrou, Ado. *Amour, érotisme et cinéma*. Paris: Le Terrain Vague, 1967.

———. '*La Maison des otages, la peur au ventre*, bourgeois et gangsters'. *Positif*, no. 17 (June–July 1956): 43–5.

———. 'La Science et la fiction'. *Positif*, no. 24 (May 1957): 29–34.

———. *Le Surréalisme au cinéma*, 3rd edn. Paris: Le Terrain Vague, 1985.

Legrand, Gérard. *Cinémanie*. Paris: Stock, 1979.

———. 'Deux ou trois choses que je sais de l'absolu'. *Positif*, no. 371 (January 1991): 50–2.

———. 'No Way Out (*Hell in the Pacific*)'. *Positif*, no. 109 (October 1969): 14–18.

———. [untitled note]. *Positif*, no. 242 (1981): 62–4.

Paranagua, Paulo de. 'Manifesto for a Violent Cinema'. *Cultural Correspondence*, special issue 'Surrealism and its Popular Accomplices', nos 10–11 (1979): 43.

———. [untitled note]. *Positif*, no. 246 (1981): 38–41.

9

Mobile surrealism: Leonora Carrington's cinematic adventures in Mexico

Felicity Gee

The collaborative nature of surrealist practice often determines exciting adventures across and between artistic media. My focus in this chapter is a screen adaptation of Edgar Allan Poe's 'The System of Dr Tarr and Professor Fether' directed by Mexican film-maker Juan López Moctezuma. *Mansion of Madness* (*La mansión de la locura*, 1973) reimagines Poe's château-asylum, dramatically heightening the story's attention to eroticism, esoteric symbolism, and gender politics. Its distinctive mise-en-scène is attributed to Leonora Carrington and her son Gabriel Weisz Carrington, who were invited by Moctezuma to collaborate on the film, Carrington credited with 'supervisión artistica' (which includes set and costume design) and Weisz Carrington with 'realización artistica'. Although neither mother nor son seemed to take their involvement in the film too seriously, the costumes and décor create a world populated with objects and tableaux that reference and repeat those present in Carrington's previous work. Moctezuma's slapstick and deliberately kitsch reimagining of Poe's tale affords the viewer a rare opportunity to encounter Carrington's creative imagination through an entirely new medium. Despite Weisz Carrington's recollection of the film shoot, outlined below, which clearly posits the experience as a form of game, the film nevertheless functions as an archive for their artistic contributions. Crafted and collected by their hands, still lifes, costumes, furniture, and locally sourced objects are suspended within the château-asylum's strange world, which, with its endless chambers and cells, echoes the 'cellular' composition of many of her paintings.

A work of black humour, threaded through with an uncanny eroticism that explores sexual power dynamics – naked female bodies served as banquets, bound or caged; *femme-enfants* chased wearing diaphanous white garments; and overly made-up women performing the Gothic trope of the madwoman – *Mansion* is in dialogue with both the Gothic and surrealism. The film is part of a mobile legacy of surrealism, and a significant work in Carrington's oeuvre. By mobile, I refer in the first instance to the migration

of surrealist artists and writers, those forced to a life in exile and those uprooted for other reasons, which resulted in the cross-pollination of surrealist ideas and styles across the world. But I also refer to aspects of surrealist practice that are adapted by individual artists around surrealism's 'shifting point of magnetism'.[1] Moctezuma and Carrington each occupy a particular position in this mobile constellation. Poe's work stages Gothic structures of repression that inspired the Paris surrealist group. Moctezuma, while not a surrealist, perpetuates the spirit of *dépaysement* in *Mansion*'s radical staging of 'madness' and its condensation of multiple spatio-temporal realities.

Housing madness

The asylum was a perennial trope in many early-twentieth-century films across the world, and was often accompanied by scenes of criminality and Gothic horror.[2] In films of the 1920s and 1930s, the dramatic potential of the nineteenth century's dark Romanticism and Gothic literature was harnessed in order to explore the hidden depths of modern life as well as the mechanical wonders of the camera. As early as 1909, Edison Studios adapted Poe's short story 'The System of Dr Tarr and Professor Fether' for the big screen, giving it the sensationalist title *Lunatics in Power*. The film only survives in reviews from newspapers of the time, which highlight its slapstick humour and criticise its perceived lampooning of the mentally ill. As a critic for *Moving Picture World* illustrates: 'The advisability of using any affliction as serious as lunacy as a basis for sport is questionable.'[3] Yet Poe's story reveals a strain of black humour in its radical inversion of the 'private Mad House', where the patients are 'soothed' and liberated, and the superintendent, Monsieur Maillard, is clinically insane.[4] 'Dr Tarr and Professor Fether' satirises French nineteenth-century state institutions and their highly irregular methods of determining what lay beyond the realm of sanity.

Poe's Gothic tales combine mad love with obsession, paranoia, and a wilful malevolence that thrilled André Breton, fulfilling his designation of black humour as the 'mortal enemy of sentimentality'.[5] As has been well documented, surrealism is often underpinned by a fascination with madness, criminality, perversion, and irrational impulses.[6] For surrealists, unexpected and marvellous aspects permeate every waking moment, removing the binary divide with which society attempts to separate reality and imagination. Film has a key part to play in the realisation of this ineffable surrealist threshold at the intersection of thought and the material world. The camera and sound-recording apparatus capture states of becoming, and editing can conjure the 'magic-circumstantial'.[7] Moreover, in surrealism,

film 'is a privileged medium for staging … ambivalent identities in signifiers in continual flux'.[8] This enables film-makers to present selves and bodies that are multiple and unbound, figures that are capable of intense spiritual and physical transformation. For Breton the ever-becoming flux of life viewed through the cinematic apparatus is inevitably opened up to absurd proportions: 'cinema, insofar as it not only, like poetry, represents the successive stages of life, but also claims to show the passage from one stage to the next, and insofar as it is forced to present extreme situations to move us, had to encounter humor almost from the start'.[9]

Film was not the medium of choice for painter, writer, sculptor, and set and costume designer Leonora Carrington. Yet her oeuvre is defined by a formal experimentation featuring transformations (in body and spirit) and thresholds (actual and virtual) which would be fascinating to see mobilised on film. Carrington's elder son, Gabriel Weisz Carrington, recalls: 'My mother was not very enthusiastic about watching films … She liked Hitchcock very much … English films, mystery'.[10] Carrington's love of mystery and her recourse to the Gothic architecture and nocturnal, tree-lined vistas of her Lancastrian childhood are evident in many of her paintings, but particularly in her writing. From *The House of Fear* (1938), through the Gothic horrors of Cardiazol-induced hallucinations in *Down Below* (1944), to her bawdy novel *The Hearing Trumpet* (1974), wicked and fantastic transmutations are staged within the walls of castles and churches, a topographically layered asylum, dense forests, and the expansive rooms of an old people's home. The plots, often beginning and ending *in medias res*, reveal what Marina Warner terms a 'macabre naughtiness'.[11] Carrington's fictional worlds, resplendent with chambers and objects, lend themselves to being imagined or transferred cinematically. Her paintings suggest movement, gesturing beyond the frame, or beckoning the viewer to experience alchemical and fantastic transformations. She invites the viewer to experience images of non-Western belief systems alongside the persisting Gothic tales, Catholic and Celtic rituals of her native England. Dawn Ades describes the imaginary world of *The Temptations of Dagobert* (1945) in terms of its 'cellular' composition. The painting, Ades argues, enables spatio-temporal simultaneity, weaving together elements which are heightened by Carrington's own experiences 'of a supernatural acuity during her breakdown'.[12]

Weisz Carrington describes how Carrington 'went through various *dépaysements*', a series of 'upheavals' stemming from 'changing habitudes or environments'.[13] These refer not only to literal uprootings pertaining to place – France, Santander, New York, Mexico – but also to 'the intrusion of fairy stories and Irish legends, that were so much a part of her imaginal mind'.[14] In her youth, the spirit of surrealism initially freed Carrington – she comprehended it intuitively, having known it before she even met the

surrealists.[15] Her rebellious lampooning of Catholicism and the nuns who expelled her from school 'naturally' drew her to surrealism, and later to her friend Luis Buñuel: 'I do have that kind of mentality', is how she once described her propensity for black humour. [16]

From Poe to Carrington: *The Mansion of Madness*

The nodes of Carringtonian surrealism align in Moctezuma's *Mansion of Madness* – black humour, magic, irreverence, Gothic spaces, and figures of the fairy-tale – resulting in a powerfully surreal 'cult object'[17] that has only recently featured in scholarship on her oeuvre.[18] In the 2016 exhibition *Leonora Carrington* at Tate Liverpool, *Mansion* played on a continual loop in the vicinity of the costumes and sketches for her play *Pénélope*, a theatrical adaptation of her short story 'The Oval Lady' (1937–38) which was directed for stage by Alejandro Jodorowsky.[19] The curators of the exhibition stated that their aim was 'to revert attention to Carrington's rich and multifaceted practice'.[20] *Mansion*'s 'multifaceted' approach to surrealism ranges from the Giorgio de Chirico-inflected classicism of the château-asylum's ruined architecture, through the erotic and hypnogogic collage of nude bodies, animal sacrifice, and encased inpatients, to the centrifugal lines of harp strings and woolly webs that appear repeatedly, mirroring the dynamic sense of movement in Carrington's paintings. Additionally, *Mansion* presents multiple sequences in which food dominates, whether in the ritual of eating (recalling paintings such as *The Meal of Lord Candlestick* (1938), *Hunt Breakfast* (1956), or *Pastoral* (1950)), the many tableaux comprised of colourful fruits and vegetables, or in the juxtaposition of human flesh and *nature morte*. Taking into account Carrington's presence on set, it is not difficult to believe that the red cabbages strewn about the asylum were her choice, since cabbages often feature in her drawings, and later were the subject of *Cabbage*, 1987.

Certainly, given Carrington and Weisz Carrington's involvement on set during filming in Texcoco, it is by no means a stretch to imagine what Francisco Peredo Castro describes as 'an artistic and spiritual concordance between mother and son' that brings into the film 'all the derivations of Leonora Carrington's fantastical universe'.[21] Mother and son, in fact, took a playful approach to their artistic roles, drawing on Carrington's signature blend of English Gothic and Mexican magic, while also advising on innovatively staged and choreographed scenes that trouble the male gaze. Weisz Carrington's recollections of working on *Mansion* with his mother are illuminating with regards to her attitude towards the project, and to the low-budget nature of its improvised unfolding:

somehow we worked together, but it was a somehow … because we would discuss things and then naturally I would have to improvise because there was nothing [laughter], so I sort of tried to do as best as I could, and that gave a kind of 'surrealist impression' … my mother and myself, we really did laugh about that … a lot.[22]

He recounts how they would gather objects for the set – taxidermied animals purloined from an abandoned natural-history museum nearby – but were really creating an 'anti-film' alongside Moctezuma's: 'maybe her usual generosity allowed me to become involved in this production. We often collaborated on different artistic endeavors usually joking and playing with anything that we worked on, it was very enjoyable'.[23] Thus, the artistic direction for the film can be seen as an elaborate game, in which chance, humour, and the macabre play a significant hand. Nevertheless, the iconography of Carrington's oeuvre is clearly in evidence throughout.

The castle in the forest

> Through this dank and gloomy wood we rode some two miles, when the Maison de Santé came in view. It was a fantastic château, much dilapidated, and indeed scarcely tenantable through age and neglect. Its aspect inspired me with absolute dread, and, checking my horse, I half resolved to turn back.[24]

Mansion's opening credit sequence, referencing this opening paragraph from Poe's story, collapses two distinct locations into a continuous loop. The exterior locale is a forest, and the interior a factory lined with rows of glass vitrines. Equine figures move through both, creating an arresting match cut: in the former, a horse-drawn cart hurtles forwards carrying Gaston LeBlanc (Arthur Hansel) and his charge Blanche (Mónica Serna); in the latter, a single white horse moves sedately through the space, a naked woman poised atop its back. Heavily tinted in shades of red and green, this sequence has undergone a laborious masking in post-production, projected on to a textured surface and re-filmed to create vertical grain and shadow. Although shot on 35 mm film stock, the effect is that of a video recording in the vein of low-budget horror. This is a fitting visual metaphor for Gaston's thrill upon seeing the château for the first time. It also resonates with Carrington's *The House of Fear* (1938), a short volume illustrated with Max Ernst's precisely executed collages. *Mansion* plays with its nineteenth-century urtext, just as Carrington's short story takes on the nocturnal chill of the Gothic and melds it with a surreal exaggeration of physical and emotional states. The mistress of the house – Fear – has only one eye (an affliction that also befalls the priest in *Mansion*), but it is six times larger than that of an ordinary human. The narrator, travelling with a talking horse, approaches the

Gothic edifice after navigating dark and narrow passages, yet passes up its enormously steep staircase with surprising agility: 'The castle stood ahead of us, and he [the horse] explained that it was built of stones that held the cold of winter. "Inside it's even colder", he said, and when we got into the court-yard I realised that he was telling the truth. The horses all shivered, and their teeth chattered like castanets.'[25] The narrator, seemingly calm and in excel-lent physical form, watches and listens as her pure fear manifests in the sound of hooves pounding the stone floors of the frozen castle. The Gothic mode becomes a means of expressing the intensity of the everyday marvel-lous, which as Pierre Mabille illustrates, demands 'true testimony from our heightened senses'. The figure of the castle, he continues, is a catalyst whereby each guest that stays for a while in its mystery will 'provide new evidence' in their stories of the marvellous.[26] Moctezuma's narrator, LeBlanc, speaks over the opening credit sequence of his happiness (even as a fallen man) in the contemplation of 'the dark valleys, the grey rocks', 'the forests that sigh in uneasy slumbers', and the sentiment of seclusion, setting the scene and the tension for the strange tale to come.

In an interview with Moctezuma, Beatraiz Reyes Nevares recounts how he 'also told me – at the exact moment when I was changing the cassette in the tape recorder – of what happened to him in Count Dracula's castle, of his love for ghost stories'.[27] We do not discover further details regarding this anecdote, but the eerie timing of the cassette spool running out and the mem-ory of a visit to Romania recall a much earlier anecdote linking the Gothic to surrealism. The journey from one realm to another in the Gothic tale enacts a rite of passage that occurs between what is *seen* and what is *desired*. As outlined in Breton's reaction to F. W. Murnau's *Nosferatu: A Symphony of Horror* (*Nosferatu: eine Symphonie des Grauens*, 1922), moving images allow for the threshold to materialise in spectacular fashion. Breton describes how Murnau's film left an uncanny impression on him that was to eventually surface in a dream of 26 August 1931. At the point in the film's narrative when Thomas Hutter crosses towards Count Orlok's castle, Breton finds himself unable to read the intertitle without 'a mixture of joy and terror'; it reads: 'when he was on the other side of the bridge, the phantoms came to meet him'.[28] To cross over is to momentarily encounter the affective space of the threshold – suspended between nameable entities – before entering a space with a completely different spatio-temporal order.

Moctezuma's forest, shrouded in fog, diffused alternately in natural sun-light and a ghastly, green filter, materialises the ineffable qualities of the psychological threshold that anticipates horrors and pleasures to come. In *Mansion*, the location of Poe's château in the south of France is retained, LeBlanc's voiceover narration informing the viewer that he is returning to the Europe of his childhood. However, the film was shot in Mexico, where

Carrington had lived since 1942. The interior scenes were filmed inside an abandoned textile mill, the ruined structure permeated by the nature surrounding it, and littered with objects and debris. Carrington's letters to close friend Leonor Fini in the late 1930s reveal a preoccupation with a similar mise-en-scène to that of Moctezuma's film: 'You had a chateau in a city of ruins and there was André (de Mandiargues) who bewitched some chickens and some butterflies and we made a dinner consisting only chickens that fell from the ceiling in flames and were hung from a tree made of foie gras.' She continues: 'Walking on I come to a chateau in ruins and full of cats. I meet you and we look at each other in a mirror. You have a lynx's head, and I myself have a horse's head.'[29] Carrington's sentences weave a magical scene in which dream, nightmare, fantasy, and neurosis coalesce. *Mansion*, following the idea of a mobile, direct and indirect involvement with surrealism,[30] appears to populate its Gothic castle with animate and inanimate objects borrowed from Carrington's oeuvre. For LeBlanc and Blanche (and her counterpart inside the castle-asylum, femme-enfant Eugénie – Ellen Sherman) as in Carrington's letter to Fini, the mysteries of the castle become interwoven with personal fantasies, mediated through animal figures that seem to access human interiority (Figure 9.1).

Figure 9.1 Juan López Moctezuma, *The Mansion of Madness*
(*La mansión de la locura*), 1973

Staging desire through the female body

Approaching Moctezuma's asylum through the mysterious forest, LeBlanc's carriage is beset by armed guards in frock coats (later revealed to be inpatients) who subsequently multiply into a stream of bestial men (some with antlers, some dressed as monks) that pose a particular physical threat to Blanche. As Alyce Mahon surmises, 'male Surrealists all too often held firm to a passive vision of woman which was indebted to nineteenth-century Romanticism and Symbolism', citing the knight-errant in pursuit of the (female) muse as a frequent motif expressed in their writing.[31] Where Carrington's stories liberate female characters from the role of muse, *Mansion's* Blanche and Eugénie are trapped within it, doomed to swoon into the arms of aptly named knight-errant, LeBlanc, who abandons all to save them from rape or ritualistic sacrifice. His foil, the asylum's superintendent, Monsieur Maillard (wonderfully hammed-up by Buñuel favourite Claudio Brook), is actually a former patient, Raoul Fragonard, who has assumed a dictatorship. LeBlanc, oblivious to Maillard's duality, hopes to interview him regarding his mysterious 'soothing cure'. This opening sequence clearly echoes the opening of Buñuel's *Belle de Jour* (1967), where the viewer is made privy to Séverine's (Catherine Deneuve) private fantasy of riding in a horse-drawn carriage and being sexually assaulted by its coachmen in the wood.[32] Moctezuma's film repeats the erotic fantasy in Buñuel's film, but where Séverine is, like Carrington's characters, actively setting up the parameters of her inner world, Eugénie appears to be controlled not only by Maillard but by the hypnotic powers of a high priest, her costumes seemingly part of their fantasies.

Carrington, the film's costume designer, creates a gold, fringed, metal headdress with an enamelled eye for the scene in which Eugénie performs a Javan dance in matching metal body jewellery (Figure 9.2). As her friend Edward James once remarked: 'She seems to recall scenery from incarnations prior to this one ... Hers are not literary paintings, rather they are pictures distilled in the underground caves of libido, vertiginously sublimated.'[33] Moctezuma's asylum certainly fits James's description, with Carrington's wardrobe direction adding character through costumes and staged tableaux that invoke ancient and contemporary world cultures (from the ritual sacrifice of chickens and day of the dead dances, to a musical score with multiple and wide-ranging world influences).

After LeBlanc drinks from a drugged wine glass, Eugénie appears to him as a naked siren, calling him to meet in the garden. Instead, we find Blanche in a garden, having been captured by asylum inpatients and prepared in a sacrificial tableau, which to the contemporary viewer might seem to reference Meret Oppenheim's performance installation *Le Festin* (also known as

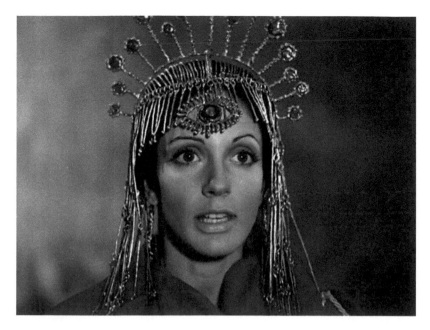

Figure 9.2 Juan López Moctezuma, *The Mansion of Madness*
(*La mansión de la locura*), 1973

Cannibal Feast, or *Spring Banquet*, 1959). Oppenheim's tableau comprised a naked woman presented on a table set with cutlery as an exquisite dish, garnished with fruit and fish. The woman was served to guests at the opening of *Exposition inteRnatiOnale du Surréalisme* in Paris (1959). Designed to question and trouble the male gaze, the body of the woman is passive and exposed. This tableau is eerily repeated in the staging of Blanche's sacrifice, where she lies surrounded by foliage and covered in fruit. An unholy priest (his robe bearing a Mayan spiral) stands over her prostrate body, squeezing grapes on to her navel. Within the context of Moctezuma's surrealist b-movie, this self-reflexive gesture is doubly subversive because it turns the gaze back on to the audience, highlighting the failure of religious and social apparatuses to protect her. James's reading of Carrington's paintings as evidence of 'underground caves of libido' drawn from sublimated images is a clear example of the way in which an individual participant in surrealist art (the viewer) brings his or her experience and perspective into dialogue with the works. From Weisz Carrington's perspective, *Mansion* was a *grand jeu*; and a viewer cognisant of Carrington's involvement would no doubt conjure various associations with her oeuvre and the aesthetic elements of the film. As Catriona McAra notes, 'Carrington's living legacies are multiple';

she and her work 'act as a force of disruption with which to question polit-
ical realities ... Her imaginative claws are sharp and catch us but she recoils
from our own grasp, forever out of reach.'[34] Despite Carrington's real pres-
ence on set in Mexico, and her hand in the costume and styling of the mise-en-
scène, the 'disruptive force' of her oeuvre is only mobilised through the
participatory act of a viewer. Whether or not the viewer understands the
finer detail of these traces and inferences depends on her knowledge of Car-
rington's work, which, nonetheless, does not influence the affective potential
that these traces might have independently.

As an example, consider the eroticism at the surface of Moctezuma's film,
which is conveyed through a series of episodes in which women are fetish-
ised and men act as clownish patriarchal inhibitors of liberty. Yet, as I have
suggested, there is potential for a feminist reading of these episodes,. In a
letter to Breton regarding the *Exposition inteRnatiOnale du Surréalisme*
(this correspondence was deemed erotically marvellous enough to include in
the exhibition), Carrington writes:

> I've long dreamed of a similar show, but I must confess that I see it as comic
> eroticism (érotisme comique) ... I visualise a room – somewhere between a
> cathedral and a Swiss (cuckoo) clock – equipped with an organ of forty peals
> of laughter multiplied through the octaves... A very rich bestiary of erotic
> appliances would furnish the room ... I'm thinking about my personal contri-
> bution to this show ... a Holy Ghost (albino pigeon) three metres high, real
> feathers (white chickens', for example), with: nine penises erect (luminous),
> thirty-nine testicles to the sound of little Christmas bells, pink paws ... Let me
> know, dear André and I will send you an exact drawing.[35]

Marvellously devilish in tone, Carrington devises a room in which the male
sex and Christianity are mercilessly poked fun at in a 'comic eroticism' that
condenses the distance between animal, human, and divine entities on a
conversely gigantic scale. The room she describes to Breton is suspended in
limbo, reverberating with laughter at the clever punning on the word organ.
The humour in *Mansion* arguably arises from the constant undermining of
Maillard's system. The labyrinthine corridors of the asylum echo with peals
of laughter, as the camera tracks the erratic movements of inpatients amid
the layers of debris, decay, and found objects (animal bones, vitrines, reams
of cloth, mirrors, clocks, chickens). Carrington dresses the male characters
in frills, feathers, and necklaces; and, unable to fulfil their sexual desires,
they become stuck in a loop of 'comic eroticism' which stems from LeBlanc's
imagination, as the entire film is subject to his unreliable narration. *Man-
sion's* exploration of the human form, like Carrington's, delights in the
comic and violent affects generated in images of blasphemy and transforma-
tion. An increasingly monstrous Maillard/Fragonard feeds the feathered

inpatient 'Mr Chicken', and encourages one of his minions to parody sexual acts on a dead, skinned calf. In another sequence, a man is revealed, cruciform, manacled to a cross, upon seeing which LeBlanc mutters ironically 'this surpasses every concept of cruelty'. The artistic direction weaves together a syncretic blend of Mayan, Aztec, Catholic, and pagan cultures that becomes a superficial pastiche of gestures and movements enacted by the inpatients. Carrington wrote of her early years in Mexico: 'For me the impact of Mexican culture was unexpected and rather frightening ... There was something very bloodthirsty, and heavy and menacing.'[36] Yet this fear was always tempered with the immense energy and potential that mixing allowed. Part experimental performance piece, part grotesque fairy-tale, *Mansion* pushes against any stable definition of sanity or decorum in its peculiar St. Vitus dance of the marvellous.

Phantasms continue to populate Carrington's paintings after she settles in Mexico City. In *The Cockcrow* (1946), for example, a group of phantoms of varying scale and abstraction are backlit against a glowing wall and red sky. The application of white oil paint and gold leaf, combined with the figures' extending shadows, creates a sense of animation and vitality against the red-toned dawn sky. A tall, antlered figure to the left of the frame emerges from a recess, as a hyena figure dances with a smaller hybrid animal/phantom figure. We might imagine how this scene could be animated through multiple, edited film frames. Similar configurations abound inside the cavernous ruins of *Mansion's* asylum captured by cinematographer Rafael Corkidi in spectacular wide-angle shots. Carrington's headpiece for Eugénie and gilded mirrors add gold accents. The multiple cages, candles, and reflective surfaces seem to revel in an impossible dance between entrapment and infinity. Strangely dressed figures emerge and recede from multiple nooks and crannies, casting shadows and reflections as they pass.

When LeBlanc first encounters Eugénie, she is seated in sombre Victorian dress, playing the harp, ringed by carriage clocks, caged mice, and candlesticks. Stretching across the back wall, however, is an abstracted black shadow, a bird-like apparition that can only have been drawn by Carrington (Figure 9.3). It corresponds to countless examples of fleeing, black shadows that frequent her paintings, and of a sharp-toothed bird figure painted on the exterior wall of the house she shared with Ernst at Saint Martin D'Ardèche. Whether a distortion of a Poe-like raven, a phantom of childhood home Crookhey Hall, a demon, or the embodied suggestion of the violence to befall Eugénie, the black shadow signals Carrington's presence clearly. Carrington's Gothic alchemy and bleak humour of the 1930s and 1940s are released in a more playful manner in the artistic interpretation of *Mansion's* script. Madness is explored through the film's collage of animate and inanimate forms, with the figure of the horse an enduring symbol of potential

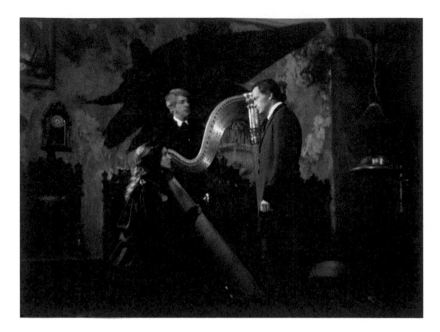

Figure 9.3 Juan López Moctezuma, *The Mansion of Madness*
(*La mansión de la locura*), 1973

multiplicity. The white horse also acts as a double on set for the artist, who believed that 'A horse gets mixed up with one's body ... it gives energy and power'.[37] In Moctezuma's torturous asylum, it transcends the chaos, an ethereal link to a possible exit from the madness.

Revolution in mutability

Mansion follows the post-1960s waning of interest in one of Mexico's most successful genres, the horror film. From films such as *Two Monks* (*Dos monjes*, Juan Bustillo Oro, 1934) and *The Ghost of the Convent* (*El fantasma del convent*, Fernando de Fuentes, 1934), to Chano Urueta's *The Witch* (*La bruja*, 1954) and *World of the Vampires* (*El mundo de los vampiros*, Alfonso Corona Blake, 1961), monsters, wrestlers (*lucha libre*), and the undead proved popular at the box office.[38] But the formula grew tired, and as Doyle Greene notes, Moctezuma contributes to a new era where 'recognizable horror and exploitation film genre conventions would become a vehicle for experimental films'.[39] In its deployment of surrealist and b-movie iconographies, *Mansion* proved popular with a cine-literate audience. Moctezuma deliberately foregrounds the European connection to art

Figure 9.4 Juan López Moctezuma, *The Mansion of Madness*
(*La mansión de la locura*), 1973

cinema by filming in English, a strategy used by some Mexican producers and film-makers at the time 'not only to penetrate English-speaking markets ... but also to win back Mexican middle-class viewers'.[40] Stylistically *Mansion* is an amalgam of European literary and surrealist tropes and Mexican mythology, brought together in the deliberately exaggerated theatricality of its actors and players (Figure 9.4).

Reflecting on the film in 1977, Moctezuma stated:

> my films belong much more in the surrealist tradition than in the Mexican one ... It was my first film and it was definitely full of references to the film makers who had influenced me: directors from the golden age of American horror cinema, Buñuel, and of course the silent masters ... Mansion of Madness puts one in mind of the kind of things that they used to show in Paris. I've seen some of the Grand Guignol shows and I loved them.[41]

Aspects of surrealism, silent cinema, and horror are deployed in the film to explore connections between eroticism and madness; it is in 'the domain of the erotic that reality and the fantastic really come together'.[42] Moctezuma's interest lies in the mutability of power rather than its fixity. *Mansion* explores the manner in which the conditions of the castle-asylum allow for a radical reimagining of order via the body and its grotesque enactment of desire.

Maillard describes his 'soothing system' as 'A metallic womb uniting man to the universe. Burning snakes curling around the pillars of a new myth'. The symbiotic commingling of technological and organic bodies exceeds categorisation, all matter amounting to energy that fuels Maillard's system. *Mansion's* 'rebellious subjects' collectively present an anarchic, childlike chaos that problematises the notion of democracy and free will. Proceedings build to a crescendo with a female inpatient's yell of 'Viva la revolución' as she shoots Maillard/Fragonard in the chest. The revolution, as frenetic as the acts that precede it, seems to lie between 'reason' and 'shadows of doubt', or in the parting line of LeBlanc's voiceover: 'Believe whatever you wish'.[43] The film mobilises madness through an embodied female resistance against the patriarchal order; as Carrington said, 'If women remain passive I think there is very little hope for the survival of life on earth'.[44] The artistic direction problematises the objectification of the passive woman in its referencing of feminist creativity, from the cry of revolution to the knowing presentation of the sacrificial tableau.

Viewed in its surrealist context, *Mansion* is a marvellous fiesta which effects 'an alchemical stage in the psychic evolution of the spectator',[45] making it above all a collaborative work. It is clear that while Carrington's work is intensely personal and interior, she desired the viewer/reader to participate in her world. Jonathan Eburne's reading of *The Oval Lady* reveals how such a transmission can occur, whereby the story 'outlines a ritual of complicity within which event the narrator becomes a participant. Lucretia herself is punished only by proxy. Instead, the screaming toy becomes the symptom – both the victim and the index – of the ritual's true violence'.[46] Similarly, in Moctezuma's tale of crime (madness) and punishment, LeBlanc is implicated in the ritualistic violence, which is further transplanted to the viewer, who is forced to bear witness to, and thereby participate in, a transference of madness. If *The Oval Lady* is dominated by the infernal scream of Tartar and *The House of Fear* by the drumming of hooves, *Mansion* threatens to instil madness through the non-synchronous and deeply unsettling cacophony of humans imitating animal sounds, ambient noise, chanting, and screams. The aural juxtaposition is surreal in its reorganisation of the castle's temporal-spatial coordinates via irrational outbursts of sound and unexpected noises that confound the senses.

Further Mexican collaborations

Mansion was not Carrington's first adventure in Mexican cinema. In 1964 she performed a cameo in Alberto Isaac's black-and-white film *There Are No Thieves in This Village* (*En este pueblo no hay ladrones*), an adaptation of the

short story of the same title by Gabriel García Márquez.[47] Carrington only appears on screen for a few seconds, her head covered by a dark shawl, seated in a church pew listening to the Curé's sermon. The actor playing this expressive priest is none other than her dear friend Buñuel. Among others involved in making the film were Juan Rulfo, José Luis Cuevas, Carlos Monsivais, Abel Quezada, Arturo Ripstein, and Alfonso Arau. The community of artists and writers living and passing through Mexico in the 1960s provided an atmosphere fuelled by mutual inspiration and adventure. For Márquez, this period made his career: 'I arrived in Mexico with twenty dollars and I left there with *One Hundred Years of Solitude*, which met with great solidarity, a magical interest.'[48] For Carrington, the period between her arrival in Mexico and the filming of *Mansion* also brought collaborations with Jodorowsky on theatrical productions, as well as contributions to the avant-garde publication *S.NOB* (1962) and work on the sets and costumes for the theatrical group *Poesía en Voz Alta*'s production *La Fille de Rappaccini* (1956).[49] Just prior to filming with Moctezuma, Carrington painted a marvellous image for Jodorowsky that seems to foreshadow her work on *Mansion*. Entitled *Escenografía para El rey se muere dirigido por Jodorowsky* (c. 1968–71), it details one of her set designs for Jodorowsky's theatrical adaptation of Eugène Ionesco's *Exit the King* (1962). The scene, created in gouache and chalk, is of a stone courtyard with a narrow, tree-lined staircase leading to the painting's arched apex. Outlined in white, spectral figures in Mexican dress, ravens, llamas, and other barely distinguishable creatures cram into the space. The courtyard seems to belong outside the human realm, although connected to it via a telephone and electrical wires. The resemblance to the castle-asylum in *Mansion* is undeniable, bearing all the hallmarks of Carrington's universe, including the interpenetration of interior and exterior space.

Conclusion

Carrington's participation in the artistic design of *Mansion* is, alongside her many collaborative ventures with film-makers, theatre directors, artists, and writers in Mexico, an important part of her oeuvre. The film repeats motifs and ideological concerns in her better-known work as a painter and writer, and enters into dialogue with it. While superficially a soft-pornographic farce, with both horror and fairy-tale vignettes, the film communes 'the interdependence of all aspects of the phenomenal and psychic worlds'.[50] Weisz Carrington notes that in Carrington's storytelling 'we have a special phenomenon where narrative-flesh renders a distinct voice to the body'.[51] Moctezuma's *Mansion* blends Poe's and Carrington's doubled 'narrative-flesh', giving rise to an erotic encounter between madness and the marvellous that is both

macabre and rebellious. Ultimately, the female body speaks over the posturing of LeBlanc and Maillard/Fragonard; it is her battle and resistance that the viewer remembers.

Carrington's work is full of phantoms and the unexplained presence of strange alchemical objects and bestial figures. Imagined cinematically, they materialise in marvellous ways. As Murnau discovered, the cinematic apparatus captures the 'play of pure movement': 'the fluid architecture of bodies with blood in their veins moving through mobile space; the interplay of lines rising, falling, disappearing; the encounter of surfaces, stimulation and its opposite, calm; construction and collapse; the formation and destruction of a hitherto almost unsuspected life'.[52] Murnau's 'unsuspected life' is often crafted into harmony and rhythm, but the camera can also be harnessed in the service of surrealism: to reveal the surreal aspects of everyday life and to conjure the affective continuum of madness in Moctezuma's film, which brings Carrington's thoughts and oeuvre into cinematic motion. Paintings and stories in which labyrinthine, bisected, and bifurcated landscapes feature (with forking realms, underworlds, and heavens drawn into networks of adjacent rooms, cells, or regions) map on to *Mansion's* topological and conceptual realms. There is a symbiotic creative energy, as well as a biting black humour, which seems to thread these aspects together, whether through actual collaborative practice in the first instance, or through a virtual engagement with Carrington's themes of madness, desire, and power in the second.

The collaboration between Moctezuma, Carrington, and Weisz Carrington was based on play and chance encounter, and it illustrates the multiple ways in which surrealism contributes to mobile legacies in film. Even if Carrington had little interest in film, save for mystery plots, her aura, her sense of fun, and her willingness to share things that delighted, frustrated, and interested her fully permeates *Mansion*. It is a film filled with her spirit. Pulp as in the tradition of Louis Feuillade's *Fantômas* series (1913–14), erotically countering patriarchal discourse in the manner of Maya Deren's somatic and hypnotic ruminations on female time and space, and playing with the tropes of silent films and Gothic adaptations, *The Mansion of Madness* offers its viewers the experience of an *explosante-fixe*. It is a mobile collage of Carringtonian inflection, a film that wears its references and fascinations on its sleeve.

Notes

1 Richardson, *Surrealism and Cinema*, 3.
2 A striking example is the avant-garde film *A Page of Madness* (*Kurutta ippêji*, Japan, 1926), directed by Teinosuke Kinugasa, in which a woman imprisoned in

an asylum performs a dance of insanity, interacting with superimposed spectres from her mind.

3 Quoted in Hayes, '*Lunatics in Power* (1909)', 15.
4 Poe, 'The System of Dr Tarr and Professor Fether', 266–82.
5 Breton, *Anthology of Black Humor*, xix.
6 See Eburne, *Surrealism and the Art of Crime*; and Matheson, *Surrealism and the Gothic*.
7 Breton, *Mad Love*, 19.
8 Adamowicz, *Un chien andalou*, 129.
9 Breton, *Anthology of Black Humour*, xvii.
10 Gabriel Weisz Carrington in conversation at Edge Hill University, 30 June 2017.
11 Warner, 'Leonora Carrington's Spirit Bestiary',12.
12 Ades, 'Surrealism, Male-Female', 201.
13 Weisz Carrington, 'Foreword', xiii.
14 Ibid.
15 Le Brun, 'Je n'a plus une seul dent', 51.
16 Angelis, 'Interview with Leonora Carrington', 42.
17 Strayer, 'Art', 110.
18 See Castro, 'On History', 330–6; and Markova and Shannon, 'Leonora Carrington on and off Screen'.
19 Dates regarding the performance of *Pénélope* in Mexico are unconfirmed, but can be narrowed down to the first half of the 1960s.
20 See Francesco Manacorda, Chloe Aridjis, and Lauren Bates, 'Leonora Transgressing Discipline', 198–9. Manacorda, Aridjis, and Bates co-curated the exhibition, with Roger Shannon acting as advisor regarding Moctezuma's film.
21 Castro, 'On History', 334.
22 Question posed by the author to Gabriel Weisz Carrington in conversation at Edge Hill University, June 30, 2017.
23 Gabriel Weisz Carrington, email message to author, 3 April 2018.
24 Poe, 'The System of Dr Tarr and Professor Fether', 266.
25 Carrington, *The House of Fear*, 30–1.
26 Mabille, *Mirror of the Marvelous*, 1–2.
27 Reyes Nevares, *The Mexican Cinema*, 104.
28 Breton, *Communicating Vessels*, 39.
29 Letter from Leonora Carrington to Leonor Fini, 5 October 1939, quoted in Chadwick, *The Militant Muse*, 84.
30 Richardson posits that the 'active form of involvement' required for a film to be considered surrealist, or to contain surrealist elements, may be direct – 'through involvement in collective surrealist activity' – or indirect – 'through an active involvement, at a distance, with surrealist ideas', both of which apply to *Mansion of Madness*. See Richardson, *Surrealism and Cinema*, 10–11.
31 Mahon, 'I Do Not See the Woman Hidden in the Forest', 1.
32 Just prior to embarking on the screenplay and eventual film adaptation of Joseph Kessel's *Belle de Jour*, Buñuel, encouraged by Serge Silberman, had been working on adapting Matthew Lewis's Gothic novel *The Monk*, which he recalls in his memoir *My Last Sigh* as 'figuring prominently in the surrealist canon' (242).

Unfortunately, this project was abandoned, the screenplay later picked up by Ado Kyrou for his film *Le Moine* (*The Monk*, 1972). Thanks to Kristoffer Noheden for reminding me of this further mobile connection.

33 James 'Introduction', 18.

34 McAra, 'A Feminist Marvellous',15.

35 Quoted in Warner, 'Leonora Carrington's Spirit Bestiary', 11.

36 Angelis, 'Interview with Leonora Carrington', 40.

37 Carrington, quoted in Warner, 'Introduction', 2.

38 For comprehensive research on the Mexican box office and distinct Mexican film genres, see Mora, *Mexican Cinema*.

39 Greene, *Mexploitation Cinema*, 168.

40 Mora, *Mexican Cinema*, 165.

41 Juan Lopéz Moctezuma in interview with J. P. Bouyxou and Gilbert Verschooten in Sitges, 1977. In *Alucarda* (Special Edition) DVD extras (2003).

42 Ibid.

43 The Mexican Revolution was an ideological civil war that stretched between 1910 and 1917, with much bloodshed, that ushered in a 'modern' era with a constitution and the emancipation of the peasant and working classes.

44 Carrington, 'What Is a Woman?', 76.

45 Orenstein, *The Theater of the Marvelous*, 287.

46 Eburne, *Surrealism and the Art of Crime*, 238.

47 And in 1965 she made another cameo appearance in Juan Ibañez's adaptation of Carlos Fuentes' *A Pure Soul*, illustrative of her willingness to participate in the full gamut of creative expression available to her in Mexico, and demonstrative of the potential mobility of ideas between artists typically branded as surrealist or magical realist (Buñuel, Márquez, and Fuentes, for example).

48 Quoted in Poniatowska, 'Gabriel García Márquez', 217.

49 See Susik 'Losing One's Head in the "Children's Corner"', 103–25.

50 Chadwick, 'El Mundo Mágico', 11.

51 Weisz Carrington, 'Shadow Children', 137.

52 F. W. Murnau, quoted in Eisner, *Murnau*, 84.

Bibliography

Aberth, Susan L. *Leonora Carrington: Surrealism, Alchemy and Art*. Burlington, VT: Lund Humphries, 2004.

Adamowicz, Elza. *Un chien andalou*. London: I. B. Tauris, 2010.

Ades, Dawn. 'Surrealism, Male-Female'. In *Surrealism: Desire Unbound*, edited by Jennifer Mundy, 171–202. London: Tate, 2002.

Angelis, Paul de. 'Interview with Leonora Carrington'. In *Leonora Carrington: The Mexican Years, 1943–1985*, edited by Patricia Draher, 33–42. Albuquerque, NM: University of New Mexico Press, 1991.

Breton, André. *Anthology of Black Humor*, translated by Mark Polizzotti. San Francisco, CA: Telegram, 2009.

————. *Communicating Vessels*, translated by Mary Ann Caws and Geoffrey T. Harris. Lincoln, NE: University of Nebraska Press, 1990.

————. *Mad Love*, translated by Mary Ann Caws. Lincoln, NE: University of Nebraska Press, 1987.

Buñuel, Luis. *My Last Sigh*, translated by Abigail Israel. Minneapolis, MN: University of Minnesota Press, 2003.

Carrington, Leonora. *The House of Fear: Notes from Down Below*, translated by Katherine Talbot and Marina Warner. London: Virago, 1989.

————. 'What Is a Woman?' In *The Surrealism Reader: An Anthology of Ideas*, edited by Dawn Ades and Michael Richardson with Krzysztof Fijałkowski, 72–6. London: Tate, 2015.

Castro, Francisco Peredo. 'On History, Myth, and the Celluloid Transfiguration of Fantastic Imagery'. In *Leonora Carrington: Magical Tales*, edited by Tere Arcq and Stefan van Raay, 319–41. Mexico City: Instituto Nacional de Bellas Artes, 2018.

Chadwick, Whitney. 'El Mundo Mágico: Leonora Carrington's Enchanted Garden'. In *Leonora Carrington: The Mexican Years, 1943–1985*, edited by Patricia Draher, 9–31. Albuquerque, NM: University of New Mexico Press, 1991.

————. 'Leonora Carrington: Evolution of a Feminist Consciousness'. *Woman's Art Journal* 7, no. 1 (1986): 37–42.

————. *The Militant Muse: Love, War and the Women of Surrealism*. London: Thames and Hudson, 2017.

Conley, Katharine. 'Carrington's Kitchen'. *Papers of Surrealism* 10 (2013): 1–18.

Eburne, Jonathan P. 'Breton's Wall, Carrington's Kitchen: Surrealism and the Archive'. *Intermédialités*, no. 18 (2011): 17–43.

————. *Surrealism and the Art of Crime*. Ithaca, NY: Cornell University Press, 2008.

Eisner, Lotte. *Murnau*. London: Secker & Warburg, 1973.

Ernst, Max. 'Loplop Presents the Bride of the Wind'. In *The House of Fear: Notes from Down Below*, by Leonora Carrington, translated by Katherine Talbot and Marina Warner, 25–6. London: Virago, 1989.

Greene, Doyle. *Mexploitation Cinema: A Critical History of Mexican Vampire, Wrester, Ape-Man and Similar Films 1957–1977*. Jefferson, NC: McFarland, 2005.

Hammond, Paul, ed. *The Shadow and Its Shadow: Surrealist Writings on the Cinema*, 3rd edn. San Francisco, CA: City Lights Books, 2000.

Hayes, Kevin J. '*Lunatics in Power* (1909): A Neglected Poe Film'. *The Edgar Allan Poe Review* 1, no. 1 (2000): 13–16.

James, Edward. 'Introduction'. In *Leonora Carrington, A Retrospective Exhibition*, 11–22. New York: Center for Inter-American Relations, 1975.

Kusunoki, Sharon-Michi. 'Surreal Encounters: Leonora Carrington and Edward James – Correspondence and Friendship'. In *Surreal Friends: Leonora Carrington, Remedios Varo and Kati Horna*, by Teresa Arcq, Joanna Moorhead, and Stefan van Raay, 116–31. Farnham: Lund Humprhies, 2010.

Le Brun, Annie. 'Je n'a plus une seul dent'. In *Leonora Carrington: La mariée du vent*, 26–53. Paris: Éditions Gallimard, 2008.

Mabille, Pierre. *Mirror of the Marvelous: The Classic Surrealist Work on Myth*, translated by Jody Gladding. Rochester, VT: Inner Traditions, 2000.

Mahon, Alyce. 'I Do Not See the Woman Hidden in the Forest: Surrealism and the Feminine'. In *Dreamers Awake*, edited by Honey Luard, 1–15. London: White Cube, 2017.

———. *Surrealism and the Politics of Eros, 1938–1968*. London: Thames & Hudson, 2005.

Manacorda, Francesco, Chloe Aridjis, and Lauren Bates. 'Leonora Transgressing Discipline'. In *Leonora Carrington and the International Avant-Garde*, edited by Jonathan Eburne and Catriona McAra, 198–9. Manchester: Manchester University Press, 2017.

Markova, Lora, and Roger Shannon. 'Leonora Carrington on and off Screen: Intertextual and Intermedial Connections between the Artist's Creative Practice and the Medium of Film'. *Arts* 8, no. 11 (2019).

Matheson, Neil. *Surrealism and the Gothic*. London: Routledge, 2017.

McAra, Catriona. 'A Feminist Marvellous: Chloe Aridjis and the *Female Human Animal*'. In *Leonora Carrington: Living Legacies*, edited by Ailsa Cox, James Hewison, Michelle Man, and Roger Shannon, 1–18. Wilmington, DE: Vernon Press, 2019.

Mora, Carl J. *Mexican Cinema: Reflections of a Society, 1896–2004*. Jefferson, NC: McFarland & Company, 2005.

Orenstein, Gloria Feman. *The Theater of the Marvelous: Surrealism and the Contemporary Stage*. New York: New York University Press, 1975.

Poe, Edgar Allan. 'The System of Dr Tarr and Professor Fether'. In *Edgar Allan Poe: Selected Tales*, edited by David Van Leer, 266–82. Oxford: Oxford University Press, 2008.

Poniatowska, Elena. 'Gabriel García Márquez: "I Tore Up All the Drafts of *One Hundred Years of Solitude* out of Modesty"', edited and translated by Christopher Wilks. *Literature and Arts of the Americas* 50, no. 2 (2017): 214–17.

Raay, Stefan van. 'Surreal Friends: Leonora Carrington, Remedios Varo and Kati Horna'. In *Surreal Friends: Leonora Carrington, Remedios Varo and Kati Horna*, by Teresa Arcq, Joanna Moorhead, and Stefan van Raay, 8–27. Farnham: Lund Humphries, 2010.

Reyes Nevares, Beatriz. *The Mexican Cinema: Interviews with Thirteen Directors*, translated by Elizabeth Gard and Carl J. Mora. Albuquerque, NM: University of Mexico Press, 1976.

Richardson, Michael. *Surrealism and Cinema*. Oxford: Berg, 2006.

Rocco, Alessandro. *Gabriel García Márquez and the Cinema: Life and Works*. Woodbridge: Tamesis, 2014.

Schlieker, Andrea, ed. *Leonora Carrington: Paintings, Drawings and Sculptures 1940–1990*. London: Serpentine Gallery, 1991.

Strayer, Kirsten. 'Art, Horror, and International Identity in 1970s Exploitation Films'. In *Transnational Horror across Visual Media: Fragmented Bodies*, edited by Dana Och and Kirsten Strayer, 109–25. New York: Routledge, 2014.

Susik, Abigail. 'Losing One's Head in the "Children's Corner": Carrington's Contributions to *S.NOB* in 1962'. In *Leonora Carrington and the International Avant-Garde*, edited by Jonathan Eburne and Catriona McAra, 103–25. Manchester: Manchester University Press, 2017.

Warner, Marina. 'Introduction'. In *The House of Fear: Notes from Down Below*, by
 Leonora Carrington, 1–22. London: Virago, 1989.
———. 'Leonora Carrington's Spirit Bestiary; or the Art of Playing Make-Believe'. In
 Leonora Carrington: Paintings, Drawings and Sculptures 1940–1990, edited by
 Andrea Schlieker, 10–23. London: Serpentine Gallery, 1991.
Weisz Carrington, Gabriel. 'Foreword: Leonora's *Dépaysement*'. In *Leonora Carrington:
 Living Legacies*, edited by Ailsa Cox, James Hewison, Michelle Mann, and Roger
 Shannon, xiii. Wilmington, DE: Vernon Press, 2019.
———. 'Shadow Children: Leonora as Storyteller'. In *Leonora Carrington and the
 International Avant-Garde*, edited by Jonathan Eburne and Catriona McAra,
 126–40. Manchester: Manchester University Press, 2017.

10

The alchemy of surrealist presence in Alejandro Jodorowsky's *The Holy Mountain*[1]

Abigail Susik

Alejandro Jodorowsky's third feature film, *The Holy Mountain* (*La montaña sagrada*, 1973), can be described variously as a cult film, a transnational production in manufacture and distribution, and a satirical-psychedelic journey of spiritual learning for a fictional protagonist.[2] A discussion of this film within the pages of *Surrealism and Film after 1945* seems to suggest that we can also characterise it as a surrealist work, yet no such straightforward designation suffices. *The Holy Mountain* clearly possesses affinities with surrealism in several notable regards, and Jodorowsky was engaged with aspects of surrealism over the course of the 1950s and 1960s. However, we cannot fully understand *The Holy Mountain* and its ties to surrealism unless we also take into account Jodorowsky's participation in the contemporary art scene in Mexico City during the 1960s.

Despite this assertion, there has been no sustained attention in scholarship granted to the important role that contemporary Mexican art in the generation that followed the Socialist Realism of Mexican Muralism played in *The Holy Mountain*, an important consideration given that Jodorowsky spent most of the 1960s in Mexico. After Jodorowsky's first visit to Mexico City in the late 1950s, he quickly became a central part of the experimental theatre and art scene in conjunction with the Panique movement he helped launch with several friends in Paris and Mexico City in 1962.[3] My analysis therefore juxtaposes the contemporary Mexican contexts of art, culture, and politics featured in the film with its surrealist intertexts. I argue that *The Holy Mountain* deploys aspects of historical and applied surrealism and influences from Mexican contemporary art and culture alongside myriad other narrative and stylistic components, as part of a multifarious critique of contemporary society and a prefigurative, pop-psychedelic envisioning of a better world.

Other scholars have already begun the work of contextualising *The Holy Mountain* in relation to Latin American cinema, cult film, and post-war experimental cinema. *The Holy Mountain* displays commonalities with

several seminal films from or related to surrealism's history, such as Germaine Dulac's *La coquille et le clergyman* (1928), with a screenplay by Artaud; Salvador Dalí and Luis Buñuel's *Un chien andalou* (1929); Buñuel's *L'Âge d'or* (1930); and the films in Jean Cocteau's *Orphic Trilogy* (1930–59), among other examples. Robert Short called Jodorowsky and his Panique associate Arrabal 'Buñuelian "disciples"' in their deployment of 'viciousness and shock'.[4] I concur with Michael Richardson that Jodorowsky's work cannot be summarised as largely Buñuelian due to its overall focus on spiritual healing, although certainly Jodorowsky's propensity for filming dead and dying animals, among other tendencies, echoes the habits of the Spanish auteur. One key filmic comparison for *The Holy Mountain* is the last film that Buñuel made while working in Mexico between 1946 and 1965, *Simon of the Desert* (*Simón del desierto*, 1965).[5] Besides containing explicit critiques of Christianity, both films take a satirical view of the quest for enlightenment and spiritual knowledge, an approach that resonates with the surrealist critique of church and state and the relation of capitalism to these societal forces.[6]

Unlike scholars who investigate *The Holy Mountain* in relation to cinema history, I take a contextualised art-historical route in order to analyse how and why surrealist elements are so evidently present among the complex set of lineages in *The Holy Mountain*. Surrealist elements are embedded both explicitly and implicitly in the film not so much as a reference or homage to surrealism but as catalytic tools that propel the viewer into the renewed psychic consciousness that Jodorowsky has sought to achieve over the course of his career – and for which *The Holy Mountain* poses a particularly psychedelic, 'pop-visionary' model.[7] This begs the interesting question of why surrealist elements are vital for a film lavishly funded by John Lennon, produced in Mexico, and screened nearly exclusively in Europe and the United States until 1975.[8] Surrealism continued to develop and in some cases flourish in France, the United States, Czechoslovakia, Japan, Mexico, and elsewhere in the late 1960s and 1970s, but what can be said of prominent components of surrealism concentrated in cultural manifestations lying outside the bounds of the surrealist movement itself, such as *The Holy Mountain*?

Surrealist elements are essential ingredients in a complex process of filmic alchemy that occurs throughout *The Holy Mountain*. Through this process, strains of cultural and historical influence are combined, distilled, adulterated, and transmuted anew into a distinct aesthetic amalgam that speaks to Jodorowsky's internationalist avant-garde genealogy and his immersion in Mexican culture after 1960. An examination of some of the surrealist aspects of this film not only clarifies the nature of the film's eclectic intertexts and surrealism's role therein but also illuminates certain features of the

widespread cultural transference of the surrealist movement itself in the period after World War II. Surrealist elements are engaged in *The Holy Mountain* with both authenticity and charlatanism, sincerity and satire, in what is ultimately a two-pronged critique of the popular esotericism of the international counterculture and the violent repression of the student movement by the Mexican government in this era. In order to investigate the nature of this filmic alchemy for Jodorowsky, I address four interconnected nodes of surreal presence in the film and consider they ways in which these nodes reveal the influence of contemporary Mexican art, culture, and counterculture upon the film: 1) the quest for the mountaintop and the influence of writers René Daumal and Antonin Artaud; 2) the disorientation of cosmic scale and the assemblages of artist Alan Glass; 3) the transformative power of the esoteric arts, to which Jodorowsky was introduced by artists Leonora Carrington and Remedios Varo; and 4) 'Alchemist theatre' and the role of Panique.

While I have thus far emphasised the transnational nature of the production and dissemination of *The Holy Mountain*, my discussion also addresses the way in which the film commented upon the Mexican student movement of the late 1960s and early 1970s, and may have influenced to some degree the popular Mexican counterculture of *la Onda*, the wave of resistance associated with the international student movement at this time.[9] Jodorowsky's fame in Mexico during the 1960s was distinctly connected to his notoriety as an anti-authoritarian experimental artist: several of his films and performances, such as *Fando y Lis* (1968), provoked public outrage and censorship, and yet his influence continued to grow with his weekly comic strip and the live rock and roll television programme he hosted for part of 1968, *¡1, 2, 3, 4, 5 a Go-Go!*, on Telesistema, with help from collaborators such as contemporary Mexican artists Manuel Felguérez and Luis Urías.[10] In light of these factors, my analysis of surrealist presence in *The Holy Mountain* also questions how the film confronts the so-called *Guerra Sucia*, or dirty war, that occurred in the late 1960s and early 1970s between some representatives of the *Partido Revolucionario Institucional* (PRI), the ruling political party in Mexico for most of the twentieth century, and radical student and political groups who agitated for social change at that time.

The quest for the mountaintop

The first node of surrealist presence in *The Holy Mountain* relates to two figures intimately involved with surrealism: the writer and poet René Daumal and the dramatist, poet, and theatre director Antonin Artaud. The eight spiritual seekers depicted in *The Holy Mountain*, along with their

teacher, the Alchemist (played by Jodorowsky), seek to abandon their egos and material ties to the world in order to find the secret of immortality on the unknown location of the sacred mountaintop. The film's primary protagonist, the Thief, initiates this quest with the help of the Alchemist and the Written Woman, the Alchemist's assistant. The Thief avidly pursues the gold promised by the alchemical process, but his desire for wealth soon develops into the yearning for spiritual knowledge, and he is eventually joined by seven other acolytes. The seekers undergo a number of purifications and trials of endurance. They abandon their identities and destroy their wealth, submit to extreme physical exertion, consume psychedelic substances, perform traumatic-cathartic psychosomatic episodes (what Jodorowsky would later call 'psychomagic'), and engage in collective magical rites.[11]

The film's mystical plot is partly based upon René Daumal's unfinished story of collective spiritual quest, *Mount Analogue: A Novel of Symbolically Authentic Non-Euclidean Adventures in Mountain Climbing* (*Le Mont Analogue, roman d'aventures alpines, non euclidiennes et symboliquement authentiques*). Daumal was not a surrealist but had many interactions with them in association with the Paris-based journal he co-edited, *Le Grand Jeu* (*The Great Game*), published from 1928 to 1930. He began writing *Le Mont Analogue* in 1940 shortly after he received the news that he had developed advanced tuberculosis, a condition most likely exacerbated by his earlier experiments with auto-asphyxiation and the inhalation of carbon tetrachloride as a narcotic.[12] Daumal's remarkable last work defies genre, but its tale of explorers in search of an invisible but real mountain on their ship, the *Impossible*, exhibits similarities to first-person accounts of ecstatic religious experience, fantasy, and science fiction. Daumal died in 1944, at the age of thirty-six, leaving *Le Mont Analogue* unfinished after four years of writing. The text was published posthumously in 1952, the year before a young and impoverished Jodorowsky arrived in Paris on a ship from South America. Jodorowsky probably read the book during his initial years in France.

Ben Cobb theorises that *The Holy Mountain*, which ends abruptly when the Alchemist breaks the fourth wall and declares his identity as the film's director, remains without conclusion in homage to Daumal's mysterious work, which famously ends mid-sentence. Cobb underscores his claim with a detailed summary of *Le Mont Analogue* in relation to Jodorowsky's film.[13] Rather than confirm this thesis, which in my opinion overstates the film's loyalty to Daumal's text, I consider how in Jodorowsky's film the surrealist critique of modern society, with its call for a revolution of the mind, cohabits with the quest for a better world through the spiritual healing of the innermost self. I believe that this comparative approach to surrealism studies is fitting because Daumal's novella was just one of several intertexts for

The Holy Mountain. For instance, the Spanish friar and mystic St. John of the Cross's late-sixteenth-century text *Ascent of Mount Carmel*, with its explanatory approach to the soul's unification with God, was also a direct inspiration.[14] Thomas Mann's 1924 novel *The Magic Mountain* (*Der Zauberberg*), which juxtaposes the peaceful realm of an alpine sanatorium with the battlefields of the Great War, was most likely another reference, given the fact that Jodorowsky's first film, 1957's *The Severed Heads (The Tie)* (*Les Têtes interverties (La Cravate)*), was partly based on Mann's 1940 novella *The Transposed Heads: A Legend of India* (*Die vertauschten Köpfe: eine indische Legende*).[15]

The trope of the fantastical journey had already appeared in Jodorowsky's science-fiction writing for underground publications in Mexico, such as the journal *S.NOB*, in the early 1960s. In 1964 he collaborated with friends to produce Mexico's first magazine devoted to science fiction, *Crononauta*, with illustrations by Manuel Felguérez, one of the artists who later worked on *The Holy Mountain*.[16] Seven issues of Jodorowsky's science-fiction comic, the first in Mexico, *Aníbal 5*, followed in 1966. By the end of 1968, a personal how-to approach to enlightenment increasingly became the subject of his weekly comic strip in the newspaper *El Heraldo de México* (1967–73), *Las Fábulas pánicas*.[17] On behalf of the international Panique collective, Jodorowsky critiqued surrealism for its apparent disdain of comics, science fiction, and rock and roll. However, Gavin Parkinson has recently reaffirmed surrealism's long-standing affinity for comics, and clarified that the movement actually maintained strong ties to science fiction beyond its foundational rapport with Jules Verne.[18]

Despite these important points of reference for the story of spiritual quest in *The Holy Mountain*, Daumal's *Le Mont Analogue* should be seen as a major source for the film. I base this assumption on Jodorowsky's interest in and engagement with esotericism, the psychology of personality, psychedelic drugs, science fiction, and extreme psychosomatic exertions as varied means of achieving expanded or renewed consciousness. Daumal, like Antonin Artaud, is a crucial figure for Jodorowsky's self-appointed cultural lineage that spans surrealism, Panique, and the experimental art, music, and theatre scene in Mexico during the late 1960s and early 1970s. During the 1930s and 1940s, the group of young writers that formed around Daumal and *Le Grand Jeu* triggered ecstasy or derangement through various means, including morphine, opium, hashish, and chemical use, as well as paranormal exercises such as tests of psychic ability, telepathy, and induced near-death experiences.[19] Artaud similarly studied altered states of consciousness and supernatural contact through narcotics, the purported use of botanical psychedelics, and esoteric knowledge, in particular during his time in Mexico in the late 1930s and after his return to France. He later merged these interests

with his theories of a Theatre of Cruelty as a ceremonial procedure for liberating shock.[20]

If, as I claim, *The Holy Mountain* interprets surrealism in part through a genealogy dominated by Daumal and Artaud, it is therefore a strain of surrealism that disaffiliates with the movement nearly as much as it aligns. In *The Holy Mountain*, the surrealist revolution of the mind is transformed into a psychosomatic 'trip' combining psychedelics with amalgamated aspects of esoteric and religious traditions, wherein internal and worldly voyages result in various stages of awakening. Daumal's reconfiguration of surrealism's revolution of the mind with ideas gleaned from G. I. Gurdjieff's mystical quest for the 'Fourth Way' in *Le Mont Analogue* was a significant influence for Jodorowsky's film. Like his friend Leonora Carrington, Jodorowsky had been drawn to Gurdjieff's teachings since the 1950s.[21] His profound interest in Gurdjieff's work was sustained during the early 1970s.[22]

Like Daumal and Artaud, Jodorowsky emphasised the new sciences of personality in addition to the Freudian psychoanalysis that surrealism largely favoured. By 1973, Jodorowsky had long studied Zen Buddhism and the Tarot. In preparation for *The Holy Mountain*, Jodorowsky and his wife at the time, Valerie, who plays the character Sel in the film, studied at the Arica School with the spiritual teacher Óscar Ichazo. Under Ichazo's supervision, Jodorowsky ingested a hit of acid in the quest for self-knowledge.[23] Ichazo's teachings focused on enlightenment achieved through self-awareness, drawing upon Gurdjieff's ideas and those of Chilean psychiatrist Claudio Naranjo. This was an elaboration of a version of Gurdjieff's enneagram, a table of nine personality types, which was also a macrocosmic view of the world and a key to enlightenment.[24] Much of the crew and some cast members also trained under members of the Arica programme and with Jodorowsky's Zen master, Ejo Takata, in advance of the film and to some degree during production, following a strict regimen of yoga, meditation, dieting, and sleep deprivation.[25] Daumal's story of a group striving to find an invisible mountain was adapted by Jodorowsky to fit the enneagram structure, with the film's seven acolytes, the Written Woman, and the Alchemist/Thief collapsed into one being, corresponding to the nine personality types and the planets in earth's solar system. The enneagram figure is visible as a motif in the film's sets and costumes.[26]

Given the concentration of these disparate sources and several other surrealist presences in the film, separate but interconnected affinities with the meaning and significance of surrealism for Jodorowsky's film are strengthened in quantity and gesture in provocative ways. For example, Cuauhtémoc Medina has argued that a 'new type of *indigenista* fantasy ... directly linked to psycho-chemical experimentation' played a significant role in the conception, production, and reception of the film.[27] The film certainly does depict

indigenous people and customs in a number of scenes that suggest post-colonial critique. However, there is no extended engagement with indigenous issues in the film. Instead, *The Holy Mountain* appears to be linked as much to an avant-garde tradition of psychotropic experimentation as to a pop-culture fantasy about Mexican shamanism. Jodorowsky's film is manifestly critical of *indigenista* fantasies, although this critique is communicated in a typically complex Jodorowskian fashion. To my mind, Jodorowsky seeks to engage the avant-garde interest in narcotics (Daumal) or indigenous psycho-tropics (Artaud) in order to pay homage to what he saw as the avant-garde critique of capitalist modernity through such intoxications. Nevertheless, this homage in *The Holy Mountain* also contains a satire of the hippie search for social transgression through neo-colonialist drug and *indigenista* tourism in Mexico.

On the one hand, Jodorowsky's method-acting quest for the mountaintop of higher consciousness via botanical psychotropics specifically recalls Artaud's purported experiments with peyote while studying the Tarahumara tribe in Chihuahua, which he described in *Les Tarahumaras* (1947). On the other hand, *The Holy Mountain* did engage with some aspects of the vision-ary psychedelia celebrated by some manifestations of the counterculture, or the international youth-movement trend in popular culture, frequently asso-ciated with hippie identity from the mid-1960s to the mid-1970s and often called *la Onda* in Mexico at this time. Jodorowsky met with Carlos Castaneda in Mexico City in advance of production for *The Holy Mountain*. He was excited by the idea of the 'spiritual warrior' that he felt Castaneda had revived in his description of peyote visions facilitated by a Yaqui shaman in Sonora. The two discussed the possibility of making Castaneda's *The Teach-ings of Don Juan: A Yaqui Way of Knowledge* (1968) into a film involving practising shamans and actual magic rites.[28] Shortly thereafter, Jodorowsky had his first experience with hallucinogenic morning-glory seeds, known as *ololiuhqui* in Nahuatl, and psychedelic mushrooms. The mushrooms were purportedly sent to him by the Mazatec *curandera* María Sabina through an artist friend, although this is most likely a myth constructed by Jodorowsky.[29] The cast also consumed psychedelic mushrooms, called *angelitos*, while filming on location at Monte Albán; they appear under their influence in one scene. Although Jodorowsky later criticised 'trendy neo-shamanism' and the fetishised idealisation of indigenous culture as an exotic other, *The Holy Mountain* nevertheless depicted shamanic cupping and mushroom ceremo-nies, using local non-professional actors as shamans.[30]

The surrealist lineages present in *The Holy Mountain* contributed signifi-cantly to the film's radicalism and interact in complex ways with what might be called its countercultural characteristics, its affinities with the interna-tional popular youth culture of the period. The film's interest in this narcotic

or psychedelic branch of the avant-garde as a complement to what Jonathan Eburne calls the 'esoteric avant-garde' is in part also a critical commentary on the influx of expatriates who moved to Mexico in search of spiritual psychedelic experiences.[31] This counterculture invasion arguably impacted the suspicion of *jipismo*, the Mexican hippie movement of *la Onda*, during the Luis Echeverría Partido Revolucionario Institucional presidency (1970–76) and may have contributed to the atmosphere that supported the *Guerra Sucia*, or violent state suppression of the student movement, starting with the Tlatelolco massacre in 1968.[32] Jodorowsky's *The Holy Mountain* establishes a shared genealogy of experimental radicalism with examples from the period of World War II such as Daumal and Artaud.[33]

The critique of colonialism and neo-colonialism in the film, which partially manifests via the surrealist-inflected intertexts of Daumal and Artaud, appears to have resulted in immediate ramifications.[34] Jodorowsky received death threats during production. After a phone call from Echeverría's minister of defence warning the director against depicting anyone in military or religious uniform in the film, Jodorowsky and his family fled Mexico during post-production, believing that a paramilitary group, the Falcons, were pursuing them.[35] The film premiered at the Cannes Film Festival out of competition as an American film, rather than a Mexican one, a few months before the Chilean coup d'état, the news of which must have shaken Jodorowsky despite his long-time expatriate status. *The Holy Mountain* was not screened in Mexico until 1975, when it appeared in a censored version.[36]

Disorientation of cosmic scale

The Holy Mountain commences with an extended credit sequence revealing the Alchemist undertaking a purification rite. Two female initiates costumed like Marilyn Monroe are ritually cleansed in the space of a magical domain. Once this process is complete and the accoutrements of the twin Marilyns have been wiped, stripped, and shaved away, the final shots of the credit sequence revert to a fifty-five-second montage of six boxed assemblages by the artist Alan Glass. Glass's assemblages are animated by cinematographer Rafael Corkidi's repeating and alternating camera zooms and tilts. The score, composed by Jodorowsky and Henry West, with arrangements by Don Cherry and Ronald Frangipane, contributes to the ceremonial atmosphere through the use of Buddhist chimes and throat singing. These effects create a visually and aurally sumptuous framework for *The Holy Mountain* that simultaneously disorientates the viewer.[37]

The Canadian artist Alan Glass became closely involved with surrealism after relocating to Paris as a young man in the early 1950s, where he soon

became acquainted with Jodorowsky.[38] Following a positive reception by André Breton, Glass was offered a solo gallery exhibition of his ballpoint-pen drawings. The exhibition was organised by Breton and Benjamin Péret in January of 1958 at Eric Losfeld's Galerie Le Terrain Vague in Paris, for which Jodorowsky wrote the preface: 'The ballpoint pen is the implement which opposes the fewest obstacles between impulse and action. It's a question of going faster than consciousness. The ballpoint pen ... comparable to jazz, improvisation, trance, auto-hypnosis. Explosion.'[39] Between 1961 and 1962, Glass took his first trips to Mexico City. He returned again in 1963 to take up residence.[40] During these initial sojourns, Jodorowsky introduced Glass to surrealist friends such as Leonora Carrington.[41] In 1971, just before production for *The Holy Mountain* commenced, Glass's assemblages were featured in a major exhibition at the Museo de Arte Moderno in Mexico City, 'Surrealismo y arte fantástico en México', where they hung alongside works by other surrealists such as Leonora Carrington and Remedios Varo, as well as selections by contemporary Mexican artists who collaborated with surrealists in Mexico during the 1960s, such as Pedro Friedeberg.[42] Glass recalls that in February of 1972 Jodorowsky asked if he could take footage of some of Glass's assemblages on display in Galería Pecanins in the Zona Rosa of Mexico City and that Jodorowsky did so without Glass's presence.[43] Leonora Carrington wrote a short incantatory text in English for the flier for this exhibition and another in Canada that year. It included phrases that resonate with the otherworldly ambiance of Jodorowsky's screenplay. 'He can tell of the journey over the glass mountain where the blood from his feet turned into scarlet leaping shrimps that fed the decapitated ogress', Carrington wrote.[44]

The artworks that appear in *The Holy Mountain* are representative of Glass's mature style of assemblages, made of found objects intricately arranged in cases. The first shot of Glass's assemblages reveals a zoomed-out detail of the central panel of the triptych *Enquire within* from 1971, consisting of a pattern of glass eyeballs set amid iridescent feathers and beetles and surmounted by a glass target (Plate 5). The second shot mirrors this expanding zoom by recording a detail of the central motif of the right panel of the diptych *Egyptian Box* (1971), with its gilded and bejewelled decorative panel. The camera's pattern of locating concentric circles within these works continues in another detail of the left panel of *Enquire within*, featuring a numbered target surrounded by peacock feathers. This is followed by a shot of an untitled assemblage from this era by Glass also containing a speckled eyeball.[45] A second untitled assemblage by Glass appears, a work that was reproduced on the flier for Glass's exhibition in Montreal in May of 1972 at the Galerie de Montréal, which reprinted the text by Carrington that had appeared in the Galería Pecanins document.[46] The lid of its box supported a

nineteenth-century wood engraving; the interior was a feathered tuft cradling a skeleton key. Footage of two final works follow: a downward tilt shot of the right panel of the triptych *Hôtel du Grand Laboureur* (1971), showing three reclining figures and a mouse, and an upward tilt shot of the spectacular, blue-hued *Sin título* of 1971 (Plate 6), including a taxidermied snake, large fake pearls, glass eyeballs, a dragon figure, and an icosahedron-shaped object.

In choosing pieces by a Mexico-based contemporary artist working in surrealism's assemblage tradition as the support structure for the film's credits, Jodorowsky frames *The Holy Mountain* as a work with self-consciously surrealist foundations. The presence of a montage of Glass's three-dimensional pieces implies that these surrealist foundations are to some degree inflected by the film-maker's personal experience. After all, Alan Glass had shared time with Jodorowsky in Paris in the 1950s and early 1960s, an era when they were both frequenting surrealist meetings and events – and like Jodorowsky, Glass had started living in Mexico City for extended periods in the early 1960s. Jodorowsky exposes the viewer to his own lived and transnational surrealism, conveyed from South America to Europe to North America, and specifically to Mexico. He does so through his selection of elected predecessors, such as Daumal and Artaud, and with explicit – and in some cases implicit – allusions to his own friends, such as Glass, who were either surrealists or had ties to the movement.

Significantly, this biographical or personal approach to citing surrealist ancestors and peers focuses largely upon a specifically Mexican legacy of surrealism – a fitting orientation given the film's highlighting of the history of Mexico and its inclusion of contemporary Mexican art and artists in the production of scene and set design. The fact that many of the surrealist friends cited or included in *The Holy Mountain* were also immigrants to Mexico from other nations, like Jodorowsky himself, also bears consideration. Rather than existing in isolation from other aspects of the film, therefore, these surrealist presences arguably function as counterparts to or components of satirical portions of the film, such as the scenes depicting the massacre of Mexican student protesters.

In the credit-sequence montage of Glass's assemblages, the ordered world of his elaborate boxes is immediately followed by a grotesque depiction of the Thief's debasement. The assemblages thus potentially serve as a contemplative tool for psychic amelioration during the ascent of the internal mind to the mountaintop. Pieces such as *Enquire within*, with its left panel featuring nine peacock feathers surrounding a target, suggest a visual microcosm of the panorama that awaits the seekers at the top of the Holy Mountain on Lotus Island: the nine immortals, forty-thousand years old, seated around the enneagram table. The filmed details of Glass's assemblages emphasise

mandala and eye shapes. These details harmonise with the dynamic, rainbow-hued sets used for scenes in the alchemical tower, which were created and produced by Mexican scenographers David Antón and Jose Durán, along with other crew members.[47] For instance, in the scene in which the eight initiates burn their money and their identities in the form of waxen self-portrait mannequins (made by the Mexican artist Antonio Neyra/Neira), they are seated around a circular table in a room painted and shaped like a human eyeball. Bird's-eye shots of this room render the eight initiates and the Alchemist as minute forms for the first seconds of the scene. Cosmic scale is once again shown to envelop and subsume human experience. From assemblage case to alchemical tower to invisible mountaintop, the scope of human achievement is shown as irrelevant in the ascent of initiation. Esoteric diagrams such as the enneagram, adapted as it originally was by Gurdjieff from the Sufi tradition, represent both the universal and the particular. The focus on the interior realm in Glass's assemblages, filmed as boxes within boxes in a dizzying *mise-en-abyme*, resonates with Daumal's interest in the invisibility of Mount Analogue and the hermetic aspect of the mountain's secrets. One of the surrealist legacies that Jodorowsky invokes in *The Holy Mountain* is this internal and limitless world of the mind.

The transformative power of the esoteric arts

There is no explicit allusion to surrealist Leonora Carrington or her work in *The Holy Mountain*, but her influence is palpable in the costumes, sets, and direction in the Alchemist's lair, and in diverse moments in the many scenes and shots that relate to two of Carrington's primary interests, the Tarot and alchemy. Carrington was one of the few active surrealist practitioners of the esoteric arts. When Jodorowsky sought out her friendship during his earliest travels to Mexico in the late 1950s, she initiated him into the Tarot, which he had already encountered in Chile as a child and young man.[48] The Marseille Tarot deck that André Breton recommended to Jodorowsky in the early 1960s has been definitive for his life and work as an esoteric practitioner ever since, as has Carrington's influence as one of his key initiators into occult knowledge.[49] Likely inspired by the French surrealists' enthusiasm for the Tarot, Carrington designed more than one deck of Tarot cards over the course of her life. Her friend Remedios Varo also completed Tarot designs in 1957.[50] Carrington's deck shows some stylistic resemblance to the twelve arcane panels, seemingly a new version of the Tarot, shown in the heart of the Alchemist's lair in the film, designed by Luis Urías based upon Jodorowsky's description, and produced by scene painters under the direction of Urías (Plate 7).[51]

Jodorowsky may also have been influenced by his earlier collaborations with Carrington in Mexican theatre, in particular her sets and costumes based on the Tarot for her 1946 play *Pénélope,* which Jodorowsky directed in 1961.[52] Moreover, the theme of occult initiation and quest so palpable in Carrington's writings, such as *Down Below* (1944) and *The Hearing Trumpet* (written during the 1960s and published in 1974), exhibit an overarching affinity with Jodorowsky's 1973 film.

Another contemporary reference for Jodorowsky during production was a 1971 film by his friend and collaborator Juan López Moctezuma, *The Mansion of Madness (La mansion de la locura).*[53] This film, for which Carrington worked as art director and costume designer, is discussed in this volume by Felicity Gee.[54] Francisco Peredo Castro's detailed discussion of this film demonstrates Carrington's influence on its memorably fantastic scenes in an asylum overtaken by its inmates.[55] The imaginative sets and costumes for *The Mansion of Madness,* created under the direction of Carrington with help from her son Gabriel Weisz, are likely a visual reference for *The Holy Mountain,* a synergy that is all the more apparent given that Rafael Corkidi was the cinematographer for both films.

Likewise, several motifs reoccurring in Carrington's paintings from the 1950s and 1960s, such as enneagram-like designs and tall-hatted wizards, resonate with the sets and costumes in Jodorowsky's 1973 film.[56] One example is her 1970 painting *The Birdmen of Burnley* (Plate 8), which depicts three figures in ceremonial dress communicating magically with seven caged birds. The figures invoke a text in their hands and a magical inscription on the floor, one section of which reads in bidirectional and mirror writing, 'The birds of prey prey the vulture from the far mountain a homely thought ... End of the patriarch's rule is the earth fossil.'

Given Jodorowsky's close friendship and collaboration with Carrington in the late 1950s and early 1960s and his familiarity with the work of Carrington's friend Remedios Varo (whose 1960 painting *The Ascension of Mount Analogue* he may have known about), it is extremely likely that the alchemical realm in his film was as broadly informed by their creations as it was by the symbolism of the major arcana.[57] The Thief scales the tower that holds the Alchemist's hermetic lair, only to pierce the hymen of consciousness with a phallic knife and demand gold. This is given to him after his body, the alchemical 'nigredo', or black matter, is cleansed through the 'albedo' process, and his excrement transmutes in an athanor.[58] With help from his associate the Written Woman, played by Ramona (Zamira) Saunders, the Alchemist instructs the Thief in various rooms of his tower, accompanied by a bestiary of magical creatures, such as a baby hippo frolicking in a fountain. Many of Carrington's and Varo's paintings recall these scenes in which the barriers between human and animal, matter and spirit are overcome in the act of studying esoteric arts.

'Alchemist theatre'

An account of surrealist elements and their motivation in *The Holy Mountain* is not complete without a brief overview of the way in which the Panique movement (*Teatro Pánico* and *Grupo Pánico* as it was called in Mexico) may have influenced Jodorowsky's film. Panique was a transnational and multimedia art collective formed in Paris in 1962 by Jodorowsky, Roland Topor, and Fernando Arrabal, and in Mexico the same year with Luis Urías and others. It was at once profoundly influenced by surrealism and critical of it.[59] Several scenes and narrative elements in *The Holy Mountain* resemble Panique's Artaudian emphasis on a corporeal experience of terror activated into euphoria through event-based expression.[60] The clearest witness in the film to this Panique inflection of Artaud is the Conquest of Mexico circus, a blood-soaked scene that involves the shocking mutilation and death of frogs and lizards dressed like Aztec soldiers and Spanish warriors in a staged explosion.[61] As other scholars have noted, Artaud included a synopsis for the 'first spectacle of the Theatre of Cruelty' in his *The Theatre and Its Double* (*Le Théâtre et son double*) of 1938, a turbulent account of the Conquest of Mexico , which concludes: 'And the sharp spasms of the battle, the foam of the heads of the cornered Spaniards who are squashed like blood against the ramparts that are turning green again.'[62]

The conquest of amphibians and reptilians in *The Holy Mountain* echoes the rhapsodic tone and violent imagery in Artaud's text, but it also adds a Panique dose of black humour in the costumed miniaturisation of this epic scene. Jodorowsky may have been recalling earlier Panique ephemerals in Mexico that utilised violence towards animals as a satirical critique of the repression of everyday violence towards the natural world in most modern societies.[63] Such themes recur in most of Jodorowsky's films of this period, recalling the Buñuelian preoccupation with animal corpses and, in the case of the burro attacked by a swarm of bees in Buñuel's *Land without Bread* (*Las Hurdes*, 1933), horrifying animal suffering.

Of *Teatro Pánico*, Jodorowsky claimed, 'I want to reach a mystical theater characterized by the search for self; a kind of alchemist theatre, where man changes, progresses and develops all his potentials.'[64] The alchemical transformation in *The Holy Mountain* of the eight initiates from criminals, capitalists, warmongers, and state officials into spiritual seekers retains some aspects of this Panique-theatre critical breakdown of the ego through chaotic juxtaposition. The seven satirical vignettes about the initiates named Fon, Isla, Klen, Sel, Berg, Axon, and Lut, for example, often evoke the unusual combination of sadism and hilarity utilised by Panique to induce traumatic catharsis. The psychomagical actions that the eight acolytes undergo – including induced visions of castration, bestiality, and incest – are

also reminiscent of the waking-nightmare aesthetic frequently achieved by the chaotic Panique ephemerals, or unscripted performances, that Jodorowsky collaboratively produced with other Panique members in Mexico City and Paris. Roughly twenty-seven Panique *efímeros* were realised in Mexico, starting in 1962. They often included real or simulated violence towards female and animal bodies, perpetrated perhaps as a critical commentary upon society's own such violence, such as the massacre of Mexican students in 1968 and 1971 in the *Guerra Sucia*, although such an orientation in no way remains unproblematic.[65] Scenes in *The Holy Mountain* such as Klen's sexually interactive and exploitative art factory, Berg's raucous relationship with his Mother and their pet snake, and Axon's psychomagical vision of pure aggression in the dog fight best evoke the paranoid atmosphere of Jodorowsky's earlier Panique ephemerals such as *Sacramental Melodrama* (Paris, May 1965).

The way in which Jodorowsky's own Panique past is linked to these elected surrealist predecessors and associated peers is explored throughout the film. Some of Jodorowsky's *Pánico* collaborators from the 1960s based in Mexico City are granted prominent exhibition space in certain scenes, while other references are more remote and refer broadly to contemporary art in Mexico after World War II. For instance, the Alchemist's red tower is part of a large public sculpture for which artist Mathias Goeritz contributed designs and ideas, the *Torres de Satélite* (1958), located in north Mexico City, by Goeritz, Luis Barragán, and Jesús Reyes Ferreira. Goeritz was an immensely influential artist when Jodorowsky arrived in Mexico, having completed many collaborations with Mexico-based surrealists. However, he was not a member of Panique and thus the inclusion of the *Torres de Satélite* likely does not possess a comparable extent of signification. In contrast, the participation of Manuel Felguérez in the film is pivotal. Felguérez, a Mexican artist closely associated with *Grupo Pánico* activities, contributed most of the works for the scenario about the art impresario, Klen, including the mock-kinetic sculptures in Klen's art factory, as well as a shower contraption with multiple brushes that covered a woman's body in a scene later cut from the film.[66] The works designed by Felguérez for *The Holy Mountain* are a keen satire of commercialism in the contemporary art world, using French conceptual artist Yves Klein's *Anthropometry* series of nude performance paintings from 1960 as a target for the joke.[67] Nevertheless, the geometric abstraction that Felguérez was known for in his own practice is traceable there to some degree, particularly in the magnificent interactive kinetic sculpture he made for the film, *La máquina del deseo*, which resembles the artist's earlier works, such as his large sculpture *Destructive Invention* (1964). More evident in the film than Felguérez's studio practice is the long history of his many contributions to and collaborations with *Grupo*

Pánico performances, sets, and actions in Mexico City during the 1960s, such as his performative mural with a live model in Jodorowsky's *Efímero de San Carlos* of 1963, *Humanisimo*.[68] Nearly all of the sculptures in Klen's art factory contain the painted bodies of live actors encased in supports that expose only breasts, genitals, and orifices, with which viewers depicted in the film can interactively manipulate and copulate. When coaxed by Klen's lover using the long rod provided, *La máquina del deseo* reaches orgasm, ejaculates a stream of liquid, and produces a *máquina* love child. This focus on satirical humour combined with erotic exhibitionism and the transgression of bourgeois sexual mores resonates with Panique aesthetics prevalent in Mexico during the 1960s and recalls Felguérez's participation in that movement.

Likewise, the multimedia artist, musician, and film director Luis Urías, who appears briefly in the film as the circus conductor, was a design coordinator for *The Holy Mountain* and significantly impacted some aspects of the sets, costumes, and props in the film. A contributor to Panique ephemerals and related events and performances, Urías was instrumental in the development of *Grupo Pánico* in Mexico from 1962 to 1974. In addition, he wrote and co-directed with Gelsen Gas the experimental Mexican feature film *Anticlímax* (filmed 1969; released 1970), including a brief appearance by Jodorowsky and poems by his sister, Raquel Jodorowsky. *Anticlímax* includes a scene in a mirrored room, the installation *Ambiente Mexico 68* (1968) by Belgian artist Luc Peire at the Museo de Arte Moderno, which may have influenced the comparable scene in a mirrored room by an unknown artist in *The Holy Mountain*.[69] However, it is also quite possible that other mirrored rooms from this period, such as Ira Cohen's Mylar chamber in Manhattan, in which Jodorowsky was photographed between 1966 and 1970, were also an influence.

Conclusion

While surrealist groups around the world were active in the 1960s and 1970s, works such as Jodorowsky's *The Holy Mountain* indicate that surrealist elements appeared in cultural manifestations outside the bounds of surrealism. This extension of surrealism in a continuum of eclectic cultural developments in this period is an important outcome of surrealism's own internationalism and political radicalism. The surrealist movement actively fostered the wide distribution of its message through its self-articulation as a political-aesthetic method of social protest and revolutionary thought: a revolution of the mind that would accompany a revolution in the material world and its social circumstances. When we interpret surrealism as a cultural

method or tool of revolt and envisioning, rather than strictly as a historical phenomenon or an aesthetic style, we reconfigure this extension of the 'movement' as a strengthening of the surrealist cause, not the dilution of 'classic' aims that has traditionally characterised the life cycle of artistic styles. In that sense, *The Holy Mountain* combines and transmutes elements of surrealism, esoteric practices, and contemporary Mexican art, performance and culture. Jodorowsky's film thus undertakes a filmic alchemy in order to cannily refashion both hegemonic and countercultural formations for its own reconfiguration of society.

Notes

1 I am grateful to Luis Urías and Manuel Felguérez (1928–2020) for their assistance with this research.
2 Santos, *The Holy Mountain*, passim.
3 Ibid., 92–3. Susik, 'Panique', 521–4.
4 Short, *The Age of Gold*, 160.
5 Richardson, *Surrealism and Cinema*, 141.
6 Acevedo-Muñoz, *Buñuel and Mexico*, 149–51; Santos, *The Holy Mountain*, 75–85.
7 Medina, 'Recovering Panic', 98.
8 Moldes, *Alejandro Jodorowsky*, 466–7.
9 Cerdán and Fernández Layaben, 'Arty Exploitation', 105; Pensado, *Rebel Mexico*, 162–70; Garcia, 'O México de Alejandro Jodorowsky em *La montaña sagrada*', 4–23.
10 Cerdán and Fernández Labayen, 'Arty Exploitation', 105; Zolov, *Refried Elvis*, 117; Hermosillo Urías, 'Pintura y television', 134–47.
11 Jodorowsky, *Psychomagic*.
12 Duncan, 'Introduction', 7–28.
13 Cobb, *Anarchy and Alchemy*, 120–5.
14 Ibid., 119–20.
15 Ibid., 2.
16 Susik, 'Losing One's Head in the "Children's Corner"', 119–22; González Dueñas, 'Jodorowsky's Art of Transmuting Wisdom', v–xii.
17 González Dueñas, 'Jodorowsky's Art of Transmuting Wisdom', v–xii.
18 Cobb, *Anarchy and Alchemy*, 34; Parkinson, *Futures of Surrealism*.
19 Polizzotti, 'Introduction', i–xviii; see also Rosenblatt, *René Daumal*.
20 Artaud, *Les Tarahumaras*; *The Theater and Its Double*.
21 Jodorowsky, *The Dance of Reality*, 243. On Carrington's 'ambivalent' relationship to Gurdjieff, whose technique is parodied in her book *The Hearing Trumpet* (published in 1976 by St. Martin's Press), see Eburne, 'Poetic Wisdom', 144; and Arcq, 'In Search of the Miraculous', 19–20.
22 Jodorowsky, *The Spiritual Journey of Alejandro Jodorowsky*.

23 Jodorowsky, *The Dance of Reality*, 251–62. Ichazo's programme also included some consumption of marijuana: Jodorowsky, *Psychomagic*, 181–6.

24 The enneagram was initially discussed by the Gurdjieff interpreter, Ouspensky: Ouspensky, *In Search of the Miraculous*, 19.

25 Jodorowsky, *The Dance of Reality*, 215–18.

26 Chignoli and Moldes have slightly different interpretations of how the film's characters matched the enneagram structure. See Andrea Chignoli, *Zoom back camera!*, 56; and Moldes, *Alejandro Jodorowsky*, 288–95.

27 Medina, 'Recovering Panic', 99, italics original; Santos, *The Holy Mountain*, 34–5, 46.

28 Jodorowsky, *The Dance of Reality*, 262–5; Jodorowsky, *Psychomagic*, 110.

29 Jodorowsky, *The Dance of Reality* , 265–8; Jodorowsky, *The Spiritual Journey of Alejandro Jodorowsky*, xi–xiii.

30 Jodorowsky, *Psychomagic*, 237; Luis Urías, email message to author, 19 August 2018.

31 Eburne. 'Poetic Wisdom', 141–62.

32 Medina, 'Un rito de antiiniciación', 695–708; Santos, *The Holy Mountain*, 85–91.

33 Medina, 'Recovering Panic', 100.

34 Santos, *The Holy Mountain*, 29, 85–9.

35 Ibid., 30–8.

36 Ibid., 34.

37 Barzel, '"We Began from Silence"', 199, 218–19; Luis Urías, interview with author, 10 July 2018; Luis Urías, email to author, 19 August 2018.

38 Nonaka, *Alan Glass*, 35–9.

39 Jodorowsky, untitled text, n.p. My translation.

40 Nonaka, *Alan Glass*, 41–61.

41 Aberth, 'Exhibition Review', 135–8.

42 Garza Usabiaga, *La máquina visual*, 95–9; Rodríguez Prampolini, *El surrealismo y el arte fantástico de México*. The fusion of Pop and Op art, psychedelia, and surrealism in Friedeberg's work may have influenced the sets of *La montaña sagrada*.

43 Alan Glass, interview with author, 2 June 2018.

44 Carrington wrote and dedicated this text to Glass in 1971: Carrington, untitled text, n.p.

45 The location of this assemblage is unknown: Alan Glass, email to author, 14 August 2018.

46 The location of this assemblage is unknown: ibid.

47 On the theme of colour in the film, see Larouche, *Alexandro Jodorowsky*, 89–90.

48 Jodorowsky, *The Dance of Reality*, 239–40; Jodorowsky and Costa, *The Way of the Tarot*, 1.

49 Jodorowsky and Costa, *The Way of the Tarot*, 6–7.

50 Varo and Ovalle, *Remedios Varo*, 341.

51 Luis Urías, email to author, 14 June 2018. The current locations of the 40 x 60 cm drawings for the film's cards and the cards themselves (2.5 m height) are unknown: Luis Urías, email to author, 12 August 2018.

52 Moldes, *Alejandro Jodorowsky*, 92–3; Susik, 'Losing One's Head in the "Children's Corner"', 119–22, 105–25.

53 Jodorowsky, *Teatro sin fin*, 328; Cerdán and Fernández Layaben, 'Arty Exploitation', 105.

54 Santos, *The Holy Mountain*, 20.

55 Peredo Castro, 'On History', 330–6.

56 Eburne, 'Poetic Wisdom', 146–7; Aberth, *Leonora Carrington*.

57 Moldes, *Alejandro Jodorowsky*, 295–7.

58 Jodorowsky, *The Dance of Reality*, 216.

59 Aranzueque-Arrieta, *Panique*.

60 Orenstein, *The Theater of the Marvelous*, 192–215.

61 Santos, *The Holy Mountain*, 116 n. 6.

62 Artaud, *The Theater and Its Double*, 132.

63 Jodorowsky and Urías were not alone in their employment of violent satire in this period. In 1973, an artist collective associated with the *los grupos* (groups) movement in Mexico, Grupo Proceso Pentágono, staged two public performances that call to mind the satire of the student massacres in *La montaña sagrada*: Gallo, 'The Mexican Pentagon', 170–6; Goldman, *Dimensions of the Americas*, 123–39.

64 Jodorowsky, 'A Mass Changes Me More', 74. See also Orenstein, 'Alchimie du Verbe and Alchimie du Corps', 29–35.

65 Alcázar and Fuentes, 'Arte de los resquicios', 149.

66 Manuel Felguérez, email to author, 26 June 2018. Margaret Hudak painted the copies of famous artworks for the scene in Klen's mansion, including René Magritte's 1964 *Le Fils de l'homme*. Luis Urías, email to author, 12 August 2018.

67 Felguérez and Ashton, *Manuel Felguérez*, 197–8. Jodorowsky may also have intended satire of contemporary art with the scene featuring a Christian cross made out of television sets, which was later cut from the Klen scenario.

68 Bustamante, 'Non-Objective Arts in Mexico, 1963–83', 227–8. See also Bustamante, 'Conditions', 137–42.

69 Urías, 'Cinetismo Expo 2013'; Luis Urías, email to author, 12 August 2018.

Bibliography

Aberth, Susan Louise. 'Exhibition Review of "Zurcidos invisibles: Alan Glass, construcciones y pinturas, 1950–2008"'. *Journal of Surrealism and the Americas* 3, nos 1–2 (2009): 135–8.

——. *Leonora Carrington: Surrealism, Alchemy and Art*. Aldershot: Lund Humphries, 2004.

Acevedo-Muñoz, Ernesto R. *Buñuel and Mexico: The Crisis of National Cinema*. Berkeley, CA: University of California Press, 2003.

Alcázar, Josefina, and Fernando Fuentes. 'Arte de los resquicios'. In *Performance y arte-acción en América Latina*, edited by Josefina Alcázar and Fernando Fuentes, 147–80. Mexico City: Ediciones sin nombre, 2005.

Aranzueque-Arrieta, Frédéric. *Panique: Arrabal, Jodorowsky, Topor*. Paris: L'Harmattan, 2008.

Arcq, Teresa. 'In Search of the Miraculous'. In *Five Keys to the Secret World of Remedios Varo*, by Alberto Ruy Sánchez et al., 19–20. Mexico City: Artes de México, 2008.

Artaud, Antonin. *Les Tarahumaras*. Paris: Gallimard, 1971.

——. *The Theater and Its Double*, translated by Mary Caroline Richards. New York: Grove Press, 1958.

Barzel, Tamar. '"We Began from Silence": Toward a Genealogy of Free Improvisation in Mexico City: Atrás del Cosmos at Teatro En Galeón, 1975–1977'. In *Experimentalisms in Practice: Music Perspectives from Latin America*, edited by Ana R. Alonso-Minutti et al., 189–226. Oxford: Oxford University Press, 2018.

Bustamante, Maris. 'Conditions, Roads, Genealogies of Mexican Conceptualisms, 1921–1993'. In *Arte ≠ Vida: Actions by Artists of the Americas 1960–2000*, edited by Deborah Cullen, 134–51. New York: El Museo del Barrio, 2008.

——. 'Non-Objective Arts in Mexico, 1963–83'. In *Corpus Delicti: Performance Art of the Americas*, edited by Coco Fusco, 225–39. New York: Routledge, 2000.

Carrington, Leonora. Untitled text. In *Alan Glass: Jueves 17 Febrero 1972*, n.p. Mexico City: Galería Pecanins, 1972.

Cerdán, Josetxo, and Miguel Fernández Layaben. 'Arty Exploitation, Cool Cult, and the Cinema of Alejandro Jodorowsky'. In *Latsploitation, Exploitation Cinemas, and Latin America*, edited by Victoria Ruétalo and Dolores Tierney, 102–14. New York: Routledge, 2009.

Chignoli, Andrea. *Zoom back camera!: el cine de Alejandro Jodorowsky*. Santiago: Uqbar Editores, 2009.

Cobb, Ben. *Anarchy and Alchemy: The Films of Alejandro Jodorowsky*, edited by Louise Brealey. London: Creation Books, 2006.

Duncan, Dennis. 'Introduction'. In *Theory of the Great Game: Writings from Le Grand Jeu Magazine*, by René Daumal and Roger Gilbert-Lecomte, 7–28. London: Atlas Press, 2006.

Eburne, Jonathan P. 'Poetic Wisdom: Leonora Carrington and the Esoteric Avant-Garde'. In *Leonora Carrington and the International Avant-Garde*, edited by Jonathan P. Eburne and Catriona McAra, 141–62. Manchester: Manchester University Press, 2017.

Felguérez, Manuel, and Dore Ashton. *Manuel Felguérez: Constructive Invention*. Mexico City: Editorial RM, 2009.

Gallo, Rubén. 'The Mexican Pentagon: Adventures in Collectivism during the 1970s'. In *Collectivism after Modernism: The Art of Social Imagination after 1945*, edited by Blake Stimson and Gregory Sholette, 164–90. Minneapolis, MN: University of Minnesota Press, 2007.

Garcia, Estevão. 'O México de Alejandro Jodorowsky em *La montaña sagrada*'. *Cinémas d'Amérique Latine* 20 (2012): 4–23.

Garza Usabiaga, Daniel. *La máquina visual: una revisión de las exposiciones del Museo de Arte Moderno, 1964–1988*. Mexico City: Consejo Nacional Para La Cultura y Las Artes, 2011.

Goldman, Shifra M. *Dimensions of the Americas: Art and Social Change in Latin America and the United States*. Chicago, IL: University of Chicago Press, 1994.

González Dueñas, Daniel. 'Jodorowsky's Art of Transmitting Wisdom'. In *The Panic Fables: Mystic Teachings and Initiatory Tales*, by Alejandro Jodorowsky, v–xii. Rochester, VT: Park Street Press, 2003.

Hermosillo Urías, Luis. 'Pintura y television'. In *Cinetismo: movimiento y transformación en el arte de los 60 y 70*, by Daniel Garza Usabiaga et al., 134–47. Mexico City: Museo de Arte Moderno, 2012.

Jodorowsky, Alejandro. Untitled text. In *Alain [sic] Glass: du 8 au 24 Janvier 1958*, n.p. Paris: Galerie Le Terrain Vague, 1958.

——. *The Dance of Reality: A Psychomagical Autobiography*, translated by Ariel Godwin. Rochester, VT: Park Street Press, 2014.

——. 'A Mass Changes Me More'. *The Drama Review* 14, no. 2 (Winter 1970): 74.

——. *Psychomagic: The Transformative Power of Shamanic Psychotherapy*, translated by Rachael LeValley. Rochester, VT: Inner Traditions, 2004.

——. *The Spiritual Journey of Alejandro Jodorowsky: The Creator of El Topo*, translated by Joseph Rowe. Rochester, VT: Park Street Press, 2005.

——. *Teatro sin fin: tragedias, comedias y mimodramas*. Madrid: Siruela, 2007.

Jodorowsky, Alejandro, and Marianne Costa. *The Way of the Tarot: The Spiritual Teacher in the Cards*, translated by Jon E. Graham. Rochester, VT: Destiny Books, 2004.

Larouche, Michel. *Alexandro Jodorowsky: Cinéaste panique*. Paris: Éditions Albatross, 1985.

Medina, Cuauhtémoc. 'Recovering Panic'. In *La era de la discrepancia: arte y cultura visual en México, 1968–1997*, edited by Olivier Debroise, 97–103. Mexico City: Universidad Nacional Autónoma de México, 2006.

——. 'Un rito de antiiniciación: *The Holy Mountain* de Alejandro Jodorowsky'. In *La imagen sagrada y sacralizada*, edited by Peter Krieger, 695–708. Mexico City: Universidad Nacional Autónoma de México, 2011.

Moldes, Diego. *Alejandro Jodorowsky*. Madrid: Ediciones Cátedra, 2012.

Nonaka, Masayo. *Alan Glass*. Madrid: Turner, 2012.

Orenstein, Gloria Feman. 'Alchimie du Verbe and Alchimie du Corps: Two Aspects of the Influence of Surrealism on Contemporary Theatre'. *Dada/Surrealism* 3 (1973): 29–35.

——. *The Theater of the Marvelous: Surrealism and the Contemporary Stage*. New York: New York University Press, 1975.

Ouspensky, P. D. *In Search of the Miraculous*. New York: Harcourt, Brace & World, 1949.

Parkinson, Gavin. *Futures of Surrealism: Myth, Science Fiction and Fantastic Art in France, 1936–1969*. New Haven, CT: Yale University Press, 2015.

Pensado, Jaime M. *Rebel Mexico: Student Unrest and Authoritarian Political Culture During the Long Sixties*. Stanford, CA: Stanford University Press, 2013.

Peredo Castro, Francisco. 'On History, Myth, and the Celluloid Transfiguration of Fantastical Imagery'. In *Leonora Carrington: Magical Tales*, by Leonora Carrington, 319–41. Mexico City: Instituto Nacional de Bellas Artes, 2018.

Polizzotti, Mark. 'Introduction'. In *The Powers of the Word: Selected Essays and Notes 1927–1943*, by René Daumal, i–xviii. San Francisco, CA: City Lights Books, 1991.

Richardson, Michael. *Surrealism and Cinema*. New York: Berg, 2006.

Rodríguez Prampolini, Ida. *El surrealismo y el arte fantástico de México*. Mexico City: Universidad Nacional Autónoma de México, 1969.

Rosenblatt, Kathleen Ferrick. *René Daumal: The Life and Work of a Mystic Guide*. Albany, NY: SUNY Press, 1999.

Santos, Alessandra. *The Holy Mountain*. London: Wallflower Press, 2017.

Short, Robert. *The Age of Gold: Dalí, Buñuel, Artaud: Surrealist Cinema*. 2nd edn. Los Angeles, CA: Solar Books, 2008.

Susik, Abigail. 'Losing One's Head in the "Children's Corner": Carrington's Contributions to *S.NOB* in 1962'. In *Leonora Carrington and the International Avant-Garde*, edited by Jonathan P. Eburne and Catriona McAra, 105–25. Manchester: Manchester University Press, 2017.

——. 'Panique'. *The International Encyclopaedia of Surrealism*, edited by Michael Richardson et al., 521–4. London: Bloomsbury Press, 2019.

Urías, Luis. 'Cinetismo Expo 2013'. *Luis Urías Museo*. Accessed 1 August 2018. https://sites.google.com/site/luisuriasmuseo/visuales/cinetismo-expo-2013.

Varo, Remedios, and Ricardo Ovalle. *Remedios Varo: catálogo razonado*. Mexico City: Ediciones Era, 1994.

Zolov, Eric. *Refried Elvis: The Rise of Mexican Counterculture*. Berkeley: University of California Press, 1999.

11

Surrealist cinema in the Anthropocene: Nelly Kaplan, Jan Švankmajer, and the revolt of animals[1]

Kristoffer Noheden

Much as ants crawl out of a hand in Luis Buñuel and Salvador Dalí's *Un chien andalou* (France, 1929), so surrealist film is teeming with animals. Two surrealist film-makers afford animals a particularly prominent place. In Nelly Kaplan's (1931–) debut feature film, *La Fiancée du pirate* (France, 1969), the young woman Marie lives on the outskirts of a small village together with a goat. In Kaplan's *Néa* (France, 1976), the 16-year-old Sibylle shares her quarters with the cat Cumes. Both protagonists are portrayed as witches who disrupt narrow-minded social orders, and they do so in collaboration with their animal companions. A contemporary of Kaplan, Jan Švankmajer (1934–) depicts animal revolts against human domination with very different means.[2] In films such as *Alice* (*Něco z Alenky*, 1987), *Lunacy* (*Šíleni*, 2005), and *Insect* (*Hmyz*, 2018), he animates animal bones, muscles, eyes, brains, and taxidermy, sometimes combined into interspecies assemblages, in ways that subvert taxonomy and instil these beings with a sense of play and insurrection.

In this chapter, I examine how Kaplan and Švankmajer imagine possibilities of interspecies revolt in pursuit of alternatives to a civilisation predicated on exploitation of the non-human, from animals to plants to minerals and beyond. The film-makers' attention to the entangled faiths of human and non-human animals is attuned to problems afflicting the epoch that has become known as the Anthropocene, even as the bulk of their films predate its naming, in which the human imprint on earth shapes the planet in ways that encompass unpredictable changes in geology, atmosphere, and biodiversity.[3] Here, I will argue that Kaplan's and Švankmajer's films seek to imagine alternatives to the instrumental view of human–animal relations that underlie the current ecological catastrophe. As a dauntingly complex phenomenon, the Anthropocene is not merely a threat to animals but to the entire biosphere. Yet, the mistreatment of animals is one central facet of the way in which Western modernity has exploited nature. While the effects of the Anthropocene are so far-ranging that scholars have suggested that they

are too vast to be grasped by the human mind, conceiving of radically different human–animal relations appears to be one tangible and potent way of recalibrating the modern imaginary.[4] In this way, these surrealist films may suggest alternatives to a civilisation hinging on speciesist and ecocidal domination.

Kaplan and Švankmajer not only contribute to a long-standing tendency to depict animals imaginatively in surrealist film, but they also draw on an ongoing surrealist critique of such interrelated phenomena as anthropocentrism, human exceptionalism, and the exploitation of animals and nature. This, in turn, has developed out of the movement's attack on Western modernity and its institutions. In 'The Second Manifesto of Surrealism' (1929), André Breton asserts that 'every means must be worth trying, in order to lay waste to the ideas of *family, country, religion*'.[5] Sixty years later, an editorial in the Chicago Surrealist Group's journal *Arsenal: Surrealist Subversion* expands on Breton's statement and declares surrealism to be 'anti-statist, anti-sexist, anti-racist, anti-religious, anti-anthropocentric, anti-academic, allergic to Western civilization and its values and institutions'.[6] Between, and beyond, these proclamations lies an often obscured history of increasing surrealist awareness of issues pertaining to human–animal relations and ecological concerns. Surrealism's approach to these matters is prescient in the light of such latter-day theoretical advances as animal studies, posthumanist theory, and ecocriticism.[7] Surrealism, however, cannot be easily assimilated to academic standpoints. Discussion of surrealism is suspiciously absent from these fields, in spite of their purportedly wide-ranging attempts at interdisciplinary excavations of radical animal and non-humanist thought and aesthetics.[8] These omissions may well be due to the fact that surrealism's undermining of anthropocentrism went hand in hand with a broader change in direction for the movement, which encompassed turns and teachings that are mostly alien to contemporary theory.

During World War II, Breton posited anthropocentrism to be one crucial factor underlying the disastrous state of the world. During the same era, surrealism set out on a search for new myths and started to conceive of art as magic.[9] Far from escapist, this development was borne of desperation and the movement's pursuit of transforming a world in the throes of mass destruction into a more desirable place.[10] In hindsight, the culmination of World War II has been pinpointed as the onset of the Great Acceleration of the Anthropocene, during which the human influence on earth becomes particularly palpable.[11] Breton was far from alone in sensing that the world was under the threat of destruction, but his invocation in 1942 of natural cataclysms in the same breath as he critiques human exceptionalism appears to be a powerful intuition about the causes and breadth of the threat and challenges posed by this era.[12] In looking to new societal models, Breton rediscovered

the writings of the utopian socialist Charles Fourier, who envisioned a society of universal harmony, predicated on desire and imagination, which also encompassed new, non-coercive relations between humans and animals.[13] For Fourier, civilisation repressed not only humanity, but its relations with other animals. In *The Theory of the Four Movements* (1808), he calls for 'absolute doubt', *écart absolu*, in relation to civilisation and its mores; the concept would be central for later surrealism, as evidenced by the 1965 international surrealist exhibition *L'Écart absolu*.[14] Seeking to create new myths through magic art, surrealism drew on Fourier in placing desire and imagination in the service of transforming not merely human society but also human–animal relations.

In the following, I will examine how, much as Breton sought solutions in arcane lore for new ways of conceiving of the world, Kaplan and Švankmajer draw on magic to create new myths in which humanity is displaced from its privileged position, which provide alternatives to the logic underlying the Anthropocene. Švankmajer's films may seem bleaker in outlook than Kaplan's, but both recall Fourier's dire diagnosis of contemporary civilisation and his insistence that it can be replaced with a world guided by passional attraction – desire, imagination, and play trumping coercion and utility – in which humans and animals too develop new relations.

Surrealism, animals, and new myths for the Anthropocene

Surrealist film was born as slime oozing out of an animal's eye. The famous opening scene in *Un chien andalou* cuts from a close-up of a woman's anxious face, Buñuel's razor blade calmly approaching one of her eyes, to an extreme close-up of a cow's eye slashed open by a knife, the vitreous spilling out. The confusion of animal and human continues throughout the film, as a close-up of a hairy armpit is juxtaposed with found footage of a spiny sea urchin, ants crawl out of a hole in a man's hand, and priests drag a piano with donkey carcasses splayed out on top. The intermingling of animal and human recurs in Buñuel and Dalí's second film, *L'Âge d'or* (France, 1930), which opens with found footage of scorpions, whose menacing interactions appear to be allegorical of human society, later parodied as a machine for repressing desire, animalistic instincts jerking under the veneer.[15] Throughout, Buñuel and Dalí undermine pretensions to human exceptionalism and elevation above nature through cuts, juxtapositions, and gags that place humans in intimate relations with animals. Similar animal intrusions occur in many of Buñuel's later feature films, from a triumphant cock in *Los Olvidados* (Mexico, 1950) to the bear running through the mansion in *The Exterminating Angel* (*El ángel exterminador*, Mexico, 1962), and on to the

ostrich staring into the camera at the end of *The Phantom of Liberty* (*Le Fantôme de la liberté*, France, 1974). Buñuel's legacy is apparent in both Kaplan's blurring of boundaries between humans and animals and Švank-majer's decentring of human exceptionalism. However, whereas Kaplan's films share similarities with Buñuel's later depiction of live animals, Švank-majer extends the tendency in *Un chien andalou* to place dead animals or body parts into new configurations with other animal bodies, humans, or objects. The works of both film-makers also need to be seen in relation to broader surrealist tendencies in animal depictions and thought, including the ecological and magical development surrealism underwent during and after World War II.

Animals, along with plants, stones, and the environments in which they exist, have been prominently featured in surrealist imagery from the move-ment's inception. Max Ernst's forests and totemic birds, André Masson's hybrids of animals, humans, and buildings, Leonora Carrington's horses and mythological creatures, Jean Painlevé's documentary excursions into the lives of seahorses and octopuses, Toyen's dreamlike animals often crossed with humans or blending into the environment – all of these amount to a prominent fascination with the non-human world in its sprawling diversity, naturalistic observation enriched by transformations both marvel-lous and uncanny. Surrealist theoretical texts have similarly expressed rad-ical views of animal behaviour in relation to the environment. Subversions of humanist reason and an envisioning of human–animal continuities can be found throughout the 1930s journal *Minotaure*, in such essays as Bret-on's 'Picasso in His Element' (1933), and Roger Caillois' 'The Praying Man-tis' (1934) and 'Mimicry and Legendary Psychasthenia' (1935).[16] These writers propose intricate links between human creativity, myths, and psy-chology and animal behaviour and morphology, so presenting unorthodox takes on the Darwinian dictum that the difference between humans and other animals is one of degree, not of kind. Taken together, these artworks, films, and theoretical texts manifest a view of nature as being riddled with agency, creativity, and mind-like qualities that challenge ingrained Western views of the non-human world as mechanistic.[17] If these expressions amount to a revolt against anthropocentrism and domination, this opposition is notably narrated as an interspecies collaboration in Carrington's novel *The Hearing Trumpet* (1974), in which humans, goats, and werewolves form a new community.

There is also a distinct ecological dimension to these surrealist depictions of interrelations across the different registers of the world, from the smallest organisms to vegetation and stones to mammals and the human mind – at least if we understand ecology to designate the often sprawling interdepen-dence and interconnectedness of organisms and their environments.[18] Such

perspectives became more pronounced in surrealism from World War II onwards. In exile in the United States during the war, Breton sought new ways for transforming a world that appeared to be on the brink of destruction. In his 1942 'Prolegomena to a Third Surrealist Manifesto or Not', published in the wartime journal *VVV*, he argues that a persistent belief in human exceptionalism underlies the disasters shaking the world, and exclaims, 'Man is perhaps not the center, the cynosure of the universe.'[19] Proposing that we need new myths of the world to displace humanity from its self-imposed position as the crown of creation, Breton outlines a myth of the Great Transparents.[20] Intended to instil a humbling awareness of our comparative lack of knowledge about the constitution of the universe and relation to other life forms, these huge creatures are superior to humans, but invisible to the unaided eye except in times of great perils such as war or natural disaster. At this point, Breton indicates that surrealism had a startling insight into the larger problem of humanity's arrogant views of the non-human world overall, and the necessity to temper this not with more facts but on the level of poetry and myth.[21]

Breton imagined the Great Transparents in the years leading up to the Great Acceleration of the Anthropocene, considered to have started in 1945 when the combined effect of the first atom bomb detonated in Nevada, the launch of new petrochemical products, and the increased use of synthetic fertilisers left an indelible mark on the planet.[22] The Great Acceleration, however, does not mark the advent of the Anthropocene, but is rather an intensification of tendencies incited by the Industrial Revolution. Donna Roberts traces surrealism's innate affinity with environmentalism to its opposition to the Industrial age and its blind belief in technological and industrial progress.[23] But, as Timothy Morton has argued, the Anthropocene makes it impossible to locate ecological problems in any one such sphere. Its effects are to twist natural relations to unpredictability, so forcing a realisation of the imbrication of humanity and geology. Henceforth, ecological awareness entails a recognition of nature's fundamental weirdness.[24] Breton's mention of natural cataclysms and war in relation to humanity's perception of its approach to non-human beings suggests an intimation of the challenges posed by the increasingly erratic world of the Anthropocene. His proposal of an antidote in the form of a new myth resonates with Morton's contention that ecological thought, now, cannot be broached by reason alone, but is tantamount to a riddle; new ecological thought can only arise through a suprarational insight into the constitution of the world.[25] Or, to put it another way, surrealism's contribution to an unravelling of the Anthropocene may be this: its refusal to reduce the world to a correlate of logic and normative human perception enables it to provoke new conceptions of the world that heed its unpredictable, unstable, and profoundly unfathomable

character. Such conceptions indicate that technocratic solutions and rational philosophies may never suffice in countering a disaster which originates with domination of a world believed to be orderly and tameable.

Following the war, Breton wrote with trepidation about the imminent threat against not just the human species but the entire planet.[26] His search for new ways of conceiving of the human relation with the world led him to immerse himself in magic, alchemy, and occultism. Breton considered the creative engagement with nature and the cosmos found in such teachings to be replete with a proto-ecological potential to mend the gap between human and nature instilled by Western modernity.[27] This transformative vision of the world was enriched by Breton's discovery of Fourier. Disillusioned with the way in which communism had been perverted into Stalinism, in Fourier Breton found the path to a new freethinking politics of 'universal harmony', which emanated from desire and its capacity to transform the world into a place of both liberty and renewal.[28] Bonneuil and Fressoz point out that where most forms of socialism have been anti-ecological in their belief in the progressive potential of industrialism, Fourier perceived the threat to the environment posed by the Industrial Revolution.[29] Anticipating surrealism's disdain for civilisation, Fourier sought to counter the dangers of industrialism by proposing a universal analogy between humanity and the world, a potent image of the reciprocal relations that bind humans to their environment.[30] His envisioning of new phases of social development included reformed relations with non-human animals, amounting to, as Donald LaCoss puts it, 'an ecological understanding of the universe'.[31] Breton's embrace of Fourier indicates some of the ways in which surrealism sought out new approaches to politics and ecology, predicated on magical views of nature and attempts to establish harmonious relationships between human and world. These, as Breton points out in a 1946 interview, fed into surrealism's continued search for a new myth.[32]

Breton's insistence that Fourier, magic, and myth could enable humanity to imagine, and bring into being, a new, non-coercive utopian world is extended by Nelly Kaplan and Jan Švankmajer, whose films share Fourier's disdain for civilisation, its oppression of desire, and its denigration of the non-human world. In their films, animals join the revolt against civilisation.

Nelly Kaplan: interspecies alliances

There is a photograph of Nelly Kaplan looking lovingly into the eyes of a baby owl; there is another photograph of her gazing with an amused expression at the cat Schrödinger, who is turned away from her and looks out over the city; a third photograph shows her attempting to manoeuvre a goat

during the production of *La Fiancée du pirate*.[33] These interactions, intimate and playful, resound with the animal friendships of the female protagonists in her films, which are further steeped in post-war surrealist concerns and tinged more than a little bit with revolt.

Kaplan was born in 1931 in Buenos Aires, Argentina, but, in her own words, underwent a second birth when she eloped to France two decades later.[34] Her Argentinean background is indeed all but eclipsed in her films and writings by continuous references to surrealism's own canon of artist and writers: Lautréamont, Arthur Rimbaud, Gustave Moreau, William Blake, Charles Baudelaire, Alfred Jarry.[35] An avid cinema-goer from an early age, when she arrived in Paris Kaplan initially made a living as a film critic. Her forays into film production started when she met veteran director Abel Gance at an event in honour of Georges Méliès at the Paris Cinémathèque and began working as his assistant on a number of films.[36] Around the same time, she became friends with several surrealists, present or former, including Breton, André Masson, Pierre Soupault, and André Pieyre de Mandiargues. While Kaplan never joined the surrealist group, she was a close friend of Breton and published writings in such journals as *Le Surréalisme, même* and the surrealist-affiliated *Positif*. Starting in the early 1960s, she directed a string of art documentaries on such surrealist-friendly topics as the Gustave Moreau museum in Paris (*Gustave Moreau*, France, 1961), André Masson's erotic drawings (*À la source, la femme aimée*, France, 1965), and Pablo Picasso (*Le Regard Picasso*, France, 1967). Then, in 1969, she made her feature debut with *La Fiancée du pirate*, which was followed by four more feature films and a television film. Funding difficulties mean that Kaplan has not made a film since *Plaisir d'amour* in 1991; she has, however, published a number of short stories and novels.[37]

Breton memorably described Kaplan as being born from the enchanted copulation of a phoenix with a chimera, a description that reveals as much about his magnetic attraction to her as it does about her mercurial nature.[38] Through his friendship with Kaplan, Breton developed such an appreciation for Gance's films that he lauded them as examples of cinematic magic art in *L'Art magique* (1957).[39] Kaplan's own films, however, cultivate a decidedly different approach to magic. Whereas Gance relied on spectacular technical innovations, Kaplan's style is closer to that of Buñuel's deceptively unassuming late films. Much as the surrealist film critic Ado Kyrou's comprehensive overview *Le Surréalisme au cinéma* (1953) asserts the fundamentally surrealist and adventurous nature of the film medium for its dialectic between reality and imagination, so Kaplan's films evoke the marvellous in the everyday; much as Kyrou considered film to be humanity's new myth, so Kaplan's films take the shape of surrealist myths.[40] As I have shown elsewhere, they do so through an evocation of many of the concerns cultivated by surrealism

in the post-war era, including eroticism, ritual, and esotericism.[41] But her films are also new myths for the Anthropocene, which present new possibilities of human–animal interaction and even revolt.

Kaplan states, 'We live under patriarchal oppression. We have to combat the "enemy" until he understands that it is not in his interest to put us down.'[42] Much as other surrealists, however, Kaplan recognises that the oppression exerted by Western civilisation works on many levels, and that it affects human and non-human beings alike. Both *La Fiancée du pirate* and *Néa* take on patriarchy and the societies that uphold its power, but they do so with a prominent focus on animals. The first film shows the abused young 'nomad' Marie enacting her revenge on the people who have preyed on her vulnerable position and exploited her for cheap labour and sexual favours. Living in a shed outside the village in the company of a goat, Marie slowly starts turning the tables. She leaves the small village in tatters as she reveals her illicit recordings of the male villagers confessing their disdain for their spouses and each other. *Néa*, on the other hand, centres on 16-year-old Sibylle, an aspiring writer of erotica in a near-symbiotic relationship with her cat Villiers de l'Isle de Cumes, or Cumes for short. She grows up in a wealthy family, but is under the thumb of her oppressive father and frustrated by her lack of sexual experience. After seducing bookseller and publisher Axel Thorpe, she proceeds to write the novel *Néa*, which, published under a pseudonym, becomes a scandalous success; the novel is shown to have liberatory repercussions throughout society. As they depict the characters breaking the bonds of patriarchy, both films also liberate desire from its subordination to exploitation and normative restraint.

Néa opens with an epigraph from Fourier: 'Attractions are proportional to destinies.' The quote encapsulates Fourier's notion that passional attraction ought to guide the constitution of society, desire and play trumping common sense and utility in a harmonious fulfilment of human needs and abilities.[43] *Néa* is about precisely such fortuitous attractions capable of transforming not only personal destiny but that of the world. Both *Néa* and *La Fiancée du pirate* also involve the protagonists' animal companions in their protagonists' breaking of the bonds of oppression. In this way, they appear to be Fourierian pioneers of new human–animal relations.

While much surrealist art depicts hybrid, mythological, or imaginary animals, Kaplan's films, like Buñuel's, feature real, live animals. Yet, as Boria Sax contends, all human representations of other animals tend to be riddled with imaginary qualities, whether symbolic, mythological, or of more unconscious varieties.[44] Kaplan, for one, evokes the rich symbolism of the goat and the cat by associating them with protagonists who are depicted as witches. A scene in *Néa* shows Sibylle reading Jules Michelet's *La Sorcière* (1862), a counter-history of the witch widely read among surrealists. Kaplan

Figure 11.1 Nelly Kaplan, *La Fiancée du pirate*, 1969

draws on Michelet's contention that witches were frequently young and beautiful in portraying Marie and Sibylle as exuberant witches who wield powers of revenge, as demonstrated by their shared command of fire: Marie burns all her belongings in a bonfire before ruining the village, and it is enough for Sibylle, rejected by her lover, to cast a stern look on a cabin for it to burst into flames.[45] But their witch-like abilities also manifest in their ongoing communion with their animal companions. In *La Fiancée du pirate*, Marie's goat companion alludes to the long-standing connection of goats with the Greek god Pan and, later, the devil, and it asserts Marie's position as a witch-like outcast, living in close proximity to a nature that Christianity has posited to be a domain of evil (Figure 11.1). Embodying mythical connections between femininity, nature, and magic, much as Breton envisioned in *Arcanum 17*, Marie establishes a bond with the goat that gives the close-minded community further reason to ostracise her.[46] Marie's bond with the goat is so strong that when the villagers seek to harm her, one of them shoots the goat; after the death of the goat, Marie takes to wearing a necklace with a pendant adorned with the silhouette of a goat's head. As for Sibylle in *Néa*, she keeps a taxidermied owl in her lair-like quarters, associating her with the feminine underworld of the Greek goddess Hecate, who is intimately connected with owls. An association with ancient pagan mysteries is fortified by Sibylle's closest companion, the cat Cumes. As the typical witch's familiar, the cat acts as convenient shorthand for Sibylle's witch-like status. The strength of their relationship is asserted by the fact that their combined names, Sibylle and Cumes, form a reference to the

Cumaean sibyl, one of the oracles in Greek mythology. In this way, Kaplan not only asserts the prophetic nature of Sibylle's writings, and with it the oracular aspirations of surrealism, but also the fact that her revolt against a narrow-minded patriarchal society is enacted in close collaboration with her cat. It is by communing that Sibylle and Cumes manage to garner the power to effect change.

The goat and Cumes, then, are partly transformed into mythological creatures, but they cannot be reduced to mere surfaces for the projection of human values. Animal studies has been critical of the prevalent representation of animals as symbols for human qualities, drives, or unconscious urges.[47] In *Animals in Film*, Jonathan Burt calls for a more nuanced approach to the problem of human identification with animals, arguing that these do not necessarily carry any fixed assumptions of anthropomorphism or anthropocentrism.[48] Many surrealist depictions of animals indicate fruitful possibilities for employing animal symbolism or totemism in combination with letting animals retain their own identity and agency. Consider Carrington's frequent depictions of horses. At once reflective of the artist's aspirations and inner turmoil and charged with their own sovereign sense of mystery, her horses suggest that an animal imagination may be conducive to greater intimacy with the non-human, while still respecting its alterity. Kaplan's films too evince a combined state of animal intimacy and alterity in relation to humans. She does not merely imbue the cat and the goat with human values, but depicts a reciprocal bond, in that the goat and the cat in their turn intrude on the human.

Such reciprocal relations and exchanges are particularly apparent in scenes where human and non-human animals exchange knowing looks or engage in collaborative action. In *La Fiancée du pirate*, Marie is shown washing the goat and talking to it about their love for one another, as she attempts to gaze into its eyes. In other scenes, the camera lingers in close-up on the goat's face longer than is motivated by the narrative, its eyes with their slanted pupils excitedly probing the surroundings, as if the camera recognises the goat's agency and sentience. As Kirsten Strom points out, similar close-ups of animals in Buñuel's films draw attention to the animal actors' own experience and feelings when being filmed.[49] Indeed, the lingering shots of the goat appear as something akin to documentary moments that threaten to rupture the narrative, but which ultimately assert the film's intimation of solidarity with non-human animals.[50] When the villagers have killed the goat, Marie buries it next to her mother, indicating that this is something much more than either a pet or a farm animal: the goat is a family member. The human–animal intimacy was strong off set, too, as Kaplan herself relates having established a telepathic communication with the goat.[51]

Similarly, in *Néa*, Sibylle appears to be much closer to Cumes than to any member of her family, or indeed to her peers. Like many other humans, she speaks to the cat as she sits around in her room. But their relationship is more intimate than that. In one scene, Sibylle masturbates in order to garner inspiration for writing erotica. Close-ups of her face are intercut with close-ups of Cumes, and Kaplan establishes a bond between them that proves to be transgressive in its intimacy. When Sibylle climaxes, a close-up on Cumes' face indicates that he too experiences sexual bliss. Kaplan further couples Sibylle's erotic inquisitiveness with her communion with Cumes when she shows her spying on the sexual acts of others in her quest for literary inspiration. When Sibylle the erotic spy parts sheer curtains to gaze at illicit lesbian lovemaking or a masturbating woman, she holds Cumes in her arms and the two look on with seemingly shared fascination (Plate 9). *Néa* is Kaplan's most sustained attempt at creating the sort of female eroticism on screen that she envisions in an early essay.[52] In the scenes where Sibylle and Cumes observe sexual acts, she radicalises her critique of the male gaze, as the new female gaze is one in which the human looks in tandem with the cat. The looks exchanged between Sibylle and Cumes as well as their interspecies gazing indicate that there is a subtle levelling of hierarchies in the natural world taking place in the film. Cumes may be an obvious symbol of Sibylle's status as a witch, but he is not reducible to that. Like Marie and the goat, the pair are also engaged in an interspecies communion that traverses the distance between photographic document and myth.

While *La Fiancée du pirate* and *Néa* are mainly focused on the transformation of human society, both films show this transformation to be an outcome of interspecies solidarity and human–animal revolt. In *La Fiancée du pirate* in particular, Kaplan demonstrates that the forces that oppress women also show a marked disdain for animals. In identifying the multi-tiered axis of oppression to work against women, animals, and non-normative desire, Kaplan joins forces with other surrealists analysing oppression with a view to its animal victims, from Breton in *Arcanum 17* to Carrington in *The Hearing Trumpet* and on to Gina Litherland and Hal Rammel in the anti-speciesist tract 'An Unjust Dominion' (1986).[53] While the animals assert the protagonists' connection with nature and their position as modern witches, they do not merely symbolise female marginalisation but actively share in the narratives of female liberation. Kaplan's films, then, point to the utopian possibility of human–animal alliances, a solidarity in revolt between humans and animals, forged through enchanted interspecies encounters. Her depiction of intimate relations between humans and animals resonate with Fourier's belief that the lopsided relations between humans and other animals engendered by civilisation would be rectified in a society based on passional attraction and universal harmony. In *The Theory of the Four*

Movements, he predicts that in a society developed according to his ideas, 'any number of other animals, such as ostriches, fallow-deer, jerboa, etc., will become friendly with man when they find him enticing enough to remain near him, which will never happen in the civilised order'.[54] In enacting desire-driven revolts aided by animal companions against the edifices of the civilisation of the Anthropocene – family, country, and religion coupled with anthropocentrism and its attendant exploitation of other species – Kaplan's films present their protagonists as Fourierian pioneers of new human–animal relations.

Kaplan's depiction of intimate relationships between humans and animals that are at once symbolical and agents and subjects in their own right functions as a form of magical mapping of new ways of coexisting in the world. They are myths about the possibility of mending the constructed gap between human and non-human that Morton traces all the way back to the invention of agriculture, the source of the Anthropocene.[55] While such representations certainly transgress the realistically plausible, they are powerful on the level of the imagination and dismantle the ingrained dichotomy of humans and other animals. For Breton, surrealism's new myth was to be a means of 'fostering the society that we judge to be desirable'.[56] Kaplan's films probe new ways of disseminating new myths of a more desirable and egalitarian world, rid of anthropocentrism.

Jan Švankmajer: animation against anthropocentrism

'I have always taken animals as my loved ones. Humanity mistreats animals when they look at them as something of lesser value. My family is presently composed of my wife, a tom cat, a dog, and me.'[57] Like Nelly Kaplan's protagonists, Jan Švankmajer conceives of animals as family members; his films also frequently depict animal revolts against social strictures as well as scientific logic. But where Kaplan lashes out against patriarchy, Švankmajer appears to be intent on dethroning humanity itself, or at the very least 'shak[ing] up the illusion of anthropocentrism'.[58] In Švankmajer's latest, and reputedly last, film, *Insect*, he approaches Buñuel's near-entomological perspective on humans, as the characters succumb to drives that shatter the veneer of civilisation and its humanist pretentions.[59] Yet, for all the cynical bleakness permeating many of his films, Švankmajer has a firm belief in the transformative power of the magical imagination, and he envisions the possibility of a new non-anthropocentric world order under the sign of such visionary thinkers as Fourier.[60] Švankmajer's cynical outlook is shaped by the Czechoslovak social climate and by his decades-long participation in the Surrealist Group of Prague.

Trained in puppet theatre and fine art, Švankmajer is a prolific artist, working in assemblage, collage, and drawing, alongside his more famous films. Having long been attracted to surrealism, he joined the surrealist group in Prague in 1971. The Prague group was forced into underground existence by the totalitarian regime, but kept up a close dialogue with surrealists in other countries. After decades of political repression, the Czechoslovak surrealists remained wary of the utopian leanings of Breton's late thought.[61] The harsh reality in a totalitarian state instilled in them an emphasis on what their main theorist, Vratislav Effenberger, called 'the raw cruelty of life' and the poetry found in everyday material reality. Effenberger's material poetics informs Švankmajer's treatment of civilisation as a heap of detritus ripe for transformation, as well as his attentiveness to the materiality of objects and animal bodies alike.[62] Already before joining the surrealist group, Švankmajer evinced a similar sensibility in short films such as *The Flat* (*Byt*, 1968) and *A Quiet Week in the House* (*Tichý týden v dome*, 1969); their stark black-and-white photography emphasises the brute materiality of an everyday environment in which the protagonists are forced to go through rituals as convoluted and pointless as those endured by Josef K. in Franz Kafka's *The Trial* (1925). Disrupting this dreary existence, Švankmajer uses animation and montage to give life to furniture, foodstuffs, stones, walls, household objects, and, in the latter film, a fleshy animal tongue, which are all made to work against their intended uses. As they frustrate and fascinate the human characters faced with them, these animated objects express a view of the material world as permeated with a trickster-like agency. In sharp contrast to Western convictions that objects are but inert matter, Švankmajer conceives of animation as an animist technique that is able to give expression to the inner, secret life of the non-human world, from kitchen utensils and furniture to mud and stones.[63] Another facet of this animist outlook can be seen in the prevalence of animals in his films and art.

Švankmajer frequently depicts animals that break out of the taxonomies imposed upon them by humans and acquire their own sense of life and agency, even when they are composed of illustrations from old natural-history books and anatomical guides, or of bones, shells, twigs, and pot lids. An early example of animal collages and assemblages running rampant can be found in the short film *Historia Naturae, Suita* (1967), in which specimens in natural-history collections revolt against captivity and the human mania for order. Quick cuts reveal otherwise obscured relations between different species, stuffed fish move in maniacal circles in their display cases, and armadillos spin on their backs. Animating taxidermied animals, creating new imaginary animals, and giving life to objects in this way, Švankmajer instils the non-human world with a capacity for revolt against human domination.

In later films such as the features *Alice* and *Lunacy*, Švankmajer refines his animation of skeletal assemblages, tongues, brains, skulls, and eyes, and lets them loose in diegetic worlds in which a repressive reality is challenged by the magical imagination.

Švankmajer's joyous invention of imaginary animals and playful animation of dead animal bodies evoke long-standing debates about the ethical problems of the use of animals in art.[64] While his works hardly resolve such issues, his treatment of animal parts is shot through with a bleak insight into the problem of mass extinction. The animals he creates, he comments, 'already exist latently, whether in a pile of cut-outs or in a pile of bones, in old taxonomy or dried fruits … It is about "the divine art of creation" which should correct the effects of ecological catastrophe on our fauna.'[65] If it sounds misguided to consider the creative imagination a solution to the very real extinction of species in the Anthropocene, Švankmajer's response harbours an insight into the need to recalibrate the human approach to animals and nature from one of exploitation, domination, and instrumental science to a mode of coexistence. Giovanni Aloi contends that taxidermy art emerging from a lineage that includes the surrealist object 'maps models for registering human/animal interconnectedness beyond scientific/capitalist optics', combined with 'a kind of prescientific enchantment capable of focusing our attention on ecosystems and interspecies existence from new perspectives'.[66] Similarly, Švankmajer's animated taxidermy specimens and animal skeletons break out of scientific strictures and are enriched by magic, myth, and imagination. The presence of dead animals, or parts of them, may have the effect of reminding spectators of the systematic killing of animals characterising this civilisation, while at the same time instilling in these dead bodies a spark of revolt. Inventing new species may appear to be scant consolation for the loss of diversity caused by the ongoing Sixth Mass Extinction, but, much as Breton intuited in *Arcanum 17*, Švankmajer believes that a civilisation that forsakes imagination and magic has little hope of changing its ways. Fourier's spectre haunts these subversions.

In 1990, following the fall of the totalitarian Czechoslovak regime, Švankmajer expressed his anti-anthropocentric criticism of civilisation in the essay 'To Renounce the Leading Role', originally published in the Czech surrealists' journal *Analogon*. In it, he argues that humanity ought to step down from its self-elected position as ruler of all other species. Tracing the deplorable current state of human exceptionalism back to the appearance of first monotheism and then the Enlightenment, Švankmajer argues that we instead ought to look to 'primitive' societies, Jean-Jacques Rousseau, hermeticism, myth, and Fourier, all refracted through surrealism, to evade human domination in favour of a more magical and egalitarian form of coexistence with the non-human world. Švankmajer's contention that

'repression ... is a tax humanity pays for civilisation' aligns with Fourier's intense criticism of the way in which civilisation thwarts life and desire.[67] Similarly, Švankmajer's inventive bestiary can be conceived as a take on Fourier's utopian vision of the emergence of new animal species following the end of civilisation; but Fourier's suggestion that the lion will transform into a peaceful anti-lion is a far cry from Švankmajer's slithering brains and animated hybrid skeletons.[68] Švankmajer indeed turns Fourier's residual anthropocentrism – as reflected in his idea of a 'universal analogy', in which the world mirrors human passions – on its head.[69] Retaining Fourier's vision of an imaginative transformation of the world under the sign of imagination, passion, and play, Švankmajer liberates it from the stranglehold of humanism and anthropocentrism, as he invites other species and things into the passional correspondences structuring a world rid of domination.

The return of that which is repressed by civilisation is particularly forcefully depicted in *Insect*. The film evinces Švankmajer's deep fascination for the morphology and behaviour of insects; it teems with ants and a wide variety of beetles, ranging from pinned specimens arranged in displays, to live creatures crawling, to animated cut-outs. Buñuel once stated, 'I'm passionate about insects. You can find all of Shakespeare and de Sade in the lives of insects'.[70] Few films evoke this sentiment in such a literal way as *Insect*, which depicts an amateur theatre troupe rehearsing Karel and Josef Čapek's *The Insect Play* (1922), while falling prey to insect-like behaviour with more than a little touch of Kafka to it. Some of the actors are increasingly overwhelmed by dark desires, including an appetite for human flesh and murderous impulses, while others are drawn to emulate the dung beetle's perpetual rolling of balls of manure or the slithering becoming of larvae.

With *Insect*, Švankmajer proposes something similar to what Allen Weiss describes as the 'Surrealist "theory" of culture' in *L'Âge d'or*, 'where the established values of sublimation are consistently challenged by the disruptive effects of perversion'.[71] *Insect* indeed continues the imaginative investigation into creative perversion that Švankmajer conducted in *Conspirators of Pleasure* (*Spiklenci slasti*, 1996), as well as the dismantling of Western civilisation in *Lunacy*. Accordingly, *Insect* recalls the Marquis de Sade's penetrating insight in the murderous passions seething inside humans, Sigmund Freud's discovery that everyday 'normal' behaviour is but a flimsy cover for the dark continent of the unconscious, and Buñuel's entomological gaze upon modern society. But whereas the opening of *L'Âge d'or* suggests a comparison between scorpions and the social interactions depicted in the film, Švankmajer goes further and destabilises human society entirely by letting the amateur actors gradually transform into insects. In one scene, an actor looks at himself in the mirror and, much as Gregor Samsa in Kafka's 'The Metamorphosis' (1915) wakes up to find himself inhabiting a beetle

body, sees the face of an insect stare back at him, the close-up warped by the rapid transformations of animation (Plate 10). The result is as much an acerbic critique of the continued repression exerted by civilisation as it is an affirmation of the animalistic inner life that the very same civilisation is barely able to hide. A new myth of insect reflections peeling off the human face may take shape here.

For Breton, the Great Transparents were supposed to bring a sense of humility to humans by virtue of these beings' position on a higher place on the *scala naturae*, that fusion of Ancient philosophy and Christianity that depicted the world as a hierarchical great chain of being with inanimate things on the bottom rung, followed by simple and then more complex animals, humans, angels, and ultimately God.[72] But a decade later, in 'On Surrealism in Its Living Works', Breton shies away from using such notions even for strategic purposes. In that essay, he refers to the great chain of being as 'the scale [humanity] has constructed', further expanding on the vagaries of a non-anthropocentric worldview and asserting that humanity is but one form of being in the world.[73] In *Insect*, a surrealist myth similarly emerges out of a collapsing of the great chain of being, as humans transform into insects. For Švankmajer, as for other surrealists, such dehumanisation is not tantamount to degradation, but is rather an expression of revolt against delusions of human exceptionalism.[74] Again, Švankmajer uses animation along with other special effects as a means of questioning ingrained ontological hierarchies. A stuttering, insecure, and perpetually tardy actor in the play rehearsed in the film finds a more agreeable form of existence when he starts living like a dung beetle. He grabs a pinned dung beetle from an insect collection brought to the rehearsal by the director, but as he lifts it the beetle comes to life. Later, as he looks out the window, he sees huge, cut-out animated dung beetles rolling their balls over preternaturally green grass. Accidentally dropping a dung beetle's ball of faeces into the toilet, he beholds it growing to an enormous size, as though it beckons him to start rolling it. Much as Breton's Great Transparents, then, Švankmajer's insects strike a blow against anthropocentrism through sharp shifts of scale at the same time as they assert the need for suprarational approaches to human–animal relations.

Švankmajer, however, is adamant that he does not intend his films to carry any kind of message. In his filmed introduction to *Insect*, he states (Plate 11):

> I wrote the script just as it came out of me, in one go, just like automatic writing. Without any rational or moral control. That's the only way you can avoid the messianic temptation of great artists to reform humankind, to improve, to warn, to refine. Won't work. Read Freud. The only good answer to the cruelty of life is the scorn of imagination, as one Czech decadent poet would put it.

In an interview, Švankmajer spoke in similar ways of the difficulty of envisioning revolutionary change in a world plagued by the catastrophes of fascism and Stalinism.[75] Yet elsewhere he claims: 'For me, the only purpose of art (if it has one at all) is to liberate people … I think the world would come to a halt without utopia. And art is that land where utopia is most at home.'[76] While *Insect* may not carry a message, its collapsing of the great chain of being and revelation of the inner insect in humans provide new conceptions of human–animal relations in the form of myths that speak to the Anthropocene and against its mass extinction. In a similar way, Švankmajer's earlier films imbue the non-human world with a sense of unpredictable life that undermines mechanistic-industrial conceptions of the world. The problem with the ongoing catastrophe, after all, is not that humanity does not know that our treatment of the planet and our fellow beings is untenable – we have been aware of the catastrophic effects of industrialism for centuries – but that we fail to imagine or implement alternatives. No matter how blackly humorous and pessimistic they may appear, no matter how void of higher sentiment, Švankmajer's animal assemblages, animated objects, and new myths of insect transformations are fraught with an injunction to live new ways of coexistence.

Much as Kaplan's films imagine new human–animal relations, so Švankmajer probes the imagination in order to envision a transformed world in which humanity is deprived of its position as the leading species. Both film-makers present new myths of a non-anthropocentric order more passional than instrumental.

Notes

1 Research for this chapter has been funded by the Swedish Research Council, 2016–01196.
2 I refer to "domination" in the sense used in the anarchist critique of power and coercion, so often shared by surrealism. See Clark, *The Impossible Community*, 94.
3 See Bonneuil and Fressoz, *The Shock of the Anthropocene*. Throughout this essay, I refer to non-human animals as animals. But lest there be any misunderstandings: humans are animals too, and the surrealists realised this early on.
4 Compare this with Morton, *Hyperobjects*; and Sax, *Imaginary Animals*, 32, 253.
5 Breton, 'Second Manifesto of Surrealism', 128, italics original.
6 'Now's the Time', 3.
7 See Conley, 'Sleeping Gods in Surrealist Collections', 19–21; Rentzou, 'The Minotaur's Revolution', 63, 68; and Roberts, 'The Ecological Imperative', 219–20.
8 See Calarco, *Zoographies*, 6.
9 See Noheden, *Surrealism*.
10 See Breton, 'Prolegomena to a Third Surrealist Manifesto or Not', 287–8,

11 Bonneuil and Fressoz, *The Shock of the Anthropocene*, 16–17.
12 Breton, 'Prolegomena to a Third Surrealist Manifesto or Not', 293.
13 See LaCoss, 'Attacks of the Fantastic', 267–99.
14 Fourier, *The Theory of the Four Movements*, 7–8.
15 See Begin, 'Entomology as Anthropology in the Films of Luis Buñuel', 433.
16 See Rentzou, 'The Minotaur's Revolution', 67–8; Breton, 'Picasso in His Element', 111–22; Caillois, 'The Praying Mantis', 69–81; and Caillois, 'Mimicry and Legendary Psychasthenia', 91–103.
17 See Skrbina, *Panpsychism in the West*.
18 Roberts, 'The Ecological Imperative', 217–18.
19 Breton, 'Prolegomena to a Third Surrealist Manifesto or Not', 293.
20 Ibid.
21 Compare this with Bate, *The Song of the Earth*, 42.
22 Bonneuil and Fressoz, *The Shock of the Anthropocene*, 16–17.
23 Roberts, 'The Ecological Imperative', 217.
24 Morton, *Dark Ecology*, 6–8.
25 Ibid., 5.
26 Breton, 'The Lamp in the Clock', 108.
27 See Irwin and Versluis, 'Introduction', ix–x; and Breton, 'Ascendant Sign', 104–7.
28 Mahon, *Surrealism and the Politics of Eros*, 108.
29 Bonneuil and Fressoz, *The Shock of the Anthropocene*, 41, 257.
30 Ibid., 184; Fabrice Flahutez, *Nouveau monde et nouveau mythe*, 405–6.
31 LaCoss, 'Attacks of the Fantastic', 274.
32 Breton, *Conversations*, 207–8.
33 For the first two, see Colaux, *Nelly Kaplan*, 104, 65.
34 Kaplan, *Entrez*, 18.
35 For references to many of these figures, see the epigraphs to the stories collected in Belen, *Le Réservoir des sens*.
36 See Dupont, 'Searching for Nelly Kaplan', 27.
37 See Richardson, *Surrealism and Cinema*, 93–5.
38 Colaux, *Nelly Kaplan*, 13.
39 Breton with Legrand, *L'Art magique*, 248.
40 See Kyrou, *Le Surréalisme au cinéma*.
41 See Noheden, *Surrealism*, 117ff.
42 'All Creation Is Androgynous', 301.
43 See Fourier, *Theory of the Four Movements*.
44 Sax, *Imaginary Animals*.
45 See Breton, *Anthology of Black Humor*, 335.
46 Breton, *Arcanum 17*, 78ff.
47 See, for example, Baker, *Artist Animal*.
48 Burt, *Animals in Film*, 25–30.
49 Strom, *The Animal Surreal*, 20–2.
50 Compare this with Burt, *Animals in Film*, 11.
51 Kaplan, *Entrez*, 266.
52 Kaplan, 'At the Women Warrior's Table', 298–9.

53 Breton, *Arcanum 17*, 58; Carrington, *The Hearing Trumpet*; Litherland and Rammel, 'An Unjust Dominion', 11.
54 Fourier, *Theory of the Four Movements*, 46.
55 See Morton, *Humankind*.
56 Breton, 'Prolegomena to a Third Surrealist Manifesto or Not', 287–8.
57 Solarik, *Jan Švankmajer*, 225.
58 Koepfinger, '"Freedom Is Becoming the Only Theme"'.
59 See Begin, 'Entomology as Anthropology in the Films of Luis Buñuel'.
60 Koepfinger, '"Freedom Is Becoming the Only Theme"'.
61 See the collective statement 'The Possible against the Current', 69. For an extended discussion, see Noheden, *Surrealism*, 166–9.
62 Effenberger, 'The Raw Cruelty of Life and the Cynicism of Fantasy', 437–44.
63 See López Caballero, 'Jan Švankmajer', 188.
64 See Aloi, 'The Death of the Animal', 59–68.
65 Solarik, *Jan Švankmajer*, 251.
66 Aloi, *Speculative Taxidermy*, 255.
67 Švankmajer, 'To Renounce the Leading Role', [2].
68 See Fourier, 'Detail of a Creation of the Hypomajor Keyboard', 47.
69 See Bonneuil and Fressoz, *The Shock of the Anthropocene*, 184.
70 de la Colina and Pérez Turrent, *Objects of Desire*, 6.
71 Weiss, 'Between the Sign of the Scorpion and the Sign of the Cross', 159.
72 Breton, 'Prolegomena to a Third Surrealist Manifesto or Not', 293; Godfrey-Smith, *The Philosophy of Biology*, 5.
73 Breton, 'On Surrealism in Its Living Works', 304.
74 See Noheden, 'The Grail and the Bees', 249–50.
75 Koepfinger, '"Freedom Is Becoming the Only Theme"'.
76 Quoted in Johnson, *Jan Švankmajer*, 156.

Bibliography

'All Creation is Androgynous: An Interview'. In *Surrealist Women: An International Anthology*, edited by Penelope Rosemont, 300–3. Austin, TX: University of Texas Press, 1998.

Aloi Giovanni. 'The Death of the Animal'. *Journal of Visual Art Practice*, 9, no. 1 (2010): 59–68.

———. *Speculative Taxidermy: Natural History, Animal Surfaces, and Art in the Anthropocene*. New York: Columbia University Press, 2018.

Baker, Steve. *Artist Animal*. Minneapolis, MN: University of Minnesota Press, 2013.

Bate, Jonathan. *The Song of the Earth*. London: Picador, 2000.

Begin, Paul. 'Entomology as Anthropology in the Films of Luis Buñuel'. *Screen* 48, no. 4 (2007): 425–42.

Belen (pseud. for Nelly Kaplan). *Le Réservoir des sens*. Paris: La Jeune Parque, 1966.

Bonneuil, Christophe, and Jean-Baptiste Fressoz. *The Shock of the Anthropocene*, translated by David Fernbach. London: Verso, 2017.

Breton, André. *Anthology of Black Humor*, translated by Mark Polizzotti. San Francisco, CA: City Lights, 1997.

———. *Arcanum 17: With Apertures Grafted to the End*. Translated by Zack Rogow. Los Angeles, CA: Green Integer, 2004.

———. 'Ascendant Sign'. In *Free Rein*, translated by Michel Parmentier and Jacqueline d'Amboise, 104–7. Lincoln, NE: University of Nebraska Press, 1995.

———. *Conversations: The Autobiography of Surrealism*, translated by Mark Polizzotti. New York: Paragon House, 1993.

———. 'The Lamp in the Clock'. In *Free Rein*, translated by Michel Parmentier and Jacqueline d'Amboise, 108–21. Lincoln, NE: University of Nebraska Press, 1995.

———. 'On Surrealism in Its Living Works'. In *Manifestoes of Surrealism*, translated by Richard Seaver and Helen R. Lane, 297–304. Ann Arbor, MI: University of Michigan Press, 1972.

———. 'Picasso in His Element'. In *Break of Day*, translated by Mary Ann Caws and Mark Polizzotti, 111–22. Lincoln, NE: University of Nebraska Press, 1999.

———. 'Prolegomena to a Third Surrealist Manifesto or Not'. In *Manifestoes of Surrealism*, translated by Richard Seaver and Helen R. Lane, 281–94. Ann Arbor, MI: University of Michigan Press, 1972.

———. 'Second Manifesto of Surrealism'. In *Manifestoes of Surrealism*, translated by Richard Seaver and Helen R. Lane, 117–94. Ann Arbor, MI: University of Michigan Press, 1972.

———, with Gérard Legrand. *L'Art magique*. Paris: Adam Biro, 1991.

Burt, Jonathan. *Animals in Film*. London: Reaktion, 2002.

Caillois, Roger. 'Mimicry and Legendary Psychasthenia'. In *The Edge of Surrealism: A Roger Caillois Reader*, edited by Claudine Frank, translated by Claudine Frank and Camille Naish, 91–103. Durham, NC: Duke University Press, 2003.

———. 'The Praying Mantis: From Biology to Psychoanalysis'. In *The Edge of Surrealism: A Roger Caillois Reader*, edited by Claudine Frank, translated by Claudine Frank and Camille Naish, 69–81. Durham, NC: Duke University Press, 2003.

Calarco, Matthew. *Zoographies: The Question of the Animal from Heidegger to Derrida*. New York: Columbia University Press, 2008.

Carrington, Leonora. *The Hearing Trumpet*. London: Penguin, 2005.

Clark, John P. *The Impossible Community: Realizing Communitarian Anarchism*. New York: Bloomsbury, 2013.

Conley, Katharine. 'Sleeping Gods in Surrealist Collections'. *Symposium* 67, no. 1 (2013): 6–24.

Colaux, Denys-Louis. *Nelly Kaplan: Portrait d'un Flibustière*. Paris: Dreamland, 2002.

de la Colina, José, and Tomás Pérez Turrent. *Objects of Desire: Conversations with Luis Buñuel*, edited and translated by Paul Lenti. New York: Marsilio, 1992.

Dupont, Joan. 'Searching for Nelly Kaplan'. *Film Quarterly* 71, no. 4 (2018): 22–32.

Effenberger, Vratislav. 'The Raw Cruelty of Life and the Cynicism of Fantasy'. In *Cross Currents: A Yearbook of Central European Culture*, volume 6, edited by Ladislav Matejka, 437–44. Ann Arbor, MI: University of Michigan, 1987.

Flahutez, Fabrice. *Nouveau monde et nouveau mythe: Mutations du surréalisme, de l'exil américain à l'"Écart absolu' (1941–1965)*. Dijon: Les Press du réel, 2007.

Fourier, Charles. 'Detail of a Creation of the Hypomajor Keyboard'. In *Anthology of Black Humor*, by André Breton, translated by Mark Polizzotti, 47. San Francisco, CA: City Lights, 1997.

———. *The Theory of the Four Movements*, edited and translated by Gareth Stedman Jones and Ian Patterson. Cambridge: Cambridge University Press, 1996.

Godfrey-Smith, Peter. *The Philosophy of Biology*. Princeton, NJ: Princeton University Press, 2014.

Irwin, Lee, and Arthur Versluis. 'Introduction'. In *Esotericism, Religion, and Nature*, edited by Arthur Versluis, Claire Fanger, Lee Irwin, and Melinda Phillips, ix–xiv. Minneapolis, MN: North American Academic Press, 2010.

Johnson, Keith Leslie. *Jan Švankmajer*. Urbana, IL: University of Illinois Press, 2017.

Kaplan, Nelly. 'At the Women Warrior's Table', translated by Paul Hammond. In *Surrealist Women: An International Anthology*, edited by Penelope Rosemont, 298–9. Austin, TX: University of Texas Press, 1998.

———. *Entrez, c'est ouvert!: Autobiographie*. Paris: L'Âge du homme, 2016.

Koepfinger, Eoin. '"Freedom Is Becoming the Only Theme": An Interview with Jan Švankmajer'. *Sampsonia Way*, 5 June 2012. Accessed 9 January 2020. www.sampsoniaway.org/blog/2012/06/05/freedom-is-becoming-the-only-theme-an-interview-with-jan-Švankmajer/.

Kyrou, Ado. *Le Surréalisme au cinéma*. Paris: Ramsay, 2005.

LaCoss, Donald. 'Attacks of the Fantastic'. In *Surrealism, Politics and Culture*, edited by Raymond Spiteri and Donald LaCoss, 267–99. Aldershot: Ashgate, 2003.

Litherland, Gina, and Hal Rammel. 'An Unjust Dominion'. *International Surrealist Bulletin*, no. 1 (1986): 11.

López Caballero, Carolina. 'Jan Švankmajer: A Magical Outlook on Life and the World'. In *Metamorfosis: Visiones fantásticas de Starevich, Švankmajer y los hermanos Quay*, edited by Carolina López Caballero and Andrés Hispano, 187–8. Barcelona: Centre de Cultura Contemporània de Barcelona, 2014.

Mahon, Alyce. *Surrealism and the Politics of Eros, 1938–1968*. London: Thames & Hudson, 2005.

Morton, Timothy. *Dark Ecology: For a Logic of Future Coexistence*. New York: Columbia University Press, 2016.

———. *Humankind: Solidarity with Nonhuman People*. London: Verso, 2017.

———. *Hyperobjects: Philosophy and Ecology after the End of the World*. Minneapolis, MN: University of Minnesota Press, 2013.

Noheden, Kristoffer. 'The Grail and the Bees: Leonora Carrington's Quest for Human–Animal Coexistence'. In *Beyond Given Knowledge: Investigation, Quest and Exploration in Modernism and the Avant-Gardes*, edited by Harri Veivo, Jean-Pierre Montier, Françoise Nicol, David Ayers, Benedikt Hjartarson, and Sascha Bru, 239–52. Berlin: De Gruyter, 2017.

———. *Surrealism, Cinema, and the Search for a New Myth*. Cham: Palgrave Macmillan, 2017.

'Now's the Time'. *Arsenal: Surrealist Subversion*, no. 4 (1989): 3.

'The Possible against the Current'. In *Surrealism against the Current: Tracts and Declarations*, edited and translated by Michael Richardson and Krzysztof Fijał-kowski, 66–75. London: Pluto Press, 2001.

Rentzou, Effie. 'The Minotaur's Revolution: On Animals and Politics'. *L'Ésprit créateur* 51, no. 4 (2011): 58–72.

Richardson, Michael. *Surrealism and Cinema*. Oxford: Berg, 2006.

Roberts, Donna. 'The Ecological Imperative'. In *Surrealism: Key Concepts*, edited by Krzysztof Fijałkowski and Michael Richardson, 217–27. London: Routledge, 2016.

Sax, Boria. *Imaginary Animals: The Monstrous, the Wondrous and the Human*. London: Reaktion, 2013.

Skrbina, David. *Panpsychism in the West*. Cambridge, MA: MIT Press, 2005.

Solařík, Bruno, ed. *Jan Švankmajer*. Prague: CPress, 2018.

Strom, Kirsten. *The Animal Surreal: The Role of Animals, Darwin, and Evolution in Surrealism*. New York: Routledge, 2017.

Švankmajer, Jan. 'To Renounce the Leading Role'. *Manticore/Surrealist Communication*, no. 2 (1997): [2].

Weiss, Allen S. 'Between the Sign of the Scorpion and the Sign of the Cross: *L'Âge d'or*'. In *Dada and Surrealist Film*, edited by Rudolf E. Kuenzli, 159–75. Cambridge, MA: MIT Press, 1996.

Index

CPSIA information can be obtained
at www.ICGtesting.com
Printed in the USA
BVHW021453141021
618899BV00014B/37